Selected Letters of Clive Bell

Selected Letters of Clive Bell

Art, Love and War in Bloomsbury

Edited and Introduced by Mark Hussey

EDINBURGH
University Press

Edinburgh University Press is one of the leading university presses in the UK. We publish academic books and journals in our selected subject areas across the humanities and social sciences, combining cutting-edge scholarship with high editorial and production values to produce academic works of lasting importance. For more information visit our website: edinburghuniversitypress.com

Edinburgh University Press Ltd
The Tun – Holyrood Road
12(2f) Jackson's Entry
Edinburgh EH8 8PJ

Typeset in 10/11.5 Adobe Sabon by
IDSUK (DataConnection) Ltd

A CIP record for this book is available from the British Library

ISBN 978 1 3995 1597 9 (hardback)
ISBN 978 1 3995 1598 6 (webready PDF)
ISBN 978 1 3995 1599 3 (epub)

Contents

Acknowledgements

I am deeply grateful to Julian Bell for granting permission for this project, and to Sarah Baxter at the Society of Authors for handling the necessary details with the estate of Clive Bell. My thanks to the anonymous readers of the proposal, and to Jackie Jones and her colleagues at Edinburgh University Press. Emily Kopley, Faye Hammill, Claire Davison and Stephen Barkway gave me valuable advice, information and feedback on the editorial matter; Helane Levine-Keating checked my translations. Graeme Trotter kindly allowed me to use an image from the Bell family albums as the frontispiece. Thanks, as always, to Evelyn for reading, encouraging, supporting and cheering me on.

Editorial Practices

All of the selected letters were hand-written, except for those previously published. I have made a semi-diplomatic transcription, in that I have preserved Bell's often erratic spelling and punctuation, but I have not attempted to reproduce the actual layout of a letter. I have added [*sic*] wherever there might have been some confusion over the source of an error in spelling.

Addresses are given as Clive Bell wrote them at the head of a letter, or from the printed letterhead, with explanations of each found in the 'Addresses' section below.

Dates conform editorially to a consistent month-day-year format. Uncertainty or best guesses are indicated by a question mark within square brackets.

Usually (to conserve paper) Bell did not begin a new paragraph on a new line; sometimes he left a slightly longer space after a full stop, presumably to indicate a new paragraph's beginning, but as this is not always clear I have transcribed the letters as written, only indicating a new paragraph where there is no doubt of his intention.

Unless indicated otherwise at their foot, letters were transcribed from the following archives:

To Vanessa Bell	The Keep, Sussex
To Douglas Gordon	Albert and Shirley Small Special Collections Library, University of Virginia
To Mary Hutchinson	Harry Ransom Center, University of Texas at Austin
To Frances Partridge	Modern Archives, King's College, Cambridge
To Lytton Strachey	British Library
To Virginia [Stephen] Woolf	The Keep, Sussex

References

Hussey, Mark. *Clive Bell and the Making of Modernism, A Biography*. Bloomsbury, 2021.

Rosenbaum, S. P. 'The Art of Clive Bell's *Art*'. G. Fløistad, ed. *Contemporary Philosophy Vol. 9: Aesthetics and Philosophy of Art*. Springer, 2007.

Woolf, Virginia. *The Diary of Virginia Woolf*, ed. Anne Olivier Bell and Andrew McNeillie, 5 vols. Hogarth, 1977–1984.

Woolf, Virginia. *The Letters of Virginia Woolf*, ed. Nigel Nicolson and Joanne Trautmann Banks, 6 vols. Hogarth, 1975–1980.

Abbreviations

nd	= no date
pm	= postmarked (i.e. envelope was present)
{ }	= Clive Bell's square brackets in original
[]	= editorial interpolation
Berg	Albert A. and Henry W. Berg Collection, New York Public Library
BL	British Library
Getty	Getty Research Institute
HRC	Harry Ransom Center, University of Texas at Austin
KCC	Modern Archives, King's College, Cambridge
Kettles Yard	Kettles Yard House and Gallery, Cambridge
Lilly	The Lilly Library, Indiana University
McFarlin	McFarlin Library, University of Tulsa
Morgan	The Morgan Library & Museum
Picasso	Picasso Archives, Musée Picasso
Princeton	Princeton University Library
Sussex	The Charleston Papers, The Keep, Sussex
Tate	Tate Gallery Archive
TSE	T. S. Eliot Estate
VW *D*1–5	*Diary of Virginia Woolf*, vols 1–5
VW *L*1–6	*Letters of Virginia Woolf*, vols 1–6

Addresses

Asheham House/Rodmell/Lewes
Virginia and Leonard Woolf leased Asheham from late 1911 to 1919, when they purchased Monk's House in the village of Rodmell.

Benmore, Lairg, Scotland
A hunting lodge in Scotland rented by Clive Bell's family.

Cassis
See La Bergère

The Century Club, New York
A private club in New York City where Clive Bell stayed on his first trip to the USA, in 1950.

Charleston, Firle, Sussex
Vanessa moved to Charleston Farmhouse in Sussex with Duncan Grant and David Garnett in October 1916. She and Duncan lived there for the rest of their lives. Clive Bell moved in with them in 1939.

The Chicago Club
A private club in Chicago where Clive Bell stayed on his second lecture tour of the USA, in 1952.

Cleeve House, Seend
William H. Bell, Clive's father, bought Cleeve House in the Wiltshire village of Seend in 1883.

Clos du Peyronnet, Menton-Garavan, France
A flat loaned to Clive Bell and Barbara Bagenal by the painter Humphrey Waterfield.

Dana-Palmer House, Cambridge, MA, USA
House owned by Harvard University. Clive Bell stayed there on his 1950 trip to the USA when he lectured at the Fogg Museum.

Garsington Manor
Estate of Lady Ottoline and Philip Morrell, near Oxford, where Clive Bell and many other conscientious objectors spent the First World War.

Glencarron Lodge, Ross-shire
A hunting lodge in Scotland rented by Clive Bell's family.

46 Gordon Square, London
In 1904, the Stephen siblings – Thoby, Vanessa, Virginia and Adrian – moved to Bloomsbury from their family home at 22 Hyde Park Gate. The 'Thursday evenings' in which the Bloomsbury Group originated took place here. Clive and Vanessa Bell took over the house for themselves after their marriage in 1907. Both of their children, Julian and Quentin, were born there. In 1916, when Vanessa moved to Charleston and Clive was at Garsington, each retained rooms at No. 46 while letting part of the house to John Maynard Keynes. From 1917–1918, H. T. J. Norton and J. T. Sheppard also lived there. Duncan Grant had rooms there from about 1919–1925, as did Vanessa Bell from about 1922–1925.

50 Gordon Square, London
Clive Bell moved here in 1922 when Vanessa moved back to No. 46. He remained until 1939, when he moved to Charleston.

24 Great Cumberland Place, W. 1
Clive Bell leased a flat here with Barbara Bagenal in 1963.

M. S. Gripsholm
Ship on which Clive Bell took a tropical cruise in 1933 with Benita Jaeger.

Harbour View/Studland/Wareham Dorset
Vanessa and Clive Bell took Virginia to this house on the coast of Dorset in 1910 to help her recuperate after a breakdown.

Hillyfields, Rye, Sussex
Home of Sydney Waterlow.

Hôtel des Ambassadeurs, Menton
In Menton, southern France, where Clive Bell stayed often with Barbara Bagenal in the 1950s and 1960s.

Hôtel Britannia
In Menton, southern France, where Clive Bell stayed often with Barbara Bagenal in the 1950s and 1960s.

Hotel Brufani, Perugia, Italia
Hotel where Clive, Vanessa and Virginia stayed on a Tuscan holiday in 1908.

Hotel Bellevue, Dresden
Clive Bell travelled to Germany in 1928 with Raymond Mortimer, meeting up there with Eddy Sackville-West.

Hotel d'Anatolia, Broussa, Turkey
In 1911, Clive, Vanessa, Roger Fry and Harry Norton travelled to Turkey to see Byzantine mosaics. While there, Vanessa had a miscarriage, and Roger Fry fell in love with her.

Hotel Excelsior, Berlin
Clive Bell travelled to Germany in 1928 with Raymond Mortimer, meeting up there with Eddy Sackville-West.

Hôtel Voltaire, Quai Voltaire, Paris
Clive Bell usually stayed here when in Paris, until it was converted to apartments in 1922.

6 King's Bench Walk, Temple
In 1902 Clive Bell took rooms in the Temple, one of the Inns of Court in London, upon going down from Cambridge.

La Bergère, Cassis
Vanessa Bell took a ten-year lease on this house in southern France in 1928.

Menton, Garavan
In the late 1950s and early 1960s, Clive Bell spent several summers with Barbara Bagenal in Menton, in the south-east corner of France, near the border with Italy.

19 rue d'Anjou, Paris
Where Clive Bell stayed on his first trip to Paris after the First World War.

3 rue Bonaparte, Paris
Location of the Hôtel de Londres, where Clive Bell usually stayed
in Paris after 1922.

23 rue Hoche, Cannes
Clive Bell rented a flat from the fashion editor Madge Garland
while staying in Cannes with Benita Jaeger in 1930.

19, via Belle Arte, Siena
A lodging house where Vanessa, Clive and Virginia stayed on a
Tuscan holiday in 1908.

254 S. Gregorio, Venice
Where Clive Bell stayed with Raymond Mortimer and Frankie
Birrell in Venice, 1931 and 1932.

People

Below are brief biographical descriptions of recurring figures in the letters. All other identifying information will be found either in footnotes or in brackets within the text of a letter. People for whom there is abundant and easily accessible biographical information are not included.

Barbara Bagenal (1891–1985) – a friend of Dora Carrington's, with whom she attended the Slade School of Art. Barbara (née Hiles) made herself useful in numerous ways to Bloomsbury enterprises such as the Omega Workshops and the Hogarth Press, at both of which she worked. She first came into Clive Bell's circle through meeting Vanessa at a party given by Ottoline Morrell during the First World War. During the Second World War, Barbara became Clive Bell's intimate companion and remained so until the end of his life.

Mary Baker (1901–1961) – an American from Chicago who was known as the 'Shy Bride' because she was reputed to have declined many marriage proposals after leaving the socially prominent Alexander McCormick at the altar in 1922. She and Clive Bell began an affair in 1931 in Venice, where her mother had bought a palazzo.

Cory Bell (1875–1961) – Clive Bell's older brother, a soldier and politician with whom Clive remained close.

François Bernouard (1884–1949) – publisher, book designer, poet and dramatist in Clive Bell's circle of friends in Paris.

Frankie [Francis] Birrell (1889–1935) – David 'Bunny' Garnett's partner in their bookshop near the British Museum, and one of several younger people on the periphery of the Bloomsbury Group; his father was the Liberal politician and essayist Augustine Birrell.

Dorothy Brett (1883–1976) – a painter close to Dora Carrington, Barbara Bagenal and Mark Gertler, Brett lived at Garsington for much of the First World War, where she also became close to Katherine Mansfield. In 1924, Brett accompanied D. H. Lawrence and his wife, Frieda, to New Mexico to help them establish a community at Taos.

Carrington (1893–1932) – the painter Dora Carrington befriended Dorothy Brett, Barbara Bagenal and Mark Gertler (who was in love with her) at the Slade School. In 1916 she fell in love with Lytton Strachey and moved the next year to live with him until his death. She began an affair with Ralph Partridge in 1919, with whom Strachey was in love, and later with Partridge's closest friend, Gerald Brenan.

Kenneth Clark (1903–1983) – typically referred to by Clive Bell as 'K', Clark was a noted art historian, broadcaster and director of the National Gallery.

Jean Cocteau (1889–1963) – one of Clive Bell's closest French friends, Cocteau was an avant-garde writer in several genres, a filmmaker, visual artist and decorator.

Sybil Colefax (1874–1950) – celebrated hostess at her home, Argyll House on the King's Road in London, and an influential interior decorator.

Douglas Cooper (1911–1984) – art historian and prominent collector of Cubist art, which he housed at his Château de Castille in southern France. Picasso's biographer John Richardson lived with Cooper in the 1950s.

Jacques Copeau (1879–1949) – co-founder of the *Nouvelle Revue Française* and manager of the Théâtre du Vieux-Colombier in Paris, for which he commissioned Duncan Grant to make sets for a production of *Twelfth Night* in 1913.

Sergei Diaghilev (1872–1929) – (variously spelled by Clive Bell) Diaghilev's Ballets Russes became the centre of artistic and social life in London immediately after the end of the First World War, producing innovative works that employed artists such as Pablo Picasso and André Derain in set and costume design, and choreographed dances to the music of Igor Stravinsky.

xvi SELECTED LETTERS OF CLIVE BELL

Georges Duthuit (1891–1973) – French art critic married to Marguerite, daughter of Henri Matisse, and one of Clive Bell's closest friends in Paris.

Roger Fry (1866–1934) – the oldest of the original Bloomsbury circle, with whom he came into contact in 1910. Renowned as an art critic and champion of modern art, Fry also founded the Omega Workshops in 1913, following the two successful exhibitions of post-impressionist painting he organised in 1910 and 1912. He married Helen Coombe in 1896, with whom he had two children, Julian and Pamela, but she was institutionalised in 1910 owing to mental instability. In 1911 Roger began an affair with Vanessa Bell, her ending of which when she fell in love with Duncan Grant caused Roger long-lasting distress. In 1926 Helen Anrep left her husband, the mosaicist Boris Anrep, with whom she had two children (Igor and Anastasia), to move in with Fry, with whom she lived until his death.

Henry Gage (1895–1982) – the 6th Viscount Gage, landlord of the Firle Estate, where Charleston is situated. Nicknamed 'Grubby' by Clive Bell, he was married to Imogen Grenfell, nicknamed 'Moggy'. They had two sons, George (known as Sammy) and Henry.

David 'Bunny' Garnett (1892–1981) – the novelist David Garnett was known by the nickname 'Bunny' throughout his life; in 1915, Bunny began an affair with Duncan Grant, whom he had met through Adrian Stephen; during the First World War, Bunny, Duncan and Vanessa Bell initially lived together at Wissett Lodge until moving in 1916 to Charleston. In 1920, Bunny and Francis Birrell opened a bookshop near the British Museum, where Frances Partridge (née Marshall) worked for a time. His first wife was Ray Marshall, Frances's sister. After Ray's death, Bunny married Vanessa Bell and Duncan Grant's daughter, Angelica, with whom he had four daughters.

Waldemar George (1893–1970) – a Polish-born art historian and critic who lived mainly in France, where he edited the magazine *Formes*.

Mark Gertler (1891–1939) – a painter who was in love with Dora Carrington, and a member of Ottoline Morrell's circle at Garsington during the First World War.

Douglas Gordon (1903–1986) – a prominent Baltimore attorney, bibliophile and patron of the arts, Gordon and his wife, Winnie, met Clive Bell in London in 1949. Gordon facilitated Bell's two lecture tours in the USA, starting with an invitation to write an essay about the Cone Collection at the Baltimore Museum of Art.

Mary Hutchinson (1889–1977) – the granddaughter of Lytton Strachey's uncle John, she began a long affair with Clive Bell in 1914 (while pregnant with her second child, Jeremy Hutchinson, the renowned barrister). Mary was close to T. S. Eliot and many other writers and artists and had a complicated relationship with Virginia Woolf. She published articles, reviews and stories under the pseudonym Polly Flinders. Her husband St John 'Jack' Hutchinson was a barrister and champion of civil liberties.

Benita Jaeger (1907–2004) – a film actress, later a sculptor, best friend of the movie star Elsa Lanchester. She married the painter John Armstrong in 1936. Clive began an affair with her in 1929.

John Maynard Keynes (1883–1946) – Keynes shared rooms with Duncan Grant at 21 Fitzroy Square in 1909, and in 1911 lived at 38 Brunswick Square with Virginia Woolf, Duncan Grant and Adrian Stephen, who were later joined by Leonard Woolf. Keynes was elected to the Apostles, a secretive Cambridge club to which many members of 'Bloomsbury' and its circle belonged, with the support of Lytton Strachey and Leonard. In 1925, the famed economist married the Russian ballerina Lydia Lopokova.

Moïse Kisling (1891–1953) – Polish-born French painter living in Paris from 1910.

Rosamond Lehmann (1901–1990) – novelist whose first work, *Dusty Answer*, established her reputation.

Janice Loeb (1911–2005) – American art student, painter and researcher with whom Clive Bell began an affair in 1937 that evolved into a close, lifelong friendship. She took classes at the Euston Road School before returning to New York at the outbreak of the Second World War.

Desmond MacCarthy (1877–1952) – Desmond befriended Leonard Woolf at meetings of the Apostles, and was an early guest at Thoby Stephen's 'Thursday evenings' in 1905. An editor, drama critic and

literary journalist, he wrote the introduction for the catalogue of 'Manet and the Post-Impressionists' at the Grafton Galleries in 1910, an exhibition for which he had accompanied Roger Fry to Paris to help choose some of the works.

Molly MacCarthy (1882–1953) – Molly married Desmond MacCarthy in 1906; both she and Virginia Woolf were nieces by marriage of Anne Thackeray Ritchie, Leslie Stephen's sister-in-law by his first marriage. Molly founded the Memoir Club in 1920, whose original members corresponded to those Virginia Woolf called 'Old Bloomsbury'. Her sometimes antagonistic relations with Clive Bell were complicated by their sleeping together in 1913.

Christabel McLaren (1890–1974) – Lady Aberconway (as she became in 1934 when her husband, Henry McLaren became Baron Aberconway of Bodnant) was a society hostess with whom Clive Bell had a brief affair in the 1920s and a lasting, though sometimes strained, friendship. Known for her beauty and charm, she also enjoyed a long friendship with Virginia Woolf.

Léonide Massine (1896–1979) – dancer and transformational choreographer who joined Sergei Diaghilev's Ballets Russes in 1914.

Lady Ottoline Morrell (1873–1938) – a celebrated literary hostess and patron of the arts whose Thursday evening parties at 44 Bedford Square in London attracted many luminaries. In 1914, she and her husband Philip (referred to by Clive Bell as 'Pipsy'), MP for Burnley and, like his wife, an outspoken pacifist, moved to their estate at Garsington Manor near Oxford. There they provided opportunities for conscientious objectors to fulfil the government's requirement of doing 'work of national importance' by farming their land. Garsington became a haven and meeting place for many writers and artists, and continued to be so after the First World War. Ottoline and Philip's daughter, Julian, was born in 1906.

Raymond Mortimer (1895–1980) – critic and long-time literary editor of the *New Statesman & Nation*; close friend of Clive Bell, Frankie Birrell and Harold Nicolson (with whom he had an affair).

J. Middleton Murry (1889–1957) – writer, literary critic and editor, married to Katherine Mansfield, and a close friend of D. H. Lawrence.

Harry (H. T. J.) Norton (1886–1937) – a noted mathematician, Fellow of Trinity College, Cambridge, close to Lytton Strachey, Leonard Woolf and Saxon Sydney-Turner. He accompanied Clive Bell, Vanessa (for whom he had an unrequited love) and Roger Fry to Turkey in 1911; during the First World War he lived at 46 Gordon Square.

Frances ('Fanny') Partridge (1900–2004) – Frances, whom Clive Bell always called Fanny, met Ralph Partridge when she worked at Bunny Garnett's and Frankie Birrell's bookshop and he was working at the Hogarth Press; Frances's sister Ray Marshall was Bunny's first wife. Frances married Ralph after the deaths of Lytton Strachey and Carrington. A lifelong pacifist and diarist, she was one of Clive Bell's closest friends.

Eddy Sackville-West (1901–1965) – first cousin to Vita Sackville-West, Eddy (whose name Clive Bell usually spelled Eddie) lived from 1926 in the Gatehouse Tower at Knole, and later with Raymond Mortimer and others at Long Crichel in Dorset. A writer and distinguished pianist, he became music critic for the *New Statesman* in 1935.

Vita Sackville-West (1892–1962) – writer married to the diplomat Harold Nicolson (1886–1968), and inspiration for her lover Virginia Woolf's novel *Orlando*. She was introduced to Woolf by Clive Bell.

Gerald (1887–1947) **and Fredegond Shove** (1889–1949) – Fredegond Maitland was a daughter of Virginia Woolf's first cousin, Florence Fisher, and married Gerald Shove in 1915. The Shoves spent much of the First World War at Garsington Manor. Gerald was an economist; Fredegond's collection of poems, *Daybreak*, was published in 1922 by the Hogarth Press.

Osbert Sitwell (1892–1969) – middle of three well-known Sitwell siblings, his older sister being the poet Edith, and his younger brother the art and music critic, Sacheverell. Osbert was a writer now best-known for his four volumes of autobiography.

Logan Pearsall Smith (1865–1946) – writer and philologist, brother of Bertrand Russell's first wife, Alys, and of Mary Berenson; uncle to the children of his sister Mary's first marriage (to Frank Costelloe), Ray Strachey (Oliver Strachey's second wife) and Karin Stephen (wife of Adrian Stephen); a close friend of Roger Fry.

Adrian Stephen (1883–1948) – youngest child of Leslie and Julia Stephen; after the marriage of Clive Bell and Vanessa in 1907, Adrian moved with his sister Virginia to 29 Fitzroy Square, and in 1911 to 38 Brunswick Square. He married Karin Costelloe in 1914, with whom he had two children, Judith and Ann.

Thoby Stephen (1880–1906) – eldest child of Leslie and Julia Stephen, and Clive Bell's best friend at Cambridge University. Thoby's 'Thursday evenings' at home at 46 Gordon Square inaugurated what later became known as the 'Bloomsbury Group'. He died aged twenty-six after contracting typhoid on a trip to Greece with his siblings, Adrian, Vanessa and Virginia.

Alix Strachey (née Sargant-Florence, 1892–1973) – see James Strachey.

Dorothy Strachey (1865–1960) – eldest sister of Lytton, Dorothy married the French painter (and friend of Matisse) Simon Bussy (1870–1954), with whom she had a daughter, Janie (1906–1960). Her novel *Olivia* was published by the Hogarth Press and became a best-seller.

James Strachey (1887–1967) – younger brother of Lytton, he married Alix Sargant-Florence in 1920 and both went to Vienna to be trained by Freud as psychoanalysts; they collaborated on the lifelong project of translating Freud's work into English, resulting in the *Standard Edition* published by the Hogarth Press.

Lytton Strachey (1880–1932) – one of the ten children of Sir Richard and Lady Jane Maria Strachey, Lytton is now best-known as the writer of *Eminent Victorians* (1918). He went up to Trinity College in 1899, with Clive Bell, Thoby Stephen, Saxon Sydney-Turner and Leonard Woolf, who became his closest friend. He had a profound influence on his generation of Apostles and was a regular visitor to the 1905 'Thursday evenings' that inaugurated what became known as the 'Bloomsbury Group'.

Marjorie Strachey (1882–1964) – sister of Lytton, a writer, suffragette and teacher; in 1914 she fell in love with the Liberal politician Josiah Wedgwood.

Oliver Strachey (1874–1960) – brother of Lytton, a military intelligence officer, father of novelist Julia Strachey.

Philippa ('Pippa') Strachey (1872–1968) – sister of Lytton, a lifelong feminist activist who organised the first major march in London for women's suffrage in 1907.

Saxon Sydney-Turner (1880–1962) – a contemporary of Clive Bell's at Trinity College, Cambridge, and the sole guest at the first of Thoby Stephen's 'Thursday evenings' in 1905 which inaugurated the 'Bloomsbury Group'. Known as inveterately silent, he was deeply knowledgeable about classical literature and opera.

Charles Vildrac (1882–1971) – poet, dramatist and gallerist in Paris, a close friend of Roger Fry.

Chronology

1879 Vanessa Stephen born 30 May.

1880 Julian Thoby Stephen born 8 September.

1881 Arthur Clive Heward Bell born 16 September.

1882 Adeline Virginia Stephen born 25 January.

1883 Bell family moves to Cleeve House in Wiltshire. Adrian Leslie Stephen born 27 October.

1895 Death of Julia Duckworth Stephen.

1899 Clive seduced by Annie Raven-Hill; goes up to Trinity College, Cambridge, where he meets Saxon Sydney-Turner, Lytton Strachey, Leonard Woolf and Thoby Stephen.

1900 Vanessa and Virginia attend the Trinity May Ball as their brother Thoby's guests.

1901 Clive meets Desmond MacCarthy.

1902 Clive awarded Earl of Derby studentship. Thoby Stephen invites Clive to visit his family on holiday at Fritham in the New Forest. John Maynard Keynes goes up to King's College, Cambridge, and is elected an Apostle; Adrian Stephen goes up to Trinity College.

1903 Clive hunting in Alberta (Canada) with his father.

1904 Death of Sir Leslie Stephen; the four Stephen siblings travel in Italy, stopping in Paris on their way home where they are entertained by Clive. The Stephens move from their family home (22 Hyde Park Gate) to 46 Gordon Square in Bloomsbury. Leonard Woolf leaves for Ceylon (Sri Lanka). In Paris, Bell meets the painter Roderic O'Conor and begins to learn about post-impressionism from him.

1905 Thoby Stephen is 'At Home' at 46 Gordon Square on Thursday evenings, the first stirrings of the 'Bloomsbury Group'. *Euphrosyne, A Collection of Verse* is privately published, funded by Clive, who has several poems in the volume. Clive woos Vanessa, assisting her with establishing the Friday Club. She rejects his marriage proposals. Vanessa meets Duncan Grant.

1906 Clive again proposes to Vanessa and is turned down. After a holiday in Greece, Thoby and Vanessa fall ill with typhoid, from which Thoby dies on November 20. Vanessa agrees to marry Clive.

1907 Clive and Vanessa marry in February and honeymoon in Paris in April, where they are later joined by Virginia and her brother Adrian. Lytton Strachey asks if they will look up his cousin Duncan Grant, who is studying painting in Paris. The Bells take over 46 Gordon Square, requiring Adrian and Virginia to move to 29 Fitzroy Square. In September the Bells stay at Playden, in Rye, East Sussex, near Henry James. In October, accompanied by Virginia, they visit John Maynard Keynes in Cambridge. The friends begin a Bloomsbury play-reading society.

1908 Julian Heward Bell, the Bells' first child, is born at 46 Gordon Square on 4 February; Vanessa and Clive are joined by Virginia on holiday in Italy in September. A flirtation begins between Clive and Virginia; she sends him drafts of her novel-in-progress, 'Melymbrosia'. Lady Ottoline Morrell invites the Bells and their friends to her salon at 44 Bedford Square.

1909 In late spring, the Bells visit Florence and Milan with Virginia, who leaves after quarrelling with Clive. They visit Bernard and Mary Berenson. Clive begins to review regularly for the *Athenaeum*.

1910 Vanessa and Clive meet Roger Fry in January and agree to assist with an exhibition of modern French paintings. In February, Virginia, Adrian, Duncan and others participate in the 'Dreadnought Hoax'. In March, the Bells take Virginia to Studland to rest; Clive meets Bertrand Russell for the first time; Virginia invites Molly MacCarthy to stay with them. The Bells' second child, Quentin, is born at 46 Gordon Square on 19 August. In October, Clive joins Roger Fry, Ottoline Morrell and Desmond MacCarthy in Paris to help select paintings for 'Manet and the Post-Impressionists', which opens in November at the Grafton Galleries.

1911 Clive makes his first contribution to *The Nation*. In April, the Bells, Roger Fry and H. T. J. Norton travel to Turkey where Vanessa suffers a miscarriage and begins to fall in love with Roger. In July, Leonard Woolf returns to London on leave from his civil service post in Sri Lanka, hoping to

woo Virginia. At the end of the year, Leonard joins Virginia, Adrian, Maynard and Duncan living at 38 Brunswick Square. Vanessa and Clive buy Picasso's *Pots et Citron* in Paris. In November, the Bells and Virginia take a lease on Asheham House.

1912 Clive travels in Italy with Vanessa and Roger. Roger introduces the Bells to Charles Vildrac, Henri Doucet and Jacques Copeau in Paris. Leonard Woolf and Virginia marry in August. The Second Post-Impressionist exhibition opens in October; Clive writes an essay for the catalogue on the works he chose for 'The English Section'.

1913 Clive's article 'Post-Impressionism and Aesthetics' appears in the *Burlington Magazine*. He begins an affair with Molly MacCarthy, sleeping with her at Asheham. In February, Roger Fry and Clive give a lunch in honour of Gertrude Stein; Fry's Omega Workshops opens in July; the Bells, Duncan Grant and Fry travel together in Italy. Virginia delivers the manuscript of *The Voyage Out* to her half-brother Gerald Duckworth's publishing house.

1914 David 'Bunny' Garnett meets Duncan Grant; Clive and Molly MacCarthy join Vanessa and Roger in Paris, where Gertrude Stein takes them to visit the studios of Matisse and of Picasso. Vanessa begins to fall in love with Duncan Grant. Clive's book *Art* is published. He writes the catalogue preface for a Jean Marchand exhibition at the Carfax Gallery. Clive begins a relationship with Mary Hutchinson.

1915 Virginia's first novel, *The Voyage Out*, is published. Vanessa stays at Eleanor House in West Wittering with Duncan and later rents The Grange at Bosham, in Sussex, where Clive also visits so that he can see Mary, who is nearby with her family. Clive and Mary visit Ottoline Morrell's home, Garsington, with Barbara Hiles and Faith Bagenal (whose brother Barbara will marry at the end of the War). In September, Clive's anti-war pamphlet *Peace at Once* is published and almost immediately seized and destroyed by the government. The Bells spend Christmas at Garsington Manor.

1916 A Military Service Act passes in January, requiring conscription; Clive works on behalf of conscientious objectors. Vanessa moves with Duncan Grant and Bunny Garnett to Wissett Lodge. Lytton Strachey, Dora

Carrington and Barbara Hiles stay with Vanessa and Duncan, Clive and Mary at Asheham; Carrington falls in love with Lytton. In October Vanessa, Bunny and Duncan move to Charleston. Maynard Keynes moves into 46 Gordon Square with J. T. Sheppard when Clive moves to Garsington to fulfil the conditions of his exemption from military service. Clive meets T. S. Eliot for the first time.

1917 Virginia and Leonard establish the Hogarth Press and publish *Two Stories* (including Virginia's 'The Mark on the Wall'). For Christmas, Clive sends friends a collection of his poems, *Ad Familiares*.

1918 Armistice signed on 11 November. The Ballets Russes returns to London; a grand party in the company's honour is held at 46 Gordon Square; Clive befriends the prima ballerina Lydia Lopokova. In Paris, Picasso marries the dancer Olga Khokhlova. Clive publishes a collection of his articles, *Pot-Boilers*. Lytton Strachey's *Eminent Victorians* appears. On Christmas morning, Vanessa and Duncan's daughter, Angelica, is born.

1919 Picasso and André Derain come to London to work on designs for the Ballets Russes; Clive shows Picasso around and befriends Derain. Clive and Maynard Keynes host a farewell party at Gordon Square for Diaghilev, Massine and Picasso. In November Clive goes to Paris where he reconnects with the painters Roderic O'Conor and J. W. Morrice and begins to expand his circle of friends there. Clive meets Erik Satie and Jean Cocteau chez Picasso.

1920 Clive's controversy with Wyndham Lewis over 'Wilcoxism' erupts, another instalment of Lewis's long-running feud with 'Bloomsbury'. Vanessa moves to 50 Gordon Square. Molly MacCarthy founds the Memoir Club. Clive befriends the critic Georges Duthuit, who will marry Marguerite Matisse, the painter's daughter.

1921 Clive meets Vita Sackville-West and her husband, Harold Nicolson. Clive's *Poems* is published by the Hogarth Press. Carrington and Ralph Partridge marry and continue to live at Ham Spray with Lytton Strachey.

1922 Clive introduces Vita to Virginia, following the publication of Virginia's novel *Jacob's Room*. Clive's *Since Cézanne* is published. In May, Clive is a guest at a dinner for the Ballets Russes at the Majestic Hotel in Paris,

attended by James Joyce, Marcel Proust and other lumi-
naries. Vanessa moves back to 46 Gordon Square; Clive
moves to Number 50. *Vanity Fair* elects Clive to its 'Hall
of Fame'; he meets the American writer and editor of *The
Dial*, Gilbert Seldes, in Paris.

1923 Clive's essays *On British Freedom* and his poem, illus-
trated by Duncan, *The Legend of Monte della Sibilla* are
published. Clive meets Frances Marshall (later Partridge)
who is working at Francis Birrell's and Bunny Garnett's
bookshop in Bloomsbury.

1924 Clive meets Mina Kirstein at a party in London and has
a brief fling with her. He publishes a long essay, 'Virginia
Woolf', in *The Dial*.

1925 Vanessa moves to 37 Gordon Square. Maynard Keynes
marries Lydia Lopokova and buys Tilton, close to
Charleston. Clive begins an affair with Bertha Penrose.
Virginia's *Mrs Dalloway* is published.

1926 Vanessa and Duncan decorate Clive's flat at 50 Gordon
Square. Clive becomes friends with Raymond Mortimer.

1927 Vanessa rents the Villa Corsica, in Cassis, France. Clive's
father dies in June. Clive begins an affair with Beatrice
Mayor ('Bobo'). His *Landmarks in Nineteenth-Century
Painting* is published.

1928 Clive visits Germany with Raymond Mortimer and Eddy
Sackville-West. Vanessa takes a ten-year lease of La
Bergère in Cassis and rents a studio at 8 Fitzroy St. Clive's
Civilization and *Proust* are published.

1929 Clive visits the General Exposition in Barcelona, where he
sees Aldous and Maria Huxley, Georges Duthuit, Frances
Marshall and Ralph Partridge.

1930 Clive meets Man Ray in Paris; stays in Cannes with Benita
Jaeger.

1931 Clive at Zurich clinic for eye treatment. His *An Account
of French Painting* is published. In Venice with Frankie
Birrell and Raymond Mortimer, Clive meets Mary Landon
Baker, the 'Shy Bride', with whom he begins an affair.

1932 Lytton Strachey dies; Carrington kills herself.

1933 Clive goes on a tropical cruise with Benita Jaeger. He is
represented as Bacchus in Boris Anrep's mosaic floor at
the National Gallery, *The Awakening of the Muses*.

1934 Clive travels to Spain with Benita Jaeger. His last mono-
graph, *Enjoying Pictures*, is published. Roger Fry dies.

1935 Julian Bell goes to teach in China.

1936 Clive is made a member of the Légion d'Honneur.

1937 Clive begins an affair with Janice Loeb. Julian is killed in Spain.

1938 Virginia Woolf's *Three Guineas* appears, three months before Clive's *Warmongers*. Ottoline Morrell dies.

1939 Clive gives up his London flat and moves to Charleston when the Second World War begins.

1940 Clive joins the Fine Arts Committee of the British Council.

1941 Virginia Woolf's suicide.

1942 Clive's mother dies. Bunny Garnett marries Angelica.

1945 Clive publishes *Victor Pasmore* in the Penguin Modern Painters series; he contributes *Auguste Renoir: Les Parapluies* to the Gallery Books series for the National Gallery.

1946 John Maynard Keynes dies.

1947 *Twelfth-Century Paintings at Hardham and Clayton* is published by The Miller's Press with a long introduction by Clive.

1948 Clive visits Picasso at Vallauris and Matisse in Nice with Mary Hutchinson. He contributes an introduction to *Julia Margaret Cameron, Her Life and Work* by Helmut Gernsheim, and also contributes to *T. S. Eliot: A Symposium*. Clive writes a preface for a reprint of *Art* (pub. 1949) but declines to revise the text. Adrian Stephen dies.

1949 Clive meets an American lawyer, Douglas Gordon, in London, who will arrange lecture tours for him in the USA.

1950 Clive sails to New York on the *Queen Mary*. He speaks at the opening of the Cone Collection at the Baltimore Museum of Art; lectures at the Phillips Collection and at Harvard's Fogg Museum. Clive stays with Mina Kirstein in Washington and reunites with Janice Loeb in New York.

1951 Clive's *Modern French Painting: The Cone Collection* is published.

1952 Clive returns to the USA for a more extensive lecture tour. Quentin Bell marries Anne Olivier Popham, and their son, Julian, is born. Vanessa moves to 26a Canonbury Square. Clive contributes an introduction to *The French Impressionists* for Phaidon.

1954 Deaths of Matisse, Simon Bussy, André Derain.

1955 Clive meets John Richardson at Douglas Cooper's French chateau.

1956 Clive's memoir, *Old Friends*, is published.

1960 Janie Bussy dies.
1961 Vanessa Bell dies.
1962 Saxon Sydney-Turner dies.
1964 Clive Bell dies on 17 September.

Books and Pamphlets by Clive Bell

Art, Chatto & Windus, 1914
Peace at Once, National Labour Press, 1915
Ad Familiares, [privately printed], 1917
Pot-Boilers, Chatto & Windus, 1918
Poems, Hogarth Press, 1921
Since Cézanne, Chatto & Windus, 1922
On British Freedom, Chatto & Windus, 1923
The Legend of Monte della Sibilla, Hogarth Press, 1923
Landmarks in Nineteenth-Century Painting, Chatto & Windus, 1927
Civilization, Chatto & Windus, 1928
Proust, Hogarth Press, 1928
An Account of French Painting, Chatto & Windus, 1931
Enjoying Pictures, Chatto & Windus, 1934
Warmongers, Peace Pledge Union, 1938
Modern French Painting: The Cone Collection, The Johns Hopkins
 Press, 1951
Old Friends: Personal Recollections, Chatto & Windus, 1956

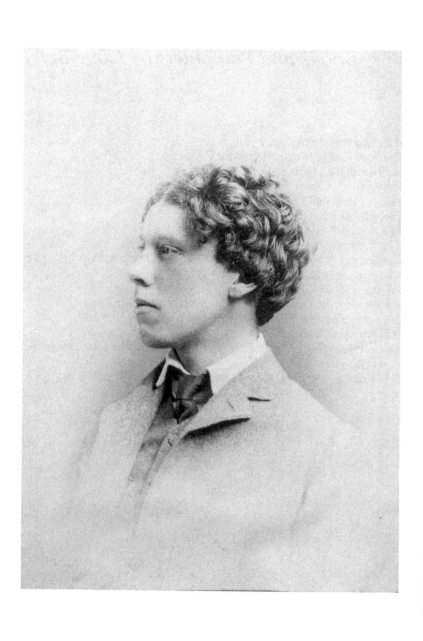

Introduction

The Bloomsbury Group historian S. P. Rosenbaum commented in
2007 that Clive Bell's reputation had long been underestimated,
noting how influential was his first book, Art (1914), and calling it
the 'first of Bloomsbury's manifestos' (217). My biography, Clive
Bell and the Making of Modernism (2021), has gone some way to
establishing how significant Bell was in the early twentieth century
both as an art critic and as an outspoken defender of the values of
individual liberty. Rosenbaum lamented that not only was there
no collected edition of Bell's writings but also no volume of his
'lively correspondence' (ibid.). Having relied heavily on that cor-
respondence to write Bell's biography, I knew that he was, indeed,
a lively, witty, opinionated and usually very well-informed letter
writer. At a private view of Vanessa Bell's 1934 solo exhibition at
Lefevre, for example, Clive observed Margot Asquith cautioning
his wife against 'hot backgrounds' in her paintings – 'backgrounds
should always be grey, my Dear'. On the same occasion, when the
somewhat deaf Ethel Smyth was introduced to Charles Laughton,
she asked him his name, telling the famous actor that he looked
'uncommonly like Charles Laughton' (27). The absurdities of life
in situations serious and trivial often struck Bell. During the First
World War, he wrote sarcastically to the New Statesman that the
government should invest in establishing private bullrings to breed
draught animals for the Front, and to amuse the upper classes.
After all, he said, it had been agreed already that 'Art, literature,
science, education – all the things that don't really matter – must
go' (68). His letters afford us glimpses of the famous – James Joyce
in Paris in 1921 – and the not-yet famous – Ian Fleming in Venice
in 1931 – observed in Bell's sometimes acerbic, often insouciant
and usually entertaining style.

 After making this selection from Bell's letters, I decided to
arrange them in eight categories to provide a sharper view of his
varied interests and passions than would emerge from a strictly
chronological sequence. Although this results in returning to the
early twentieth century at the start of each section, the arrangement

affords a more coherent perspective than strict chronology would allow, enabling us to see how Bell's thinking might change on a particular subject (politics, for example), or how it remained the same: his belief that war can only ever make the world worse than it is never budged.

Bell is, of course, a character in the story of the 'Bloomsbury Group'. In 1907 he married Vanessa Stephen, whom he met through her brother Thoby, his best friend at university. Clive Bell thus became Virginia Woolf's brother-in-law, and his sometimes tempestuous relations with her form an important part of modernist literary history. Woolf and Bell were united in their profound pacifism, and Bell's direct involvement in protecting the rights of conscientious objectors when Military Conscription was introduced in Britain in 1916 is an aspect of his biography instructively augmented by seeing in full the letters he wrote on behalf of and about COs, among whom he was himself numbered.

It is as a champion of modernist art, however, that Bell is best known. His opportune meeting with Roger Fry in 1910 led him to close involvement with the iconoclastic exhibition of post-impressionist painters at the Grafton Galleries in London that many have interpreted as being what Virginia Woolf had in mind when she wrote that 'on or about December 1910 human character changed'. Throughout his long life, Bell revered art as the pinnacle of human achievement, its appreciation affording the most transcendent of human emotions. His public letters took on all those who challenged innovative art, engaged delightedly in outraging his enemies (and sometimes also his friends) and ranged, too, into matters of popular culture and politics.

Bell was born during the reign of Queen Victoria and lived long enough to have been able to hear the Beatles on the radio. His appetite for life never flagged. He had been galvanised as a young man by his experiences in Paris meeting painters and their models, which set him on a path from which he never deviated. He fell deeply in love with France and all things French, finding in that country a network of friendships and acquaintances as rich as any he had in England. For Bell, France was where modernist painting flowered, but, with Fry, he sought its roots in the ancient mosaics of Turkey and Italy. Late in life, Bell travelled twice to the United States, lecturing about the artists he had known, and visiting as many of the great private and public American collections as he could.

Running through Bell's life and letters, entwined with his love of art, is his love of women, and of his friends. In Rosenbaum's

view, Clive Bell's womanising contributed to the relatively diminished stature of his reputation among his contemporaries, but although Bell had many love affairs, and could sometimes write letters to lovers that are embarrassing in their desperation, I think it is unfair to call him a 'womaniser'. His great liaison was with Mary Hutchinson, but one of his earliest intimacies was with his sister-in-law, Virginia, to the drafts of whose first novel he gave astute attention. He took women seriously, always, and nearly all of his affairs began and ended in friendship.

Arranging this selection of letters as I have leads to a certain arbitrariness in their appearance under a particular heading. The boundaries between each of the following eight sections should be understood as porous: a letter to or about Virginia Woolf, for instance, might have quite a lot to say about art. Furthermore, some figures – Woolf, Picasso, Vanessa Bell – inevitably are not as confined by categorisation as others might be. Readers who wish to trace references to any particular person in letters across all eight sections should use the index as their map. I have chosen to include only complete letters, rather than extracts. The losses incurred by this decision seem to me to be well outweighed by the benefits of preserving Clive Bell's voice in a particular moment, to a particular correspondent.

1

Bloomsbury Circles

In March 1910, Lytton Strachey asked his young cousin Duncan Grant if he had heard that 'the Bloomsbury set' (Hussey 75) had gone to Studland, on the Dorset coast, because Virginia Stephen had had a breakdown. The phrase had not yet acquired its infamous connotations, but it would not be very long before 'the Bloomsbury Group', often shortened to just 'Bloomsbury', would implicate both Strachey and Grant, as well as Vanessa and Clive Bell, Virginia Woolf and several others in their circle of friends as members of an influential clique that has been fiercely admired and equally fiercely attacked for over 100 years now.

The origins of 'Bloomsbury' lay in Cambridge University, but the group was named for the London neighbourhood where the four Stephen siblings – Thoby, Vanessa, Virginia and Adrian – lived from 1904, following the death of their father, Sir Leslie Stephen. Wishing to keep his Cambridge friendships alive, Thoby was 'at home' on Thursday evenings in 1905 at 46 Gordon Square. It was there, too, that Thoby died, aged twenty-six, following a family trip to Greece in 1906 where he contracted typhoid. As Thoby – whom his friends called 'The Goth', apparently on account of his solid appearance – lay dying, his best friend, Clive Bell, kept vigil with Virginia, who was at once appreciative of his company and deeply sceptical about his intention of marrying her sister. Once married, Clive and Vanessa took over Number 46 for themselves, while Virginia and Adrian moved to lodgings nearby. 'Bloomsbury' continued to flourish, a centre for that group of friends whom Virginia Woolf later dubbed 'Old Bloomsbury' – thirteen people who also happened to constitute the 'Memoir Club' that was created by Molly MacCarthy in 1920 as a way to encourage her husband, Desmond, to write. The Memoir Club itself persisted into the early 1960s.

That 'Old Bloomsbury' nucleus, only a few of whom actually lived in Bloomsbury, found itself invited before the First World

War to the grand literary and artistic salon of Lady Ottoline Morrell in Bedford Square. The introduction of Roger Fry to the group in 1910 ensured that Bloomsbury would always be associated with radical innovations in visual art. With the outbreak of war in 1914, and then the introduction of conscription in 1916, Bloomsbury's circles continued to widen, rippling out to the Morrells' country estate at Garsington, near Oxford, which became a refuge for conscientious objectors, and to Charleston, the farmhouse in Sussex leased in 1916 by Vanessa Bell so that her lover, Duncan Grant, and his lover, David 'Bunny' Garnett, could fulfil their obligations to work the land in lieu of fighting. It was at Charleston that John Maynard Keynes wrote The Economic Consequences of the Peace in 1919.

In 1914, Clive Bell had begun a serious affair with Mary Hutchinson (a cousin of Strachey's). Bloomsbury would be strained when Clive tried to introduce Mary to its inner circle, as it would again be when Maynard Keynes fell in love with the Russian ballerina Lydia Lopokova. By 1924, Lytton Strachey was living with Dora Carrington and Ralph Partridge at Ham Spray in Wiltshire. David Garnett had bought Hilton Hall, near Cambridge, with his first wife, Ray Marshall, whose sister Frances began an affair with Ralph in 1923. By the 1920s Bloomsbury's overlapping circles had multiplied and continued to spread geographically, romantically, intellectually and aesthetically. Old Cambridge associates – Bob Trevelyan, Sydney Waterlow – and high-society hostesses – Sybil Colefax as well as Ottoline Morrell – augmented the networks that had begun to flourish in Gordon Square before the war.

Leonard Woolf wrote in his autobiography that what the outside world called 'Bloomsbury' had never really existed, yet he identified the death of Lytton Strachey in 1932 as marking the end of 'Old Bloomsbury'. Clive Bell believed that whatever 'Bloomsbury' might have meant, it was ended by the First World War, yet for the whole of his long life Bell took the trouble to correct misconceptions and emend facts about those old friends of his who were assumed to have belonged to the Bloomsbury Group.

Perhaps the most useful way to think of the Bloomsbury Group is as that space in a Venn diagram where most of its circles overlap. Above all, the term denotes a group of friends tied together by affiliations of profound love, with all that emotion's passion and ambivalence. Clive Bell's letters are full of references to people who are not usually considered part of 'Bloomsbury' and yet were so, in a sense, by virtue of their ties to him. His own circle intersected with the upper reaches of the beau monde, and, of course,

with the intellectual and artistic life of Paris, where he had a network of friends as dear to him as those in London. Bloomsbury was Bell's chosen family, those with whom he quarrelled, about whom he gossiped, upon whom he relied, and those whom he loved most deeply.

To Saxon Sydney-Turner
Friday evening Nov 1906 [pm Nov 17] 6 King's Bench Walk,
 Temple

My dear Turner;
 we have been through some awful days since you left. On
Sunday the Goth [Thoby Stephen] developed typhoid; since then
he has been in a critical condition, more or less delirious a good
part of the time, and often in great pain. Virginia & I have been
allowed to see him at times, not that we could do much good, as
his mind has been pretty vagrant throughout; but familiar voices
seem to have comforted him a little. Today comes the first good
news; he has had a much better night; the pain is decreasing; &
the nurses declare that "he is round the corner". We are all feeling
a good deal happier.
 As you may suppose, this has not been of much assistance to
Miss Stephen's rest cure.[1] However, I gather that she is going on
very well and that the doctors are more than satisfied. I'm afraid
that I have no other sort of news; at present, you will readily
understand that, saving 46 Gordon Square, I am not greatly inter-
ested in "external reality".
 I called at your rooms today, but could see nothing worth
forwarding. I will write again soon and send you some good
news.

Yours ever, Clive Bell
Sussex

Note

1. i.e. Vanessa, who had also returned from Greece ill and was conva-
 lescing at 46 Gordon Square, attended by her sister, Virginia.

To Saxon Sydney-Turner
Tuesday afternoon [pm Nov 20 1906] 46 Gordon Square

My dear Turner,
 Thoby died this morning; very peacefully, & without any pain.
They operated last Saturday morning, & I have been here ever
since.

I think that we are all standing it as well as could be expected; but it is almost impossible to realize as yet precisely what has happened.

We shall all leave town at the end of this week.

Yrs ever, ACHB [Arthur Clive Heward Bell]
Sussex

To Lytton Strachey
November 23 1906 6 King's Bench Walk, Temple

My dear Strachey,
I am living at Gordon Square & only sleeping in my chambers. Sometimes too I sleep at G. S.

Would you come and see us there; if you ask for me it will be all right; I shall probably be up stairs with Vanessa, but I should very much like to see you. On Monday I leave for the country, staying there two or three days only, I shall be back by the middle of this week.

It would be particularly kind if you would see Virginia sometimes. She dreads losing all Thoby's old friends, & they were the people for whom she most cared.

We should all, I think, be the happier for seeing you.

Yours ever, Clive Bell

To Ottoline Morrell
April 5 1910 Harbour View/Studland/Wareham Dorset

Dear Lady Ottoline,
I doubt whether anyone keeps you 'au fait' with our state, but then I have no very good reason for supposing that anyone thinks you particularly curious about it. However, I believe you will be glad to hear that our invalid grows daily less placid and more caustic, which may be regarded as a very good sign, and a return to normal conditions.[1] Normal conditions, I may say, are not very well suited to close quarters in a lodging house, but they are encouraging. Poor Lytton Strachey; he has fallen ill again and

must leave London and all its intrigues; he leaves it, however, with that comely young poet Rupert Brooke; – a poor substitute for your Tuesday evenings – to which he is careful to tell me he has been invited –, but still a substitute. Dust and Ashes! He had some thought of joining us, it appears, and I hope if I disuaded [*sic*] it will not be imputed to me for uncharitableness. A knot of decrepit Byrons and Chateaubriands asserting their individualities round a patent stove affords an atmosphere depressing for a convalescent, or, indeed, for one that is whole. If you have ever grown weary of the mysterious and misunderstood, you will know why we all long for the classic breadth, the dignity and lucidity, of 44 Bedford Square. The truth is, I live amongst people who are interested in society only in so far as it affects the individual, and I long sometimes for the company of those whose respect for individuals depends, somewhat, on their social value; who are less inclined to blame the world for being unsympathetic than the individual for being an egoist. This clumsy sentence sums up pretty well the difference between the Romantic and the Classical spirit; and suggests, I hope, in some degree, the regret I feel at not being elsewhere at this moment 11.0 P.M. Tuesday April 5.

Yours very sincerely, CB
HRC

Note

1. The Bells had taken Virginia to Studland to recuperate from a breakdown.

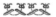

To Virginia Stephen
Monday 12.45 [May 2 1910] Hillyfields, Rye, Sussex

My dear Virginia,
 Your letter to Vanessa, with its excellent report, I have just opened & read with the greatest pleasure. Your mind too, I think, must be pretty well to write such a brilliant little affair. How the day's going to pass is more than I can guess, for it's pouring down & has been doing so since 10.0 last night. However it's all extraordinarily beautiful and green and good-smelling outside the glass doors of the drawing-room, and the fire burns moderately within. After I'd finished Saturday's letter I went for a

longish walk with Sydney [Waterlow[1]], over the marsh past Cam-
ber & down to the pebbles. S. spoke heavily but with conviction
& some feeling about literature and all our friends – Trevelyans,
Sangers, Youngs, Cornfords, Darwins, young Cambridge and old.
But I felt lonely and home-sick and wanted to see you, so much
that I tried to hunt up some excuse for going back with Vanessa
today. I only succeeded in making myself silly, and slightly dis-
agreeable. After dinner we got onto the theatre & Jack Pollock[2] –
whom S. thinks rather absurd I fancy – from that to the Shaw
school, and from the Shaw school to the cultural classes, which S
& I agreed in attacking bitterly. Alice was patently uneasy – from
culture and pseudo-culture, from the general to the particular;
and so you see, by easy stages to Freshfields, Booths &, often on
the tip of my tongue, Pollocks. We did them in finely, the tradi-
tion that I hate with the implacable hatred of the parvenu. Nessa
was prodigiously wise and sensible. I was acid and garrulous.
Alice silly rather and behind-hand. We told the Dreadnought
story[3] and went to bed; it was an anti-climax. What disturbs me
here is that I can never be rational with Sydney alone, he is too
nervous and too anxious to understand one; that the animals
are encouraged to be pestilent; and that, lacking [?*illegible*] I am
costive. Alice Dew appeared here yesterday, but I glowered her
out of the room in next to no time. That woman seems to have
taken almost as great a dislike to me as I have to her. She is
plaignante [*complaining*] & geignante [*whining*]. Sydney seems
to be thoroughly bored with H. J. [Henry James].[4] He does sound
intolerable. With his little meticulous ways and conventionali-
ties, and takings of people aside to assure them that their friends
have made 'a profoundly unfavourable impression', and his
absurd, positive judgments on all forms of modern art and mod-
ern minds which strike him as in 'deplorable taste'. He sounds
rather like a refined old sensualist without a soul, who cares for
noone unless it be Mrs. [Fanny] Prothero & [Gaillard Thomas]
Lapsley. But, of course, Sydney may easily be quite wrong. I've
been reading Wordsworth while Alice [Waterlow] brushed the
dogs, changed the flowers, saw that there was a sufficiency of
ink & paper, spoke to the servants; got a penny in change for
something, read the Morning Post, dropped pleasant remarks, &
finally took her pets and her water-proof for a scamper into the
town. I suppose you won't be so thoughtful as to send me a card
by the country-post?

Yours affectionately, Clive

Notes

1. Sydney Waterlow, a diplomat, was a friend of Clive Bell's from Trinity College. He proposed to Virginia Stephen when his first marriage (to Alice) broke down.
2. Frederick John Pollock was Alice Waterlow's brother.
3. Virginia, her brother Adrian, Duncan Grant and others impersonated Ethiopian royalty to gain access to a highly guarded British warship, causing a scandal when the hoax was revealed.
4. The writer Alice Dew-Smith leased The Steps in Playden from 1907 until about 1920. Henry James lived at Lamb House in Rye from 1897 to 1914.

To Desmond MacCarthy
[?1912] 46 Gordon Square

My dear Desmond,
 I never know quite how seriously you and Molly should be taken when you talk about money and the way you have to work to get it. But if it means that you're a slave of editors it's damnable. So, if it does mean that, will you let me lend you a hundred pounds indefinitely, or untill [sic] you make your first thousand over a comedy. To me that would mean a loss of just five pounds a year – on the hypothesis that I should invest my balance or sell out rather than overdraw –; to you it might mean a breathing space from journalism in which to get done something that you want to do. I don't apologize for my proposal – as I'm sure Leslie Stephen would have done – because I know that you know that I'm too fond of you to feel the least difficulty about saying this sort of thing. But you should know that I'm quite consistent, and have always held it absurd that amongst friends one should want money and another have it. A hundred isn't much; but it may be just the useful sum if you want a month or two of liberty: afterwards anything may turn up. So, please don't stand on your dignity if you've any use for it – not for your dignity. That's an encumbrance always. If I weren't so sleepy I could read you a fine lecture on the Christian virtues.

Ever your affectionate friend, Clive Bell
Lilly

To Mary Hutchinson
November 28 1914 46 Gordon Square

It is one o'clock on Saturday night and I'm not in the least sleepy.
Shall I read the fifth act of *The Rehearsal*, which I picked up last night
and found far more amusing than it was in Cambridge days when I
wasn't deep in the seventeenth century, or shall I gossip a little with
you my dear Mary? I foresee it will become a habit with me, a craving
rather, to gossip with you – and that's a misfortune – the craving to
gossip – when one's crony is a hard-hearted young woman. You don't
guess how much you're becoming a necessity, and I dare say it's as
well that you don't. I must certainly go abroad after Christmas. I've
been wishing you here all this evening: we've been very happy: Ka
Cox,[1] Norton, Lytton, Vanessa, Clive. First we baited Lytton almost
beyond endurance, proving that one half of his conversation springs
from vanity and envy and the other from Henry Lamb.[2] However
when he left us at 11.0 he was still benign and intending to call on
you tomorrow. Then we settled down and discussed Love, Life, and
Art and Education and the Human Heart from private schools to
the grave. I do wish you'd drop vaguely into the Bloomsbury circle. I
believe it would amuse you and you it. {Rather a risky ellipsis that.}
Don't you love the look of square brackets?
 I'm rather in disgrace with myself and Vanessa and Duncan.
While we were talking did you hear a bell ring tentatively over the
telephone? That disgusting tawdry woman. Would I meet the Lav-
erys? Lavery had asked her – "no remarks however offensive to
himself could possibly blind him to the extreme importance and
significance, etc. etc. etc." You figure it, flattery such as the heart
loveth. And Pamela Lytton – a relation of yours I think – and an ex-
beauty, most anxious Dinner at 8.15 on Thursday.[3] O baronne
I fell. You see how I give myself away; try not to like me the less.
You see, too, how badly and hastily I've written it – trying to get the
shame off my mind.
 Ottoline has a prospective friend for Marjorie [Strachey] – Jos.
Wedgwood, separated from his termagant of a wife and in search
of a companion. They met tonight at 44, and I'm not sure how
much either knew of the match-making. Jos has already about ten
children, and for all that he's pretty young, and amiable, and (God
forgive us all) hideous.
 Sunday
 Odd's my life! I read that fifth act when I woke up, and glanced
through an edition of Ben Jonson's poems that Bob Trevelyan[4]
had given me, and sauntered down about 11.0 to get some coffee

and found the door barred, bolted and shut against me because the painters were decorating the dining-room. Was ever man so abused! decorate anywhere; and now they're at it again. God speed the plough. Well, when you come on Tuesday you'll see the extent of their mischief.

Is Mrs. Gregory your dearest friend? If so, don't believe Duncan who says that she's a regular take-in for poor Gregory who married a lovely art-student in Paris and finds on his hands an ill-favoured chatelaine. Comme l'esprit rend médisant [*slanderous*]! as poor Liane is said to have exclaimed when she discovered that her husband called her alcove "le paradis perdu", and that her lover had christened it "le tombeau d'illusions", her friends "le palais d'industrie". But, after all, you're not much interested in Liane de Pougy,⁵ nor in what Duncan says about Mrs. Gregory. And what I believe you're most interested in is just what one never writes letters about even when one's far less ill and delabré [*dilapidated*] than I am today – l'élan créateur [*creative impulse*]. I feel that very soon life's going to become one too many for me again – and then flight will be the only thing. So, one tries to find a north-west passage through the complexities of having been born with the capacity for about six different lives and time for just one of them. I want you to be a part of that: will you?

Yours affectionately, Clive

Notes

1. A friend of Virginia Woolf's from 1911, she was emotionally entangled with Rupert Brooke. In 1918 she married Will Arnold-Foster.
2. Painter, younger brother of Walter Lamb (see p. 40n4 below). Lytton Strachey was in love with him.
3. Probably Helen Lavery, married to the painter John Lavery, and Pamela, wife of Victor Bulwer-Lytton.
4. Robert Trevelyan, a friend of Roger Fry's, and a poet later published by the Hogarth Press.
5. Famed Folies Bergère dancer, lover of Natalie Barney, and author of several books drawn from her own life.

To Mary Hutchinson
January 7 1915 46 Gordon Square

I am as sleepy as an owl and as tired as a tread-mill, and my brain is rather like a just too lightly cooked and far too cold

poached egg. Beauty, or beauty's surviving brother [*unidentified*] is playing Mendelssohn's songs, without words, and, if I may be allowed to judge, without sufficient practice. I am too stupid to work. I am too weary to budge from my arm-chair but, as you see, have discovered in my pocket a fountain pen with a little purple Asheham ink in it.[1] For some inexplicable reason I have been trying all day to read Greek. And now I can try no more. I am utterly épuisé [*exhausted*]. And it is only half past seven. What can I do? What but share my exhaustion with her whom I take for the least long-suffering of women. Poor Mary! Poor me, I am going the right way to work to fortify your heart. I am behaving like Roger who has insisted on Vanessa taking him a sole and eating it with him at eight o'clock precisely, though his temperature is below normal. I shouldn't like you to feel so sorry for me that you'd feel you must be kind. All the same I shouldn't like you to forget that one can't always be on the crest of the wave. Even Duncan felt the need of Quentin's society this afternoon though he'd spent the night, or such part of it as remained, with Bunny in his studio. It seemed to me that nearly all the love-making was carried on by the males *inter se*. But it was all very promiscuous, and pleasantly civilized I thought. Rather like "Twelfth Night": it wouldn't have been very surprising if Bunny had turned out to be a girl and Vanessa a boy: and noone seemed quite to know how he or she was going to pair off: to be sure, I've no idea how anyone did. I've been trying to sleep for five minutes, and now it's a question whether I have the energy to stir down for dinner. I've a mind to take a glass of wine and a captain's biscuit where I sit, and pretend I'm a literary invalid. Perhaps if I did that and put on a snuffy sort of dressing-gown I should write like Charles Lamb instead of writing as if I had a cold in the head. {Dear purist have you feelings about 'like' even in familiar correspondence?} Never mind, pity the sorrows of the stupid who have colds in their heads all the time. Think of their correspondents. Their purple ink gives out never. They are merciless and they never know how much they hurt. Now I know when I'm boring you and do it deliberately. That seems to me preferable. [Goldsworthy Lowes] Dickinson[2] arrived suddenly and stayed to dinner. It is 11.0 and he has just left me. We had a very delightful and very literary conversation. Amongst other things we talked about Gilbert Cannan[3] at Cambridge and after. I am wide awake now and as intelligent as a prick-eared fox-terrier; but it's too late to give you a taste of my quality. Let us hope the fit will last till 3.0 tomorrow at the

bridge; unless the rain pours down in which case I shall come to Cheyne Row.

Clive
P. S. I have reread this letter and think I should make a rather good somnambulist.

Notes

1. i.e. from Asheham House, rented by Virginia Woolf from 1911.
2. Friend of Roger Fry and a lifelong proponent of a League of Nations.
3. Novelist and dramatist whose 1916 *Mendel* was based to some extent on the painter Mark Gertler's early life.

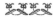

To Vanessa Bell
Tuesday [1916] 46 Gordon Square

Dearest Dolphin,[1] you can imagine how happy your good news made me. For I think it is really good news & that all is pretty sure to go well now. Besides the whole situation is improving: but we must keep the agitation up[2] – in the house, in the country, as individuals – do impress that on all your friends. Give them a moment's peace and they will fall asleep and we shall have to begin all over again.

I was at Garsington for the week-end – O[ttoline] & P[hilip], Lytton, Brett, Mlle. Ridoux, Carrington, Lieutenant Carrington (her brother) mademoiselle & the children. But there was a letter from you to her ladyship & she will doubtless reply telling you how we had all gone for a pic-nic in the woods, and that the maids were all bathing, and one of them got a cramp and was drowning, and none of the others could swim, when up came a motor-car to the door containing the prime minister, Elizabeth Asquith, Mrs. Keppell, Montagu and Venetia and Robby Ross,[3] and she will have told you how Robby dived in and rescued the lady-groom (that was her function) just as she was sinking for the last time, and how the prime minister conducted an enquiry into the circumstances, and left a note saying 'all's well that ends well'.

You will be more amused to hear that old Lytton is most distinctly épris [*enamoured*] of Carrington (the female one); he discovered suddenly that he was profoundly moved by her legs. I

suppose he will soon discover that she has an amazing soul. Her ladyship is said to be distinctly jealous and to show it. Certainly she starves the young woman: so she does me, but I have never taken that for a gage d'amour or anything of that sort. As a matter of fact I think she is jealous & I think she does show it. I should like to come to Wissett[4] for a few days soon and see you all; but, seriously, what about the vermin? On Thursday we are to have a reading at Guildford in which Lady Strachey is to take the part of the citizen's wife in the 'Knight of the Burning Pestle'. I see anti-conscriptionists most of the day & write statesmanlike letters to The Daily News during the night. I also see Mary, Roger, the Stephens, the Shoves etc.. Don't you think you might come to London for a few nights when your tribulations, & tribunations, are over – past? I will send Julian his book as soon as I can get it. Please thank them both for their letters. I think it would be almost impossible to <u>send</u> butterfly-nets but I asked Saxon to take them with him.

CB
Sussex

Notes

1. Both Clive and Virginia used this affectionate nickname for Vanessa.
2. i.e. regarding the government's treatment of conscientious objectors.
3. Herbert Asquith, replaced in December 1916 by Lloyd George; his daughter Elizabeth; Alice Keppel, mistress of King Edward VII; Edwin Samuel Montagu, Venetia Stanley's husband; Venetia Stanley, Asquith's lover and confidante; Robert Ross, literary executor of Oscar Wilde.
4. Before finding Charleston, Vanessa Bell, Duncan Grant and Bunny Garnett lived at Wissett Lodge in Suffolk.

To John Maynard Keynes
Tuesday [June 18 1918] Garsington Manor

Dear Maynard:
 I quite agree: it is intolerable that my amorous friends should have made use of Sheppard's room.[1] I had strictly charged them to enter none save my own at the top of the house. I have written Sheppard a letter of personal apology, and to Borenius a sharp

complaint coupled with a demand for the key. I can do no more, and there that matter ends.

There all might have ended, I think; but you have chosen to write me such a high and mighty censorious letter that I am bound to say something in reply. In the first place, are we, or are we not, all tenants standing on an equal footing as regards 46? If not, why not? Is my share of the expenses too small? If so, let me know what you would consider equitable and either I will pay it or betake myself and my belongings elsewhere. If we are on an equality, there must be either no rules or rules for all. Do I understand that you wish to make it a rule that noone shall in any circumstances lend a room unless he be in the house himself – I don't like it . . . however. I once spent a week-end alone with Captain Sheppard, for instance, was that illegal? And the matter doesn't end there. I am in the habit of entertaining my guests at restaurants: that is what I like, it is not what everyone likes. Is it lawful for one tenant to request the other tenants to be out for dinner, or to impose his guests on the family circle? And there are other questions to be decided.

All this is great rubbish, of course. Noone detests rules more cordially than I; and I believe you will do me the justice of admitting that were such ridiculous things to exist at Gordon Square then I should certainly be the last person ever to complain of an infraction of them. Also I see how extremely irritating to you all must have been what happened on Saturday night, and how natural and reasonable it was to be vexed. But I think you don't see how very difficult it is to refuse someone who has been one's partner in an escapade when he asks for the loan of a room which he knows that you possess and that you won't be using. And however much annoyed one may be, I want to suggest, that one doesn't write to a friend the sort of letter you wrote me,

Yrs, Clive Bell
KCC

Note

1. John Tressider Sheppard, a Cambridge contemporary of Clive Bell's, lived at 46 Gordon Square during the First World War. Clive had given the art historian Tancred Borenius his house key for an assignation with Marie Beerbohm.

To Mary Hutchinson
October 3 1918 1917 Club

Dearest Polly, even this Bolo¹ club is a less tortured and perplex-
ing spot than Gordon Square, and so I will try to write you a line
from it, and give you some account of my doings since we parted.
Roger's luncheon party was a great success. Both Massine & Diag-
alief (?) most agreeable and thoroughly equipped in French – a great
comfort after other Russians I have met. Their enthusiasm for the
cubists seemed to me something doctrinaire though sympathetic. I
doubt whether either has much positive taste in pictures. Massine,
however, was enthusiastic about Duncan also which pleased me.
Roger has now undertaken the arrangement of two picture exhi-
bitions – Massine's private collection, and a show of Delaunay's
sketches. Later in the afternoon I received the most astounding
piece of information about an eminent writer of our acquaintance
from an undeniable authority. His publisher told me, on the author-
ity of Lady Ritchie, that Mr. Lytton Strachey was about to marry.
"Whom"? "Well . . . er . . ." (in an undertone) "er . . . a . . . lit-
tle woman he has been living with for some time. The family is
delighted". Mr. Asquith imparted the same bit of news to Maynard
during the week-end. Lytton himself seemed incredulous; but as,
yesterday morning, he confessed that he had to go back because
Carrington had made such a scene on his setting out – she felt
sure he'd stay, and he had gone so far as to exclaim "Very well
I won't go at all" – it almost looks as though there were some-
thing in it. Surely only married couples behave so ill to each other?
The object of Lytton's visit was to get himself photographed for an
important American newspaper syndicate. "Where should he go?"
I said "Photo by Elliott and Fry of course". However, he didn't feel
quite up to that yet I suppose, so I suggested your man in Hanover
Square. He is probably returning tonight for the party; and has, I
dare say, already written about it all to Mary of whom he is really
very fond. That evening the party at Gordon Square consisted of
the household, plus Molly, [Siegfried] Sassoon and Lytton. It was a
pleasant, quiet affair. Life is so full just at present that I can but give
you the heads of events. Yesterday I lunched with Robbie [Ross]
at that damned Automobile Club, the party consisted of Robbie,
[Hugh] Massingham, Edith Sitwell and myself. The uproar was so
great that conversation was almost out of the question. I learn't that
Ozzie [Osbert Sitwell] was addressing his prospective constituents.
I may have more to tell you all about this when I am rather more
at leisure. Already I am grossly late for Clifton. Tonight there is

to be a party at Gordon Square for the Russian dancers and some thirty amateurs; both Jessie [a servant] and her helpmate have been struck down by some disgusting lower-class disease; Norton arrived unexpectedly last night; Vanessa is arriving this morning; Duncan is to decorate all the rooms in the house before dinner-time, procure cups, glasses and food and paint a negro: I can't imagine what is going on there now: my duties ended with going to fetch a doctor. Pozzo [Maynard Keynes] bears up feverishly. Molly dines with me. Last night I found at Gordon Square Oliver [Strachey] with his tart (a rather pretty girl) and Faith.[2] Well, well, Garsington will be a relief by tomorrow at any rate; and from there I will give you my considered opinion on Anonymous, which, however, will not be as valuable as the blue stockings I fear. My cold is still very distressing.

I must fly.
Clive

Notes

1. Slang for traitor (used ironically here by Clive). The club was founded on Gerrard Street by Leonard Woolf and others as a place for socialists to gather.
2. Faith Henderson was the sister of Nick Bagenal, whom Barbara Hiles married in 1918.

To Dora Carrington 46 Gordon Square
January 30 1919

My dear Carrington,
 I fear this will turn out to be a business-letter rather than the Collins [letter of thanks] which is, however, what it purports to be. In the first place, I am sending you a consignment of the magical powders which will, I hope, arrive in good case and produce an immediate effect. In the second, I beg of you to send on all my letters: it is a great bore they're having been posted before my telegram arrived as I fancy one or two of them may be important. I have seen Roger, deeper in affairs and more like the mad hatter than ever; he is very sensible, on the whole, and most charming and I hope for the best. Mary, meanwhile, is looking after Pamela [Fry] who has developed influenza at Durbins [Roger Fry's house]: I only hope she mayn't catch it herself. The cold here surpasses

belief, though no snow lies in the square, I dread a catarrh and am far from gay. Nevertheless, Alix [Strachey] is gone and two tons of coal arrived on Monday. Above all, my dear Carrington, your kindness to me and le vieux's [Lytton] leaves a very very pleasant impression on my mind. Thank you both – I love you.

Yours ever, CB
HRC

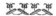

To Lytton Strachey
February 19 1919 46 Gordon Square

My dear Lytton, you would have heard from me long ago if I had not every day half expected you here. A rumour got about that you were coming to town and I supposed that your knowledge of the fact that two ton of coal had just entered the house would lead you to apply for my spare room. I fancy you have chosen the better part; the state of this city is indescribable. Quocunque aspicias [*sic*] nihil est nisi pontus et aër [Ovid: "*In whatever direction I look, there is nothing except sea and air*"] – pontus, well slush, filth, deliquescent horror and death, and people falling down dead in it from the influenza. I guard my room and write articles for the Americans. The New Republic tempted me and I fell: do you know, they pay ten pounds for an ordinary two thousand word article. I have contracted to deliver one every other month. More journalism is afoot I gather from an almost affectionate letter from Murry ("My dear Clive" "Yours ever") who proposes a meeting tomorrow. I always like seeing Murry because I think him intelligent and well-educated, also I am curious about that ménage – one hears such stories – but I can't suppose he will have anything to offer that should shake one's resolution to keep out of the papers. I think Mary's business may turn out well but I'm by no means sure. At present she is at River House and Jack is in a nursing home recovering from the strain of losing his temper. The plan is that Mary should have a little house of her own on Ham common or somewhere of that sort and live in it with the children. Jack would have chambers in London and come down for week-ends strictly as Mary's guest. I don't know whether it would work, but it might. Roger, as you may suppose, is immensely sympathetic and finds "suppressed complexes" in everything. He has five or six important jobs on hand, a theory of

aesthetics to account for various peculiarities in the ballet, another
to account for savage art, a theory of the Mongols, various French
poets, a house-moving, an intrigue, and a cold in the head. I dined
with him on Monday night and found him charming. Creavey [*The
Creevey Papers*] I read just after it came out – just after I left Cam-
bridge it seems to me. It is one of my stock recommendations, and
I have even thought of reading it again – for I suppose one's knowl-
edge of the world has increased since those days, though I can't
say I notice it – but anyway my memory's too good. Some of the
London book-sellers are hawking about 'Le petit Pierre' as a new
Anatole France. I fancy it is only an old Pierre refurbished. How-
ever it was new to me – sentimental, childish memories moralized
in a way that is often affected, and at times tolerably laborious, but
containing exquisite things, exquisite paragraphs. Did you know
that in the twelfth century they came within measurable distance
of écraséing l'infâme?[1] It seems so. And what with their admirable
Romanesque architecture and sculpture, their glass, their frescoes,
their poetry, their ribaldry and reckless fucking I begin to take an
interest in those people. Alas! "the literature of the subject" is not
appetizing and I have nothing to recommend. I cannot make use,
myself, of the ticket you so obligingly sent because tomorrow after-
noon I am to receive a visit from her ladyship [Ottoline]. She is stay-
ing at Garlands hotel in Suffolk Street, and I await her coming with
that mixture of curiosity and fear that has brought so many young
people to their ruin. I have no idea what she has been up to all this
time though I heard something of her the other night from Brettie
[Dorothy Brett] whom I met at the ballet with Julian Huxley and la
petite Mam'zelle [Juliette Baillot, whom Huxley married this year].
J. H. is a typical young Oxford don; a shocking talkative bore, who
suits his manners to his company and regaled me with descriptions
of the more notorious monuments past which his military duties in
Italy had led him – a decent fellow withal. Mlle. Juliette has cut her
hair and already lost some of her looks. I prophecy for her a grand
success in Oxford where her exquisite Parisian culture – though to
be sure she has never been nearer the capital than Lyon, and in the
railway train at that – will make a most exciting impression. Talking
of foreigners, on Sunday I had a very good and very amusing lunch
at the Savoy with Massine and Diaglief (?). Nominally, I had gone
to hear the former propound his aesthetic theories, but as he speaks
French very very slowly and not very accurately, and as both D. and
I when slightly tipsy are extremely voluble, he soon dropped out
and merely looked nice and intelligent. D. was really very bright,
with disobliging anecdotes about our eminent contemporaries and

quite sensible comments. They asked me to come again which I shall do. You almost certainly know that poor Pozzo [Maynard Keynes] has been ill, and losing his money since at Monte Carlo: there I lose sight of him, he may have won it all back by now. Norton, who turned up last night for a Quakers' meeting ostensibly, is at this moment below stairs, with Alix I dare say. But I know little of that affair and cannot much credit the more interesting rumours – Virginia, for instance, pretends that he is now known to visit rubber stores –, certainly it is true that Alix has covered her shabbiness with a fine new cloak, a fur hat and long white gloves. But I forget – James is with you – as usual I am sending coals to Newcastle. I have seen something of Virginia – at the top of her form; of course I was bowled over, but I picked myself up smartly and looked as though nothing had happened. No more wallowing for me – that is the one advantage of growing old. Duncan has been in town, perturbed but charming; the singularity of his adventures as usual came up to expectations. There seems to be some hope of rubbing Bunny off onto Frankie [Birrell] and poking the pair of them into a second hand book-shop. [Boris] Anrep and Logan Pearsall Smith after quarrelling through a long luncheon party at last came together in abusing Bloomsbury – so presumably they know what Bloomsbury is. Vanessa, after going through unspeakable horrors, has apparently outridden the storm. Aunt Annie hurries about London telling the "joyful news" that "Clive and Vanessa have come together again over the little baby."[2] Everyone else has the influenza.

Clive

Notes

1. Voltaire's infamous phrase 'écrasez l'infâme' (*crush the vile thing*) referred specifically to the Catholic Church.
2. Anny Ritchie was the sister of Leslie Stephen's first wife, Minny Thackeray. The baby was Angelica Garnett.

To Mary Hutchinson
May 28 1919 46 Gordon Square

The first thing I did after I reached Victoria, dearest Polly, was to telephone to Virginia: then I went home and washed myself and went off to tea at Richmond. Virginia was most gracious

and lively, her monthlies notwithstanding. She had soon asked me what I thought of "Kew [Gardens]", and then what Mary thought of it. I said she liked it, but that of course she had some criticisms up her sleeve. Whereupon Virginia said 'Damn her'; but in fact she was in high good humour with all the compliments she has been getting. Logan Pearsall Smith thought it would be so nice if they [i.e. Hogarth Press] would print an essay of Elia [Charles Lamb] beautifully and charge a guinea for it. I begin to fancy you must be right about Trivia [an anthology compiled by Smith]. I got back to the Commercio to find that Vanessa had poséed me a lapin [French idiom for being stood up] and gone off with Roger to see the ballet from a box, in the company of Mary Butts (whom Roger is painting naked) Pippa [Strachey], Oliver [Strachey] and his wife [Ray Costelloe]. So I dined with Norton and [Edward] Wolfe and sauntered back through Soho to read till Roger returned with V. and Norton and gossiped into the middle of the night. Yesterday I devoted entirely to income-tax and didn't leave the house till six o'clock when I tried to cross the road to register a letter at Euston. But the road was filled with some hundreds of thousands of people who were waiting to see a man who hadn't crossed the Atlantic.[1] A singular race the English. Lytton, Norton, and Vanessa dined and we had some fun, baiting le vieux a little beyond the verge of his endurance in this hot weather. The great joke is about Ott. – I heard of it from Virginia too – : her fury at not having been asked to a supper-party that was never even arranged [for Picasso and Derain] is boundless – also that Nelson, Brettie, Gertler and Chile[2] were not asked. Apparently one can neither give a dinner-party, nor not give a dinner-party without inviting the old whore and her train-ballage. In revengence [sic], she insisted on Osbert giving a party for her tonight. Osbert, as he was giving the party at his own house and paying for it – by cheque I presume – supposed himself entitled to ask whom he pleased, and the first person he asked was Vanessa. However he is very much bored by the whole thing, Derain & Picasso loathe parties, and there seems to be a great chance that it will fall through at the last moment. At all events Osbert has written to Ott. trying to wriggle out; but she may hold him. According to Lytton, her rage against "Bloomsbury" is beyond all bounds: first he tried to soothe her, then gave her a piece of his mind. Lunch time: I will write a better letter in a day or two.

CB

Notes

1. The *Daily Mail* offered a £1,000 prize for a successful transatlantic flight.
2. The painter Álvaro Guevara.

To the Editor of *The New Statesman*
April 1 1922

Good Words

Sir, – Maybe your Affable Hawk was, as he says, "born to be moderator between them both" (Mr. Shaw and Mr. Bell)[1] – the very phrase suggests a mind overflowing with good intentions – but he would stand a better chance of success were he to mend his manners. It is useless to insinuate that Mr. Shaw may be a little overstepping the bounds of old-world courtesy in calling me "a voluptuary and a fat-head," if he, himself, a few lines lower down is going to call me "blooming, balmy and fatuous." I resent none of these pretty familiarities; one could no more mind being called fatuous by a man with such a style, than one could mind being called voluptuary by a gentleman in jaeger. Only I would point out that Mr. Shaw, your Hawk, and other periodic apostles of sweet reasonableness are bringing controversy and criticism to such a pass that, before long, instead of discussing what a writer says, we shall be concerned only with what he eats. The injunction "Be personal" is construed by our modern masters in a sense that would have astonished the school of 1880: so Affable Hawk must not be surprised if, when next "his colleague," Mr. Desmond MacCarthy, publishes a volume of essays, the reviewer, instead of observing merely that "these papers are written in a style which reminds us of a greasy old retriever-dog making himself a hole wherein he will ultimately lie down," should, not content with these critical observations, go on to remark that this is all one can expect of a seedy intellect debilitated by a plethora of food, drink and tobacco and unsupported by habits of scrupulous personal cleanliness. Should it come to this the Hawk must not be surprised – though I shall be distressed, and shall very likely write to the papers about it. For to say such things of our friend, Mr. MacCarthy, would not be more offensive than calling me "voluptuary and fat-head, a blooming, balmy, fatuous, irritating, replete, thumb-in-the-arm-hole, open shirt-front young

man," and certainly not less inexact. At least, that is how it strikes me; but then I may be prejudiced.

Yours, etc., Clive Bell

Note

1. George Bernard Shaw and Clive Bell had been sniping at one another in the letters columns since Clive had mocked Shaw's play *Back to Methuselah* in 'The Creed of an Aesthete'. Shaw called him 'a fathead and a voluptuary'. Writing as 'Affable Hawk', the pseudonym for his weekly column, Desmond MacCarthy had attempted to reconcile the two, to no avail.

<center>⚜ ⚜ ⚜ ⚜</center>

To Lytton Strachey
August 19 1930 Charleston

My Dear Lytton,
 they tell me there is to be a meeting of the Memoir Club on September 6th – it seems odd I know, but so Molly has decreed; and they tell me you are coming to stay here, which is all very well. But I hope you mean to stay a little longer than from Saturday to Monday. I am myself going away about the 27th of August for a week, to the Wharf [home of the Asquiths] and then to the colonel [Cory Bell] for a day or two, but I shall be back on Thursday September 4th for certain. So will you come on the Friday, or better still stay on a few days into the following week? We can offer you all the normal attractions and possibly a young friend of Julian's into the bargain. And when you reply you might answer one or two questions. For instance, did you prefer your Irish or your Brittainy – I'm sure I don't know how the English form is spelt – friends? Did you go to bed with Diana [Mitford] or with Wogan [Phillips]? One gets inquisitive about things of that sort in the country – you know how one is – and besides Duncan is insatiable for gossip. So we should like to hear all about it, about your present and your immediate future. In return I will tell you that we are all extremely quiet and industrious, notwithstanding a fleet of cars, no less than three – four if you count the pot which hasn't moved however since it got frost-bitten the winter before last. Raymond and Frankie paid us a fine bank-holiday visit and we never stopped talking from Saturday evening to Tuesday morning. I shouldn't be surprised if Vanessa

had had almost enough of it; though we argued it very learnedly. Fanny is coming at the end of this week and I hope we shall have grouse in her honour. The Woolves are always with us – Virginia in a pretty bad temper, partly because Chatto is publishing some poems of Julian's and Tom has paid him a compliment,[1] partly because she feels that the general fall in Nicolson stocks in some way reflects on her – and then it is disagreeable to have to admit that the Hogarth Press has had a financial success – and from that and from another angle Vita's success appears vexatious.

Yours, Clive

Note

1. Julian Bell's *Winter Movement* was published while he was still a student at Cambridge.

To Raymond Mortimer and Francis Birrell
March 13 1934 50 Gordon Square

My dear Raymond ⎫
 Frankie ⎭ for I assume by this you are together, let me see whether I have any news that may not have reached you through other sources. A mild – a very mild – stir was created by [C. R. W.] Nevinson threatening Chatto with a libel action because I had called a picture of his "feeble." Chatto having no taste for trouble, suggested – reasonably I think – timidly according to others – removing the note and the illustration to which it applied. I agreed. With the result that I have sold 750 copies [of *Enjoying Pictures*] before one single review has appeared, and that poor Mr. Nevinson's name goes onto a secret black list, apparently known only to publishers and editors, of people who are likely to make trouble and had better not be mentioned in print. Then there is Vanessa's show chez Lefevre – magnificent in my opinion – an extraordinary advance on anything she has shown before. Also it is highly successful from the dealer's point of view so far. Incidentally it has involved Duncan in a squabble with Jack Hutchinson, in which Hutchie has behaved with characteristic legal pig-headedness and native vulgarity. Julian, it appears, again stands quite a good chance of a fellowship, but has set his heart on going [*sic*] professor of English to a Chinese university. So much for family news.

Darling Christabel [McLaren], whom I thought alarmingly tired and ill a fortnight ago, is now completely – save for her figure – herself again. We went to see Lydia give a surprisingly good show in the Doll's House. We went – a party – to see The Country Wife at the Ambassador's Theatre – hardly expurgated at all – and laughed so heartily that some of us almost fell out of our seats and I thought Christabel would be delivered of a baby on the spot. The party consisted of Christabel, Vanessa, Duncan, Sam, Hambro, and myself. We had a very lively supper – as you may suppose. My flirt with Jenny de Margery[1] persists – she is not so much a precieuse ridicule as a pretentieuse aimable –; I lunched then the other day to meet [Jean] Giraudoux, who is delightful – we must all get to know him better, maybe Raymond knows him well already. Old Sib was there with a toothache. The Compagnie de Quinze is in London – guaranteed by that admirable Charles Laughton; I have seen Copeau's daughter and a pretty little member of the cast who is an amie de Georges – Sylvie Bataille. The play "Don Juan" by Oby {??} – is that how one spells his name? – was a showy, empty business, beautifully acted. But not so showy and empty as Mr. Coward's piece – which is something awful, and boring, boring. I wonder whether his faithful public, and Desmond, will ever notice that. Yvonne Printemps was of course brilliant: she always is. There is a life of Elizabeth by Neale and a life of Pepys by Bryant to read, for those who like biography. I do. You will be glad to hear – at least I hope you will – that our clamour has been effective and that the B. B. C. pronunciation committee has been dissolved much to the grief of Mr. Pé-ars-al Smith to give him his diaeresis. For the rest, I have seen Peter Quennell and Victor – both in excellent case – and whom else? I hardly know. Oh, Frankie, they have returned, from Elm Park Road, a copy of Winston's Marlborough, which alas! I never lent you. I shall keep it against your return. At Vanessa's private view there were some gay moments. Angelica, with some eight or ten of her pretty school-mates, came up for it, and this created a pleasant aviary-like effect. Then Margot [Asquith] went round with Vanessa giving her hints on painting at the top of her voice, and especially warning her against "hot backgrounds" – "backgrounds should always be grey, my Dear." I like this woman more and more, and I think we should make the most of our opportunities. We shall not look upon her like again. Then, old Ethel Smyth, who is now deafer than any post – like Beethoven – was introduced to Charles Laughton. "What's your name, what's your name? I didn't catch: you're uncommonly like Charles Laughton." I don't think I've

much more news – except that it's raining – and certainly I've no more time. Pray give my love to all the inhabitants – especially the merveilleux Janie [Bussy].

Clive
Princeton

Note

1. Wife of the French diplomat Roland de Margerie, one of Clive Bell's closest friends.

To Sybil Colefax
October 18 1945 Charleston

Dear Sybil
 I am delighted to hear that you are giving Barbara Bagenal a chance. When she was a student in Paris and at the Slade she showed considerable promise. Then came marriage and babies, and the old, old story. Now the children are grown up and she is free – more or less. I see no reason to suppose that she has lost her talent; but she has lost confidence. So encourage her if you can.
 I never see you. Whose fault is that? Not mine altogether. I am become like Mr. Jorrocks[1] – and when the M. F. H. [Master of Fox Hounds] dines he sleeps and when he sleeps he breakfasts. I mean that since Bunny and Angelica returned to Hilton[2] I have no permanent abode in London. Rooms in hotels become harder and harder to come by. And so, though I often think how pleasant it would be to attend one of Sibyl's 'ordinaries', I do nothing about it. However, sometime next month I shall be in London for the inside of a week; and so – you have been warned.

Yours ever, Clive
KCC

Notes

1. Mr Jorrocks, a comical cockney greengrocer who loves hunting, was the creation of Robert Smith Surtees. *Jorrocks's Jaunts and Jollities* is one of the books Clarissa Dalloway sees in Hatchards' window in *Mrs Dalloway*.

2. Bunny Garnett bought Hilton Hall, near Cambridge, with his first wife, Ray, in 1924.

❧❧❧❧

To Mary Hutchinson
Easter Monday [April 22] 1946 Charleston

Dearest Mary, you will probably wish to have some news of Tilton. Maynard died as suddenly as possible. Lydia had brought him in a cup of tea at ten o'clock in the morning: he made a grimace and collapsed. Lydia didn't realise that he was dead; but old Mrs. Keynes, who happened to be staying in the house, and was called into the room, did. I had known for some time, and so probably had you, that any of these heart attacks which have become so common with him of late might be fatal. He might just as well have died that night at Covent Garden as yesterday morning. Duncan seems to think that Lydia did not know this. Maybe she didn't. She is behaving with great sense and calmness; less emotional, and indeed more natural than she generally is. What the later reaction may be one can't guess. And what is ultimately to become of her is what everyone is asking. The fact is, she has no friends – Vera Bowen and Mrs. Grenfell are become – without any sort of coldness, merely by force of circumstances – acquaintances. I should suppose she will live in London – in part of 46 perhaps. Her quiet and natural behaviour makes her seem to me rather pathetic. I fancy she may want Vanessa and Duncan to go with her to the cremation at Brighton – on Thursday I think: she will hardly wish for me, or for Leonard (who has been with her this afternoon and formed the same opinion of her state of mind as we had formed). Old Mrs. Keynes, an admirable person but eighty-five, is staying on: Geoffrey [Keynes] came down last night but must get back to London tonight (it is now about seven o'clock), however Maynard's sister Margaret (Professor A. V. Hill's wife) is arriving, and she is pleasant and sensible. Of practical details I at present know nothing.

Maynard came here to tea on Thursday, alone, and stayed almost till dinner time. I have seldom known him in better spirits. He was extremely gay and full of projects. We talked of Roger – about whom I happened to have written something for the Americans – and of the fine show at the Tate, and plans for future shows of French painting. He was delighted with Kingsley Martin's misadventures in the Russian zone, abused the government, and took more than half seriously a wild project of

Duncan's for a gala performance at Covent Garden in honour of Shaw's ninetieth birthday to end with a laurel-crowning by a pretty young actress (not Dame Sybil Thorndike) in the manner of Voltaire. Probably he would have realised it triumphantly. I have some reason to think that he had been given, and was much pleased to have been given, the O. M. [Order of Merit] a few days before his death. But as there has been nothing about this in the papers I may be wrong. The last thing he said to me was that he had something in mind to write about Lytton, and that if he could get it done he would read it at the next meeting of the Memoir Club. That is all I have to tell you for the present, dearest Mary: if I hear more that might interest you I will write again. I am relieved to hear that the worst of your house troubles are no longer menacing; and for the others – we must hope for the best. Particularly I am glad to think I shall see you on May 8th. After all I believe it will be a tête-à-tête.

Yours, Clive

To the Editor of *The Times Literary Supplement*
August 27 1954

The Bloomsbury Group

Sir, – In his brilliant notice of Mr. J. K. Johnstone's *The Blooms-bury Group* your reviewer[1] has been led by his author into error. This error seems to me sufficiently important to merit correction. Roger Fry's aesthetics owe nothing to G. E. Moore's ethics.

People forget how very much older was Roger Fry than the rest of the so-called "group": for instance he was sixteen years older than Virginia Woolf. His intellectual formation had been quite different from ours, and in that formation *Principia Ethica* played no part. Some time after the book was published (it was published in 1903 when Roger Fry, who was older than Moore, was thirty-six) he read it and disagreed with almost all its conclusions. To tell the brutal truth, he called the doctrine "sheer nonsense" and continued so to call it, thereby as nearly shocking Moore's passionate admirers – of whom I am one – as Moore's passionate admirers were capable of being shocked. Over a long course of years I frequently discussed aesthetics, and sometimes ethics, with Roger Fry, and I know for certain that he arrived at his conclusions by ways

of thinking and feeling that had nothing to do with Moore's. I have shown this letter to the two people alive who knew Roger Fry best, or at any rate knew best what he thought and felt about art and aesthetics. They assent to all I have written, so I beg you, sir, and your reviewer to believe that Roger Fry's aesthetics owed nothing to G. E. Moore's ethics.

While I am about a disagreeable task may I correct two more mistakes? Both are trivial; but as the review will be treated, and rightly treated, as authoritative, it is desirable that it should be accurate in the smallest details. I am misquoted as saying that the group of undergraduates (Virginia Woolf's "six young men"), who may be called the founders of Bloomsbury if such an entity really did exist, came together at Cambridge in 1904. They came together in 1899. Whence it follows that Maynard Keynes was not of the number, for the very good reason that he came up in 1902. And, by the way, Leslie Stephen was not an apostle.[2]

Clive Bell

Notes

1. The (anonymous) reviewer was the poet Frances Cornford, grand-daughter of Charles Darwin.
2. The secretive Cambridge Conversazione Society of which many of the 'Bloomsbury Group' were members.

To Leonard Woolf
September 31 1960 Charleston

My dear Leonard,
 You may or may not know that old Saxon [Sydney-Turner] is now more or less confined to his bedroom. Mrs. Manning – his keeper – finds it almost impossible to pilot him downstairs and harder still to push him up again. This means no television, and consequently increased gloom. Also you may not know that next month he celebrates his eightieth birthday. A few of his friends have decided to give him a television set, and to give it at once so that he may see the Cambridgeshire [cricket match]. It must be a fairly large set, as he could not see small figures from his bed. The total cost, plus installation, may amount to a hundred pounds. As Ralph Partridge and I have each put up twenty-five, and Barbara has given

twenty, there is no financial crisis. Only it was thought that you and Vanessa and Duncan, and one or two more perhaps, might like to be in on the project, or at any rate might dislike being left out of it. So no more need be said, and the matter can be left to your good pleasure and discretion. But before folding up this sheet, I should like to tell you that I consider Sowing about the best autobiography of our time. Certainly it is the best that I have read for many a long day. Barbara has given Saxon a copy. Raymond – another staunch admirer – wondered whether she was being perfectly tactful. How would he take the character of Aristotle?[1] "He will be delighted to have filled a dozen pages" was my reply. Saxon has resolutely refused all his life to push himself forward in any way; but he is not averse from being pushed forward a little by others. He complains that few of your reviewers refer to him by name. By God that was a silly notice in the Supplement. However, William Morris said "I don't mind what reviewers say so long as they say it at length".

Yours ever, Clive
Sussex

Note

1. In the first volume, *Sowing*, of his autobiography, Leonard reprinted a character sketch of Saxon he had written in which he named him Aristotle.

2

Virginia

Thoby Stephen, Clive Bell's best friend at Trinity College, Cambridge, kept photographs on his mantelpiece of his beautiful sisters, Virginia and Vanessa. When they attended the May Ball in 1900, the sisters would have had the opportunity to meet the friend whom their brother had described to Virginia as 'a sort of mixture between Shelley and a sporting country squire' (Hussey 9). Two years later, Thoby invited Clive to visit his family in the New Forest, where the Stephens had rented a house. Soon afterwards, Clive visited the sisters at their home on Hyde Park Gate in London, and when the siblings travelled in Europe in 1904 it was natural that they stopped in Paris on their way home so that Thoby could see his friend Clive, who was living there.

Clive and Virginia shared the agony of watching Thoby die after his doctors had misdiagnosed as malaria the typhoid he had contracted in Greece in 1906. Vanessa, who by then had twice rejected Clive's marriage proposals, lay ill in the Stephens' house at Gordon Square, suffering from the same disease that killed her brother. To Virginia's amazement, her sister agreed to marry Clive on the day their brother was interred. She experienced the marriage – which necessitated her and her younger brother, Adrian, looking for a new home – as a second bereavement. Her relations with Clive would never be straightforward, refracted as they were through her intense intimacy with her sister: he was both conduit and threat to that relationship.

For his part, Clive was as smitten with Virginia as he was with Vanessa. When she shared with him the early drafts of her first novel – called 'Melymbrosia' at the time – he was both flattered and awestruck, and gave her honest critique. When the Bells' first child, Julian, was born, Clive and Virginia embarked on a flirtation that caused deep pain to Vanessa. When Virginia was courted by Leonard Woolf, Clive's jealousy gave rise to bitter recriminations

in letters to his friends. But Clive and Virginia remained always close, a closeness that sometimes led to exasperation, irritation and malice. They both loved gossip; they were both deeply pacifist; they shared the pain of Thoby's death. Clive flashes through Woolf's fiction, glimpsed in the Paris scenes of Jacob's Room, *and again in aspects of the character of Bernard in* The Waves. *In his memoir,* Old Friends, *Clive wrote that although he had known many very gifted and clever people, he had known only two geniuses: Picasso and Virginia Woolf.*

To Virginia Stephen
Saturday April 18 1908 46 Gordon Square [written from
 Cleeve House]

My dear Virginia,
 You are far too deeply sophisticated to end a letter with a
reference to a young man. Still, kissing Julian and Nessa's eyes
is rather formal stuff at the best, and would provide an inse-
cure escape for a person of your intellectual weight.[1] So, on the
whole, I prefer to disregard superficial appearances, or at least
to suspend judgment. You see I reject the hypothesis that you
acted out of pure malice, as you did when you persuaded me to
think it possible that you were going to the West Indies for six
weeks.
 Have you ever noticed that the atmosphere of the private bar
is more perceptible than that of feminine purity? Perhaps it is
well – for women. Mrs. Raven Hill,[2] Mrs. Armour,[3] Mrs. Clive
Bell; three young or youngish women: mothers, how beautiful
do they sit, each in her own shy nursery smiling down Madonna-
like on a smiling child. Last night they dined with three men; Mr.
Raven Hill, Mr. Armour, Mr. Clive Bell; artists, young mem-
bers of the youngest Bohemian clubs, stained by drink and lust
and too warm contact with a sin-be-sodden world. How would
they have blushed (they would have blushed, I swear to you
they would) these men who sat smoking their cigars and drink-
ing their port and talking of music-halls and dances and bull-
fights, blushed to have heard one sentence of the conversation
that was going forward over the way in the ladies' withdrawing
room. Your sister will perhaps repeat it to you, though certainly
I hope she will not. You will be glad to hear, at any rate, that
she is much the better for her half hour's bawdy talk. "Varium
et mutabile semper"[4] – it is just because women are so deli-
ciously soft in some places that they are so exquisitely hard in
others; and you who are as feminine as anything that wears a
skirt (I forbear a more scientific description) are too much of
a genius to believe in your own sex – or in one's either. By all
means go out and observe your fellow creatures lest you share
the fate of Saxon; it may be you will find that they are really a
little lower than the angels, but in any case I am sure you will
find that the average woman is inferior to the average man; and
for this reason: the average woman hopes she is something even
meaner than what the average man would wish to become. We,
of course, are all extraordinary people to whom no general laws

apply; but Vanessa like some beautiful black velvet foil takes the measure of her peeresses and can judge their colour to a shade. Her apprehension is so sure that she is rarely descried, and yet she continues to get confidences. Explain me that.

This letter won't mystify you, I fear, but it may please, and that is as much as I can hope or wish to achieve. No matter how sharp green eyes may be, they look all the better for smiling.

Yours ever, CB

Notes

1. See her letter to Clive Bell, 15 April 1908 (*L1* 324–325) in which Virginia asked Clive to kiss her sister and nephew.
2. Annie Raven-Hill, Clive's neighbour in Wiltshire with whom he began an affair in 1899 that continued intermittently until 1914.
3. Wife of the *Punch* cartoonist G. D. Armour.
4. Virgil: 'woman is fickle and ever-changing' (but Clive has omitted the word 'femina' from his quotation).

To Virginia Stephen
May 7 1908 46 Gordon Square

My dear Virginia,

I think I won't go to bed without saying 'thank you' for your letter [see VW *L1* 329–330 6 May 1908]. I suppose I shall forfeit all my reputation for self-confidence and character when I say that, on the top of Rosewall [in Cornwall], I wished for nothing in the world but to kiss you. I wished so much that I grew shy and could not see what you were feeling; that is what happens always, and one of the worst things in human nature. Well, it's no use crying over spilt mink (as Nessa would say); only it strengthens me in my belief that it's of very little consequence if we say and do those things that we ought not to have said and done. What does matter is that we should not leave unsaid & undone those things which, by some divine emotion, we know that we ought to say and do. There are no hymns or harmoniums to excuse this letter,[1] only my own feelings and a belief in you which perhaps almost equals your own.

Yours ever, CB.

Note

1. In his previous letter, from Seend, Clive had complained of being disturbed by the sound of hymns and a harmonium from a nearby chapel.

To Virginia Stephen
Monday night [May/June 1908] 46 Gordon Square

My dear Virginia,

I can't resist writing a note to tell you that I am very happy and that I have thought a great deal about you since Friday; not more than during the black, preceding fortnight I daresay, but how differently, with how new a delight. I want to come and see you, but I scarcely know what I should say if I did; for you object, with some reason I think, to the common tenor of our conversations and I know not any art of talking but to say what I happen to think at the moment, and what I always begin to think vehemently after half an hour's conversation with you is just what had better incandesce unspoken. Do you truly understand and believe what I told you? If so, it should be easier for you to forgive the irritating way in which I often talk, especially when Adrian is with us – the robust, manly way, I mean. You see it's impossible to say "That's what you and I think about it; but Virginia has a view of the world which makes what she says about it worth a great deal more than all we shall ever think." Well, as high seriousness is out of the question and I don't much care about playing at being serious, I take refuge under the nonsensical and patronizing tone. You needn't listen unless you like, very often you don't; there are always fire-lighters or their equivalents.

I don't think you quite realize either that my private undertakings, for the most part, I set at their true value – zero precisely. If you did you could never have been so blind; you must have seen what things really do count for me, and that they count so much as almost to seem too good to be true – sometimes. But, vaguely, you do see, I hope, that you did what I could never have dared to do, and that consequently I am wonderfully happy and fonder of you than ever – if that's possible.

Yours affectionately, CB

To Virginia Stephen
August 23 1908 Glencarron Lodge, Ross-shire

My dear Virginia,
 there seem to be no very sufficient grounds for thinking that
this letter will ever reach you; but if it should, try to recall the
last Highland piece by the late Sir E. Landseer, R. A. which you
were unable to avoid in strolling through our public galleries, then
you will see what we are laughing at. It is really comic and agree-
able too, watching Nessa as she realises the visions of her earliest
days provoked by expensive Christmas cards; the sun shines, the
heather is very purple, the shallow burns leap from stone to stone,
and the mountains are perfectly unpictorial.
 Nevertheless, when one has been watching for three hours and
is sufficiently tired to be unaware of the inequalities of one's rest-
ing place, it is well enough to lie in the heather and contemplate
the view with a pipe in one's mouth: the critic should be cold and
restless. But, to tell the truth, I go too much to the Opera to appre-
ciate this country. No, I don't care about Cintra nor Barcelona
either; but what is your objection to an ordinary well-sounding
name?[1] I don't understand it and so I appear unsympathetic; Polly
or Catherine would be adequate to my taste. Your ephemeridae
will keep you out of mischief at Manorbier, but I wish I were there
to talk about your opus and give you what I conceive to be a very
necessary up-blowing. Your jests about hap-hazzard matters are
decidedly ill-timed. It is, I suppose, very delightful to indulge your
fancy with piece-work and to re-christen your characters once
a fortnight, but the form, which I was pleased to believe I had
detected beneath the loose draperies in the first hundred pages,
was a hard, solid, thing, not to be changed and chiseled without
splinters. Perhaps, however, I am to some extent unjust; so far as
piece-work goes, that is well enough when, as here I think, the
stuff is not of that fluid quality which needs must be moulded at
white heat. You take my distinction between marble and bronze?
The only question is – Am I right in my judgment?
 Vanessa will have told you all about our guests; we have cer-
tainly come in for the pick of the basket. [Thomas] Greg is really
clever and amusing, a thoroughly sympathetic character; Armour a
good man. I prefer either of them to H. Y. [Hilton Young[2]] so there!
But suppose one of them were in love with Virginia? Well, I believe
I should be consistent. By the way, I was quite right about H. Y., I
judged him better than Vanessa; I could never admit for a moment
any other explanation than that the letter had not reached him.

I must speak seriously and bluntly of your Italian luggage; you should wear winter combinations & two other flannel garments which I need not specify by name, more particularly as I detest the figure of speech which confounds an essential of female underwear with an essential of male over-wear. Vanessa is going to buy you a cholera belt, and I would advise you to hunt up your Greek mosquito net. Let us by all means go to the [Bernard and Mary] Berensons' house next summer. Could we all crowd in though; that depends, I think, on whether there are bed rooms in the attic and whether your servants would sleep in them.

Vanessa seems quite happy here but I don't quite know how she is going to amuse herself. The weather is gloriously fine, but sketching is almost impossible – for two reasons. In the first place, when the sun shines and there is no wind, the midges are so numerous and murmerous as to make sitting out little less than torture; in the second place, there is nothing to paint. Have you ever seen a picture of Scotch scenery that was at all better than the top of a chocolate box? There may be a Turner but I am not sure. The reason, I think, is this; the picturesque cheesemonger who takes the train or char-à-bancs from Inverness to Loch Alch sees exactly the same thing as I see and experiences the same emotions. I look out of the window; there are the mountains just as I might see them at Burlington House;[3] there is nothing more to be said or felt; they are utterly, hopelessly, obvious. If Monet were let loose here he might do something, at least he would make an interesting mess which would not attempt to resemble what he saw with his eyes. But I doubt it; no, the Scotch mountains in fine weather would provoke the mightiest genius to nothing appropriate to plastic expression which was not commonplace, and the scenery is commonplace, though I am not suggesting that I am a mighty genius. And that reminds me that Walter Lamb[4] speaks in a letter of 'her (Virginia's) kind of imagination, constructive humour', is he right? Well, I'll say no more about Walter and his letters, I must leave him to fight his own battle, only too happy to escape his fate. But do I really escape? When you have twenty spare minutes will you give yourself the trouble of reading through all the letters I have written you of late and telling me anew how you like them. That request is made in all honesty so harden your heart and give me an honest reply. I sometimes fear that I may be too much at ease in Zion [i.e. heaven] – it is a common fault of polite people – and it would be too wretched not to please you with letters that give me

so much pleasure. For it is a pleasure to write to you, and even to write differently would be exciting.

Yours affectionately, Clive Bell

Notes

1. Virginia and Clive had been discussing possible names for characters in her novel.
2. Edward Hilton Young, a contemporary of Clive Bell at Cambridge and suitor of Virginia Stephen.
3. i.e. the Royal Academy of Arts.
4. A Trinity College contemporary of Clive Bell, he proposed to Virginia in 1911. His younger brother was the painter Henry Lamb.

To Virginia Stephen
Friday [February 5 1909] 46 Gordon Square

My dear Virginia,
 if you really expected me to be disappointed with Melymbrosia, it must have been, I suppose, that you thought I might be disappointed with the last volume, that I should feel you had compromised with the Conventional & fallen away from the high – transcendent almost – task that you set yourself at the beginning. I do not feel that, and presently I will tell you why. My quarrels are all, or nearly all, with Vol. 1 and that is still so far from being finished that one hesitates to criticize it. But I do think it will be a difficult matter to make it supple, and I don't know that I like the new draft as well as the old. We have often talked about the atmosphere that you want to give; that atmosphere can only be insinuated, it cannot be set down in so many words. In the old form it was insinuated throughout, in the new it is more definite, more obvious, & to use a horrid expression, 'less felt' – by the reader I mean. To give an example; Rachel's day-dreams flood one's mind with an exquisitely delicate sense of Rachel on a ship, alone; the sea-gulls conjure up nothing but rather commonplace visions of sea-voyages for health or pleasure. The conversations, stiff though they were, created wonderful pictures of the speakers' surroundings; the conversations have for the most part gone, and that first difficult forenoon has gained in consequence; but the two letters from Helen, most interesting in themselves, are as stiff

and unreal as the old conversations, and coming on the mind in the state which you have been able to produce, by what has gone before, they seem inappropriate.[1]

For the first volume, I suggest, less definition and a reversion to the original plan of giving an atmosphere, which atmosphere you must remember has got to serve through chapters of incident & criticism which are coming later. In this part of your book I shouldn't bother much about the characters of your people; I think they tell their own story beautifully along with the ship, and the less one knows about their antecedents the better perhaps. Then, I must tell you again that I think the first part too didactic, not to say priggish. Our views about men & women are doubtless quite different, and the difference doesn't matter much; but to draw such sharp & marked contrast between the subtle, sensitive, tactful, gracious, delicately-perceptive, & perspicacious women, & the obtuse, vulgar, blind, florid, rude, tactless, emphatic, indelicate, vain, tyrannical, stupid men, is not only absurd, but rather bad art, I think.

To sum up my animadversions, then; – I feel, in the first part, that to give more 'humanity' to your work you have sacrificed the 'inhuman' – the super-natural – the magic which I thought as beautiful as anything that had been written these hundred years; in so far as the book is purely Virginia, Virginia's view of the world is perfectly artistic, but isn't there some danger that she may forget that an artist, like God, should create without coming to conclusions; lastly I think you should be careful not to wonder how some other novelist would have written your book – as if he could have written it! If you can manage to extract all the meaning from this short paragraph (about 6 pages full) you will know all I have to say against Melymbrosia.

I can now say, with a clear conscience, what I think about your novel – that it is wonderful. As I read it I was perhaps most struck by what I took for the improvement in its prose. It seemed to me that you gave your words a force that one expects to find only in the best poetry; they came as near the truth underlying them as it is possible for words to come I should think. This refers, of course, to particular passages; in some places the style was quite bald, but these I took to be mere notes; I don't think I need retract a word of my praise from any at all finished passage. Though Helen is by far the best character, the Dalloways enjoy the advantage of being more like the people whom the world knows.[2] They are very amusing, and more than life-like; them you have stripped quite naked at all events. I am stunned &

amazed by your insight, though you know I have always believed in it. Of Helen I cannot trust myself to speak, but I suppose you will make Vanessa believe in herself. Rachel is, of course, mysterious & remote, some strange, wild creature who has come to give up half her secret; but she is quite convincing as one reads, and in no true sense of the word unreal. I am not so sure about Valentine & Vinrace,[3] that they are both good characters & interesting. Now about the last part, it is of course, at first sight, less startling – more customary. But the whole situation is seen in such a new, such a curiously personal way, by Rachel, that I think it is really the best part of the book. I cannot tell you how interested I am in all the old figures – the inmates of the hotel – seen so differently by Rachel, as entities, and as combinations. At first I thought it a mistake to put Rachel outside the hotel, later I saw the genius of it. And then the pic-nic; that is why I say the novel has lost none of its early promise. Honestly, I think it challenges comparison with Box Hill [in Jane Austen's *Emma*] & holds its own & holds something more. Nothing could be more alive, or more subtle. Nothing is said to show that it was just half a failure, but everybody feels it, except Rachel who is thinking about better things. How on earth, by telling us what it was like at noon, do you show us what it was like at five, at sunset, and at night? Believe me the pic-nic is your master-piece, it surpasses anything in the first volume. Now, how are you going to finish it? Surely the Dalloways must appear again, & the Mary Jane?[4] Unless, indeed, you have invented some new, undream't of form? Well, I shall see some day.

If parts of your novel are notes, what is to be said about this letter?[5] You must consider it the merest jotting down of stray ideas. It is sure to be full of stupidities, and almost unintelligible I'm afraid in parts. I have had no time to give it a semblance of form or even to find the right word. I hope you will be able to make something of it, but besides being rather unintelligible it is probably also illegible.

Yours affectionately, CB

Notes

1. Rachel Vinrace and her aunt, Helen Ambrose, are characters in *The Voyage Out*.
2. Richard and Clarissa Dalloway make their first appearance in *The Voyage Out*.

3. Valentine was an early name for the character Ridley Ambrose; Vinrace is Rachel's father.
4. An earlier name for the ship in *The Voyage Out*.
5. See Virginia Stephen to Clive Bell ?7 February 1909, L1 373.

To Virginia Stephen
nd [1909?] 46 Gordon Square

My dear Virginia,
 I dream't last night that you were come, and that you had read me a volume of short stories; then, waking, I knew that Walter Lamb slept below. Wherefore I slept again.
 Downstairs the beautiful grey manuscript was awaiting me, but not, alas! the authoress by whom we are forsaken; shall I not see her again before I set out for the country?
 If it be vanity (be sure it is not modesty) I will rest content with this single fragment; but how should I spend better the long solitary days of spring, than in loving emendation of a corrupt text by our one great living lyricist. If you believe that you have anything else worth reading, you must believe also that I would be at any pains to read it. {Pray note the restrained position of 'also'.}

> "Through many hours of long philosophy
> I sat most patient, till one touch'd at length
> On genius; whether, in it's [sic] utmost strength,
> To express the ideal universally
> Were its mere end x x x
> x x x x x x x x
> These men, being over-just, had missed the true,
> And lost themselves in smallness, being "small."
>
> x x x x I think that thou do'st know
> The real, which is and was, remains alone
> The truly universal, which doth show
> Itself in form and rhythm x x x x"
> x x x x x x x x x x x
> With pomp of flowers above philosophy."

{This appears to be a fragment of a sonnet, found amongst the papers of an obscure but highly interesting poet of the early 20th century. It is written on a sheet of large fool'scap on the 'reverse'

side of which one seems to be able to decypher [*sic*] the follow-
ing: – "To V. S. suggested by a certain philosophic debate on the
nature of genius."}

{{V. S. The great contemporary novelist (1882–1972)?} Ed.}
Yours ever, CB

To Virginia Stephen
December 25 1909 Cleeve House, Seend

I cannot think of you as forlorn, my dear Virginia, even eating
your plum pudding alone in a Cornish Inn, which, according to
the authorities, is the forlornest fate that can overtake a spinster.
Are you alone though? I daresay not. That is a thought which has
come to me during the first sentence & will, I hope, not poison the
whole letter. It is 6.0; by eating no tea I have done something to
counteract the effect of midday port & pudding; Vanessa is play-
ing with her child, my family is asleep or at church, what better
can I do than sit by my dressing-room fire and write as I smoke
my bird's eye [a type of tobacco]? I don't think I'll tell you any-
thing about our presents, except that I got a beautiful 'Bewick's
Birds' (large paper copy 1826) in 2 vols. Nor will I say much
about Vanessa, who, for all I know, will be writing about herself
in a few minutes. So, about what shall I write? My own fam-
ily. They wouldn't interest you, though they interest me a good
deal; indeed, I begin to find them both interesting & amiable.
That's because, at least, I'm on the side of the vulgar & efficient;
Vanessa, I believe, gets farther & farther away from them daily;
that's because she's refined. I'm always prowling, you see, about
the edge of that uncompromising natural frontier. Did I tell you,
by the way, that Norton had discovered that beauty was 'the only
thing that mattered'? I believe I may expect a letter from him in
support of this paradox. It applies, I understand, to people as well
as to inanimate objects.

> There was a young person the sum
> Of whose qualities rendered him dumb;
> Though of dominant mind,
> And supremely refined,
> His eminence lay in his bum

I may yet be the Ruskin of young Sodom. Sodom, a name that, at once, plunges one into religious history, reminds me to tell you that I have begun 'Orpheus' & find it absorbing. I've half a mind to turn anthropologist; only I've also been reading Hardy's poems which suggest that there may be another & a better way of looking at life. About my own way of looking at life I am, or ought at least to be, greatly concerned. For instance, I met Mrs. Raven Hill at Paddington on Thursday & thought her delicious and fleshy in a fur coat; and then I dream't about Sapphism all night, and read the politics in the Times next morning. The trouble is, I fancy, that I look at life in a good many different ways, & that I don't necessarily dislike what I know to be second or third rate. I'm glad you've gone to Cornwall and not to the [New] Forest – that sounds like Saxon; but I prefer thinking of you there and perhaps when you are walking about with noone to talk to, (if there is noone to talk to) you will recollect that it was in Cornwall last year that we had our first quarrel. Is that sentimental? Well, remember you have committed yourself to liking the Blue Bird. All the same, I'm glad you won't show it to Adrian. As I walked about this morning I reflected that this is Christmas day, and that if I were a Christian it might mean something very exciting to me. But I came to the sensible conclusion that I shouldn't at all like to be a Christian – not even a Roman Catholic – and that it would be a very poor sort of excitement. If one liked that sort of thing one might keep Shakespeare's or Milton's birthday.

Ever yours affectionately, CB

To Virginia Stephen
Sunday [August 21 1910] 46 Gordon Square

Dearest Virginia,
 it was seven when your telegram arrived, and so there was no possibility of catching the country-post. I was in my bath, so Saxon replied, appropriately I hope. Nessa had a very good day and slept in the afternoon; she was normally tired in the evening; had a good night; and Wood, who has just left her, says she couldn't be going on better. This last applies to the baby [Quentin Bell b. August 19] also. I wish we could feel quite the same about you. I am not easy; never since you came back from Twickenham[1] have you been quite yourself. You haven't yet recovered your

wonted vitality, your devilry, your 'je ne sais quoi', have you? You're not entirely the Virginia that I used to know, though you've become more so since the early summer. What I want you to do is to let me know, from time to time, what you think about yourself. I should attach far more importance to that than to the most elaborate medical or physiological details. Will you simply tell us whether you feel yourself to be going forward or going back or stationary; and tell us quite honestly? Saxon came for his game of catch soon after luncheon. He showed no undue surprise at the news of Gratian's[2] arrival; not having seen me at Queen's Hall on Friday he supposed (he said) that something of the sort might have happened. He was a little displeased at the child being male, not because he had himself any particular preference, but because, in his presence, you had permitted yourself to speak of it as 'my niece', from which he inferred that it was to be a girl. The one thing he was glad of was that in future Julian [b. February 4 1908] would not be called 'baby'; this I take to be a bit of conventionality, for I don't think Julian ever is called 'baby'; and if he were & if Saxon noticed it, I don't suppose it would produce the slightest effect in him painful or otherwise. But I'm sure he thinks it most undesirable to call babies 'baby', and that on occasion he thinks it right & appropriate to make this clear. Meanwhile a telegram arrived from [Dr. George] Savage and another from Gerald [Duckworth], who wrote in French from Deauville. As I know he hadn't meant to go there a few days ago, but had intended to spend the week-end with the Anthony Hopes, I conclude that a sudden and affectionate message from his French whore called him over seas. After dinner S. & I busied ourselves over a jeu d'esprit for your entertainment. It has to do with 'beautiful words'; and may some-day reach you as we were both pleased with our wit. I shall send you a p.c. before starting for Brighton tomorrow, & try to write again after dinner.

Yrs C.

Notes

1. Virginia had been at Burley, a nursing home run by Jean Thomas in Twickenham.
2. One of the names by which Quentin Bell was called in the first weeks of his life.

To Virginia Stephen
Tuesday night [August/September 1910] Cleeve House, Seend

Dearest Virginia,
 how lucky for the Apes [one of Virginia's nicknames] that they're
not to be teased; because, were it otherwise, I should devote four
sides to insinuating that when conscience and kindness and usages
of polite society had all failed to provoke a letter, one tweak of their
curiosity about personal affairs sufficed to produce eight enchanting
pages. However, I won't look a gift horse in the mouth, not I; thank
you very much for a charming letter which has been a source of joy
and merriment for a long summer's day. You'll forgive my having
asked Vanessa to mention something to you in the hope of goading
you into writing, won't you? But you mustn't think I've refrained
from writing for so long out of vulgar pique; on the contrary, I've
been on the point of beginning a letter any time these last ten days;
only whenever I sat myself down with an idea, a letter's come from
Vanessa to say that you were probably moving on to some unknown
address the day after tomorrow. I don't like to think of my prose
wandering from pillar to post and from post-office to R. S. O., and
at last into the unsympathetic hands of Mr. Sydney Buxton, Postmas-
ter General. You will appreciate my feelings, I think. What you say
about yours is really interesting; it rather sounds as if you were on
the threshold of a literary period (as Adrian will have to say when
he begins to write History). At least, that is what I prefer to think;
for to speculate on what exactly it is you want to say to the man you
will love is not a congenial occupation [see VW L1 434]: that way
ill-temper and irritation lies, if not madness. You'll see what a jolly,
hearty, well-feeling, affectionate, slap-you-on-the-back-with-a tear-
in-one-eye, manly, pseudo-insouciant, 'damme'-don't-care-a-rap-
have-a-cigar-old-chap attitude I shall take up about your marriage in
the future. But I hope you're going to write something about women
first, before your sharp edges get blunted in the bed. About men too
for that matter: so don't waste time or be over nice about journalism.
The Times is as good a pulpit as another; and, so far as I can make
out, half the best things that have been written were journalism once.
Have I caught the breezy, muscular style? Here is a note from Lytton
in another, which, perhaps, you will like better. I sent a civil, curtish
answer, and felt a beast for my pains. But, I daresay, it's better to feel
a beast than a fool; and he who sups with the Devil . . . you know.
Well, you've not been bit as I have, and so you're not shy. You see
I can play at proverbs with Old Nessa herself. We passed very near
each other this afternoon: Dorothy [Clive's younger sister] drove me

up to the downs; and as I went under the embankment at Lavington the Cornish Riviera was signalled. I could give you such an account of Salisbury plain on a September afternoon; but I should be inviting reprisals and I won't. I suppose you wouldn't care to hear either way why noone – not even Plato – has yet devised a satisfactory utopia. Roughly it's because they don't know what sort of a world would be delightful to live in; but I do. Vanessa has been getting such a series of letters from each of us that she is now in a position to determine finally whose she prefers; you might ask her – it's the sort of question she likes. Do you think you could remember to bring *Zarathrustra* (is that the spelling?)[1] with you; I assume it's one of the books one ought to read. There were several other questions of the same sort I meant to ask, but it's struck twelve now, high time to go beddybies. Julian saw a goat today and said 'I sometimes call Aunt Ginner goat.' I suppose that don't strike you as particularly clever. People take things in such different ways: most likely you'll reckon this letter vexatious as well as stupid. Yet it wasn't meant to be either; though I confess that for the last twenty minutes I've been a thought too sleepy for thinking. But I want you to believe that I found your letter as pleasant as it was, by implication, explicit – I tumble into paranomasia every other word –; I understood it all, even those things that you meant me to understand [*sic*]. I will do my best to be good; but you know it isn't easy; so will you write again to encourage me in my good resolutions.

Yrs affectionately, C.

Note

1. *Thus Spake Zarathustra* by Friedrich Nietzsche, which Clive was reading in a French translation by Henri Albert.

To Virginia Stephen
Thursday [January 12 1911?] 46 Gordon Square

Dearest Virginia,

as I lay in bed this morning I made up my mind that your review would be in the supplement, that I should get a distinct and delightful emotion from it, and should write to tell you all about it. Bruce Richmond[1] has defrauded me of the greater pleasure, but he shall not cheat me of the lesser. I will write to you anyway; if only to ask whether you seriously expect us at dinner tomorrow night, and to tell

you that W. [Walter Lamb] thinks to sit and talk with you the most delightful way of spending an afternoon conceivable. Also, I might tell you how at the Grafton Galleries I met Birrell and Jacobs, of young Cambridge, thoroughly 'au fait' with the Post-Impressionists and the Pantomime, I need hardly say; and Will Vaughan whom I conducted through the rooms, and who expressed the most surprisingly enlightened opinions. I took W. L. to lunch at the 'Rendez-Vous' as Vanessa had her paramour here. A letter has come from Lytton which seems to give fair ground for supposing that he is become a womanizer. The rumour is abroad at any rate. Walter Lamb praises your fancy and your looks. I did not tell him that on Friday night in your black velvet coat and hat and red-pink carnations you looked so lovely that I utterly lost my nerve and head for a time, and could only stumble through the end of a conversation and tumble silent into a taxi-cab. But I should like to repeat the experience, because I know that from the same circumstances I could recover the same sensations; and they were exquisite, whether with delight or pain or both I'm not positive. Well, you know you half promised to come to me when you felt lonely; and somehow, not having seen you for days, and you being gone into Oxfordshire, I feel oddly lonely myself, – jealous of Walter Lamb I suppose. Could I come to tea with you on Sunday?

Our party last night was a success decidedly. Hot argument about the P. I. P; later, about Forster's novel [*Howards End*] which Janet and Walter attacked rageously [*sic*] and George defended with tepid praise. George always cuts up stupid when it comes to the point, but I think he's really a good creature. We all took rather a fancy to Miss Hawtrey. Norton thinks I am one of the rare people who can conceive and relish – and who do in fact – spend some of the best part of their lives in conceiving and relishing – "imaginative realities." {I think I know what he means.} He wishes he were one; he knows noone at Cambridge who is. To make the compliment perfect, this he says, is the power that you possess in a pre-eminent degree, the power that distinguishes you so sharply from the rest of his acquaintances. Evidently you are the great one; but Duncan & I possess something; and noone else anything at all!

Ever yours affectionately, C.

Note

1. Editor of the *Times Literary Supplement*.

To Virginia Stephen
[January 25 1911] 46 Gordon Square

Many happy returns of the day, dearest Virginia, and how thrilling
to guess sometimes for an hour or two at all that may fall between
them. Here are books: some of them you have read perhaps, if so
let me carry them home again. There are good things by Swin-
burne in one, and fine by [Charles Montagu] Doughty in another.
I don't know much about the Irish Molière [Lady Gregory] but I
am curious. I wasn't very spry this afternoon, but I don't apolo-
gize because I think you feel how much I enjoy coming to sit with
you, as the old Seend women say, whether I am bright or dull, you
gay or depressed. I'm not nearly so shy of being importunate now
that I believe you realize what it means to me; and I think you do
because otherwise you wouldn't have written last Sunday. I liked
that. I'm no longer afraid of your being kind to me; it's a too drastic
sort of discipline and leaves too little happiness unblighted. Besides,
it's more than three parts vanity and self-torture. Your letters are
always a joy, greater than you can guess, and when I can believe
their cause to be pure affection greatest. This is a queer sort of birth-
day letter, all about myself, to say nothing of the grammar. It's a real
commemoration all the same; for an event that recalls the past year
and you sets me thinking on you and the past year. I am amazed
at some things, the way I have been managed since Twickenham
days amongst others. Shall we ever talk of that I wonder? Well, it's
not only in feminine powers of management that you have grown.
I admire you more than ever. I think you're more beautiful, more
charming, and more like a genius than when you were twenty-eight.

Ever yours affectionately, C.
Berg

To Virginia Stephen
Monday [April 3 1911] 46 Gordon Square

Dearest Virginia,
I wonder whether you could manage to see me before I start for
Constantinople?[1] While we are apart a good deal may happen; and
I have an irrational foreboding that something will. Probably, I
imagine that you will fall in love, or, at least, that someone will fall
in love with you. At any rate, if your feelings are about to suffer

some great change, it would be a comfort to me, in Constantinople or London, to know that my own little niche was secure. I assume, you see, that I have a niche. But have I? If you are too busy to see me will you send an affectionate line reaffirming what you said, but I was too unhappy to believe, the other night? Please, this is private.

Ever yours affectionately, C.

Note

1. Clive, Vanessa, Harry Norton and Roger Fry were travelling to Turkey, intending to continue on to Italy and Greece.

To Virginia Woolf
July 19 1917 Garsington Manor

My dear Virginia, before I go to bed I am determined to tell you that I think your story ["The Mark on the Wall"] extraordinary. It quite took my breath away and made my head spin as your writings used to do in the days of my nonage. If I were still a paid expert I daresay I could give it a poke or two, but only with one of those paper sticks that are, or were, our wands of office. All that one could say would be that it wasn't something else, that it's perfection didn't happen to be that of Candide or Twelfth Night or the Princesse de Clèves. It is perfect: but I wouldn't have you think that that's all I can see in it. The stuff of it seems to me infinitely subtle and profound and exciting; and the phrasing and choice of words exquisite. It's most surprising and as clear as day, so clear that the admiring quidnuncs [nosy people] will tell us, I foresee, that you have shown us all how to do it. You have only got to put down what goes on in your own head, they will say. Why that's just what Mr. James Joyce did, and a damned silly mess he made of it! No, you have got to put down what goes on in Virginia's head: and I have never doubted – you know I haven't – that what goes on there is about as exciting as anything in the world.

Shall I post this letter now and risk having said something terribly ridiculous, or shall I wait for the sober morning mood?

Yours ever, Clive Bell

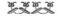

To Virginia Woolf
Tuesday [June 11 1918] Garsington Manor

My dear Virginia,
 here is my subscription [for the Hogarth Press], not too late I
hope. Pray, let there be nothing of Ferguson about it.[1] It's a won-
der I ever get time to read anything seeing what my life is – a mere
alternation of thrills and scrapes. You're quite wrong if you sup-
pose that there isn't a younger generation that's up against us as far
and as firmly as anything can be up or against. Didn't I spend half
last night defending 'The Voyage Out' and 'The nail in the wall'
[sic] against an extremely clever though unfortunately silly young
Irish mathematico-philosophical-novelist, to whom Dostoievsky is
the first word and Tchekov the last? And damned well I did it too. I
wish I'd seen you when I was last in town. Shall I ever see you again?

Yours ever, Clive

Note

1. Katherine Mansfield's friend J. D. Fergusson had made a print for the
 Hogarth Press publication of *Prelude* but the Woolfs disliked it and pro-
 duced some copies without it. See Virginia Woolf to Clive Bell, *L2* 246.

To Virginia Woolf
July 13 1918 Garsington Manor

Well, yes, my dear Virginia, pretty good your Katherine Mansfield
[*Prelude*]. Very well observed, very well remembered, seen sharply,
and interesting – O it holds one right enough: but nothing to set
the Thames on fire or, what is more important, turn the head of
your fastidious brother-in-law – as other works have done. Doesn't
it go on? Have you seen this week's Nation? Murry has made it his
business to put poor Siegfried in his place – rather ungenerously I
think; for though that beau jeune homme is no more a poet than
the pig that grunts despairingly outside my window he has written
epigrams that are quite amusing. Murry, it seems, had been asked
to review the book[1] by Her Ladyship who is, of course, furious,
and has, of course, risen to the bait and dispatched incontinently
an indignant letter. Well, next time you explain to Philip that
Murry quarrelled with them, not on my account, but on theirs, I

daresay he will believe you. I didn't mean to impose the holy count on you;[2] in fact I had told him that before dinner he must go; but you were so graciously pressing. Mary was much touched by your amiability, to which she was unable effectively to respond, sickening as she was, as she discovered herself to be a few hours later, for the influenza. I hope she didn't give it to either of you. I am looking forward to your visit next week-end. Will you, perhaps, escape her ladyship for an hour or two and pay a call on me?

Yours ever, Clive

Notes

1. Siegfried Sassoon's *Counter-Attack and Other Poems*.
2. Tancred Borenius, the Finnish art historian. See VW *D1* 164.

To Virginia Woolf
November 8 1927 50 Gordon Square

Dearest Virginia – thank you. If anyone in the world can make me happy it is you; and assuredly I was not made for unhappiness.

Here is the first half of Civilization.[1] Please don't take it as a fait accompli – on the contrary it is essentially inachevé. Its story is told in the dedicatory letter – truly. Its present form was given it when I was too wretched and distraught to know what I was writing. And now I hate the sight of it. If enough remains of the original impulse to make it interesting and worth reading, tell me and I will print it. If not, tell me; and I will extract a couple of articles for Tom [Eliot] from the second, untypewritten, part and throw the rest away. Nothing could give me less pain. Besides, I have other projects.

10.45 tomorrow: here: don't be late.

Clive

Note

1. Clive Bell's *Civilization* was published in 1928, with a three-page dedication to Virginia Woolf.

To Virginia Woolf
Thursday [?late 1927] 50 Gordon Square

Dearest Virginia,
 I have been meditating Tom's demand for an article [for *The Criterion*], and I had thoughts of writing for him something about Proust – now that the great work – which appears much more amazing seen as a complete whole – is finished. Toying with the idea on my way to Cambridge, I began to give it a definite shape, and realised that what I wanted to say would far exceed the limits of a short article – such as Lady Rothermere loves. What would the Hogarth Press say to it as an essay? If it said 'Yes', I would start re-reading the book on Monday and try during the spring to snatch six weeks from my turbulent life for composition – preliminary composition. Let me have your views and those of the firm.[1] Shall I see you on Sunday? Today I go with Julian to Seend. In any case keep me a cinq à sept [i.e. 5 p.m.–7 p.m.] next week.
 I do hope you and Leonard are coming to Charleston. Your presence would give more pleasure than you guess to

Your affectionate brother-in-law
P. S. Poor Bobo [Beatrice Mayor] is anxious and triste.

Note

1. Clive's monograph *Proust* was published by the Hogarth Press in November 1928.

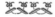

To Virginia Woolf
October 15 1928 3, rue Bonaparte, Paris

Dearest Virginia,
 thank you for giving me the best book [*Orlando*] published since . . . since . . . Tristram Shandy . . . no, since The Lighthouse. The Lighthouse, I mean, seems to me to be about "more important states of mind". But need one compare? Why should one, when one need only admire – admire the marvellous originality and ingenuity of the form, the poetry, the phantasy, the wit. Yes, I enjoyed the wit, and I only hope I missed nothing, for its subtlety is considerable. For instance I rejoiced in the maliciously concealed rhymes (e.g. page 126, 243) and 'The hostess is our modern Sibyl' but once

or twice I wasn't quite sure whether I got the full flavour – whether or no an apparent gaucherie was an accident or not. But what I admired most – the respect in which this surpasses all your other books – was (it sounds intolerably professional) the writing. I did not think it was still possible to use English (an ancient language) in that way – in the way of the seventeenth century I mean – every word as bright and clear as a new sovereign and as distinct as a telegraph pole. That is certainly the most remarkable thing about the book – the value given to words. How I wish Sir Edmund Gosse were still alive to enjoy it. Certainly you have invented a new way of dealing with time – or rather the utterly capricious movement of time – so perhaps I wasn't altogether wrong in comparing you with Proust. Also, like all great inventions, it looks extremely simple once found. It is bound to give some pain: Your quiet but firm assumption – that the one thing essential in a work of art – the thing that conditions everything and can condition everything in any way it pleases – is the artist's mind – comes hard on the Wellses and the Bennetts. I suppose I could make criticisms if they interested me: there are moments I think when the poet gives place to a lady with a grudge, and one notices them; and, on first reading, I found the finale a little long and a little too lyrical; so I must begin the book all over again.

I think to be back on Sunday; and if I am, perhaps I shall see you at 37. Another thing: Tuesday (30th) is Vita's night in London, and I want you and her and Desmond to dine with me. It is a long way off, but will you keep it for me?

I enclose a cutting.

Thank you dearest Virginia for a miracle of beauty and invention.

Clive

To Virginia Woolf
Sunday Feb. 16th ? [?1929] 3 rue Bonaparte. Paris VI

Dearest Virginia if it weren't so cold I could do better. To be sure the papers say that 'the grand cold' is a thing of the past, and one's always glad to know that sort of thing for certain. Particularly as that's the only way in which I could know it; for in this room – boiling radiators notwithstanding – it's impossible to be anywhere but in bed: and I can't write in bed. I hear you are better and I hope it's true. I hear that all London is ill; that all the baths

are empty and all the W. C.s full. Here we have nothing worse to
complain of than slight colds in the head and blue noses: "nous
sommes déja benis" [*we are already blessed*] as the pharmacien
at Cassis says and even M. Homais [in *Madame Bovary*] might
have said. Paris without its Americans even at −15° is enchant-
ing: the French have invaded the restaurants, and even the boîtes.
All my friends are here, since the midi under a foot of snow is
unbearable. They give parties, one goes to plays and movies, one
reads in bed, one even writes a little: one does not suffer from
nostalgia. No, I don't want to be back in your country when an
oppression, like a heavy, undigested meal, weighs down on all
the subtler intellectual activities – except always the writings of
Virginia Woolf of which I have just been singing the praises to
the intelligent Georges Duthuit. He finds Orlando a bit difficult
in English, and wonders what is being done about a translation.
I bid him stick to the original. No, I'm out of love with your
country of intellectual provincialism and self-conscious vices and
general elections (and Alice forbears to forward The Nation, and
I haven't even taken the trouble to put Mr. Scott-Moncrieff right,
though the story he describes as 'obviously apocryphal' is con-
firmed by a recently published letter of Proust).[1] All the same I
shall probably flit through London in about ten days time, col-
lecting books and clothes and visiting my aged mother. A gay old
ghost – may I haunt 52 Tavistock Square a little? Of Vienna I shall
say nothing. I enjoyed myself fantastically but I didn't see Vienna.
For one thing it was too cold. For the first time in my life I knew
what it was to be afraid of the weather. And then the Viennese
are too poor. I don't think I saw a single private car driven by a
chauffeur; but I saw thousands of people who manifestly hadn't
got enough to wear or to eat. I don't like seeing that sort of thing
though I don't mind hearing about it – and all in the midst of
departed splendour – it's not pretty. How proud Maynard must
feel of having helped to win the war. When the weather gets a
little warmer I am going to Marseille; and some day I suppose
I am going to Cassis, and some day to Sicily. And next autumn
– God willing – I am going half round the world to Saigon,[2] but
between now and then lies Charleston so there's no need to begin
to be valedictory. Clive

Notes

1. See Hussey (270–272): Proust's English translator, C. K. Scott-
 Moncrieff, had taken issue with some of Clive Bell's claims in his

monograph *Proust* (1928) when he reviewed it in the *TLS*. Clive responded in a letter published in the *TLS* 28 February 1929.
2. He did not go to Saigon.

To Virginia Woolf
Saturday [?November 30 1935]

Dearest Virginia,
 I spent the greater part of last night listening to such eulogies of Virginia Woolf as I have never heard – from two highly intelligent people too, Madame Paul Valéry and Edmond Jaloux. What the latter had to say I thought really interesting and subtle, and at times beautiful. Perhaps he thought so too, for he begged me to repeat it to you, saying that he had often tried to write it but that it was too personal and would look on paper extravagant. I will try some day, but really it made me almost unbearably self-conscious to remember that I had ever embraced you. He has a photograph of you and often tries to decide, he tells me, how far your writing corresponds with your appearance. They cannot fit perfectly, he maintains, because you are superhuman or at least "magicienne". "Mais s'il nous est permis d'appliquer le mot génie à un humain I really can't go on, it would make me blush. Naturally – 'by far the greatest writer of our age' – but that is nothing. Madame Valéry, too, is very <u>fine</u> and perceptive.
 All this went on at the magnificent table of the Princesse de Polignac [Winnaretta Singer], a superbly vigorous old lady, who is gradually becoming the great-aunt of the French aristocracy. After dinner one of her beautiful great-nieces – they all have good looks – came up to me and said that her "tante Winnie" was much too shy to ask such a favour, but that she happened to know that to meet you was the thing she desired most in the world – to be sure she has little left to desire. As she is a noble and intelligent old lady, who cares generously and practically for art – she has done more for artists than anyone else in Paris – I went straight to her and asked her to fix a day on which she would be in London, saying that I would write to you forthwith, as I do. She chose December 12th (Thursday) lunch at 1.30. If you will make a point of coming, you will give a great deal of pleasure to a very fine old lady as well as your affectionate brother-in-law, Clive

To Virginia Woolf
Sunday [July 1940] Charleston

Dearest Virginia,
 I make it a rule, so far as I can, not to write to authors about
their books – no, not even when they send me copies, and on this
occasion I lack that excuse. But I am going to send you a line to
say how much I admire your life of Roger, partly because I con-
sider it the best biography that has appeared for many a long day,
partly because I believe my impression is not exactly the same as
that of other of its admirers. I am conscious of no disconcerting
break between the first part (which ends in 1910 I take it) and the
second. A break there is and must be, because in that year, as you
delicately and admirably make clear, R. began a new life, the life he
should have begun to live as soon as left Cambridge. But, for my
part, I find the texture beautifully even, the narrative gliding over
the points without a jolt. Also I found the first part – a good deal of
which was news to me – fascinating – nowise inferior to the last. I
admire the way in which you allow your own point of view to reveal
itself only in the style – witty without flights, as it should be in a
biography. And I am so old-fashioned as to enjoy the taste, tact and
straightforwardness withal, with which you deal with a series of
delicate situations. In fact, dearest Virginia, I consider this book, in
its own and proper way, as good as your very best – The Lighthouse
or Orlando. Knowing, as you do, what I think of these, you will also
know that this is about as fine a compliment as I can pay any book.

Yours, Clive

To Mary Hutchinson
Monday [March 31 1941] Charleston

Dearest Mary – I have some hope this will reach you before
rumours, certainly before any newspaper announcement. And I
think it is less shocking to get bad news by letter. I'm afraid there's
not the slightest doubt that Virginia drowned herself about noon
last Friday. She left letters for Leonard and Vanessa; her stick and
footprints were found at the edge of the river. Since then nothing.
Of course one hoped against hope for a day or two that she might
have wandered off crazily, and might be found sleeping in a barn
or buying biscuits in a village-shop. But by this time – especially

under war conditions – it is almost inconceivable, were she alive, that something should not have been heard of her. However, as her body has not yet been found there is no positive proof. Leonard, as you would guess, is, superficially at all events, perfectly calm. Vanessa has stood the shock much better than Duncan or Quentin or I expected. We feared some utter physical collapse – something comparable with what happened to her after Julian was killed. So far, at any rate, she seems only sadder and more silent than ever. For the rest of us, for you and for me, Duncan, the children, Vita, Desmond, it's an appalling loss which, it seems to me, one won't be able to measure for a while. For Virginia herself – I don't know. She saw her doctor – a woman doctor – on the Thursday. Leonard says that she (the doctor) was reassuring. But if Virginia felt that she was in for another two years of what she had been through before, only to wake up to a world which will be the world another two years of war has made of it, I only wonder at her courage. But this is idle speculation, for the present at least. All we can do is to try to console each other – Leonard and Vanessa in particular. If I know any more I'll tell it to you on Wednesday.

Clive

To Leonard Woolf
August 6 1955 Charleston

Dear Leonard–
 I think I have collected the bulk of Virginia's letters to me: probably I shall come across two or three odd ones later. Very roughly they fall into two categories – early and late. You won't be surprised to hear that all are brilliant and that the later are scurrilous to a degree. These of course are the ones that amuse me most. They are full of pastime and prodigality and fascinating gossip (possibly untrue) about my friends. I fear they are at present unpublishable. To be sure, they contain a few pretty compliments to myself which could offend no one; but these might look oddly standing by themselves. The case of the earlier ones is different. The better part of these is concerned with writing and with ideas – more often than not with Virginia's writing and ideas – and with books in general. Though to one as old and frivolous as I gossip is the thing, to the young and thoughtful I believe the early letters might be of profound importance. They are certainly interesting. But God! How

touchy we were in our young days. I seem to have kept but one letter in its envelope. I fancy you could date approximately most of the later letters from internal evidence: Dating the early would be more difficult. Nessa could help. I shall send them all; and need I say you can make what you like of them. But someday I should like the originals back. I imagine you are in no hurry, and they would make a large and clumsy parcel to send through the post. So I suggest they should stay here till you come to Charleston or Charleston comes to you. May that be soon.

Yours, Clive

To Leonard Woolf
August 24 1956 Charleston

Dear Leonard,
 Thank you very much for returning Virginia's letters, promptly and in good case. I quite see that there are references to the living – Lydia, Peter Lucas, Hom, if he still be alive[1] – which it might be awkward to publish. Ottoline and Ka [Cox] – their reputations I should say – must take their chance don't you think. I hope you will be as sparing of the blue pencil as you discreetly can be. Anyhow it's for you to decide since you will be blamed. As a matter of fact I have a notion that the earlier and less "gossipy" letters – the letters in which Virginia talks about her writing and her difficulties as an artist – are the most interesting. I will confess that I very much hope you will print a letter dated "Tuesday, Hogarth House," and beginning "I've always thought it very fine, etc". Vanity? Not exactly perhaps. But there is a sentence – "you were the first person who ever thought I'd write well," which seems to me the finest feather I shall ever be able to stick in my cap.[2]

Yours ever, Clive

Notes

1. Lydia Lopokova, F. L. Lucas, H. O. Meredith.
2. VW *L2* 167 (24 July 1917).

3

War

Clive Bell is better known as a writer on art than on war and peace, yet his opposition to conscription and his activities on behalf of conscientious objectors during the First World War were as important to him at the time as his championing of modernist art – indeed, in some ways they were aspects of the same belief in the inviolable nature of individual liberty. In Peace at Once, *his banned pacifist pamphlet, Bell laid out an argument from which he would hardly waver throughout his life: that war was always the worst possible evil. His pacifism was shared by many in his circle in 1915, but by 1939 he was in an isolated minority of absolutists and appeasers. But his forthright conscientious objection to war was always rooted in the broader conception of liberty he articulated in* On British Freedom, *published by Chatto & Windus in 1923: 'It is for civilization – for which, by the way, we are supposed to have fought the war – that I am pleading: and though I am aware that liberty alone will not give it us, yet I am certain that no nation can be truly civilized till it possesses a far greater measure of personal freedom than is to be enjoyed in this or any other Anglo-Saxon community' (86).*

To Mary Hutchinson
August 21 1914 Benmore, Lairg, Scotland

Chère Baronne,
 I am sending you some grouse to prove that there are things I
don't mind killing. For that matter, I don't so much mind killing or
being killed Germans, French, Russians or English. What I do mind
is watching the collapse of civilization. For the next fifty years noone
is going to take much interest in the things for which we care. All the
more reason why we should care for them very much so please take
me into your confidence about your play. If I may judge from your
letters – and why shouldn't I? – you write extremely well. Even your
hand-writing is as full of force and character as mine is of sweet inef-
ficiency; all the same mine has one obvious advantage. But doesn't
it depress you to think that when everything was going on swim-
mingly, when even the working-classes were becoming frivolous and
losing their moral sense, we should be put back to a state of early
victorianism. Perhaps you don't think anything of the sort: I do. Bar-
bara [Hutchinson] and Julian [Morrell] will be much too busy mak-
ing the money that Lord Kitchener has spent to have any patience
with new ideas and restless intellects. Crude seriousness about all the
things that we have discovered don't matter and the virile virtues for
the rising generation – God help them. As for us, chère dame, young
and lovely as we are, we shall find, I think, when the war is over that
our lives have been cut in two. So far as "the world-movement" goes
we shall be out of it. So we shall have to take refuge in our private
feelings, aesthetic emotions and personal affections. We are lookers
on for life. Well, I dare say we shall bear it. You have got the peace-
party and its spokesman, poor Philip Morrell, so much on your mind
that the letter you should have addressed to 46 Gordon Square you
addressed to 45 Bedford – the house next to his. Will you address me
before long to Asheham, Rodmell, Lewes? I hope so. Have you read
the confessions of a fool yet? And if so do the physical characteristics
seem to fit?[1] I sometimes write verse still: alas! never poetry.

Yours ever, Clive Bell

Note

1. Clive's calling Mary 'Chère Baronne' drew on a character in August
 Strindberg's *The Confession of a Fool*.

To James Strachey
September 17 1914 Asheham House, Rodmell, Lewes

Dear James,
 do you ever see your brother [Oliver] in the War Office? I will
explain why I ask. What I mind about this war chiefly is that it is
a cursèd bore. It's like being a permanent and compulsory specta-
tor at a University match that's going to last three years. The only
way of mitigating the boredom is, it seems to me, to take a hand
in the game. I am ineligible for all the active forces on account of
an unhealed rupture for which I wear a truss. This is pure red-tape
as I have been ruptured from my nonage since when I have been
in the habit of hunting and shooting and have been on a big-game
expedition to Alaska. I liked the idea of becoming an interpreter
but found that I was disqualified for becoming one with the fight-
ing forces, for medical reasons. But it seems possible that I might
be acceptable in the Army Service Corps or Medical Corps, at a
base, or on the lines of communication. Do you know how one
applies for such posts? Shall we see you here on Friday Sep. 25?

Yours, Clive Bell
BL

To the Editor of *The Nation*
January 16 1915

Conscription

Sir, – Once again there is talk of conscription. Before many months
are passed a score of gentlemen living in the West-End of London
may feel it their duty to order every serviceable male in Great
Britain to prepare himself to kill or to be killed. In these circum-
stances, it seems to me possible that the sort of people who read
THE NATION, the people who call themselves Liberals, will like
to know what is being thought and felt by many of those who,
without being consulted, may be compelled to serve. During the
last three months I have had some opportunities of discovering the
mind of those young men in the middle and wage-earning classes
who have not felt it their duty to join the Army. They are numer-
ous, but they find it difficult to make themselves heard. May I try
to indicate, very roughly, what they think and feel?

Of course, the richer and older people maintain that they ought not to be given a hearing. According to them, these young fellows are worthless, contemptible wretches. They are not, I admit, patriotic – that is to say, they feel differently from patriots. But is it quite safe to assume that the feelings of a patriot afford an infallible criterion in ethics? Is it prudent to forget that the difficulty of patriotism has ever been that it makes morality conterminous [sic] with frontiers? We need not discuss that now: what I am sure of is that there are a great many people who do not feel that passionate patriotic emotion which can answer, without hesitation, the question: "Ought I to kill or be killed for the country in which I was born?" and that these people are not all blackguards.

I want, if I can, to state their case – the case of people who do not feel a blind, overwhelming, patriotic emotion. Such people exist; in fact, there are a great many of them. They have, some of them, sentiments of loyalty, devotion, and responsibility; but those they feel, not towards any particular nation, but towards humanity. They care about the fate of the world, and they cannot, even for a moment, detach from the world one particular part of it, and care for that alone. Therefore, when they are invited to go abroad and kill or be killed, they ask for reasons. "What good," they ask, "will our victory do?" And by this question, some mean merely, "What good will it do me?" But others mean "Will it be a means to universal good?"

I have no hard words for those who look simply to their own interests. A working man has, before now, asked me bluntly whether he would be worse off under foreign rule. He has wanted to know whether he would have to do more work for lower wages, and whether he would have to pay more in rent and taxes. I do not know what the correct answers would be, but the questions seem to me reasonable. They are raised daily in third-class railway carriages, and no one answers them. When I am questioned, I can only reply that some have told me that my foreign investments would be adversely affected. I forbear to add that, like most serious writers, I have in my portfolio plays, stories, and essays that I should be free to publish in Germany but may not print in England. German domination would mean, I imagine, an immediate loss of political liberty and gain of moral and religious. But that is not what my bread-and-butter pacifists want to hear about.

Very often, however, a young intellectual of the lower middle class will raise the ethical question. "Am I sure that the terms of peace imposed by the Allies will be a means to good? If I am not, for what am I to fight?" I have met plenty of young men – and the

rich and the elderly had better know it – who would die cheerfully for the things in which they believe – Socialism, Free Speech, for all I know, Land Reform, who cannot feel that this war raises any clear issue between Good and Evil. And, as a matter of fact, no one can seriously pretend to know what would be the ultimate ethical consequence of an extension of German, or English, or Russian influence. Indeed, it is open to question whether the extending of any political influence has much effect on the things that have absolute value. To be sure, one may say that a conquered people have intended to impose a superior civilization on their conquerors. One may speculate as to whether the conquest of France by Germany would lead to an extension of German or of French culture. But as Germany shows no signs of being able to conquer France, these questions, besides being unpalatable, are more or less academic. Nevertheless, the young clerk who thinks of enlisting on purely ethical grounds is sure to raise them.

The upper classes do nothing of the sort; nor need they. They do not fight for England on purely ethical grounds. They have a deep, instinctive patriotism, in which all doubts and questionings are drowned. They are not concerned with absolute good; the fate of their country is what they care about. They have no objection to arguments that support their instincts, but they do not need them. They are ready to die for England, and let universal good look after itself. In their self-sacrifice they are magnificent. But they are less magnificent, I think, when they arrogate to themselves the right of compelling people who do not share their feelings to fight their battles. The spectacle of the rich and the old, with their instinctive patriotism and great possessions, forcing to the front a reluctant and rational proletariat would be a not very edifying spectacle. If patriotic fervor and intellectual conviction be absent, for what is the conscript giving his life? The discussion is taking a nasty turn.

I want not to be nasty; but I do want upper-class conscriptionists to know that there are a great many people who do not feel a violent instinctive sentiment for the country in which they were born, and are by no means so confident that great universal good will follow from a victory for the Allies as to feel justified in giving their own lives or taking those of other people. They may be wrong, but they certainly are not vile; and I suppose they have some right to opinions and feelings. In their view, what Mr. G. L. Dickinson calls "the governmental theory" is a frightful illusion. They do not believe that the things for which men are being asked to give their lives have much relation to the lives of human beings. It is no good talking to them about "national honor" and "national existence."

A nation for them has no reality beyond that of the people who are grouped together under its name. If they have got to die, let it be for some definite human good, not for an abstraction.

The people who feel in this way are, for the most part, young and poor. They do not like the German Government, neither do they like their own. As for Germans, Frenchmen, Russians, Englishmen, they like some and dislike others. The things that they care for, their ideals, are above and beyond nationality, and are disfavored by all Governments alike. The quarrel between the governing classes of Europe is, they assert, one which does not concern them. These views, I want Liberals to believe, are more common than Cabinet Ministers or leader-writers suppose. I do not say that they are sound; I say that they ought to be considered.

I think the governing class should ask itself whether it has a right, without consulting the people, to compel those who do not share its sentiments and ideals, who consider those sentiments and ideals absurd and barbarous, to die for them nevertheless. That is a perfectly fair statement of a question that arises the moment conscription is seriously mooted. The governing class will claim most likely that it has the right. Will Liberals agree? Probably. Then, for God's sake, let us have no more cant about personal liberty or democratic control. If, without taking the opinion of its victims, the governing class has the right to send men to die for the things in which it believes, it has over them precisely the same right that the owner has over his slave – the power of life and death. – Yours, &c., Clive Bell

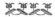

To the Editor of *The Nation*
September 4 1915

Mr. Clive Bell's Pamphlet

Sir, – Some time ago I did myself the honor of sending you a copy of my pamphlet, "Peace at Once." I dare say it still lies in the cellars at Adelphi Terrace. If so, pocketing my modesty, I will ask you to take a look at it. In a moment I will tell you why.

If it be lost, I must ask you to believe that a good many rather eminent people have read and criticized it, and differed, some of them profoundly, from the views it advances, but that not one of them has suggested that it is seditious or provocative or improper in tone, temper, or style. Indeed, from the only eminent person – unless

the editor of "The Times" is to be considered eminent – who is attacked personally, from Professor Gilbert Murray[1] it won a particularly obliging letter, in which that ingenious scholar reaffirmed his conviction that two wrongs may somehow make one right. I tell you all this because, if you happen to have lost the copy I sent you, it is from your distinguished friends that you must take your opinion of my pamphlet.

All the unsold copies of "Peace at Once" have been destroyed by the common hangman, I like to suppose, on the order of a police-court magistrate, at the instigation of I know not whom. "Peace at Once" was a simple statement of the case for peace and a criticism of the arguments for continuing this war. We must assume, therefore, that the arguments in favor of war – in favor of this war, at any rate – are regarded by the Government as essential dogmas the questioning of which is a crime, and that until the Government desires peace it will be illegal to say, publicly, that peace is desirable.

And now, at last, I come to my reason for troubling you with this letter. If you are satisfied, by personal inspection or by the judgment of people you respect, that my pamphlet is nowise seditious or offensive, but has been suppressed simply because it produces arguments in favor of views which are not those of the governing class, will you not reconsider your opinion as to the issues at stake in this war? My pamphlet is of no consequence, but its suppression should be of some, I think, to those who hold that the particular brand of tyranny under which Germans are said to groan is more evil and oppressive than that which we enjoy in this country. Are you still of the opinion that we are fighting for freedom? – Yours, &c., Clive Bell

Note

1. Regius Professor of Greek at Oxford University, and Vice President of the League of Nations Society, with whose pamphlet *How Can War Ever Be Right?* Clive Bell takes issue in *Peace at Once*.

<center>※ ※ ※ ※</center>

To Vanessa Bell
Friday night [January 1916] 46 Gordon Square

My dear old creature,
 honour bright my hands have been pretty full. Maynard is right: loving & labouring are two men's job. This is only a line

to say 'cheer up': the affairs of the C.Os seem really to be in good posture at last. Walter Long [Unionist MP] is the difficulty but I believe we shall best him. I have breakfasted with Lloyd George, I have interviewed ministers & members. Things are going well I really believe. There has been a queer revulsion in the house – the Irish horrors have had something to do with it I dare say. Last night it was positively sympathetic – Tories & colonels saying that something ought to be done. I will write a real letter when I can & send the children presents. I was up till 3.0 last night (Thursday night!) and today I have been holding conferences and writing minutes till 9.0.

CB

To the Editor of *The New Statesman*
February 5, 1916

Sport and War

Sir, – No one realises more acutely than I that this is no time for extravagance. In these days every British shilling and every ounce of patriotic energy should be devoted to national service. Art, literature, science, education – all the things that don't really matter – must go. Yet I venture to believe that the Government, once its attention has been drawn to the subject – will recognise the expediency – nay, the necessity – of encouraging the creation of private Bull-Rings. The matter has long been in my mind, and the statesmanlike attitude of our rulers towards fox-hunting emboldens me to speak out. For you know, I suppose, that the Government has besought the Hunts to continue their useful activities and has offered to exempt their employés [*sic*] from military service.

You are aware, sir, that bulls are sometimes used for moving artillery; but you are not aware, perhaps, that the best class of bull is produced only when bulls are bred, not for military, but for sporting purposes. You might have supposed that if the army wanted beasts the army would be able to breed its own or, at any rate, to induce the breeders to supply them. But you will observe that the War Office, and the War Office should know, has decided that the farmers cannot breed horses for the Government, and that if the cavalry want remounts they must buy hunters.

It will be objected, I dare say, that in this war we are making very little use of bullock-trains. True enough: fortunately our Government takes rather longer views than some of its smart critics. It might similarly be objected that in this war we make very little use of cavalry, and, further, that the horses which are being bred now can scarcely be of military age before 1921. Over a few furlongs you can race a three-year-old and even a two-year-old, but I question whether any horse of less than five will stand a long day's hunting or a forced march. Might not our arm-chair critics have the grace to remember that there are probably more good sportsmen and good judges of cattle in the Ministry than in a whole institute of journalists?

So, if anyone is going to argue that the best sporting bulls are not, necessarily, the best draught animals, I shall simply decline to split hairs with him. Let him say straight out, if he has the pluck, that in the South African War cobs and rough ponies were what served the army best and that hunters proved almost useless, and let him, if he has the cheek, pretend that the same causes are likely to produce the same effects. In these matters I prefer to trust Lord Landsdowne.

I submit, sir, I have made out my case for bull-rings. That they will absorb a certain amount of useful money and labour I shall not deny; on the other hand, they will promote the breeding and improve the breed of bulls and provide a great deal of healthy, harmless amusement for the upper classes. Do, please, bring this matter to the notice of our Government. You, who stand well with all Ministers save one, will easily persuade them to cast favourable eyes on what is at once a national service and a manly recreation. – Yours, etc., Clive Bell

To Vanessa Bell
Saturday [spring 1916] 46 Gordon Square

Dearest Dolphin,
 I believe Mary has given you a pretty full account of our Garsington doings, and any way in this weather you won't need much entertainment. Maynard says you were ill but are better and I think I should have heard from you were it not so. As for me, I live in a world of agitation and uneasiness, which is not at all what I like. I suppose we shall be conscribed in a few weeks and I dare say I shall be in jail before Duncan and Bunny. Well,

well, it's no good crying over milk that may not be spilt. Molly rang up this morning to ask whether you would take her for a week at Wissett[1] as a paying guest from Monday. I was not particularly encouraging because I doubted whether you would much want her, and I think she is going to propose herself to Virginia. But if you would like her then you might send her a line. I am going to tea there this afternoon, and Mary dines with me so I am still in the thick of the ladies. Tomorrow I am going down with Roger for a night to Guildford. It seems too absurd not to enjoy this Italian spring in the country.

I enclose a copy of my memorandum [concerning treatment of CO's] which may amuse you. I imagine it has got me into the black books of the ginger[2] pacifists, but as I have conferred with Clifford Allen[3] & Bertie [Russell] at every step they needn't be so grand about it. For the present, however, I fear that there is very little to be done. Next Saturday I thought that perhaps I would come down to Wissett and stay till Tuesday if that would suit you. If I get took in a month or two I think it might be a good idea to clear this house, store all superfluous furniture, and protest to the landlord that in the absence of the bread-winner it was impossible to pay rent. Seriously it is a plan to consider. Let me know how you all do.

Clive
P. S. Will you return the memorandum

Notes

1. In early 1916, as conscientious objectors, Bunny Garnett and Duncan Grant worked on a fruit farm at Wissett in Suffolk that had belonged to a cousin of Duncan's mother.
2. 'Of a group, organization, etc.: that provides spirit or stimulus in a party or movement; that presses for stronger or more radical policy or action' (*OED*).
3. Co-founder of the No-Conscription Fellowship.

To Professor Gilbert Murray
May 11 1916 46 Gordon Square

Dear Professor Gilbert Murray,
 I was sorry not to have you for lunch yesterday, especially as you would have found Roger Fry here and we might have amused

ourselves with some talk. I breakfasted with L. G. [Lloyd George] this morning: he was most sympathetic, as he always is I believe, and fairly practical. He wants a deputation to Asquith with cut and dried proposals, which he will back: schemes are making accordingly. I got the impression that something might possibly be done. If anything is done, or even begins to be done, I will be sure to let you know.

I certainly didn't set out on this venture with the intention of 'jobbing', but I perceive I am going to end by it – only vaguely though. The fact is the Board of Trade seems to be taking 'industrial reconstruction after the war' seriously in hand. It is a subject about which I have views and at which I should be glad to work; and as I'm too infirm to make a really interesting conscientious objector it seemed to me possible that the government might be willing to employ me, and so and so, how familiar you must be with what should follow.

Your journey into France was very mysterious – another secret I suppose.

Yours sincerely, Clive Bell
P. S. L. G. made the interesting admission that he would have been shot rather than serve in the Boer War.

To Professor Gilbert Murray
Friday May 1916 Garsington Manor

Dear Professor Gilbert Murray,
Roger Fry saw Sir Ian Hamilton today, he was thoroughly sympathetic and said he believed he might persuade [John] French to do something. I don't know how that may be.

I think it most important that the scheme should be known as "the Gilbert Murray scheme", and so spoken of; by this means ministers may be made to perceive that our agitations are all directed to a definite end and are not the vague flutterings of philanthropy. Also, I think it most important that you should yourself see the Prime Minister. Do you think you could possibly manage it?

If the government will do nothing about tribunals do you think they could be persuaded to accept a week or two of resolute resistance under persecution as evidence of conscience?*

There would be no need to make concessions of this sort very public. And if the government would come into our scheme for

creating a department under the Board of Trade to deal with labour in general and not only C.Os, it seems to me that we might keep the matter very dark indeed.

I am to see [Thomas Edmund] Harvey[1] about the middle of next week. I write under great difficulties in a room full of chattering people; but I should like, before I go to bed, to thank you most honestly for the trouble you have and are going to take for us.

I hope if I can be useful you will send for me. I shall be here till Tuesday; after that 46 Gordon Square W. C.

Yours sincerely, Clive Bell
*special tribunals would of course be much best.

Note

1. Liberal MP for West Leeds, largely responsible for inserting the 'conscience clause' into the Military Service Act.

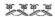

To the Editor of *The Daily News*
May 22 1916

The Conscientious Objector

Sir, – The letter of mine which you were good enough to print last Wednesday has already produced a small crop of private inquiries from people who want to know how precisely I should propose, if I had the chance, to work my scheme. The machinery, I said, was simple. Will you allow me to lay it before your readers?

(a) The appointment of a committee under the Treasury or the Board of Trade. This committee might have the status of a special department of the Central Tribunal, appointed to hear conscience cases. It should be composed of men who are in general sympathy with the war policy of the Government, but who understand the nature of a conscientious objection – e.g., the Bishop of Oxford, Professor Gilbert Murray, Lord Bryce, Mr. Clutton Brock, Dr. Clifford, the Rev. F. B. Meyer.

(b) All conscientious objectors, whether still at liberty or in civil or military custody, should have the right of appeal to this committee. Applications should be made in writing – in the first instance – and should contain full statements of the petitioner's opinions, with some account of their development. The applicant

should produce evidence of his good faith, and should, if possible, obtain letters in support of it from men of standing – e.g., ministers of religion, members of Parliament, professors or other teachers, known authors or journalists, officers in the Army or Navy.

This written evidence should be tested and arranged by an active sub-committee, containing representatives of the anti-militarist organisations. If this were done, it seems probable that in very few cases would it be necessary for the special committee to summon the applicant in person.

(c) The committee should have power to grant conditional exemption and hand the applicant on to the Pelham Committee.[1] But if this is to be done the Pelham Committee should aim rather at securing the maximum of benefit to the State than the maximum of discomfort to the conscientious objector. No conscientious objector should receive better wages than a private in the Army, but to turn a first-rate mechanic into a very bad ploughman is as absurd as it would be to send Mr. Asquith as a private to the trenches. Both could be justified by the cant phrase "equality of sacrifice," neither can be justified on grounds of national expediency.

Clive Bell

Note

1. The Pelham Committee was responsible for assigning 'work of national importance' to conscientious objectors.

To Vanessa Bell
Wednesday [1916] Garsington Manor

Dearest Dolphin, what fun it was at Charleston and how charming you all were! We enjoyed every minute of it including our exquisite walk across the frost-bound park. The train doesn't start till 9.23 and it's quite easy to make the connection by underground; so, if the government leaves us any trains, I think our monthlies ought to work. Will you order a dozen of whisky from the Stores (Empire Whisky) before the government stops that too? I will go snacks: And will you suggest to Saxon Saturday Jan 13th for our first merry meeting. I can't help thinking the political news good. Of course they may give us Hell during the next twelve months: but things were bound to get worse before they got better. Asquith

& Co. would never have dared to make peace – though I believe they want it – with the gingers beyond to call them traitors and offer to win the war. Now, if the gingers come in there will be a real opposition – powerful & supported in the press. It won't begin at once, but it will begin. And that opposition must become pacifist – there's no other line for it. So long as the moderates were in the alternative government was ginger: with the gingers in the only alternative is negotiators. I think now it's only a question of how long it will take for [Lloyd] George & [Edward] Carson to become unpopular and how much harm they will do us before that happy day. Once they become unpopular, the moderates come in with a free hand and that means peace. So much for politics. During my absence there were fine goings on here, as there usually are. Mr Birrell, – Shepherd, Mansfield, Brett, Ethel Sands, Elliott [i.e. T. S. Eliot]. On Monday came Maria [Nys] for a week and the Miss Dudleys for a night.[1] Ottoline is in a great state of mind because it has been put about, she says, that Maria lives with Anrep: does she? Maynard is suspected of spreading the scandal. Mr Chappelow[2] is here too: he is a lower middle class bore of the worst description: he ought to suit her ladyship. Even the Miss Dudleys were too clever for her, and she spoils every sort of conversation by her stupidity and insolence. She can't let the talk flow along over her head, but must be forever bobbing up like a lousy old bitch in a tub – drowning all beneath her whining and baying. Curse her. I am still pretty-well in her books; the Shoves not. It seems probable that Adrian [Stephen] will not be allowed to come here though Philip is trying to get round the tribunal. Have you heard anything more about it? Ottoline is trying to get up an affair with Murry: she writes to him and he leaves her letters about. She tells him that we are all superficial – especially Lytton who got on her nerves and had to leave. I shan't be in London this week; but shall come up – God willing – towards the end of next. There was only one thing I didn't like at Charleston: need you do so much house-work? Because the bloody government has made slaves of Duncan and Bunny need it make one of you? And why don't you paint more? Mary & I both thought the still-life at Gower Street which we took for a Duncan quite exquisite. Don't tell Maynard about the Maria business unless he will promise not to make out to H[er]. L[adyship]. that I started the scandal: I'm sure I didn't. And if my hunting waistcoat – the yellow one – is at G. S. could you send it?

Your, CB

P. S. If you see Jack Hills[3] or others in London don't say anything about my being a C. O.

Notes

1. Maria Nys would marry Aldous Huxley in 1919. Helen Dudley had been engaged in the USA to Bertrand Russell but he lost interest in her by the time she arrived in England in 1914; her sister Dorothy wrote poetry.
2. Eric B. Chappelow was a conscientious objector whose plight was referred to in the House of Commons by Philip Morrell.
3. A solicitor who had been married to Vanessa Bell's half-sister, Stella Duckworth, and was an influential early friend of the Stephen sisters.

To the Editor of *The New Statesman and Nation*
November 18 1933

The Pacifists' Dilemma

Sir, – My old friends the pacifists – those of them, that is, who have not become militarists under the respectable colour of Communism – appear from your Correspondence columns to be in a state of some perplexity. Should they stand for complete unilateral disarmament? Shall they arm in defence of the League [of Nations]? Or shall they do their best – this, I fancy, is the policy favoured by THE NEW STATESMAN AND NATION – to land us, in the interests of peace, in another private war, with Germany or Japan, or both? It is a sad muddle to be in, and comes, unless I mistake, of being a little muddle-headed; for the arguments are a good deal stronger now than they were when we were all of a mind in the good old days of the last great war.

Defensive arms are things of the past. The best experts assure us that the next war will be waged from the air, and that the killing will be done by some few thousand brave and resolute men, or possibly women, precipitating aeroplanefuls of gas, bugs and bombs on the heads of us below. If by "arming" were meant devising means of protecting our heads from these lethal precipitations, I, for my part, should be all for armaments. But "arming" in the minds of intelligent and realistic military men, who are, of course, extremely rare, means nothing of the sort; it means devising larger and more rapid vehicles and strengthening the brew.

That being so, we shall not make ourselves or anything else safe by arming. Neither can we make ourselves quite safe by disarming. Nevertheless, since one of the commonest motives for pelting others is the fear that if not pelted in time they will pelt us, any nation that puts itself out of a position to pelt makes itself less likely to be pelted. Completely disarmed we are not safe, but we are safer. Any policeman will tell you that in a brawl it is generally the man with a pistol in his pocket who gets shot.

To be completely disarmed is then, in itself, some protection; while to be armed, besides being a provocation, is, under present conditions, no protection whatever. All that our military advisers promise us is that while we are being suffocated or dying of cholera in London, the people of Paris or Berlin or Tokio will be getting it too. To me, that is no compensation; and so far as I can make out the only people who may come well out of the arrangement, apart from the manufacturers, are the few thousand brave and resolute fellows who will be flitting about above the gas-fumes.

But if armaments are no protection they are a considerable expense. We pay for them directly in taxes and indirectly in general loss of purchasing power. What is more – and this is the crowning folly which gives the needed touch of farce to a situation which some might otherwise be inclined to take tragically – our armaments are not only useless for defence but most of them, and the most expensive, equally useless for offence. For if the next war is to be waged with microbes and chemicals from the air, and is to be over in a few days or weeks when the populations of all the belligerent countries have been pretty well exterminated, of what use are battleships, field-guns, tanks, infantry and – yes – would you believe it – cavalry? For we are still training cavalry. That's the way the money goes. To quote a British admiral – "scrap the lot."

Clive Bell

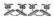

To the Editor of *The New Statesman and Nation*
September 28 1935

Sanctions[1]

Sir, – I am not so foolish as to suppose that anyone cares much about my political opinions. My excuse for writing is the hope

that, by stating my own position, I may roughly indicate that of a number of people who find themselves in this question out of sympathy with all official parties.

Sanctions mean, or at the very least may mean, war; no one denies it. If I am not surprised at finding many of my old friends who were conscientious objectors during the last war, and are now above military age, arguing that "this war is different," it is because I am no longer surprised by any manifestation of thought-less rage. To be sure, this war is different because no two wars are alike; but the position of the convinced pacifist has not changed, nor have the arguments he has to meet. Do my young friends of the Left – those who cannot remember much about the controver-sies of 1914 – really suppose that there were no good and honest arguments in favour of the last war? Do they imagine that moral indignation was not genuinely kindled by the invasion of Belgium? Do they believe that liberal-minded men were insincere when they proclaimed that justice must be imposed by force? Do they doubt that those wise men who argued that war with Germany was inev-itable and that this was a preventive war to be fought in peculiarly favourable conditions, argued out of anything but their proper wisdom?

The answer of the pacifist was then what it is now; or the posi-tion of the pacifist is not "different." No matter how bad a place the world may be at any given moment, a war can only make it worse. Injustice in Serbia, Belgium or Abyssinia is better than uni-versal disaster – disaster, as we know too well, which does not end with its cause. No war will ever end war; on the contrary, war begets war, even though it be waged in the name of peace. No war is inevitable, and therefore no preventive war justifiable. Grant that the brakes have failed and that our car is rushing down a mountain pass; because the driver believes that beyond the next corner there is a tree across the road, he is not justified in swerving straight over a precipice. It is just possible that he mistakes in thinking that the tree has fallen; even if it has, it is conceivable though improbable that some intelligent and benevolent person will have removed it; and there is always the hope – by far the best – that, thanks neither to intelligence nor good will, but by some sheer fluke, we shall scrape by somehow.

Never make war to-day because war seems inevitable to-morrow. Who knows? To-morrow we may all be sober. Anyhow, we shall have gained a day.

Clive Bell

Note

1. Sanctions were imposed on Italy by the League of Nations after Mussolini's invasion of Ethiopia (known at the time as Abyssinia).

To the Editor of *The New Statesman and Nation*
December 28 1935

Sanctions and War

Sir, – Some time ago you were good enough to print a letter from me in which I pointed out that sanctions might mean war. As this letter was treated by the intellectuals of the Left with the contempt which it deserved, a second letter from me can do you no harm.

It is the opinion of those who are in a position to know that "we are very near war with Italy" (I am quoting one of them). They also think that a war between England and Italy might very probably become general. Even if general war were avoided, they admit that the defeat of Italy – always supposing that it is Italy who is defeated – would lead on to civil war in that country certainly, and in France and Spain very probably. In fact, though here they smilingly suggest that perhaps I am going a bit too far, they would not deny that, if England makes war on Italy now, by this time next year those of us who are not dead may be wishing that we were.

I do not believe that this is what the majority of English people desire.

Unfortunately, the people of England are being bamboozled by two distinct sets of warmongers. I think they have a right to know the truth.

Most Socialists and many Radicals have for a long time wished to crush Italy. Any determined attempt to crush Italy means war in Europe. That is no longer in dispute. The avowed motive of Left-wing war-makers has been love for the League, their unavowed motive hatred of Fascism. Beside this group now stands another, the Young Patriots – for it is to be observed that those who were old enough to bear arms in the last war are generally pacific. This young conservative group also professes love for the League, but its true motive is wounded vanity. As one of its leaders put it to me the other day, "We can't take it lying down from these b——y wops." I think it desirable that the people of England should know that they

are being asked to smash such fragments of European civilisation as survive, and sacrifice such happiness as they may extract from their individual lives, in order (*a*) to gratify the reckless spite or, if you will, the righteous indignation of a group of Socialists and Radicals; (*b*) to stanch a wound in the pride of our Young Patriots.

Finally, it should be known that Mr. Baldwin and his colleagues are well aware of both dangers: the probability of war, and the probable consequences of what no doubt he would prefer to call "a Mediterranean conflict." But it is an odd fact that men who are not afraid of being responsible for what may be the most appalling disaster in history are frightened out of their wits by the cackling of the *Times*. I congratulate Mr. Geoffrey Dawson: with Pope he may fairly boast:

> "Yes, I am proud; I must be proud to see
> Men not afraid of God, afraid of me."

Clive Bell

<center>❦ ❦ ❦ ❦</center>

To Vanessa Bell
October 3 1938 Charleston

Dearest Nessa – your letter reached me here this morning. I was in London all last week and came down on Friday with Janice [Loeb] who wanted to paint my portrait. I shall return to London tomorrow after tidying up here. Janice and Lottie went off at crack of dawn today – the [Euston Road] school opens at ten o'clock. Next Friday I go to Seend, and after that I have thoughts of Paris. But all my plans are unsettled by having no plans. One feels like Lazarus. I must say I am looking forward to public affairs, and especially parliament, these coming days. Last week everyone was frankly panic-stricken, and no wonder. I dined on Tuesday with Harold Nicolson, who told us very clearly and convincingly how very much more horrible it would all be than anyone had supposed, that it was bound to last four years, that the Russians hadn't the slightest intention of intervening seriously – until all the world was war-weary and ready for a bloody revolution at any rate; and to the question "Then is it worth it?" replied, as I expected, "Of course we must fight, we can do nothing else." It didn't seem to have occurred to him that we could <u>not</u> fight. Wednesday's scene of emotion was natural enough

and comic – stout Labour members in the House of Commons blub-
bering like fat prep-school boys. And today they are all as bold as
lions, were longing to have a crack at Hitler all the time and are
damned well going to tell Chamberlain so. They had best get to New
York first and join the American leader-writers who make so very
free with French and English lives at three thousand miles distance.
What seems to have struck very few people as yet – but it will – is
the real miracle – the historical event [i.e. the Munich Agreement].
The people of two great nations have said quite deliberately "Yes,
of course it's a national humiliation, loss of honour, loss of prestige,
betrayal, etc. etc. etc.; and by comparison with war, what does it
matter?" What's more, I fancy the people of Germany and Italy
were saying much the same thing. That's the stunning new fact in
the world. The triumph was for general common sense. Chamber-
lain was but a mouthpiece – a good one in my opinion. And what's
more still, I believe the people are quite ready to say it again. So The
New Statesman and Quentin and their friends make me less uneasy.
 Meanwhile one-armed Stanley has been enjoying himself at all
events. He's an air-raid warden. Every cottage in the brooks has
its complement of gas-masks, and Lottie [Hope] has two. The dolt
[Walter Higgens] is said to have been beside himself with fear; he
summoned Grace [Higgens] home, and home she is. The Woolves
invited me to tea yesterday, but I decided to give Janice such day-
light as there was, and didn't go. I hope to see Maynard this after-
noon. There has been a lot of rain, but the garden is still in great
beauty – especially the michaelmas daisies. I picked figs and pears
this morning. All the peaches in the walled garden ripened and
were delicious. There seems still to be some hitch about 50 G. S.
If Miss Galtran takes over I shall leave after Christmas; if Adrian
remains landlord I will do what I can to suit his convenience, but
go I must. I saw Raymond in London, and Mary Baker (en route
to Ireland & America) and a whole posse of notables at the Beef-
steak Club. Also I saw K. [Kenneth Clark] in the National Gallery,
the best part of which is closed. I don't know whether you see the
New Statesman, but if you do I may say that I think Raymond
[Mortimer] considerably overpraises Graham Sutherland. On the
other hand, [William] Coldstream, [Victor] Pasmore and Graham
Bell deserve more than a perfunctory word of praise.

Yr, CB.
Tuesday P.S. There was a violent S. W. gale last night and the
wall was blown down – just where it fell last time, but worse.
I hesitate to give orders for rebuilding, because I suspect there

ought to be buttresses to make up for the loss of the wind-break, for which we have to thank old Stacey. The potting shed also has been blown down. If you want something done immediately I think you had best write to Grace. The poor garden is ruined for the year, without the collapse of the wall the wind would have done that. CB.

To the Editor of *The New Statesman and Nation*
December 17 1938

Conscription

Sir, – Lord Baldwin has said, and Mr. Churchill has repeated vehemently, that "unless the democracies are prepared to make the same sacrifices as the totalitarian States the democracies will go down." In other words, if you mean to meet violence by violence you must become violent; if you mean to stand up to the Nazis you must adopt Nazi methods – at very least you must have conscription. This is so obviously true that anyone with a modicum of intelligence must see it, and, I should have thought, anyone with a modicum of honesty must say it. But what does the Labour Party say? Assuredly the Labour Party is in favour of conscription. But if some authoritative member of the Party – always supposing such a person to exist – would make a clear statement on the subject, it would be of the greatest help to those who are now in the throes of choosing between evils.

Clive Bell

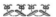

To the Editor of *The Times*
September 1 1939

The Welfare of Humanity

Sir, – We, the undersigned British subjects, are deeply concerned because the nations of Europe are acting as if the only choice left to us is war or bankruptcy. Looking back, we can see clearly that

we have all made mistakes: the mistakes cannot be remedied by trying now to apportion the blame. But, with sufficient resolution, we can begin instead to look forward and determine to make a fresh start. If certain guiding principles are followed we are convinced that a way of escape is open from the poisonous atmosphere, compounded of suspicion and fatalism, that is at present stifling discussion. May we venture to formulate these principles and to suggest how they might be applied? Only the broad steps can be indicated; it must be left to others, better fitted than ourselves, to work out the details: –

(1) The welfare of humanity is one and indivisible: no nation seeking its own advantage at the expense of others can hope to gain its end.

(2) The first consideration in the administration of any country, colony, or dependency should therefore be the well-being of its inhabitants, whatever their race or colour; a strong nation that exploits for its own purposes a weaker nation, or colony or dependency, will in the long run bring disaster to itself.

(3) By pitting nation against nation in the present crisis we shall but sow the seeds of a still more bitter harvest of enmity and hatred; only by placing the interest of the whole community of nations before the narrower interests of individual nations can a just and lasting peace be secured.

(4) In the light of this conclusion it is self-evident that the prosperity of other nations – Germany and Poland, France and Italy, Japan and China, small nations as well as great – is indispensable to the welfare of Great Britain.

(5) Accordingly we desire to see an equitable distribution of the world's resources and, as a first step thereto, the provision for all concerned of a rightful share in the political and economic development of Europe, and its colonies and dependencies, subject to the principles enunciated above.

(6) With these objects in view we would respectfully urge those in authority in our own country to invite immediately the collaboration of the rulers of other nations in an attempt to devise means – possibly on the basis of representative federal institutions – for their attainment.

(7) We believe that to attack such problems sincerely and with a single mind would be productive of so much good will that the nations would be led, naturally and inevitably, to beat their swords into ploughshares and their spears into pruning hooks.

Yours faithfully,

CLIVE BELL, J. D. BERESFORD, VERA BRITTAIN, GEORGE E. G. CATLIN, J. HUTCHISON COCKBURN, D. EMRYS EVANS, HUGH L'A FAUSSET, A. RUTH FRY, DOROTHEA GIBB, R. A. GREGORY, H. HARTRIDGE, T. EDMUND HARVEY, W. G. HUMPHREY, D. CARADOG JONES, K. JORDAN, L. C. MARTIN, E. G. PACE, MAUDE ROYDEN, E. B. VERNEY, J. S. WHALE

To the Editor of *The Times*
September 16 1939 Charleston, Firle, Lewes, Sussex

The Black-Out. An Excess of Zeal?

Sir, – Assuredly it is time that Air Raid authorities began to cultivate a sense of proportion, or a little sense even. In this remote corner of England the zeal of our wardens is provoking mild disaffection. Seeing that by night trains on the electrified Southern Railway illuminate the whole of our valley with streaks of lightning, we rustics are not so simple as to suppose that a German aviator, should he have the whimsical notion of entering England by Beachy Head en route for London, would pry out from his lofty situation a chink in a blind the size of a sixpence, when his trail was blazed for him by a stream of flashes. Nevertheless, ploughmen and shepherds, eating their suppers after a prolonged day's work, are being harassed and rebuked because a quarter of an inch of light shows beneath the kitchen door or because the blind fails to render the window lower in tone than the side of the house. The wardens themselves, sensible and unpaid, agree with their victims that the whole thing is absurd, but plead instructions from a higher authority. And the "higher authority," when discoverable, can think of no better excuse than that he is so pestered by busy-bodies and informers that he must do something to placate them. Meanwhile, though living in a part of England on which no one in his senses would waste a bomb, solitary ploughboys working in the heart of the Downs and children scaring birds have been warned that they are liable to a fine of 10s. for going to work without gas-masks.

Yours faithfully, Clive Bell

To the Editor of *The Times*
May 27, 1940 Charleston, Firle, Lewes, Sussex

Are We at War? Horse Racing and Other Diversions

Sir, – This morning I bought a newspaper described as "Sports 4th
Edition." It consisted of eight pages, six of which were devoted to
horse- and greyhound-racing. To be sure, it may be argued that
after giving the corn, for which poultry-farmers were clamouring
all the winter, to racehorses, it would be a pity to get no good of
them. Nevertheless, if the Government does not stop racing of all
sorts for the duration of the war, its demands on the life, labour,
and property of all its citizens will hardly be taken seriously.

Yours faithfully, Clive Bell

To the Editor of *The New Statesman and Nation*
July 27, 1940

Fifth Columnists[1]

Sir, – Will you help me, if not to extirpate at least to discover
the latest meaning of this repulsive tag? There are people who
do what they can to help the enemy by betraying secrets, cutting
telephone wires, blowing up bridges, persuading soldiers and sail-
ors to mutiny or desert and such like activities: these are properly
described as "traitors" and are occasionally shot. There are others
who happen to hold political opinions different from your own;
these, I think, may be the people you mean when you speak of
"Fifth Columnists."
 Clearly a man's "war aims" – to use another unpleasant phrase –
may, and sometimes must, be conditioned by his political opinions.
You, yourself, have described this war – correctly, in my opinion –
as a war for Socialism: you cannot be surprised if those who happen
not to be Socialists (three-quarters of the population, say) feel their
ardour cool appreciably as they read your words. Last week I had
the privilege of spending the day with one of the most eminent of
social philosophers and publicists alive; and he demonstrated, by
what seemed to me unanswerable arguments, that the only weapon
which could destroy Nazism was a European revolution, succoured

and perhaps controlled by Moscow, while the only way in which such a revolution could be brought about was by making ceaseless war on Germany. When we had won, or partly won, the war, Russia might be counted on to win the revolution. With his customary honesty and acumen, he admitted that to compass his ends considerable sacrifices would have to be made, e.g. the destruction of about half the population of Europe and of things which I for my part consider far more valuable. To achieve his aim – a European or, preferably, world-wide revolution – he was prepared to make these sacrifices. Also he admitted, most fairly, that there were people – patriotic people – who did not desire a bloody revolution, and that they, too, were prepared to make sacrifices for their ideals: they might even further sacrifice the glorious hope of hanging the Führer. Are these, perhaps, the people you have in mind when you speak of "Fifth Columnists"? If so, I beseech you to try again. After all, the attitude of these people is intelligible and no wise disloyal; and, anyhow, it would be a poor thing if the statesmen of the Left could find no better label to stick on their opponents than a vague neologism translated from the Spanish of Franco.

Clive Bell

Note

1. A term referring usually to supporters of an enemy within one's own country, derived, as Bell explains here, from the Spanish Civil War (see *OED*).

※ ※ ※ ※

To the Editor of *The New Statesman and Nation*
November 16, 1940

Rumours

Sir, – There are rumours, based on what foundation I know not, that Herr Hitler will, in the course of the winter, put forward a plan of general appeasement. Should he do so, it is to be hoped that the people of this country will be allowed to know the facts and possibilities of the situation. Certain independent experts have always held, and it begins to look as though they were right, that Britain would not be invaded because an invasion could certainly

be repelled. These same experts think that British Forces, even with such aid as they may hope to obtain from America, will be unable to conquer the continent of Europe. Also they think poorly of our chances of starving Germany out; because, they argue, though it is probable that before long the people of Europe will be extremely hungry, it seems unlikely that German soldiers and munition-makers, with unlimited powers of requisitioning, will go short. The notion that the unarmed and ill-fed populations could rise successfully is generally dismissed as silly.

If these assumptions be correct, what remains? A bombing match between Great Britain and Germany. Some believe that by incessant bombing Germany could destroy our efficiency; but they agree that before she achieved that end her own efficiency would have been reduced by three-quarters at least. How would she stand then? Whatever happens, the British war finished, Germany must find herself between two great powers, America and Russia, neither of which has any reason to love or trust her. Therefore, say some, she would promptly make a dash for the Ukraine and the Black Sea. No, say others, she would raid South America and try, with Japanese help, to get control of the Panama Canal. There are those even who maintain that, content with her achievements, she would settle down to the task of reorganising Europe under German hegemony. Clearly her chance of realising either the first or second aim must be greatly reduced if her resources have been depleted to the tune of seventy-five per cent, while the task of reconstructing Europe will be harder than ever when the most productive parts of it have been laid waste. These are the facts and opinions of which the British people should be told. The possibilities are matters of inference from these facts and opinions. If it be true that Germany can neither be conquered in the field nor starved out, it is improbable that she will desist from waging war till the British Navy is destroyed or neutralised. We have reason to believe that she cannot destroy the Navy. In that case she cannot get all she wants. Neither, unless we can command, and command before long, overwhelming forces by land and air, can Great Britain get all she wants, i.e. the liberation of Europe and the security of the whole empire. Germany may appear to hold the court cards; nevertheless there are some fair-sized trumps in our hand. The question is – Have we anyone who can play them?

Clive Bell

To the Editor of *The New Statesman and Nation*
March 7, 1942

Stalin's Policy

Sir, – No one, it seems to me, not even the editor of THE NEW
STATESMAN AND NATION, has realised, or at any rate admitted,
the importance of M. Stalin's Order of the Day to the Red Army.[1]
It is a statement of Russia's war aims. Russia intends to recon-
quer her frontiers of 1941. A likely result of Russian victories will
be, M. Stalin thinks, the ousting of Hitler and his crew; but the
ousting of Hitler is not a Russian war aim. On the contrary, her
frontiers reconquered, Russia will be ready to make peace with
whatever German government happens to be in power. Not one
word is said about "new orders," "European reconstruction," or
things of that sort; neither is M. Stalin concerned with the ideals
and ambitions of others: all he insists on is restitution of Russian
territory. This is the policy one would expect from that sagacious
autocrat who inherits the place and power of Peter the Great and
Catherine. Let us hope the British and American Governments
have taken note of it.

Clive Bell

Note

1. Reported in *The Times*, 24 February 1942, p. 5.

4

Arts and Letters

Clive Bell's life changed in Paris in 1904. He had gone there with half-hearted intentions to conduct research for a Cambridge fellowship dissertation for which he had been awarded a scholarship, but he abandoned that when he found that the life led by artists and their models in Parisian cafés was far more to his liking. It was not until 1910, however, when he happened to meet Roger Fry on the railway platform at Cambridge that Bell's career found its true path as a tireless champion of modern art. By giving popular expression to the ideas of 'significant form' and 'aesthetic emotion', Bell would forever be associated with the upheavals caused in English cultural life by post-impressionist painting. When the Russian Ballet returned to London after the First World War, with sets and costumes designed by Picasso and André Derain, Bell was again at the forefront of explaining this radical new art to the public.

Throughout his life, Bell entered into controversies about the arts with gusto. Although in many ways his literary tastes tended more towards the eighteenth century, Bell remained committed to an ideal of aesthetic liberty, convinced and dedicated to convincing others that a society's freedom could be measured by its tolerance for unfamiliar art.

To Francis Cornford[1]
[1910] Harbour View/Studland/Wareham Dorset

Dear Cornford,
 Would you be willing to accept, vicariously, a word of thanks
for Mrs. Cornford's poems. It was by accident that I lighted on
the little volume at Denny's in the Strand, my fortunate curiosity
made me turn over a page or two and then of course I bought
it. I can't think of the modern poetry that has interested me so
much. What one feels, I think, is that it expresses, or rather sug-
gests, such a remarkable and attractive mind. I don't mean to
depreciate the art; the simple musical effects are delightful; and
the Chinese poems, which I take to be experimental unless they
are very early, are the best of their kind that I know. But it is the
half-intimacy one gets with a curious, whimsical character that
excites and moves. After reading the poems, we all (my brother
& sister-in-law,[2] my wife and myself that is to say) admitted
that we knew Mrs. Cornford, or knew her better as the case
might be, and that, I suppose, gives well enough the meaning
I am trying to convey. I liked the modern note too, the almost
pagan simplicity and honesty, but more subtle and intellectual
than paganism. I wish I had not been starting for my holiday,
as I should have liked to write something about them in my
pompous old Athenaeum. We are all more or less convalescent
here, though my sister-in-law, Virginia Stephen, is the only one
who has been at all seriously ill. A Cambridge 'reading-party'
consisting of [Bertrand] Russell, [C. P.] Sanger, [Ralph] Hawtrey,
[Gerald] Shove, and Bob Trevelyan, are just leaving us for
London – that is all our news, and all we desire. I fancy you
must have known Robertson [*unidentified*] well; I had not seen
much of him lately, but some of my friends will feel his death a
good deal I'm afraid.
 I hope you won't find this note extravagant; or worse. I am
apt to write wildly when I'm excited; and the poems did excite
me.

Yours very sincerely, Clive Bell
BL

Notes

1. F. M. Cornford, classics scholar, married to Frances Darwin (Charles
 Darwin's granddaughter). *Poems* was the first of Frances Cornford's

several volumes of poetry, which include *Different Days*, published by the Hogarth Press in 1928.

2. i.e. Adrian and Virginia Stephen.

To Francis Cornford
April 9 1910 Harbour View/Studland Bay/Wareham

My dear Cornford,

If I hadn't left the book in the pocket of my great-coat and my coat in the cloak-room at Bournemouth, it would be easier for me to explain what I meant by 'Chinese'. Take [Herbert] Giles's translations, as poetry they aren't up to much, but they will serve; you won't go far without coming upon some poem that reminds you of a landscape by Corot, or rather of an interior by Degas, or better still of one of those exquisite Chinese paintings on silk that seem to me so immeasurably superior to anything we have done in Europe since 1400, or before for that matter. Well, then look at some of the poems at the beginning of Mrs. Cornford's book, – one interior I recollect in particular – and you will see what I mean. Chinese impressionism and terseness, – getting down an effect in as few words as possible.

Do you find, I wonder, that you become more and more bored by the professional writer; the person who always has a book 'on the stroke', and has no sooner corrected his or her proofs and taken the inevitable 'breather' in Cumberland or Tuscany, that he looks about for a new 'subject'? Are you sick of modern English poetry and modern French prose? As I grow less young I find that I only care for books the reading of which is something of an intellectual or emotional experience. I've no quarrel with the people who write frankly to amuse, Balzac, Peacock, or the adventures of Sherlock Holmes; but you may read the best Victorian biography from cover to cover and shut it up the same person as when you opened it. I like books that change, or modify, or enrich my appreciation of life or my attitude towards it; and the reason why I'm particularly grateful to Mrs. Cornford is that the reading of her book was an intellectual and emotional adventure. Life can't be precisely the same after one's been through it; some things have acquired new value and meaning. By this time I must have given you the first column at least of a front page article, which one generally finds to be more than enough. I shan't write any more. I continue to stay in this delightful place with my sister-in-law – Virginia Stephen – who

is now convalescent or rather recovered. But so long as the weather remains glorious there seems to be no very good reason for going away.

Yours very sincerely, Clive Bell
BL

꙰ ꙰ ꙰ ꙰

To Molly MacCarthy
Sunday [October 1912] 46 Gordon Square

Dearest Molly,
 I have frittered away the whole day trying to write a story untill [*sic*] at half past four I discovered that I had missed lunch, that it was tea time, and that the children wanted me to play with them. And so I didn't come. You won't have missed me but I have missed a chance of seeing you. Still in case you should feel lonely or bored or sad I could come about 6.0 tomorrow or Tuesday, or any time on Thursday. I must get those damned Post-Impressionists done too: it looks as though I should have to burn the mid-night oil. Last night I read Samson Agonistes and today am prostrate in my nothingness. What is it? What sort of emotion, I mean? Where does it come from? That chorus "All is best, though we oft doubt" [Milton, *Samson Agonistes*]; you may say if you like that the poetry is carried on a mood, that there is a change of feeling from resignation to triumph. All I've got to say is that neither resignation nor triumph ever made me feel anything like that. I don't presume to know what Milton felt. But if all that life can make me feel in a hundred years could be rolled into five minutes it would be nothing like it. No emotion that comes from mere experience can be half so terrific, so absolutely anihilating [*sic*], so utterly beyond everything. No, believe me, Art is something much bigger than experience and deals with much bigger emotions. What? Whence? I'm sure I don't know. Am I maundering? Do you know those early people – Wyatt, Surrey, Lodge, Brooke, Southwell, Drayton, Barnefield,[1] and the great anonymous of the period? You'll find the best of them in the Oxford Book [of Poetry], they're amazing. What a literary litter! Patience; it's not often I write such stuff. How are you and to what decision have you come? Shall I find a letter waiting for me in the morning to tell me all about it? It's tempting to sit up all night writing my article[2] and to be ready for the postman's knock at 8.0. But there might be nothing but a

circular from the British Empire Trust; and, as it is, life is too full of deceptions.

Ever yours affectionately, C
Sussex

Notes

1. Poets of the sixteenth century.
2. 'Post-Impressionism and Aesthetics', *Burlington Magazine*, January 1913, in which Bell first expounded his theory of 'significant form' at length (and which Leonard Woolf disagreed with in a lost typescript to which Bell's letter to him below responds).

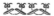

To Leonard Woolf
[February 1913] Asheham House/Rodmell/Lewes

My dear Woolf,
 (a). About "secondary form" I am with you. I don't hold that it is essential to the most moving works of visual art; but to eliminate three dimensional space would be to rob art of some of its most moving forms. Also, I agree, that to create three dimensional space is, in a sense, to represent.
 (b). On no other important point have you joined issue with me at all. I expected the question-begging paragraph and found it at the end. My whole point is that I am as much moved by "S. Sophia, Persian bowls, and Chinese carpets" as by "Giotto's frescoes and the pictures of Cézanne." I insist that a theory of aesthetics must be based on the experience of the person who elaborates it. Your experience differs from mine, since you are more profoundly moved by pictures (and statues I suppose) than by buildings, pots, carpets, etc. Naturally, you explain your different experience by a different aesthetic. Had I not been at pains to make clear that for me pictures & pots are on the same footing, and that no hypothesis which makes the best picture necessarily superior to the best rug will square with my experience, your remarks – most interesting in themselves – would also have been relevant criticism of my essay. As it is, you don't disprove, or even criticize, my aesthetic, but offer an alternative. Very likely it is preferable to mine; but that is not the point. Also, it is because I hold that personal experience is the only foundation for a theory of aesthetics that I have

taken so much trouble to say what sort of art I like. My catalogue of favourites is extremely important to my argument, and the elaborate fun you are pleased to poke at it seems, if you will forgive me for saying so, to indicate a lack of understanding.

(c). "Many descriptive pictures possess, amongst other qualities, formal significance, and are, therefore, works of art." That sentence is enough to save me from any fear of dilemma when I admire the works of artists far more realistic than Cézanne. In fact, I never meant to suggest, and I don't think I do suggest, that 'likeness' is either bad or good in itself. It is irrelevant. A form may be both very 'like' and very 'significant'; many are both. But a man who devotes his energies to making illusions or recounting facts will have little to spare for creating form. Most artists, I fancy, will always have to get a hint from external reality, chiefly because it is so very difficult to invent satisfactory forms. Form, however, can be invented; and I know of invented forms as significant as any that come from outside.

(d). The root of our differences is, I believe, that we are thinking about different things. Your account of your aesthetic experiences makes me suppose that they are altogether unlike mine. It seems that you first establish the relations of the forms in a picture to the objects of life and then get your emotion. In my case the emotion comes first; afterwards I may or may not make out what the forms represent: often I don't. Like all Cambridge rationalists you assume, I fancy, that every one must see and feel as you see and feel. But I find that I don't, and that Duncan and Vanessa don't either. It seems to me possible, therefore, that your aesthetic explains your feelings & states of mind, and that my aesthetic explains mine. I dare say that setting out from the data of your own experiences you are more competent to draw right conclusions than I am. Unfortunately I am pretty sure that your experience, your feelings and states of mind before works of art, are quite different from mine, and it is in my own (and those like them) that I am vain enough to be interested.

Yours ever, Clive Bell

P. S. This all seems to be written in a horrid, controversial "scoring-off" tone. That's really your fault: it's the tone of the type-written article. It's not meant that way, however. What I want to say is that I don't think your criticism really touches me because we seem to set out from different experience. My article was, of course, only prolegomena. There's a lot to be worked out yet. But the only disturbing question seems to me to be that of three dimensional space.

It had, in fact, occurred to me some time ago; and I mean to worry it out, if I can, in my book [*Art*].
Berg

❧ ❧ ❧ ❧

To the Editor of *The Nation*
February 22 1913

Mr. Roger Fry's Criticism

Sir, – It seems to me that even Mr. Bernard Shaw has missed the point of Mr. Fry's article.[1] That point concerns Post-Impressionism only indirectly. There are two opposed views of Art, one of which I will call the "official," the other the "aesthetic." According to the former, the value of a work of art depends (a) on the accuracy with which visible objects are imitated; (b) on the prettiness – or beauty, if the word be preferred – of the object selected for imitation. According to the other view, the value of a work of art depends entirely on its power of provoking a peculiar emotion, called "aesthetic"; the imitation of objects is valuable only in so far as it is a means to this end. The meaning, therefore, to be attached to every term in art-criticism will depend upon the class to which the critic belongs. For instance, when Sir Philip Burne-Jones speaks of a "well-drawn" figure, he refers to its anatomical correctness; whereas, when Mr. Fry praises the "drawing" of Matisse, he means that it is aesthetically moving. This habit of using identical terms to mean totally different things is one of the chief causes of that cloud of exasperated misunderstanding which envelopes all discussions of Art.

Mr. Fry deplores the unfamiliarity of the official class with the aesthetic view of Art. I do not know that I share his regrets. What I deplore is the insincerity that leads people who take the official view to affect an admiration for such duffers as Giotto and Cimabue. Poor bungling old Giotto, with his shaky perspective, is incomparably inferior to any boy or girl who has carried off an Academy medal as an illusionist. And what would Sir William Richmond say to one who chose to portray heads as harsh and distorted as those which the masters of S. Vitale have given to the attendants of the Empress Theodora?[2] This, by the way, is a difficulty which official restorers have had the unfortunate honesty to appreciate. But what does Mr. Shaw say? He says that Tadema "has painted faces superbly (a very high achievement)." If Tadema's faces are superb, it can only be because they are superbly accurate

imitations of pretty faces. If that be good Art, then the Art of Matisse is thoroughly bad; for, in Matisse, you will find not so much as an attempt to imitate pretty things. Perhaps Mr. Shaw will say that he is pleased by the skill of the illusionist, and is moved by the form and color of Matisse. He is welcome to all the pleasure he can get; only I would remind him that the cinematograph is a more amazing manifestation of human ingenuity than any piece by Sir Lawrence, and that the illusions it creates are far more complete than any he can hope to see in a picture gallery. – Yours, &c., Clive Bell

Notes

1. 'The Case of the Late Sir Lawrence Alma-Tadema, O. M.', *The Nation*, 18 January 1913, pp. 666–667.
2. i.e. The Justinian Mosaic at S. Vitale, Ravenna.

To Lytton Strachey
Thursday [November 7 1913] 46 Gordon Square

My dear Lytton,
 it has been quite impossible to write to anyone: I have taken l'espèce humaine in horror: it's too dreadful. These foul smelly animals sweating beneath their greasy scraps of other animals, with their disgusting natural functions and slimy organs, their exhalations and evacuations, their decay. It came over me walking in St. James's Park, watching the decent decomposition of the leaves, floating beautifully to the ground, beautiful in disease and corruption. Think of a rotting corpse, Lytton, think of an old man's body, think of indigestion and diarrhoea, think of every mouthfull of food you eat, think! think! Or rather forget; I am contriving to do so. I suppose I have been possessed of blue devils. My book [*Art*] has preyed on my mind. Chatto and Windus accepted it immediately which was flattering I suppose. They pay all costs, of course, and give me 25% on all sales; that seems well enough. The price is to be 5/- and each chapter will be fronted with an illustration.
 I'm afraid I'm out with your Henry [Lamb] again. He wrote to me about [Stanley] Spenser's picture. I replied that I had spent almost all my money but that I would suggest it to [Frank] Rinder, the next purchaser.¹ At the same time I tried to explain in a very friendly way why I thought £60.0.0 too big a price. For one thing,

I said that an unknown English artist could hardly expect amateurs of painting to give so much for one of his pictures when they can get works by Piccasso [sic], de Vlaminck, Derain, L'Hote, Herbin, Friesz, Marchand, Picart le doux, Ottmann, Girieud, Chabaud, Camis, Asselin, etc for prices ranging from 400 to 1000 francs. Duncan asks 20 or 25 pounds for his. My Piccasso cost 14:[2] Roger and I bought a recent Piccasso the other day for 32. Then I pointed out that it was senseless to talk about a picture being worth 'so much'. A picture's worth everything or nothing. Painters have to live that they may paint; owing to the silly way in which things are arranged they have to sell pictures to live. That can be their only object in selling – if they're artists. So, as a picture kicking about the studio's of no use to an artist, he'd better sell it for what he can get instead of refusing to sell it till he gets what he thinks it's worth – how he makes the computation I can't guess. Well I tried to say all this in a pleasant sort of way to Henry. But I'm afraid I failed. Anyway, I conjecture from his reply that he took it in badish part. Tant pis; that's no reason why I should go all over it again to you. Molly's been ill and away at Bexhill for a fortnight, baiting with the O. B. [Oscar Browning] so far as I can make out. Roger's been away too, and only just back, tedious with tales of [Henri] Doucet and of his own paintings. I see no one but art-critics, and read Sidney (Sir. P.) and Petrarch. [Gerald] Shove has abandoned his dissertation and contemplates life-insurance, and suicide after Christmas. Adrian is sunk in Love and Saxon in disease and mondanité. I have visits from Francis Birrell and long interviews with art-dealers from whom I want photographs. I read Surrey and Wyatt: but you see it all comes hard on an energumene [fanatic]. Have you heard that Karin [Stephen] went to Paris, bought a cwt of plasticine, rolled out a quantity of little figures which she propped up all over her room, & then rushed for a 'taxi' and hurried round to Vildrac in search of a photographer, which is all a great secret and un peu trop fort? According to latest advices she is to stay in Paris for ever and become a sculptor – in the manner of Michelangelo rather than of Matisse. Two totally disconnected people, neither of whom are in sympathy with 'the mouvement', rang me up within a few minutes of each other to say that one [William] Roberts had been dismissed from The Slade for "cubism". "Wasn't it a shame?" "Could I do anything for him?" I knew enough of my interlocutors to know what Roberts had been expelled for, and he is now working at the Omega.[3] He has talent and is very, very pretty. But I daresay he is a friend of yours: I surmise he is a regular member of the sweetheart brigade. You'd better do your Christmas shopping in Fitzroy

Square, at present he is alone with the ladies and Duncan. I saw Hester Ritchie[4] outside the London Library yesterday in an ulster [overcoat] and side pockets. She is enormous; and her face has come out all over mulberry-coloured blotches – something awful.

Yours ever, C. B.
BL

Notes

1. For the Contemporary Art Society (founded in 1910).
2. In 1911 Clive and Vanessa Bell bought *Pots et citron*, the first Picasso work to enter an English collection. Vanessa told Virginia that it cost them £4.
3. The Omega Workshops, founded in 1913 by Roger Fry, at 33 Fitzroy Square.
4. Leslie Stephen's niece by his first marriage, to Harriet 'Minny' Thackeray.

To Mary Hutchinson
Wednesday night [1914] 46 Gordon Square

All is well, my dear; I have your fur and the letters. And now rather vaguely and tipsily at 1.0 on Thursday morning I write to tell you so. Duncan and I have been sitting talking about art. It began with Beethoven, and the extraordinary insignificance of things like war, politics and dominion by comparison; then we got on to what was really the point of it all and why it seemed to matter so much more than anything else; and so on and so on. And now there's nothing more to say except that I think I hadn't at all recovered from the effects of Beethoven before I had said good-night to you. And so I said nothing else. You mustn't suppose on that account that I'd nothing else to say. I was simply ecrasé [*crushed*] as I'm apt to be after music, and talked automatically. If I'd known you better I should have held your hand and said nothing. Shall I ever know you better? It won't be my fault if I don't. Perhaps it will be though. Au fond, d'you know, I find you an intimidating person. That's probably because I like you better than I know you. Still, there's a thrill and a reality in the unknown; & I rather suspect you are unknowable. Frankly, does anyone know you? From your last letter I half inferred that I was in some sort of disgrace; now I'm more hopeful. Well, one day, I suppose, we shall become a part of the

Absolute and know everything – to be sure German philosophy's out of fashion – but how very exciting it will be.

Yours affectionately, Clive

To Vanessa Bell
[?May 1919] 46 Gordon Square

D[earest]. D[olphin]. Please come to London. Please help me. Please tell Roger. We have promised the ballet [Ballets Russes] to give a reception for Picasso & Derain at Gordon Square. Friday May 23rd, after the ballet, say 11 o'clock. They want some of the beau monde & some artists if possible. Mary has promised to come and give a hand. We could come to Charleston for the Monday & Tuesday night, but we must be in London by Wednesday, and I think it would be better if we all were in London for the whole week. I count absolutely on you, Roger, Duncan, and [Edward] Wolfe as a sort of committee – to organize and decorate. Will Roger dig out some of his grand friends? It must be a great success in the half bohemian, half mondaine style. If you are coming up on Monday tant mieux [*all the better*]; anyway tell Roger that he is as deeply compromised as I am and that he must give a hand. Will he let me know when he gets back?

CB
Sussex

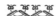

To *The Burlington Magazine for Connoisseurs*
June 1919

"Significant Form"

Gentlemen, – The repetition of what has already been repeated is tedious, I know; but your readers will remember, I hope, what the Bible says about answering the directors of public galleries, and will blame not me but Mr. MacColl.[1] "The parrots of the press", says he, "frequently repeat this incantation ('designing in depth') just as they repeat Mr. Clive Bell's 'significant form'. Mr. Clive Bell sets out to be absurd, or, in any case, succeeds in saying the

precise opposite of what he may be presumed to have intended, namely, 'insignificant' or 'meaningless' form." In my book "Art" I explained precisely why I called works of art not "beautiful forms" but "significant forms": for the benefit of a certain Mr. Davies I repeated this explanation in "The New Statesman"; this explanation I reprinted in a collection of my essays, called "Pot-Boilers." If Mr. MacColl has criticised my theory without reading my writings he has done something foolish. If, having read them, he still cannot understand why I call works of art "significant forms", I fear he must be dull. I leave it to him to impale himself on whichever horn of the dilemma may appear to him the more appropriate.

I would inform anyone who has read Mr. MacColl's letter and has not read my writings that I use, and always have used, the term "significant form" in contradistinction to "insignificant beauty", *e.g.* the beauty of gems and flowers and butterflies' wings. The forms created by artists – by painters, potters, sculptors, architects, textile-makers, etc. – are, I maintain, different in kind from flowers and butterflies, and provoke emotions different from the emotions provoked by these. They have a peculiar significance. Whence this significance comes no one can say for certain. But I put forward as a hypothesis – "the metaphysical hypothesis" I called it – the suggestion that in a work of art an artist expresses an emotion, whereas the flower and the gem express nothing and are, in that sense, insignificant. Be that as it may, what is certain is that I made it perfectly clear to those men and women – and apparently there are thousands of them – who have been more fortunately endowed than Mr. MacColl that when I spoke of "significant form" I did not mean "insignificant form".

Yours faithfully, Clive Bell

Note

1. D. S. MacColl, Keeper of the Wallace Collection, had taken issue with an article by Roger Fry and criticised Clive Bell in the course of his argument with Fry.

✻ ✻ ✻ ✻

To Mary Hutchinson
July 9 1919 46 Gordon Square

Darling, the sun is shining once again and I've time only for a note on plans – such plans too. Last night I went to the ballet

and met Jack there. He had met Picasso and Massine at lunch and they were almost positive that the Picasso ballet [*Tricorne*] would be on Friday week. He (Jack) had already taken a box for his bella, Lady Diana and her husband, and was counting on me to look after you. Je ne demande pas mieux [*I ask nothing better*]: so I have taken a couple of stalls. Then I fell in with Picasso who was charmingly welcoming – asked me to come and see what he was doing and to lunch – he is always at Gennaro about 1.0. I suggested Wednesday in next week and promised to warn him by post-card. He then asked me to take him to the East-end – I suppose we might do that afterwards. You will be enraptured to hear that 'le gros' [Derain] means to return for Picasso's ballet but – O Marquise, préparez votre mouchoir [*get out your handkerchief*] – "avec sa compagne". Nevermind, we will have a partie carrée [*dinner for four*] one night after the ballet and you shall do your damnedest. Then [Ernest] Ansermet wanted me to meet Stravinsky who will probably be here by the end of this week, and Picasso's collaborator, [Manuel de] Falla the musician; so I said we would call for all or some of them on Tuesday about 1 o'clock. I went to call on Lopie [Lydia Lopokova] with Jack but found too many admirers in her loge, so retired behind the scenes while Thamar was being performed to chat with Picasso. However, pensez-y donc [*think about it*], a message was brought me from la prima ballerina requesting my attendance now that "elle etait seule"; and considering the way in which you flirt with your poet [T. S. Eliot] it would have served you only right if she had flirted with hers.[1] But she didn't. Only we have arranged that on Thursday week we are all to lunch together, visit Hampton Court, perhaps have tea with Virginia, and so home. Le petit Cocteau va venir, and the ballet seems to think he would exactly suit Lady Ottoline. Also, on Tuesday night Roger wants us to dine with Forster. Does all this suit you? A lovely white garment has arrived for you in tissue paper. I must fly. C

Ansermet and an agreeable musician called Clarke came back with me and kept it up till two o'clock this morning.

Note

1. Clive Bell had written a poem 'To Lopokova Dancing', delighting her.

To the Editor of *The Athenaeum*
August 28 1919

London Posters

Sir, – Your correspondent A. M. is not quite accurate in attributing
the Russian Ballet poster to Picasso. The figure, which is by Picasso,
was not drawn for the poster, but pitch forked into it. The lettering
is not by him, neither is the arrangement. In a word, this is not a
Picasso.

But I wish you could induce A. M. to tell us more about posters.
We are always talking about popular art – an art that shall exist
outside museums and galleries. Well, if such an art there is to be, it
must consist of posters and suchlike, not of chapbooks and morris-
dances and folk-songs and arts and crafts in the open. Nothing
could be more helpful to enthusiasts for popular art than intelligent
criticism of posters. Only, unluckily, most of us, professional crit-
ics, know next to nothing about them.

Yours faithfully, Clive Bell

To the Editor of *The Nation*
September 27 1919

The French Pictures[1]

Sir, – Ten years ago I should have felt inclined to argue with some
of your correspondents. To-day it would be absurd. Even "The
Times" now admits officially that the battle is won and, in its
special French supplement (September 6th), recognizes Cézanne,
Renoir, Van Gogh, Gauguin, and *le douanier* Rousseau as the
old, and Matisse, Picasso, Derain, Lhote, de Vlaminck, &c., as
the young masters of modern painting. The same truths were, of
course, recognized long ago by "The Times" art critic; but, for
my purpose, the judgment of a highly trained and sensitive expert
counts as nothing in comparison with the pompous pronounce-
ments of a special supplement. It must now be obvious to all that
the battle is over, and that Dr. Greville MacDonald and his friends
are the gallant defenders of a lost cause. As such they are entitled
to our affectionate esteem, for which, however, they are not likely
to thank us.

Nevertheless, I should be glad, in all friendliness, to offer them some word of advice. For instance, who has been telling Dr. Mac-Donald that when a baby picks a flower it takes it to its mother? Don't you believe it, doctor. It was this fellow, not the cubists, who was pulling your leg. When a baby picks a flower it puts it into its mouth, and, if given time, swallows it. There was a bit in the papers the other day about a child's dying from having thus swallowed a scrap of lettuce. What might not have happened had it been a dandelion or a peacock's feather? I call it a shame to put such jokes on "a family man," which is what I take the doctor to be.

The Philistine seems anxious to learn, so I will do my best to help him. In the first place, it is a mistake to attack an artist by name until you have taken the trouble to make sure that the picture complained of is really his doing. And, then, about that "Flora" of Praxiteles, the title of which, by the way, should have put my critic on his guard. We have but one authentic statue by Praxiteles, "The Hermes" at Olympia. Lord Leconfield's "Head of Aphrodite" is supposed to be not very far from the original; and the following copies are reckoned by experts to have about them some reminiscence of the real thing: "The Silenus," "The Satyr," two figures of Eros, "The Artemis," "The Zeus," two figures of Dionysos, and "The Apollo." All existing copies of the "Aphrodite of Cnidos" are generally considered too feeble to give any idea of the original. It is to be presumed, therefore, that our Philistine has either dubbed one of these copies "Flora," or – and this seems more probable – wandering through the Vatican, has been enchanted by some bit of Roman rubbish which, in a gallery from which the rude breath of scholarship is appropriately enough excluded, still bears the thrilling label "Praxiteles." May I hope that this little controversy will suggest to Philistine, who seems to be a good, modest sort of man, the extreme impropriety, not to say folly, of meddling in matters about which one knows nothing?

I cannot tell whether the gentleman who prefers to conceal his name will be glad or sorry to learn that "Claude Lantier" is Zola's conception of Cézanne. In any case, this scrap of information should help him to tidy up his mind by showing him that the movement, of whose beginnings Zola wrote in "L'Oeuvre," is the one that to-day triumphs throughout Europe and America.

Finally, may I say how happy it made me to see a letter from Mr. Cobden-Sanderson. I had made sure that he was dead. It is a pity that he will not read my book, which might have put him in the way of new aesthetic pleasures. But Mr. Sanderson I sus-

pect would regard it as an act of disloyalty to care much for anything for which Morris had not cared; and loyalty is a virtue that excuses worse things than obstinacy and ill-temper.

Yours, &c., Clive Bell

Note

1. Clive Bell's review of the exhibition 'Modern French Pictures' at Heal's Mansard Gallery elicited a number of scornful letters, which he answers directly here.

To the Editor of *The Art Review*[1]
September 12 1922

Dear Sir,
 it is always a pleasure to see The Art Review, but I must admit it is a greater one when The Art Review happens to contain so flattering an article as yours on my book Since Cézanne. Thank you very much for it. Your story about [Ezra] Pound at the Doré galleries is most entertaining, and gives a pretty exact idea, I fancy, of how Pound picks up his surprising erudition. Am I wrong in thinking that Pound is an impressive humbug? – I don't know him, have only met him once that's to say – and why he impresses I can't imagine, his writings are feeble enough trash. But he impresses the French – who can never understand or read a word of English – by telling them that he represents America; and of course they play up. I wish you would come to England and have a look at Duncan Grant: he's the best painter, I fancy, we've produced for some time – not that that's saying very much. Shall I send you some photographs of his things when I get back to London in October? By the way, it's good to see you reproducing [Jules] Pascin. He is a charming artist, and not nearly well enough known. He's also a charming man; but I dare say you know that better than I do. For a long time I've been wanting to pipe my little whistle on his account, but reserve the tune until he can be persuaded to have a show in London. And so, thanking you again for your much too amiable notice, I remain

Yours sincerely, Clive Bell
Morgan

Note

1. A personal letter, not for publication.

To John Middleton Murry
January 11 1923 50 Gordon Square

My dear Murry,
 It was with such a shock that I read this morning in *The Times* of Katherine [Mansfield]'s death that I feel I must write to you, though I know that nothing I can say can be of any use or comfort. When one has not heard for a long time of an invalid one always assumes that all is well; and the last time I saw Katherine she looked so beautifully well – so ominously beautiful I suppose – that the news this morning utterly bewildered me. One can never be just to the living; and it was only when I read the little notice in the paper that I realised quite how much talent – genius if you will – and what promise we had lost. Of what you have lost it would be merely silly to speak. Please don't answer this.

Yours, Clive Bell
HRC

To T. S. Eliot
September 25 1927 Charleston

My dear Eliot – (for I doubt it would be familiar to call you Tom so strange are we become). Whose fault is that? Not mine. Here is a story by my friend Beatrice Mayor, which she thinks the N[*ew*] C[*riterion*] might care to print. I think it rather long; I think it remarkable however. Possibly you saw her play "The Pleasure Garden" at the stage society: to my taste it is about the best that has been written in England in our time. Would you consider it, and if you don't want it return it to me at 50, Gordon Square? There I shan't be permanently established before the middle of October; but that will be my address. When I am established I

shall make one more attempt to get you to dine with me and meet a few of your forgotten friends. I read The journey of the Magi with great admiration.

Yours ever, Clive Bell
TSE

To T. S. Eliot
July 26, 1930 Charleston

My dear Tom, how very pleasant to see your hand-writing again – or rather your type-script. I believe it's two years almost since last we met. Probably you know the reason, which is that I have expatriated, as the old procuress says in that comedy which was begun by – Fletcher was it? – and finished by Buckingham. I keep a vague lien on the flat, which is generally let however; and spend a month or so each summer at Charleston. I do mean though to spend a good part of this autumn in London and the devil's in it but we'll dine together one night.

Now about this very flattering proposal. You may or may not know that in January 1932 there's to be a grand show of French painting at Burlington House. A syndicate of publishers have bribed me to write a little ad hoc treatise, which I am doing with extraordinary pleasure for I know nothing about French painting before 1800 and learning is what I really enjoy. All the same learning is long and it will take me all the time I am allowed – to the end of next July – to get the essay written and tidied up. After that, if you are still in the same mind, we might have another dinner and a discussion.

I don't know whether you ever get news of me through Virginia. There's not much to tell. I am glad to notice that my child [Julian Bell], who seems to spend a good part of his time railing against the Tomists, always speaks of the master with becoming respect.

Yours ever, Clive Bell
TSE

To Jim Ede
Sunday [1931] Charleston

Dear Ede
 I've just finished Savage Messiah which I find fascinating. How intelligent of you to get hold of the documents, and how well you have managed them. It makes a most remarkable book. I missed knowing Gaudier – perhaps it's as well – though I see he could have been delightful. My God what a woman [Sophie Brzeska]. They both come out with extraordinary vividness – and how clearly Middleton Murry and K. M. are brought to mind. A remarkable book.[1]
 I expect Heinemann will have seen to it that it falls into the hands of the right people. For my part I shall be singing its praises for weeks to come.
 So with much thanks,

Yours, Clive Bell
Kettles Yard

Note

1. Ede's biography of Henri Gaudier-Brzeska, *Savage Messiah*, was published in 1931.

To Stevie Smith
September 15 1936

Dear Miss Smith,
 I have only one fault to find with your enchanting book [*Novel on Yellow Paper*]. Why do you say that you are a 'foot-off-the-ground person'? I think, I hope, I know what you mean. But if I do, then assuredly I am a foot-on-the-ground person – both feet. And yet I find your book one of the best I have read for some time, and – as you might say – I read an awful lot of books – in several languages what's more.

Yours sincerely, Clive Bell
McFarlin

To The Editor of *The Times*
November 30 1940

Sir – I believe you and some of your readers will be shocked to learn that the ceiling of the [Whitehall] Banqueting Hall is still unprotected. Every one – except perhaps those whose duty it is to look after it – knows that this ceiling, albeit in poor condition, remains an important example of Rubens's later style. To remove it to a place of safety would be no very arduous task, as the paintings are on canvas; and the removal would afford an opportunity for much-needed cleaning. Surely there remain in England people of taste and power to insist on this elementary duty to civilization being carried out at once.

Yours faithfully, Clive Bell

To T. S. Eliot
December 30, 1940 Charleston

My dear Tom,
 For weeks I've been meaning to write and tell you what I thought of East Coker. I think it is a work of immense beauty – probably the best you have given us since The Waste Land, which is saying a great deal. I'm rather glad that you have taken a holiday from play-writing – not that I didn't admire all three extremely; but it is in the meditative poem, I think, that your genius – yes, though I dislike big words as much as you do – is seen to greatest advantage. Anyhow, this is a masterpiece in subtlety of movement and command of language, and in relating what I can only call apparently disparate poetical ideas. Also the mood is to me deeply sympathetic. To my mind the poem proves not only what everyone would admit, that you are our greatest living poet, but that you were – as I always maintained – when Yeats was alive.
 Where are you? I must address this note to Faber & Faber because I don't know. And is there any chance of your coming this way in the new year?

Yours ever, Clive
TSE

To Evelyn Waugh
June 3 1945 Charleston

Dear Evelyn Waugh,
 Imagine, if you can, my surprise and even greater delight, yes-
terday, when arriving for lunch at the Beefsteak Club, I found your
handsome present. I had thought, when Charles told me there was
something for me, it might be a few ounces of China tea such as
that most open-handed of men Jack Lawrence of Twinings some-
times leaves for me. It was even better – which is saying a good deal
these days. I haven't read a word yet, nor shall till tomorrow eve-
ning. Immediately after lunch I joined Raymond Mortimer and he
is staying with me for a couple of nights. But that is no reason why
I shouldn't write to thank you at once, for I know that I shall enjoy
Brideshead immensely because I enjoy immensely everything you
write.[1] Even Raymond, "while deprecating certain tendencies,"
agreed that I had a great treat in store. Thank you again, and again.

Yours, Clive Bell
BL

Note

1. In *Brideshead Revisited* (1945), Waugh places a copy of Clive Bell's
 Art on his character Charles Ryder's bookshelf.

To Evelyn Waugh
June 12 1945 Charleston

Dear Evelyn Waugh,
 I am very glad I wrote you a formal letter of thanks before I read
your book, because, if I write again, you will know that it is not out
of good manners but enthusiasm. It is a masterpiece – the best novel
written in English, or French either I strongly suspect, since . . . since I
don't know when. If I were to say The Lighthouse you would accuse
me of family prejudice. I find it most beautiful and horribly moving.
That I should delight in the writing I knew beforehand – it is even bet-
ter than I had expected. This is unquestionably your best work so far.
 What old Peter Quennell may be up to I'm sure I don't know.[1]
And some others? I suppose there must be stress – conflict – in a
drama. And I should have supposed that conflict between sacred

and profane love – natural paganism and a sense of sin if you prefer it – was at least as good a motive as another. Propaganda? It's no more propaganda than Madame Bovary. Thank you. I congratulate you with all my heart.

Yours, Clive Bell
BL

Note

1. Quennell's review of *Brideshead Revisited* appeared in the *Daily Mail*.

To the Editor of *The New Statesman and Nation*
February 23 1946

Mr. Bodkin and Mr. Fry[1]

Sir, – To argue with Mr. Bodkin would be as unprofitable as distasteful. I wish to state that between our first meeting in January 1910, and the Exhibition at the end of that year, I saw Roger Fry constantly; that his enthusiasm for the artists he was planning to present was intense when we met and increased as he saw more of their work; that he selected the pictures himself and selected them in a mood of happy appreciation.

 May I add that, like most of Roger Fry's friends, I took the passage from *The Approach to Painting*, quoted by Mr. Mortimer, to insinuate that somehow or other Roger made money out of the business: this insinuation I judged too silly to need contradiction. Now, it seems, Mr. Bodkin has eaten his words, and I hope that he enjoyed them more than I did. At least he has said that he did not mean what he appeared to mean. We must conclude that his power of expression is even feebler than we had supposed.

Clive Bell

Note

1. In *The Approach to Painting*, Thomas Bodkin had insinuated that Fry had colluded with Parisian art dealers in promoting post-impressionist paintings to dupe gullible collectors into buying them.

To the Editor of *The Times*
November 21 1946

The National Gallery

Sir, – By all means let trustees and directors of galleries remember that to clean a picture is to take a risk; that a man with a swab in his hand is a man exposed to temptation; that the removal of ancient repaint may give a familiar masterpiece an uncomfortable appearance; but let them not forget that what we want to see is all that remains of what the master painted and not the muck of ages, and that a battered fragment of what the master really did paint is always to be preferred to a slab of opaque varnish or the plausible improvements of any restorer, ancient or modern. We hope, therefore, that when it comes to a choice – as occasionally it must – between risking some damage to some part of a picture in order that the rest may become visible and leaving the whole securely hidden behind a wall of venerable dirt, the risk will be taken.
 CLIVE BELL, DUNCAN GRANT, ERIC MACLAGAN, RAYMOND MORTIMER, WELLINGTON

To Douglas Gordon
December 11 1949 Charleston

Dear Douglas Gordon,
 Very many thanks for your letter of excellent advice, which I shall follow in every detail. With luck, it seems to me I may be in New York on the evening of the 8th, and I think I shall ask Janice Lowenstein [formerly Loeb] to meet me, as probably a little guidance will not be unwelcome. One more of my pestilent questions, and then I think I have done till we meet. Do you happen to know [Rowland] Burdon-Muller? I fancy he has some sort of position – honorary and ornamental I surmise – at the Fogg. He collects drawings and Chinese porcelaine, and has, I believe, something to do with the arrangement of the museum collections. His great friend – whose name of course I have forgotten – was perhaps director of the Oriental Department. Anyhow, he – the friend – died last spring, and left poor Burdon Muller very sad and lonely, and left him also the task of presenting a Cézanne water-colour to the Museum at Aix-en-Provence. It was there that I met him; and we saw a good deal of each other. He was extremely generous with

his car. We made little archaeological expeditions together. Since I am going to Harvard I should like to make him aware of the fact a little in advance. Indeed I should like to see him. It may be I shall fall in with some friend of his – Roger Senhouse for instance – in London next week. It may be one of them will know his address. It may be none of them will. Anyhow, if one of my American protectors should chance to know him, it would be an "act of love and kindness" to tell him that I was coming.

The Frick collection must be magnificent.[1] I have long hoped to see it. Some of the acquisitions I did see when Roger Fry was buying for Frick, but most I know only by photographs. The Phillips collection – how very kind of Mr. and Mrs. Phillips – I know by repute alone. I asked Benedict Nicolson – the editor of the Burlington – probably you know him – if he saw the Etta Cone collection, when he was in America before the war. He said of course he did, and that it was one of the finest collections of French nineteenth-century painting he had ever seen. I dare say this will be the last letter I shall write you before I sail; for in three weeks time, or a little more, I shall be saying, like "the old man in a boat" – "I'm afloat, I'm afloat." But whether it be or not, I want to say now, what I am not very good at saying, that I am well aware of the immense trouble you have taken on my account, and of your goodness to me. I am not ungrateful.

Yours very sincerely, Clive Bell

Note

1. Henry Clay Frick (1849–1919) bequeathed his 1914 mansion and its collection of artworks from the Renaissance to the nineteenth century as a public museum in New York City. His daughter Helen bequeathed its world-renowned art reference library.

To Douglas Gordon
February 18, 1951 Charleston

My dear D. G.

Thank you for your letters. Thank you even more for the immense trouble you take on my behalf – is it really worth while, I wonder. About the unpleasant subject of lecturing I shall think no more till I hear from you again – only this will I say. It seems

from letters that reach me and proposals from publishers that what people really want of me are reminiscences. It's not flattering; they don't care a fig for my ideas. Well, of course, I can remember a good deal about the early days of <u>Fauvisme</u> and Cubism; and about Lytton Strachey, Maynard Keynes, Roger Fry etc. etc. As for Bonnard, if I were to talk about him chez Duncan Phillips it would be pleasant to illustrate my observations with pictures from his collection. Probably there are slides; and photographs that could be sent to me here.

You say you have had two letters from me. I hope one of them was accompanied by the photograph of an early Matisse that Marguerite Duthuit hopes to sell in America. I don't imagine Baltimore will wish to buy it; but I should be very glad to have something to show which would prove that I had not forgotten to push the wares of an old but by no means easy-going friend. Also I hope you received my comments on and appreciation of your admirable article.

Yours, Clive

To the Editor of *The Times*
March 3 1952

National Collection of Photography. Fostering Appreciation and Study

Sir, – The exhibition of "Masterpieces of Victorian Photography," which Mr. and Mrs. Gernsheim arranged for their collection for the Arts Council at the Victoria and Albert Museum last summer, aroused much interest, both here and abroad.

It was the first full-dress exhibition of Victorian photography ever arranged, and came as a revelation to critics and public alike. Never before had photography – that truly Victorian offspring – been seen to such advantage. Aesthetically as well as technically the photographs were remarkable: how had they remained hidden for so long? And why, indeed, should the entire field of Victorian photography have suffered such neglect in Britain, where photography as we know it was born, and where throughout the Victorian era most of the epoch-making discoveries were introduced? However, other European countries are not more interested. There is not a single museum or other public institution in Europe where the

progress of photography can be studied – in spite of the indispens-
able part in our civilization played by photography. This neglect
has made it extremely difficult to recover representative specimens
of early photographic art and documents related to it. In another
generation a mass of material of high historic and aesthetic value
may be gone for ever.

It seems, therefore, high time that a public collection of pho-
tographic art should be started containing the best work of the
nineteenth and early twentieth centuries with the finest of to-day. Mr.
and Mrs. Gernsheim are willing to present their collection to form
the nucleus of such a public collection, provided suitable accommo-
dation can be found, and a sufficient grant obtained to provide a
centre. This would not only have the function of preserving old pho-
tographs and promoting research; it would also encourage develop-
ments in the art of photography and foster public appreciation and
study through exhibiting work of leading contemporary photogra-
phers from all over the world and by acquiring examples of their
work. The collection should be a non-profit-making educational
organization, which could do for photography what the British Film
Institute and the National Film Library do jointly for the film.

The structure of the Gernsheim collection shows exactly what
a public collection of photography should be and would thus
form an ideal foundation for such a museum. It has the following
sections: – (1) 12,700 original nineteenth-century photographs,
including exceptionally fine collections of the greatest masters; (2)
a library of 2,000 books and journals on photography, including
all important publications relating to the pre-history of photog-
raphy from the sixteenth century, and 200 books illustrated with
actual photographs stuck in – the forerunners of present-day book
illustration; (3) 85 autograph letters and manuscripts of famous
photographers and scientists; (4) a representative collection of
photographic apparatus before 1900; (5) examples of the early
forms of cheap portraiture prior to photography; and (6) examples
of the pre-history of cinematography.

It is obvious that such a collection would serve several pur-
poses. In recent years the advantages of photographic records
over other methods of illustration, so far as nineteenth-century
events, social history, fashion, and portraiture are concerned, have
been increasingly accepted. Historians, art editors, and journal-
ists could all draw on the collection's library and obtain prints
of the photographs for publication at the usual museum fees. For
this purpose a photographic department should be attached. We
believe this scheme to be of national importance, deserving the

support of everybody interested in photography as an art, a social record, and an educational force. Yours, &c.,
CLIVE BELL, RALPH DEAKIN, TOM HOPKINSON, GERALD KELLY, GILBERT MCALLISTER, NIKOLAUS PEVSNER, J. B. PRIESTLEY, J. R. H. WEAVER

To Douglas Cooper
January 6 1953 Charleston

Dear Douglas,
 It is a pleasure to receive a letter from you, even though it come with a string of questions – to which, I fear, I have given inadequate replies.[1] But, really, Douglas, really: "before 1890." For how old do you take me? I was born in 1881, and first heard of "modern painting" when at Cambridge I came across Mauclair's book.[2] I went up in October 1899. I repeat, my answers aren't up to much and may be inaccurate sometimes. Discussing your questions with friends, I may very probably recall odd facts. If I do, I will hand them on. It's a pity we can't meet. I had thought of coming to the midi in March; but things have turned up – there are people and pictures I want to see – and so I shall go no further than Paris (I don't suppose Paris will be much colder than Nice). Anyhow I count on being in Paris during the two middle weeks of March; so, should chance or misfortune draw you to the capital – good fortune for me – send a card to L'hôtel Royal Condi – rue de Condi. I forget the telephone number. I have just had a striking Christmas card from Georges Duthuit. It's snowing here.

Yours, Clive
P. S. I'm writing a full-dress article on Renoir for the Times Lit. Sup. I can hear you sharpening your pen.
Getty

Notes

1. Cooper sent Clive Bell a questionnaire to assist in his research for a catalogue of the Courtauld Collection commissioned by Anthony Blunt.
2. Camille Mauclair, *The French Impressionists (1860–1900)* (1903).

To Edward Nehls[1]
September 2 1955 Charleston

Dear Mr. Nehls,
 by all means print the scrap if you want it.
 By the way, you may have noticed that Lawrence says some-
where in his published letters (I can't give the reference) that
Maynard Keynes alone in "Bloomsbury" subscribed for Lady
Chatterley's Lover. This is characteristically untrue. I have on my
shelf my subscription copy, duly signed, and numbered 578.

Yours sincerely, Clive Bell.
HRC

Note

1. Author of a three-volume *Composite Biography* of D. H. Lawrence.

To the Editor of *The Times*
October 11 1959

Matthew Smith

Sir, – When my friend John Russell, writing admirably of Matthew
Smith, speaks of "his unbefriended earlier struggles," perhaps he a
little overstates his case. Certainly he should know, since the artist,
who died in his house, was, during his last years, one of his closest
friends.
 But old men forget. I cannot give precise dates, but I know
that very soon after Matthew Smith's return from Paris Roger Fry
saluted him in print as a painter of talent and high promise: and in
those days Fry's opinion carried weight. Not long afterwards the
Camden Town Group – at the time by far the most interesting in
England – accepted the newcomer as a valuable recruit. Sickert,
characteristically, admired and mocked.
 Before the first war Matthew Smith was exchanging pictures
with Duncan Grant. And, long before this, if we may trust the story-
tellers, he had been insulted by [Henry] Tonks at the Slade – an
almost infallible proof of merit and a title to consideration.
 All this, I know, does not mean that Matthew Smith's works
were bought by rich collectors or praised by journalists who write

about pictures in the daily papers and are sometimes called "art critics," but it does suggest, I think, that they were appreciated by people of sensibility and intelligence.

Clive Bell

5

To the Editor

Clive Bell got his start as a journalist writing reviews for the Athenaeum, *a rather staid holdover from the Victorian era. In the years following the First World War he became a frequent commentator on art for magazines such as* Vogue, The New Republic *and* Vanity Fair, *and contributed often to the correspondence columns of national newspapers and other journals. His letters appeared most often, however, in the various iterations of what had begun as the* Athenaeum. *That magazine was absorbed in 1921 by* The Nation, *edited since its founding in 1907 by Hugh Massingham. In 1923, a consortium headed by Maynard Keynes bought* The Nation & Athenaeum *and installed Hubert Henderson as editor, with Leonard Woolf serving as Literary Editor until 1930. In 1931, it merged with* The New Statesman, *a Fabian weekly previously edited by Clifford Sharp. Desmond MacCarthy was its literary editor from 1920, writing a weekly column under the pseudonym 'Affable Hawk'. Raymond Mortimer became its literary editor in 1935.* The New Statesman and Nation *was edited until 1960 by Kingsley Martin. Through all these changes, Clive Bell supplied witty, combative opinions on topics ranging from politics to the price of books. He was as likely to train his sarcasm on a close friend (like Desmond MacCarthy) as on an enemy (like Wyndham Lewis), and he showed no compunction about using what some referred to as Bloomsbury's 'parish magazine' to promote the work of his friends. For a wider public, such as the readers of the London* Times, *Bell could write in more measured tones, and by the end of his life he was taking the trouble to set the record straight when erroneous claims were made about those he had known intimately.*

To the Editor of *The Eye-Witness*[1]
August 5 1912

Tests for the Feeble-Minded

Sir—Not long ago I was dining at the house of a famous "mad doctor"—"alienist" is the genteeler word—in company with half a dozen specialists, "mentals" for the most part, all eminent in that profession, any two members of which are to have power over the liberty and manhood of the poor. Knowing that I "take an interest in art and that sort of thing" my host produced after dinner a collection of paintings by people imprisoned for lunacy. There was nothing very remarkable about them: though to one who looks at thousands of pictures because he is paid for looking, their general level appeared refreshingly high. That is beside the point. They were not produced for my refreshment: they were produced for sport and the honour of the profession.

The experts had the pleasure of assuring me that they could infer from each picture the degree and nature of its author's insanity. I begged for enlightenment, and learnt that the madness of an artist can be measured by the manner in which his picture differs from what his doctor sees. Now whether artists should compete with photographers is a question on which I hold strong opinions, for a statement of which I shall expect to be paid. In fact, they never have. No respectable artist does attempt, or ever has attempted, to set down exactly what he sees, much less what a "mad doctor" sees. These men of science, therefore, have been basing their conclusions on a hypothesis which every extension lecturer knows to be false. They have not taken the trouble to verify their premises—such are the methods of science—but on the strength of their conclusions they are ready to castrate and imprison the poor—such is the conscience of the profession.

To push the matter further is inartistic. I am too angry to care about that. There are comparatively few painters in England, and the people who go to Burlington House may well think that they deserve whatever fate the doctors have in store for them. The public may not appreciate fully the light thrown by my story on the wonders of science. To ruin utterly the breeding business it is necessary to make the public uneasy. Now the Eugenist reckons crazy and "feeble-minded" any one who differs greatly from the normal, and his notion of a normal man is—a Eugenist. Make

that clear and the battle is won. On such terms who will not be ashamed to purchase a sense of security?

Yours faithfully, Clive Bell

Note

1. Desmond MacCarthy contributed to this weekly paper, edited by Hilaire Belloc.

To the Editor of *The Nation*
May 9 1914

The Government and National Art

Sir,—Well-informed people tell me that the Treasury will be asked before long to increase the sum which the nation devotes annually to the purchase of works of art; better-informed people add that the Treasury, on behalf of the nation, will decline to do anything of the sort.

Has it occurred, I wonder, either to amateurs of art or to His Majesty's Ministers that, without taking a penny from the revenue, but by performing an act of simple justice, it is possible to supplement handsomely the funds of the National Gallery?

It is agreed, I think, that a modern State should subsidize all schools of painting or none, because it is agreed that there is to-day no school so obviously and pre-eminently right as to make all others indisputably wrong. In contemporary European painting, there is no such thing as orthodoxy: there is no one school to which the mass of expert opinion can agree to do homage. In these circumstances, the modern State must either support some vast permanent exhibition, where everyone will have a right to show his work, or it must disestablish and disendow contemporary art, and devote its art-fund to the acquisition of ancient works, about the merits of which there is at least some general agreement.

Now, by handing over to the Royal Academy a large part of Burlington House, the nation is paying, at present, a heavy annual tribute to one particular school of painting. This is unfair to all the other schools: it is also unfair to the taxpayer. If the Royal Academy is unwilling to pay a fair rent for the premises it enjoys, it is the business of the Government to find a new tenant. The

money so obtained will be a welcome addition to the funds of the National Gallery.

Thus, by performing a simple act of justice, the Government might do a real service to art. It is as desirable that contemporary artists should compete on equal terms as that ancient masterpieces should be saved for the nation. The present state of affairs is unsatisfactory, because, while it starves the public collections, it is unjust to living painters—not least to the more competent and magnanimous Academicians, who must feel acutely the humiliation of being fed with an official spoon.—Yours, &c.,

Clive Bell

To the Editor of *The Nation*
August 10 1918

The Coming General Election

Sir,—it is much to be hoped that Mr. Gerald Gould will succeed in drawing from THE NATION an opinion as to the duty of Liberal electors at the coming general election. That the opinion of THE NATION will carry great weight is certain: what precisely it will be is less so. Will you allow me to lay before you and your readers certain considerations which, if just, are bound to influence your decision and theirs?

As "The Times" has already perceived, both the Liberal and the Conservative parties are dead. They perished with that old aristocratic civilization which received its death-blow from the war: they were parts of it. It is a pity, I think, that the old civilization could not have survived another fifty years, by when Europe, had she kept the peace, would have accumulated sufficient wealth and culture to have passed, without much pain or danger, into a new phase. But the milk is spilt; and with it go those Liberal and Conservative parties which were the direct descendants of pre-Reform Bill Whigs and Tories. What remains?

On the one hand the Bagmen;[1] on the other, the Trade-unionists. Neither party belongs to the old civilization—that is to say, neither takes for granted the social structure and the traditional values that were taken for granted by both Liberals and Conservatives. Nevertheless, each seeks to retain certain elements of the past. The Bagmen hold the field: the present Government is Bagmanist,

though, as "The Times" has noticed, there remain in it survivors
from the old *régime* for whose extinction "The Times" imperi-
ously calls. The backbone of the party is the exploiting class—the
business-men, from "the captains of industry" to the petty shop-
keepers; but it is strongly reinforced by those wage-earners who
are attracted by its specious economics or are in sympathy with
its social policy. Its economic system, as everyone knows, is based
on Protection and offers in return high wages; its social policy
consists in a deification of the herd instinct, and results in a strict
bar-parlour morality, an enfranchisement of the meaner passions,
and a steady hostility to free personal expression in life, thought,
and art. Of the foundations of the old order the one it insists on
preserving is Capitalism. It clings firmly to industrialism and pri-
vate ownership, not only on economic grounds, but because the
exploitation and domination of man by man is temperamentally
congenial to its members. It is the sworn enemy of Collectivism;
but it offers the proletariat good wages, the satisfaction of domi-
neering over and injuring foreigners (called Imperialism) and, at
home, the pleasure of "downing" anyone whose tastes, ideas, or
way of life are unpalatable to the majority. A party with such a
programme is sure to be popular.

The only force that can, with any prospect of success, oppose
this formidable combination is Trade-unionism. The strength of
the Trade-unionist party is its idealism—its essential decentness, I
should say. To the doctrine of exploitation it opposes the doctrine
of brotherhood; to the deification of herd instinct the free develop-
ment of the individual, subject only to the limitations of Social-
ist economics. Its weakness lies, of course, in the fact that most
of its members are uneducated; they are ignorant and they have
not been taught to think; consequently, for all its fineness, Trade-
unionism will hardly realize the civilization of which it vaguely
dreams without coming some infernal croppers. Never mind: it
has a dream that may come true, while Bagmanism is the mere
nightmare of the homing season-ticket holder.

Another point to be noted is that what the Trade-unionists
would take over from the old civilization is its culture. They seem
to have an almost pathetic belief in thought, in art, and in knowl-
edge—pathetic because they believe in these things without very
well knowing what they are. Unlike the Bagmen, who will tol-
erate such thought and knowledge only as can be shown to be
of practical value, the Trade-unionists seem to have an instinctive
respect for pure thought and scholarship and research. They seem
to value the things that make life valuable without quite knowing

what they are; therefore, though the Bagmen are inevitably their enemies, the remnants of Aristocracy and Culture need not be unwilling, it seems to me, to accept their leadership. The exploiters, the people who love money-making, are the natural foes of Socialism, but those who love money merely for what money buys might surely pocket their pride and an incompetence pension from social democracy. Let the genuine aristocrats make an effort and renounce their family ambitions, expecting for their children only such chances and prospects of happiness as are open to all, and I see nothing to prevent their joining the Labour Party. For the artists and thinkers who are willing to share their treasure there is surely a place in the Collectivist State: at any rate, let them be sure the Bagmen will suffer the antics only of obsequious and well-disciplined apes. Artists, aristocrats and scholars should reconsider their positions in the light of these facts. After all, they are not money-grabbers but gentlemen, and henceforth the Labour Party is the Gentleman's Party.

For, at present, the Labour Party is the only political representative of what Trade-unionism stands for. One may not altogether like its official policy; that is a secondary matter. The important thing is that the Labour Party stands, awkwardly enough, for the best hopes of mankind, and that it is the only political force that can possibly make headway against the party that stands for men's basest lusts and fears. In these circumstances, it seems to me, for Liberal men and women to waste their energies in fancied loyalty to party-names or the names of party-leaders would be ridiculous and worse. In that new world which the war has hastened into existence there is no third choice. The future belongs to the Trade-unions or the Bagmen, and the political representatives of Trade-unionism are the Labour candidates. In the light of these facts, whatever may be the schemes or ambitions of a few gentlemen sitting on the Front Opposition Bench, the duty of those millions of liberal-minded men and women who at this coming general election will have to settle the fate of England is surely not obscure.— Yours, &c., Clive Bell

Note

1. 'A bagman is one who administers the collection of graft money from either the underworld or the business world and its subsequent distribution among politicians and civil servants' (*OED*).

To the Editor of *The Athenaeum*
March 19 1920

Wilcoxism[1]

Sir,—I should be sorry to quarrel with Mr. Wyndham Lewis about anything so insignificant as his art or my character; neither would I bother you and your readers with such trifles. But Mr. Lewis has shown so much good will in recognizing his symptoms that I feel bound to come again to the rescue. Am I not his doctor?

Yes, I fear he has got it. If he will consult our leading authority he will find that unmeasured personal abuse of those who do not admire us sufficiently is the normal accompaniment of Wilcoxism in its advanced stages (*vide* "The Worlds and I" *passim*). He will find that exquisite sensitiveness to the least reflection on one's professional reputation is highly characteristic of this distressing complaint. It is my duty to tell him that only by playing remorselessly on this last humour can one hope to make a cure.

Frankly, the symptoms disclosed in his letter are grave. I observe with alarm that when Mr. Lewis touches what one might call "the reputation complex" he loses his wonted candour and confidence. For instance, he seems to deprecate the comparison with Lionardo [*sic*], saying that R. H. W. spoke only of his possessing "certain affinities" with that master—Rhoda Hero Dunn, you will remember, had only "an almost Shakespearean quality in her verse." He forgets that R. H. W. added that "he (Mr. Lewis) has less skill of hand (than Lionardo da Vinci), but more sense of humour and the same passion for experiment and contempt for an easy task." And, positively, he does not remember, or did not at the time of writing, that R. H. W. was so obliging as to discover that certain of his (Mr. Lewis's) drawings were "strange scribbles, very unlike the drawings of Sir William Orpen, but not unlike the notebooks of Lionardo."

What a wretched memory! And Mr. Lewis is so modest in his forgetfulness, too, that I hardly care to remind him of that statement by R. H. W. which, though he forgets it, was the occasion of my article—"that he (Mr. Lewis) could, if he so desired, become the Prince of Expressionists and beat Matisse and Derain at their own game." If only books were as easily read as picture galleries are visited, Mrs. Wilcox would have said that Zona Gale could have beaten Tchehov and Tolstoi at theirs. So it was in the critic, not the artist, that I detected signs of this poor lady's trouble. But,

of course, Mr. Lewis is right in speaking out the moment he discovers signs of it in himself.

If Mr. Lewis takes my advice he will run through "The Worlds and I," underlining every sentence that gives him pain. It is a brutal remedy, but the best I can devise. After that I prescribe rest. Let him keep quiet for a few months and, at the end of them, he may find himself blest not perhaps with all that R. H. W. gives him, but with a better memory and better manners and a sense of humour which, if not quite equal to that of Lionardo, will at least preserve him from publicly losing his temper because someone admires him less than he admires himself.

Yours faithfully, Clive Bell

Note

1. In her autobiography, *The Worlds and I*, the American poet Ella Wheeler Wilcox described several of her friends, such as Rhoda Hero Dunn, as literary geniuses. Clive Bell defined 'Wilcoxism' as the notion that any English painter could be as good as a French one, singling out for scorn the critic R. H. Wilenski's comparison of Wyndham Lewis to Matisse and Derain. This initiated a public feud between Lewis and Bell, of which this letter is one instance.

To the Editor of *The Nation & Athenaeum*
April 16 1927 Cassis

Are Books Too Dear?

Sir,—I am glad Mr. Keynes has at last discovered what has always been known to those who read French—that books in France cost a fifth or sixth of what they cost in England. I am gladder still that he realizes that the French read far more than the English, because this may help him to believe what I have often told him, that the French are far more highly civilized. But I am sorry that Mr. Keynes's sympathy with "business" should have led him to suppose that the remedy for the exorbitant price of English books lies with the public. If the public bought more, argues Mr. Keynes, the price of books could be reduced. Agreed: but how can the public buy more with English books at their present fantastic price? And if the public did buy more what guarantee have we that publishers would reduce

their prices? Obviously it is for the publishers to move first: let one of them put on the market a large, cheap edition of a reputable book and see what response he gets from the public.—Yours, &c., Clive Bell

To the Editor of *The Nation & Athenaeum*
April 19 1930

D. H. Lawrence

Sir,—I am sorry Mr. Forster[1] is unable to answer Mr. Eliot, but I daresay he is not very good at definition. Particularly I wanted to know what is meant by saying something "straight out." It is a phrase, I have noticed, frequently used by high-minded controversialists, apparently to give an air of nobility and audacity even to some exceptionally silly remark: but what precisely does it mean? I hoped also to discover what was meant by "high-brow." I used to surmise that it meant an intelligent and well-educated person; but then what reason has Mr. Forster for supposing that such people have been unfair to the works of D. H. Lawrence? They have been critical: but then intelligent and well-educated people have been critical of Shakespeare, and of Mr. Forster, and even of themselves. Perhaps speaking "straight out" means merely being uncritical. That, I admit, is a quality which Mr. Forster may have reason to admire.—Yours, &c., Clive Bell

Note

1. E. M. Forster had complained in a 29 March article that Lawrence, 'the greatest imaginative novelist of our generation', had been ignored by both 'low-brows' and 'high-brows'.

To the Editor of *The New Statesman and Nation*
January 12 1935

Francis Birrell

Sir,—Your admirable obituary notice of Francis Birrell necessarily says little or nothing of what made Frankie a delight to his friends.

He was one of those fortunate people whom everyone laughed
with and everyone laughed at. True it is that his journalism was
better than his books and his conversation better than either; true
that his talk was clever, witty, informed and immensely vivacious;
but that does not quite explain his popularity. I have never known
anyone, almost incapable of flattery, as he was, so universally
liked. Everyone loved him, his old Eton and Cambridge friends,
intellectuals and athletes, fine ladies and philosophers, French
workmen and English *demi-mondaines*. Soon after the war I intro-
duced him to my brother, a professional soldier and Conservative
Member of Parliament; Frankie made no attempt to conceal the
fact that he had been a conscientious objector and was a Socialist;
they got on like one o'clock from the first and remained touchingly
fond of each other to the end. We were staying together in Venice
when it was suggested to him—by Ian Fleming I think—that he
should take part in a golf tournament on the Lido. Frankie appears
to have been the life and soul of the party; what is more, despite
his habit of snatching off his enormous, dirty black hat and rush-
ing after his ball as soon as he had hit it, he won, but character-
istically tore up his card, feeling that he had been handicapped
on looks rather than form. I think the secret of his charm was
that he combined with intelligence, high spirits and a fine sense of
humour, extraordinary goodness. All these qualities shone out in
his slightly fantastic but winning countenance. Everything about
him was characteristic. His very shabbiness was expressive. But it
was his profound goodness—goodness I need hardly say untainted
with priggishness or sanctimony—which seasoned all. I think his
was the most lovable character I have ever known.

Clive Bell

To the Editor of *The New Statesman and Nation*
August 29 1936

English Hotels[1]

Sir,—A statement of my own experience may throw light on the
controversy now raging in your columns. Much have I travelled in
France, and I have travelled in England, too. On my French tours
never have I had a companion, no matter how patriotic or ascetic,
who did not look forward with unconcealed, indeed with loudly

expressed, pleasure to lunch. I have never known, nor ever heard of, anyone, except Mr. Woolf, who looked forward to lunch in an English inn. On the contrary, my companions have often resorted to embarrassing shifts, to say nothing of dangerous driving, in order to cadge lunch in the house of some vague acquaintance, not for reasons of economy, but to the sole end of not having it in a hotel. What is more, when no hospitable board could be reached in time, they have brought from the most unlikely shops sausage-rolls, buns, and even hard-boiled eggs rather than face the rigours of a British table d'hôte.

No doubt Mr. Woolf will maintain that my friends were wrong in looking forward to an hotel lunch in France and avoiding one in England. I state but the fact.

Clive Bell

Note

1. Bell's contribution to a debate between Raymond Mortimer and Leonard Woolf over the relative merits of English and French hotels.

☙❧☙❧

To the Editor of *The Spectator*
October 22 1948

A Liberal's Point of View

Sir,—The last time I appeared on a political platform, I appeared as chairman of the South St. Pancras Liberal Association, thirty-five years ago unless I mistake. I am a Liberal still; but should I be asked at the next election to appear on a Conservative platform, I should not refuse. I should appear as a Liberal, and I should make my position clear; I should explain that, in my opinion, it is the duty of all thoughtful men and women, be they Liberal, Conservative or, for that matter, Labour, to do what they can to change the Government; I should add that I do not see how that can be done, in existing circumstances, under the present, unfair, electoral system except by voting Conservative.

The Government must be changed if we are to stand a chance of averting disaster. "Disaster," I know, is a word freely used by politicians and publicists who rarely trouble to explain what they mean by it. May I explain what I mean? We are spending more

than we earn; that is agreed. The gap between spending and earning is bridged by American charity. American charity will come to an end. What, if things go on as they are, if our domestic policy remains unchanged, happens then? An equal, or probably a greater, number of people—the inhabitants of this island—will have less to consume; there will be less food, less tobacco, less paper, fewer clothes, fewer films for everyone. The standard of living will fall. There will be less raw material; consequently there will be unemployment. Also, since there will be even fewer goods pursued by an equal quantity of paper money—the Government opposes stringent deflation—the value of money will fall, and the British man or woman, be he or she wage earner, pensioner, stock or savings-certificate holder, may wake up any morning to find that his or her pound-note will not buy a box of matches.

That is what I call "disaster." On the final consequences I need not speculate. Only I will point out that disaster of this sort can easily lead to civil war or something like it. When townspeople are hungry because they have no money or because the money in their pockets will not buy food, they may collect in bands and go out to the country to seize what eatables they can find. The countrymen may resist. That, it seems to me, is as like civil war as makes no difference.

How might disaster be averted? By reducing expenditure and encouraging production. How can expenditure be reduced? By cutting subsidies, by stopping temporarily all public works, by decreasing the number of civil servants and curbing the extravagance of those that remain. How can production be increased? By offering producers the only proven incentives—profit and liberty. You can induce a man to produce more by allowing him to take and keep as much as he can earn, and by giving him liberty to enjoy as he pleases the fruits of his labour—to buy uncommon luxuries, to own his own house, to travel, to found a family, to make himself what he is pleased to consider better than his neighbours. The more intelligent members of the Government know all this. The less intelligent cannot follow the argument. (And it must be confessed that an additional reason for getting rid of the present administration is that it contains an unreasonably high proportion of people who are not intelligent.) But, clever or stupid, Ministers cannot do what some of them know ought to be done because they are bound by dogma. To reduce expenditure and encourage production in the only ways that are likely to be effective is contrary to Socialist doctrine. And the men and women who govern us are doctrinaire Socialists, not only before they are citizens, but, it would seem, before they are human beings.

That is why thoughtful men and women, irrespective of party, must try to turn the Government out. But, since I began as a Liberal, may I as a Liberal end with a word of party politics. If at the next election we vote for Conservatives, as I think we should, is it too much to hope that the Conservatives, if they come into power, will devise some electoral scheme under which Liberal opinion shall be fairly represented?

Yours faithfully, Clive Bell

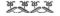

To the Editor of *The Times*
September 7 1950

Art Students' Privilege. Copies That May Be Masterpieces

Sir,—Is it not recognized, by all lovers of art, that to offer facilities for copying masterpieces, not to students only but to painters of all ages, is an essential part of the duties of a national collection?

Yours faithfully, Clive Bell
Travellers Club, Pall Mall, S. W. 1

To the Editor of *The Times*
September 8 1951

Students and the National Gallery

Sir,—It is just a year since you wound up a controversy concerning the rights of students to copy in the National Gallery with an admirable leading article. "Perhaps the director and the trustees will reconsider the matter" were your final words. For anything I know the director and trustees have thought of nothing else ever since. What I do know is—nothing has been done.

Yours faithfully, Clive Bell
Charleston, Firle, Sussex

To the Editor of *The New Statesman and Nation*
April 19 1952

Sir,—Mr. Aneurin Bevan is sometimes described as the Lloyd George of the Labour Party, and there are Liberals who believe that he will do for that party what Lloyd George did for mine. May I suggest that possibly he will turn out to be, not the Lloyd George, but the [Stanley] Baldwin of Socialism?

As in the Thirties, so to-day the prime object of all parties should be to preserve peace. How is it to be done?

There are those who say that probably it cannot be done; but that if it can be done it will be done by not arming at all. Anyhow, they argue, war, if it comes, will be a war of atomic bombs and bacteria, and we can rely on the Americans and Russians to drop enough to destroy everyone, themselves and ourselves included. Let us spend such money as we have on pleasanter things and leave it to our rich neighbours to pay for the means of their and our destruction. That makes sense.

There is another argument that makes sense. The only thing that really matters is to prevent war. Only the Russians will let war loose, and they will not do so unless they feel pretty sure they will win. Let us arm to the teeth so that they cannot feel sure. To prevent war is worth any sacrifice—I underline the word "any." That too makes sense.

What makes nonsense is to do as Mr. Baldwin did—arm partially. That is asking for trouble, and making sure you cannot meet it when it comes. And that, so far as I can make out, is the policy of Mr. Aneurin Bevan.

Clive Bell

To the Editor of *The Times*
November 20 1954

Henri Matisse

Sir,—May I correct some of the mistakes made in your obituary notice of Henri Matisse?

(1) Matisse was never a member of the Communist Party.

(2) Dufy was not a fellow-student in Gustave Moreau's studio. He was 10 years younger than Matisse. Rouault, Marquet, and

Simon Bussy were the fellow students who became his most inti-
mate friends.

(3) Matisse did not marry at the age of 24; he married at the
age of 28.

(4) It is a wise child that knows its own great-grandfather, but
there is no evidence whatever for supposing that Matisse had a
drop of Jewish blood in his veins.

(5) Matisse was not a Norman but a Picard.

Yours faithfully, Clive Bell

6

Francophile

Clive Bell's love for all things French was often a source of irritation to the British arts establishment. In an epistolary battle with Wyndham Lewis, Bell once wrote that 'at any given moment the best painter in England is unlikely to be better than a first-rate man in the French second-class', a sentiment unlikely to win over even the most tolerant of his critics. His wide circle of friends in France, first in Paris, and later in the south, included not only the painters who were also friends with Vanessa Bell, Duncan Grant and Roger Fry, but writers such as Georges Duhamel and Georges Gabory. Among his closest French friends were Jean Cocteau, who introduced Bell to his own circle, including the musicians known as Les Six, and the painter André Derain. Bell certainly considered Picasso a friend and treated him as such, but always with the understanding that the artist lived within a milieu he could never completely penetrate.

Both of Clive and Vanessa's sons studied in Paris with a private tutor, Henri Pinault, and before he went up to Cambridge Julian had the benefit of introductions to his father's friends, among whom one of the closest was Matisse's son-in-law, the writer Georges Duthuit. Clive was at home in France but never made a home there, as Vanessa did at La Bergère in Cassis. At the end of his life, Clive and his companion Barbara Bagenal regularly joined the many English expatriates on the Côte d'Azur amongst other prominent figures such as Winston Churchill, W. Somerset Maugham and Graham Sutherland.

To Mary Hutchinson
November 1 1919 19 rue d'Anjou, Paris

Darling, my legs have almost given way, and I have turned into the
pretty little café Voltaire opposite the Odéon to rest them and drink
a glass of vermouth – so you perceive that a letter can be nothing
but a parergon. This is a Sunday – la fête des morts – the shops
all shut, and all the little parisiennes trotting about in their black
frocks – I won't deny, however, that in their very short skirts – that
they know how to make not ridiculous – and their long bottines,
with just a little gap of stocking showing between the two, I find
them extremely seductive. All's one for that – I have my accounts to
render. The first thing I did was to walk – I couldn't deny myself the
pleasure of walking through the streets of Paris even though all the
shops were shut – towards the gare du Nord; it was not till I was
almost there that I took a cab; and then I took a porter and went to
the "consigne", where, as was to be expected, I found one douanier
pretending with a very ill grace to deal with a score of victims. It was
done at last and I took my kit-bag to my nasty hotel, paid off my
'taxi', and walked through the Tuileries garden and over the river
to the Quai Voltaire. The hotel seemed to me more sympathetic
than ever; the ladies in charge (one of whom is young and distinctly
pretty) most affable; and they have almost – almost but not quite –
promised me a very attractive room for Monday. Unless you hear
from me, therefore, I would ask you to address your letters to 19 rue
d'Anjou (VIIIeme) but after Monday I hope my address will be Hotel
Voltaire, Quai Voltaire. By the time I left the hotel the east wind was
beginning to howl and a few flakes of snowy hail were falling, and it
was then, had I been wise, that I should have gone back to my hotel
and put on my fur coat. Instead I went to lunch early, and then to
the salon d'automne. There I arrived so early that for some time I
had the vast palais almost to myself. But the cold Bear in mind
that this great over-grown conservatory is unheated, that the glass
roof has not been entirely repaired since the bombs and schrapnel
[sic] and that in some rooms a miserable piece of white sail-cloth
flapping in the wind was one's sole protection. My impression of
the show is good – a fine panel of five Friesz (one immense), six
Matisses, 3 Bonnards, Lhotes, a curious Marchand, Flandrin, Mon-
dzain, Van Dongen (one picture at least interesting) (some young but
I've already lost my catalogue) but it was quite impossible really to
look at anything – one had to keep moving – the cold, the cold! Of
course I ran into Rose Vildrac, who has some official position in the
show, and consequently a partially warmed little room to herself.

To my shame I didn't recognise her: she recognised me. Then came Vildrac. But I didn't see the exquisite flapper (according to Roger) – their daughter. However, I am to suggest a day to dine with them en famille – a day next week. Before I left, the place was packed and there was about half a mile of motors outside. The coup de foudre is not yet: I saw no femme fatale: but the parisiennes are as nice to look at as ever. The only two things here that are thoroughly unsatisfactory are the weather and the lack of small change; and they may both ameliorate. At present I notice no fundamental change; but today having been a Sunday has perhaps made it difficult to judge. If insecurity is in the air I don't notice it: for that matter Paris always has the air of being slightly insecure. When I see these people going about their business I'm often inclined to say "e pur si muove" [*and yet it moves*] – or words to that effect: yet somehow it does move to a better tune than anything else in the world. But I have got to go and dine with [James W.] Morrice and the amis du quartier: I'm late already and I've scribbled a makeshift of a letter. Shall I ever have time to write better?

Clive

To Vanessa Bell
[November 1919] Hôtel Voltaire, Paris

A thousand thanks for your splendid long letter to which I will shortly make a suitable reply. I dined with Picasso on Sunday and he seemed uneasy about Parade.[1] As soon as your letter arrived I dashed across to the rue La Boëtie, but he was out. However, I met Madame on the stairs and gave her the good news, & on Friday I lunch with them to meet Cocteau & Satie, when I shall translate your letter in full. I think I can promise you a most friendly reception from all the best artists here – Picasso, Derain, Matisse (?), Friesz, Marchand, Vlaminck, Goncharova, Bracque, Marquet, etc. They are curious about Duncan from my accounts and very well disposed towards the English. At the moment it is impossible to find rooms or servants – the refugees from the north have not yet gone back. They say it will soon get better. Considering the rate of exchange, I think the cost of living is, if anything, less high here. I am very sorry about Julian.

CB

Note

1. Ballet composed by Erik Satie for the Ballets Russes, with scenario by Jean Cocteau and sets and costumes by Picasso.

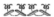

To Mary Hutchinson
November 16 1919 Hôtel Voltaire

Darling, yesterday's weather really surpassed by too much all that is permissible in the matter of weather. From midday Friday it continued to snow, and to snow ferociously. On Saturday morning not only was the snow still battling down from a lump of cold and dirty lead that did duty for the sky, the whole city was covered to a depth of from six to nine inches. They manage these things better in London. The traffic began to circulate miserably, horses falling about in every direction, the pistons began to struggle to their work, and before long the six to nine inches of snow was reduced to six to nine inches of brown adhesive freezing mixture. The only attempts made to clear the streets were made by those individuals who had the courage to push the setting mass away from their own doors and towards someone else's – thus increasing the general horror. And all the time it was battling down and the wind howling in every direction. My first instinct was to stay at home and write about Courbet, although I was engaged to lunch with [Léopold] Zborowski and his friends. I felt, however, that that would be a tame poor-spirited way of taking life; and, furthermore, your letter of the preceding day had put me in a great need of cheerful company. So I pushed out into it, hoping for a 'taxi' that never appeared of course: and in the end I was glad. All Zborowski's party turned up – Z – [Moïse] Kisling – [Othon] Friesz – Charles Guèrin – & a young good-looking French painter whose name I did not catch, also a 'bourgeois intelligent'. I cannot much admire the work of Kisling, though, as you know, it is much admired. It seems to me vulgar and tolerably banal. But Kisling himself is an amusing figure. He is the old rapier modernized, having modelled himself I surmise on what Picasso was. He is powerfully built and powerful looking; he has a good, broad, unrefined head. He looks humorous, merry and determined, and dresses un peu en boxeur with a light suit and a check cap. He is a great drinker, womanizer, and something I believe of a duellist. He took a fancy to me and asked me to join an immense déjeuner he is giving today in

his studio to some twenty painters. That is where I am going in a moment. Derain is to be of the party, and it was suggested that I should pick him up on the way – to make sure of getting him out of bed. I perceive that I am regarded as Derain's particular friend, which is very flattering. After lunch I went on with Friesz to his studio and had a look at what he was doing. He is small and literary-looking, infinitely refined, and ever so little pompous: he is not so good a fellow as [André Dunoyer] de Segonzac but he is extremely good in his own deliberate and slightly elaborate way. He invited me to dinner on Wednesday. There is a romance in his life. The last time that I saw him – in 1913 I fancy – he must now be forty-one or forty-two – he was just back from Germany whither he had fled with a girl of nineteen – a distant relation I believe – two or three hours after her marriage. One divines the history. She afterwards became extremely mondaine and is said to have given him a good deal of pain, and to put the finishing touch to her cruelties is now gravely poitrinaire [*consumptive*] and has to live on the top of a mountain in Switzerland whither Friesz is going in a few weeks. I got back here at about five o'clock and wrote my note on L'Atelier de Courbet; then at half-past seven (by this time the snow had more or less stopped) Copeau called for me and I took him to dine at Laperouse. One of the pleasantest habits of the best French restaurants nowadays is to give one a hot brick to put one's feet on the moment one takes one's place at table. It made all the difference last night. We had a very good dinner and a very good talk – mostly round and about books. Also, Copeau told me how when he was in Switzerland with his company a mysterious lady had written begging him to go and see her. At first he paid no attention; ultimately he went. After a certain amount of commonplace conversation, the lady told him how she had for years adored the most remarkable man in the world, how the only thing she had ever greatly desired was to have a child by him, how she had failed, and how her life was now at an end. The most remarkable man in the world was Roger; the lady Mlle. Savary.[1] We went to the Deux Magots and drank some grog, and fell in with the brother of Remy de Gourmont, in whose black books was Copeau for having refused a play by the illustrious dead, a writer about whom I was glad to find that Copeau shared my unfavourable opinion, and so home by midnight. This morning the sun is shining and I am off to my déjeuner chez Kisling.

<u>Monday</u> Yesterday was the sort of day that English people would expect one to spend in Paris. Kisling's feast was very fine – in the old style – a vague row of tables, put together anyhow with

rather few knives and forks, masses of food, and oceans of drink. I found myself placed next Alys Derain with Derain not far away, on the other side of me was the très jolie, très slim, très long-booted Mde André Salmon – a bit too silly for my liking. I don't know the names of most of the guests. The numbers were about equal and some of the ladies were very much the thing for a studio. The young man Krog [Per Krogh] who paints such bad pictures was one of the nicest and one of the nicest looking people in the room: also he plays the accordion. I think you would admire Mde. Kisling. She dresses and cuts her hair in the bunny style. She has one of those remarkable woolf-like French heads with a large nose and immense eyes – at once virile and soft. But Derain was the hero of the party: he is treated with tremendous respect. He ate, drank, talked, sang, made speeches (it was polling day), disguised himself as an idol with an immense roll of canvas as his phallic emblem and white wine dripping from it – before which we all bowed down and worshipped – played melancholy Wagnerian strains on the concertina, and gave two or three remarkable pas seuls. A good many people dressed up and Kisling painted himself rather brilliantly in the manner of Derain. As the afternoon wore on and no lights were lighted and dancing continued and liqueurs were still drunk a certain affection-ateness began to manifest itself. So far as I was concerned it confined itself to a frequently interrupted conversation – for I refused to dance – with a young French lady with very red lips who had been at the déjeuner but whose name I failed to catch, and who in the penumbra of a pardonable error once or twice drew her bare arm across my mouth – which reminded me of old days. She then pressed me to go to a certain party next Thursday where she would certainly be – and where I shall not go. She got no more from me than a warm pressure of the hand on parting; but, as I said, I was grateful to her for recalling old times. So far as I saw there were no very serious embrassades even during the langours and antics of the dances which were, however, performed in the richest apache style. I wonder what you would have thought of it. I came home just in time to clean myself and take a taxi to 23 rue la Boëtie. More or less by accident we went to dine in one of those typical Montmartre restaurants where one has a shocking bad meal and miserable wine but sees the life which so shocks and fascinates Mr. Arnold Bennett. Masses of whores, bad champagne popping partout, very few American officers, feathers, confetti and celluloid balls pelting in every direction: a raucous band playing and couples dancing every-where between the tables and down the alleys. Madame Picasso – la belle Olga – and she was looking very pretty – naturally attracted

a good deal of attention and before long several handsome young gentlemen were pelting her with balls and feathers. Both Picasso & I were amused by it all. It was so long since either of us had been there. We decided that you must be taken one Sunday night. And we went on to the bal Tabarin where they still dance their 'quadrilles réalistes'. As we walked down the mountain it began to snow; I went in and had a cup of tea in the rue la Boëtie; talked art a while; and came home through a blinding snowstorm at half past two. This morning the weather looks better and I must go off to Rosenberg immediately.

Clive

Note

1. Madeleine Savary had been governess to Fry's two children.

To Vanessa Bell
November 20 1919 Paris

D. D. tomorrow I lunch with Picasso, to meet Cocteau & Satie, and I shall take the opportunity of reading your letter [about *Parade*], translated bien entendu. You make me eager to see it, and I like your account immensely. Mary seems to think that the stalls were inclined to be superior, but that the students (as she calls the upper gallery) carried all before them – tant mieux. I haven't yet seen Matisse, but I suppose I shall see him if he hasn't gone straight to Africa. I think I must have seen everyone else. I seem to see most of Derain & his Alys (a femme du peuple such as one finds here sometimes, infinitely distinguished, intelligent, formidable, enigmatic, beautiful). Some people would say that she was like you – but she isn't. That long parenthesis has upset me – I continue – I seem to see most of Derain & Mde. Derain, les Picasso, Friesz (who is married to a charming woman, they say, & has a charming child – but both are in the country at present), Marchand, the Vildracs, Copeau. The activity & excitement of the painters here is unheard of: there seems to be no end of pictures & picture-dealers. It all impresses me a good deal – even their passions and jealousies – I imagine Florence in the fifteenth century must have been something like it. It has rained or snowed – sometimes both – almost every day since I've been here, and for all that I've never once been bored or

depressed. With children, however, I suspect it might be a little difficult at this moment. There are, apparently, no servants, little milk, and less coal. All that is sure to right itself; indeed I have noticed an improvement since I arrived. I strongly recommend you & Duncan to come for a bit in the spring and look about you. Even the things the painters say often surprise me. I perceive they all like & rather admire Roger but laugh at him. They consider him doctrinaire in his views; very few of them seem to realise that he makes pictures himself. I don't press the point. If I were a painter I should certainly live here. For the children, the difficulty is French. In French it is quite clear to me, that any child can get, at a very moderate price, an education far superior to anything I had. And apparently they have the knack here of making the creatures learn. The children seem really to understand things. Only, the education is given in French. Shall I consult my translator, M. Renoir, who is a professor au Lycée? As for me, I don't know that it would be possible to write here. The writers I meet are certainly not encouraging. I fancy if one is going to write in English one had better live in England. But I might, by some arrangement have a truckle bed chez vous at Paris. I should be very willing to spend two or three months in every year here. However, I suppose I ought not to judge too much by the present; so far as that goes there can be no doubt that I am rather a success.

I'm afraid the children are giving you a very bad time. By this, at any rate, they should have recovered their health – unless Quentin has caught the disease from Julian. I presume you will pack them off to Seend the moment the holidays begin. Evidently, they were a great success there. Mary talks of coming to Paris, but I don't know whether she will succeed. She seems pretty low, & if her Paris scheme falls through it will be the last straw I fancy. I hope you & Duncan will be kind to her – you can be so easily because she has a great admiration for you both. Please don't repeat this last sentence. Which makes me think of Virginia: is 'Night & Day' having an adequate success? I see no English papers except 'The Athenaeum'. Last Sunday I went to an immense drunk in Kisling's studio – he is a bad artist but an extremely genial barbarian – about 20 painters and 10 writers. A pic-nic déjeuner, boundless drinks; attractive women, music, dancing, fading day, evening, no lights!!!!! Derain was the life & soul of the party.

CB

P. S. Today I read your letter to Picasso, and to Satie and Cocteau (his collaborators). It had an immense success; & Picasso showed

himself a good deal touched. You were quite right: he did paint it
[the drop-curtain] himself.
CB

To Virginia Woolf
Sunday November 23 1919 Hôtel Voltaire, Paris

My dear Virginia,
 since neither my eloquent post-cards nor your own interests are
strong enough to induce you to send me (at my own expense too!) a
few copies of 'The Snail' of 'Kew Gardens' for the French amateurs,
I suppose I must write a letter. But you wouldn't have got it, let me
tell you, if last night I hadn't fallen into a sweating fever, dream't of
the devil, woken in a fright, gone to sleep again, dream't of the back-
sides of beautiful young ladies, woken worse off than ever, given it
up as a bad job, taken my temperature, and decided that I had <u>la
grippe</u>. Well, I haven't got the grippe; but I've had a shocking bad
cold & cough which I'm in a fair way to curing by having stayed
in my room all day, with a little soup and next to no tobacco and
Casanova and correspondence. No wonder I've given way at last,
running about Paris for a month and every day it raining or snowing –
often both. But it was my French translator – and to translators all
things are pardoned – who finished me off. He invited me to dinner
on Saturday and, being a professor, had, of course, a wife and three
children and no fire. And that reminds me, talking about translators
and doing my best to vex you, my Dutch translator has been here to
see me, and my Italian, while poor Herr Westheim has to stay where
he is. My life here is fantastic: a round of lunches and dinners with
pictures in between. I shall soon have lunched or dined with every
painter in Paris. Seriously, I think the present state of painting in
France extraordinary. (1) Renoir, Matisse, Picasso, Derain, Bonnard
(2) Maillol, Friesz, Vlaminck, Braque, Modigliani, Lhote, Marquet,
Puy, Marchand, Segonzac, Marie Laurencin, Gris, Leger, etc. etc.
all alive, and think of those who are only just dead. On the other
hand French literature nevertheless, I wish I saw more of the
writers. The 'Nouvelle Revue' crowd is really all I know person-
ally;[1] though the other day at lunch with Picasso I found myself next
to Cocteau and found him perfectly charming – and O so pretty!
Picasso, Derain, Copeau & Marchand are the people of whom I
seem to see most. I perceive that Claudel is coming my way, but I
fancy him pompous and boring. Jules Romain is still about the best

of the lot: he is amusing, and talks amusingly. Ottoline will soon be a recognized cult here, supported by Mrs. Stoop and Mrs. Colefax. Whenever Picasso and Derain want to have a laugh they recall her frantic ways, her indefatigable "chasse aux lions" and then Picasso describes his brief visit to Garsington, with Pipsy, and the live-stock, and Brettie and the pugs and "ce petit homme qui avait l'air d'un souteneur [*pimp*] et faisait les Cézannes." Sometimes I am called upon to give an account of her fall downstairs for which I have to draw largely on my invention. Mind Virginia, all this is for you and you alone. By the way, Vanessa sent me a splendid description of 'Parade'; and as the next day I was lunching with Picasso & Cocteau and Satie, his collaborators, I read it aloud, translating as I went, and it had an immense success. Really, I wish Dent could be given to understand that he is paid to write on music and not on the visual arts. To get R. W.'s imbecile impertinences on Matisse and then Dent on Picasso in the same number is rather too much. Well, Katharine on 'Night & Day': what about it?[2] And is she really dying? She's not very subtle poor thing, but she's damned clever. And I like cleverness. The young don't. 'Cause why? 'Cause they can't follow. I keep pestering the people I write to for news of 'Night & Day' – what do the reviewers say? What does the world think? Won't you tell me? Do you think the French could understand it? Shall I put Thibaudet on the track? – he pretends, at any rate, to understand Mallarmé, to say nothing of Shakespeare. I now perceive that I was not quite well enough to write a letter – not wide awake enough at all events. Too late. Still, send me some news, in return. I shall be here till the middle of next month.

Clive

Notes

1. Founded by a group including André Gide, Jacques Copeau and Jean Schlumberger in 1909, the *Nouvelle Revue Française* was edited from 1919–1925 by Jacques Rivière. The publishing house Gallimard was founded in 1911 as an offshoot of the journal. To his lasting regret, André Gide turned down Proust's *Swann's Way* when he offered it to the *NRF* in 1912.
2. Mansfield's review describing *Night and Day* as a traditional novel 'we had never thought to look upon . . . again' was published in *The Athenaeum*.

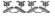

To Mary Hutchinson
November 28 1919 Hôtel Voltaire

Well, my little darling, are you happier? Your lover has nothing to amuse you with: for last night I dined with poor old [Roderic] O'Conor and took him to see Gertrude Stein's Picassos. I wish you could see that collection: it is really remarkable – almost a complete sequence. Both O'Conor & I were deeply impressed: the versatility and variety are of course amazing, and the taste, and the invention: and it is extraordinary how every time one notices that through all his evolutions, there is something solid and permanent that persists. One sees where a good deal of Derain comes from too, not that Derain is a bit the smaller artist for that. {I am off to see him the moment I have finished this note – him – not Madame Alys.} A man we were unjust to in London was Dufy. He has spent the best part of his life designing silk fabrics for the Lyons merchants. I have seen a certain number of his pictures lately – he has a charming talent. Do you know, I fancy there are no writers in France – how much that explains? Jules Romain is amusing, Cocteau is clever, [Georges] Duhamel is sentimental, Anatole France is almost a hundred, and Blaise Cendrars makes a great deal of noise. By the way, that Mr. Flint who has just published an anthology of French verse is here reckoned a mere imposter. Everyone, from Gide to Cocteau, agrees apparently that he knows nothing about French and nothing about literature, and that he is of a pretention and a vulgarity (in his choice) that is insupportable. Personally, I have seen only the cover of his book which, as [Guy-Pierre] Fauconnet said this morning, 'est un de ces choses drôles qui ne sont pas drôles' [*one of those funny things that aren't funny*]. My dear, Fauconnet is charming, and so good looking – and he made me a little declaration. Perhaps it is as well that you are not coming – on dit qu'il adore les femmes spirituelles [*they say he adores spiritual women*]. He was the inventor of the école martine. All the early things are by him. He showed me portfolios of his designs, amongst which I'm not sure that I didn't recognize your little speckled "silken dalliance". At any rate I couldn't resist giving him a picture of 'la femme la plus charmante en Angleterre' – 'la plus jolie de jolies laides', 'qui aime bien les choses de chez Poiret[1] et les porte exquisement'. Naturally he is eager to meet her. But first he is going to dine with the Picassos and me – one day next week. He seems to be on good terms with everyone, except Poiret, with whom he has quarrelled, but especially with the Picasso Cocteau set. I assume he is tolerably mondain. He reminds me slightly of Antoine Bibesco, only he is intelligent

looking, and obviously sensitive, and much less heavy. I had better confess that I grow more and more reactionary every day. I don't mean in matters of art – though there I grow more and more eclectic. For instance I have more sympathy with the young cubists than any of the French critics I believe. But I grow more reactionary in the sense that I get to care more and more for our grand European tradition – the tradition of Greece & Rome, of Florence, Cosimo de Medici, Elizabethan England, Louis XIV, Dryden, Voltaire et les honnêtes gens. I detest the lower classes, who can't understand and want to destroy. I think a few thousand people in London & Paris of more importance than all the babies in eastern Europe and their mothers and fathers to boot. I can only begin to take an interest in the barbarians when they are efficient slaves. A really accomplished garçon de café, such as we had waiting on us today chez Weber, is worth fifty thousand Bonar Laws[2] and fifty million discontented miners – an accomplished & contented miner – a useful slave that's to say – may be worth almost as much as my garçon de café. But by comparison with any one person who counts – an artist, a scholar, a sensitive amateur, an exquisitely civilized person of any sort – the whole lot of them signify precisely nothing. There! You know the worst. And I have a notion it is very much what you think. Only get your two months: we shall know what to do with them. Our feelings. What about yours? Mine will not change till you are grown so old that you cannot even 'make up'. And, then, perhaps, we shall find some tepid substitute to suit our miserable condition.

CB

Notes

1. Fashion designer Paul Poiret, whose clothes Mary wore 'exquisitely'.
2. Bonar Law at this time was Lord Privy Seal in Lloyd George's government.

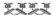

To Pablo Picasso
June 18 1920 46 Gordon Square

Mon cher Picasso,
 d'après ce que m'ont dit plusieurs amis j'ai l'impression que vous êtes un peu étonné, pour ne pas dire fâché, parce que je ne suis pas venu vous dire "au revoir" – surtout après cette merveilleuse lettre

que vous avez été assez charmant de m'écrire. Vous saviez bien, Picasso, que vous voir est pour moi une veritable joie. Sincèrement, je ferais la voyage de Londres à Paris pour passer quelques bonnes heures auprès de vous. Mais je sais que vous êtes obsedé d'importune et j'ai horriblement peur d'être de leur nombre. Et puis – chose que peut-être vous ignorez – c'est très délicat d'aller déranger Picasso le matin, ou l'après-midi, quand il peut être en train de travailler. Puisque je vous crois un grand – un très grand – artiste eh bien . . . faire une visite pendant la journée à un grand artiste n'est pas autre chose que de supposer qu'une heure de ma bavardage vaut bien une heure de son travail. Vous ne vous figurez pas combien cette idée m'intimide. Et c'est précisément cette idée-la. Avec Derain, par exemple, tout va bien: s'il vient au café prendre l'apperitif [*sic*] et causer c'est que le moment est propice et qu'il le veut bien. Mais monter chez quelqu'un qui peut être entrain de faire des choses importantes – avouez que c'est fort. Plus d'une fois je suis venue jusqu'au pied de votre escalier quand subitement j'ai été défourmé par cette idée: je me rendais compte de l'impertinence de l'échange que je me proposais: une heure de ma compagnie contre une heure de votre travail. Mettez la chose au plus bas et au plus pratique, cinq cent francs C'est payer un peu chire le plaisir de ma conversation. Vous devez avoir les jours et les heures de reception, comme une belle dame, je saurais en profiter; ou bien m'indiquer franchement le moment où je ne serais pas de trop. En attendant, si vous avez imaginé pour un instant que vous voir n'était pas pour moi un très grand plaisir – mais véritablement un grand plaisir – je vous affirme, mon cher Picasso, que vous êtes bien moins sensible que vos tableaux vous proclament.

Ever yours affectionately, Clive Bell
Picasso

[*My dear Picasso,*
From what several friends have told me, I have the impression that you were a little surprised, not to say angry, that I didn't come and say goodbye – especially after that marvelous letter you were so charming to write me. You know well, Picasso, that seeing you is a true joy for me. Speaking sincerely, I would gladly make the trip from London to Paris to spend a few hours with you. But I know you are beset by people importuning you and I would hate to be one of them. And then – a thing you perhaps

*ignore – it is difficult to disturb Picasso in the morning, or the
afternoon, when he might be working. Since I believe you are a
great – a very great – artist well . . . to visit a great artist
during the day is nothing more than to suppose that an hour of
my chatter is worth an hour of his work. You've no idea how such
an idea intimidates me. It's exactly that which stops me. With
Derain, for example, everything is easy: if he comes to the café
for a drink and conversation it's because the time suits him and
he wants it. But to climb up to see someone who might be in the
middle of making something important – you must admit that's
serious. More than once I've come to the bottom of your staircase
only to be suddenly overcome by that idea: I'd become aware of
the impertinence of the exchange I was proposing: an hour of my
company for an hour of your work. At the lowest, most practical
level, five hundred francs That is paying rather dearly for the
pleasure of my conversation. You should have days and hours to
receive people, like a beautiful woman, then I could take advan-
tage of that; or tell me frankly when my presence wouldn't be an
intrusion. In the meantime, if you imagine for an instant that see-
ing you is not a great pleasure for me – truly a great pleasure – I
have to tell you, my dear Picasso, that you are less sensitive than
your paintings declare.]*

To Vanessa Bell
Saturday night [October 25 1920]

D. D.
I shan't send off this note till I know for certain the name of the
hôtel, but I see that your destination is Cassis. All the painters
believe in it – absolutely sheltered – in a narrow valley running
down to the sea – and a hotel where they make special terms for
artists who wish to stay a certain time. Everyone speaks well of
this hotel but noone can recall its name, however three or four
people have promised to let me know it tomorrow or the next
day {Perhaps I'll let this go and send the name on a post-card}.
And you ought to look sharp, they say – already it's difficult to
find a lodging for the winter in the midi. I've seen a certain num-
ber of people – the Picassos (with whom I found that Spanish
painter who came to 46 once): on the whole I like Picasso better
than anyone here, except, perhaps, half a dozen others. It's said
that Mde Olga's going to have a baby, but I wasn't on the look

out when I went there and so can be sure of nothing. It's said also that [Tamara] Karsavina may have to have her leg cut off but I suspect that's a lie. M. Diaghileff & his troupe are about to tour the English provinces, but I daresay you knew that. I have seen the Matisse exhibition which is most disappointing – one or two lovely things and many that are pretty – a few that are downright insensitive and common. I have glanced at the salon d'automne, where I fell in with Bonnard, I purposely left the Renoirs for another day – only just glancing at them. There is nothing very thrilling – even the vulgarity of Van Dongen becomes normal at last – he makes one see how entertaining Sargeant [sic] might have been had he been a European. I like Roger's picture extremely. It is far the best thing he has ever done, in my judgment. It hangs beside two or three pictures by Girieud and very much more than holds its own. I saw Rose Vildrac for a moment today, but not for long enough to get any gossip about her holiday party – except that she enjoyed it very much. I think Charles may be less discreet. I have seen Marchand and Bernouard: Derain is away for a day or two in his "auto." I am just going to dine with [Edmond] Renoir. The beauty of Paris is unheard of; also, the pleasantness. They have a much more settled and comfortable air than we have. They are much more like what they were before the war. I notice an immense change for the better since June. On my way to Picasso's yesterday I met within the space of twenty yards no less than two Rosenbergs[1] – one seldom has such luck as that. In Bernheim's window is the Renoir of fish on a plate that Maynard didn't buy; I can't help thinking he was wrong – it is an extraordinarily fine thing. By the way, today at lunch I read an article in Le Matin mostly about Maynard – perfectly polite though dissentient. I don't see what he has to complain of: besides I see no reason to suppose that the French are all wrong. They are doing Cosi fan tutte at the Opera Comique and I shall go to hear it. Need I say that I travelled out with Lady Colefax?

CB
P. S. Is the strike bothering you? Are they going to settle it?

Note

1. The brothers Paul and Léonce Rosenberg both were art dealers.

To Mary Hutchinson
October 29 1920 Hôtel Voltaire, Paris

Darling, write again to your lover, another charming letter to match
the last. I am well, or almost so, up very much and about, and
before making any more plans I want to know yours. The shoes
are being sent off this afternoon by avion – they are addressed
to Vanessa – if you are in no hurry I should like to present them
myself – I hope they will fit. What then? I had [Thomas Wade]
Earp and Bernouard to lunch yesterday and afterwards we went
to the Vildracs – later to Earp's bank for money – and then to see
Copeau and take tickets for the Vieux Colombier, where we go
together next week. I told you, I think, that I had told him that
I did not much want to meet Nancy Cunard, and that when he
seemed hurt and inclined to expect a reason, I had offered that, as
she was very great friends with several people who did not much
like me, I thought that she might find my acquaintance gênant
[*embarrassing*]. Well, I don't know whether he repeated any part
of this extremely discreet conversation, but he came back to say
that Nancy Cunard would particularly like to see me & that she
had always regretted not knowing me better and that she imag-
ined I avoided her. All this is entre nous of course, but is it once
again Jack? As, in fact, I don't feel particularly drawn towards her,
all I could do was to suggest that she should join our party next
Tuesday (when I dine with Earp and go to the Vieux Colombier,
which, as she cares only for dancing, it is improbable that she will
wish to do) and let it go at that. But all this is curious. You may
depend upon me for making no scenes: all the same, if I find that
Jack has been up to his usual tricks I shall be horribly tempted
to show him up. In the evening the Picassos dined with me, chez
LaPerouse – very charming – yes she is enceinte [*pregnant*]. Picasso
drew me on one side and told me about it; and afterwards, walk-
ing home under the moon, we all talked about it. She is horribly
frightened and lonely and depressed: I wish you were here – so
do they. Picasso, too, is strangely isolated and solitary. He talked
to me about art and his art with a seriousness, a bitterness, and
a lack of reticence, which he has never shown to me before; and
when we parted he embraced me – I don't mean kissed but hugged.
He is conscious of being horribly alone. They both talked about
you with great affection. However, Lady Colefax had been to
cheer them up. She had also invited Cocteau to lunch, and he had
forgotten all about it – elle le merite bien [*she deserves it*]. This
morning I hurried off to see Cocteau, whom I found shaving, and

se maquillant [*applying makeup*] in the best and most traditional style. I told him about Picasso – you know that they have been at odds for some time – and he appeared to be a good deal upset. He said he was going off to see them this afternoon – c'était son droit puisqu'il était témoin de leur mariage [*it was his right since he was witness to their marriage*] – but God knows how Picasso will receive him. I like Cocteau; & I think him very good looking. Mlle Germaine Tailleferre is in London: You ought to be nice to her don't you think? This afternoon I have a thousand letters to write.

Clive

To Mary Hutchinson
May 7 1921 Hôtel Voltaire, Paris

Amie, I lunched today with Leslie [Jowitt] – Madame [?Kohhan-ski] and Charles [?Symenaski] made up the party – chez Lapérouse; she is a good girl, but silly, very silly – and stupid. She tells me that your motoring tour is abandoned and that you will be in Paris – les deux mondes, avenue de l'opera – on Wednesday. I shall keep Thursday and Friday free as long as I can – but you know I am recherché – and now the beau monde begins to invite me – but there I am adamant – I even declined the pleasure of being in the same ball-room with M. Millerand [President of France] last night. Tâche d'être libre jeudi ou ven-dredi pour déjeuner [*try to be free for lunch Thursday or Friday*], chez Lapérouse, 12.30. Yesterday morning I went to see Segon-zac's pictures and then Segon himself. I found him getting up in one room while a young lady was getting herself up in another. Naturally I only stayed long enough to drink a glass of Porto and allow madame to finish her toilette, and then slipped away in time to spare her blushes. We are going to arrange a dinner for next week. In the afternoon I went to the Ingres vernissage – an immense crowd and so far as I could see a thoroughly interesting show. I shall go and look at the pictures next week. Tout Paris was there, and most conspicuous in the thick of it, Jean Cocteau. I went off alone with [Georges] Auric, whom I like. Tonight I dine with the whole band[1] – Saturday – and afterwards I believe we are going to hear some nigger music,[2] and afterwards I fancy chez Madame de Polignac or some such lady – at least Cocteau has issued the mot d'ordre "en smoking", which is a bore. At the

deux magots there was rather a good aperitif – Derain, Segonzac, Durenne and his wife, [Adolphe] Basler and of course Bernouard, and two or three more. At eight o'clock Derain jumped up and said he must have a taxi as he was dining with [Ambroise] Vollard – and [André] Salmon was going too, "and you must come with me, said he, and find fault with the Cézannes". Nothing I should have liked better – but really one can't do these things – one isn't Bernouard. Besides, Vollard is such an odd tempered old fellow, and it's years since I saw him. Derain insisted: "if he shows the least sign of bad temper I shall take you out to dine with me on the boulevards". But really one can't do such things: I might have spoilt the whole evening. Derain went away rather cross I'm afraid. I went to dine with Bernouard chez Michaud and he fell in with Darius Milhaud. When he had gone, Bernouard, who was by this time very drunk, said – il y a un critique anglais dans la chambre à côté – un sale type – qui parle tout le temps dans un français de l'anglais de l'opéra bouffe de ses livres et de leur valeur, je vais l'inviter de boire une petite verre – toute réflexions faite, il doit être americain.[3] So he staggered out officiously and came back with two of the most deplorable specimens of our species that I ever saw. And who do you think the critique anglais qui devait être americain was? Bernouard did not know. But the creature immediately thrust an immense card under my nose and on it was the name of your favourite author – James Joyce. His companion, who happily spoke not one word of French, was called [Robert] McAlmon, edits a paper called Contact (a copy of which was also thrust immediately into my hand – you shall have it) and gives himself out as the most intimate friend of the well-known American poet – T. S. Eliot. God, what a couple. Joyce did not seem stupid, but pretentious, underbred and provincial beyond words: and what an accent. McAlmon is an American. They both think nobly of themselves, well of Ezra Pound and poorly of Wyndham Lewis. They feel themselves, as writers, nearest to Swift and Rabelais: though how Mr. McAlmon became aware of this kinship I don't quite know. I talked a little in English with Mr. Mac, while Bernouard broke in drunkenly on Joyce's incessant monologue of self-appreciation. He is, I should say, exactly what a modern genius ought to be – something between an American traveller in flash jewellery and a teacher in a Glasgow [sic] socialist Sunday-school. I'm sure you would like him. But don't ask me to bring about the meeting: Bernouard will manage that – or Earp – but no – they would think Earp intellectually beneath them: and they would be right.

Toute réflexion faite, I prefer them to the eiffel-towerists.[4] But I
am making myself disagreeable, so I shan't go on.

CB

Notes

1. The composer Georges Auric was one of Les Six, the musicians associated with Cocteau and Satie.
2. The racist term Clive Bell also used in his 1921 article 'Plus de Jazz' (see Hussey 233–237).
3. [*there's an English critic in the next room – a dirty type – who speaks continually in the French of an English opera bouffe about his books and their value, I'm going to invite him over for a drink – all things being equal, he must be American*].
4. The coterie around Nancy Cunard, who frequented the Eiffel Tower restaurant in London.

To Mary Hutchinson Hôtel Voltaire
May 12 1922

Darling, I was extremely glad to get your little telegram, as your
last letter disquieted me all day – too ill to eat an ice, gone back
to bed – what has been the matter with you all? Vanessa has been
lying speechless at 46 for three days, and was only just up when she
wrote to me, Virginia had a temperature of a 102 and was going to
be bled. What plague is this that has befallen the beauties? And you
have missed the one week of glorious weather; that is, if things are
with you as they are with us – it has begun to rain again, which I
don't much mind, it has turned cold, which is damnable. I wrote on
Wednesday; what have I done since then? Well I have seen all Derain's winter work which simply takes away my breath – especially
a series of large drawings which seem to me just about as good as
drawings can be. Before I went away I had the nearest approach
to a scene of emotion that I certainly, and perhaps any <u>man</u>,
is?am? likely to have with Derain. He tried to explain what
he wanted to do, said that since the war he had felt, as an artist,
very lonely because he thought noone else was after the same thing,
that his painting had ceased to be "modern" and that when he saw
his pictures so utterly unlike those of his contemporaries whom he
most admired, he couldn't help mistrusting himself and wondering

whether his work wasn't all nonsense; that it was the enthusiasm of a few people, of whom I was one, that had continued to give him confidence in himself, and that now he couldn't help believing that his art had un certain valeur, and that he had never seen so clearly or felt so happy in his life. Talking of Derain's happiness, I have a notion that his relations with Alice are as usual slightly agitated; and that probably was why he asked Satie and me to dine with them à la maison that night – the first of her return from the country where she is sitting to d'Espiaux [i.e. Charles Despiau] for a bust. It was a charming evening with a good deal of rather serious conversation about art – French sculpture (Derain has a fine XIIIeme century head and a madonna) etc. At one moment we were talking about credit, and I was amused to hear Derain say "Je pense que Keynes peut expliquer tout ça" [*I think Keynes could explain all that*]. Satie is a witty old fellow, and very amiable: I wish I could understand his music better. Yesterday I had meant to spend the day at St. Cloud, but already the wind was turning nasty so I went sight-seeing and lunched chez Gauclair, when I was almost overtaken by that most treacherous of wines – le rose d'Anjou. In the afternoon came your telegram, and I was just sitting down to write to you when Kisling called and carried me off for a long palaver in a bistrot de luxe on the rive droite. He was full of amusing gossip about the [Sidney] Schiff-Lewis visit – did you know that [Wyndham] Lewis had persuaded a Polish Jew named Waldemar George to write a denunciation of Roger – "ce sinistre vieillard qui pèse sur tout effort moderne en Angleterre" [*that sinister old man who weighs down all modern efforts in England*]? After publishing it, M. George had the happy notion of reading Roger's book and found out of course that what Lewis had told him was all a pack of lies – so now he has published a retraction. I think if you realised what a sale [*dirty*] type that Lewis is, and the contempt all les amis feel for him and his work and his dirty ways, you wouldn't even let him squeeze your hand under the table. I also heard a bit of scandal against another enemy of mine, whom I, however, was praising to the skies as a très gallant homme – [Tadeo] Slavinsky: but this is in confidence. During the war, when Slavinsky was an officer and Kisling 'simple soldat', the latter entrusted to that great Polish gentleman a sum of money for his old mother – the typical Jewish widow, I imagine, au fond d'un ghetto in some obscure town in Poland. Slavinsky of course spent it; and was only induced to refund at the insistence of a lawyer. So perhaps our Iris [Tree] is not in such very good hands after all. The ménage à trois continues merrily – save that [Curtis] Moffat is drinking himself to pieces they say – "sometimes she comes into the

café with one husband, sometimes with the other". I went back with Kisling to dine in the quarter and fell in with Derain & [?Kremnitz] (the poet). Unluckily Mon[d]zain was of the party, and as Kisling and he are sworn foes the situation was uncomfortable: oh these Poles! Did I tell you of a little méchanté of le cammerade Picasso which I thought rather witty? I met him as I came out of Kahnwei-ler's show[1] (Derain, Braque, Leger, Gris, etc.) and he asked me what I thought of it. I was enthusiastic. "Moi j'aime bien les Juan Gris" said Picasso. I also heard (from [James W.] Morrice this time) that Tonks was Conder's pet antipathy; he couldn't abide him: "Vanity, vanity, here comes the preacher" he would say as the well known figure hove in sight. You see I have something for all my friends today. D'you know I don't think very much of Katherine Mansfield [*The Garden Party*] – she is sentimental in a vulgar underhand way, and, as you say, it is mere cinema – she can't construct a story or make a real point – and it is all so obvious, you see the end coming a mile off, and it is always the same end. But what an eye! The first is the best, and if she had concentrated on *Prelude* I believe she might have made a goodish book of it. On Monday I shall force the old gorgon to say yes or no about your room, and I feel sure it will be 'yes': if it is 'no' I shall find something else. How delightful to go pleasuring about Paris with the charmingest girl in the world.

Clive

Note

1. Daniel-Henry Kahnweiler, prominent Parisian gallerist and early champion of Picasso and the Cubists.

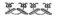

To Virginia Woolf
May 21 1923 3 rue Bonaparte

Dearest Virginia, the bad habit has somehow been established of my writing to you when I am en voyage – about melanism or anything. Wouldn't it be much better if you wrote to me sometimes when I was away? But, as I have a compliment – but then! you no longer care for them; well as your husband has a compliment . . . It fell out this way. I had been with [Moise] Kisling to Arthur Rubinstein's superb concert, where, after listening to the very latest thing in Brazilian cinema-ragtime, we were allowed to wallow a full three quarters of an hour

in Chopin; and when, afterwards, Mde. Erasouris [Errázuriz] invited us all to supper, I, perceiving that Stravinsky was invited and having already perceived that he was in a devilish humour because Rubinstein had played nothing of his amongst les jeunes, declined. Instead I took Kisling off for a drink at "Le Boeuf sur les toits" and there found Detuit [Georges Duthuit] (who likes to be described not as "critique d'art" but "Esthéticien") who had to confess immediately that he had just been engluering [*covering in mud*] me fiercely in his book – his first book – and then to confess by implication and sheepishly that he had drawn the two charming young men from Oxford who were sitting beside him to his table and had then discovered – what I could have told him – that, though he can read, he couldn't speak English. So I had to make myself pleasant for a minute or two, during which the young gentlemen (whose names I never learnt) informed me that they didn't think much of Middleton Murry, and that if I wanted to see how criticism should be done I should get that week's Nation (I hadn't seen it) and read Mrs. Woolf on Huxley: she was the one to write. Of course I got it; and, of course, discovered that not Mrs. but Mr. Woolf was entitled to the compliment.[1] However, next day I met Mr. Croly of the New Republic on his way to Italy, not with Mrs. Willard Straight, but with someone of whom we have never been allowed to hear a word, with Mrs. Croly, a stout, personable, philanthropic American lady of fifty or thereabouts, who might any day turn up at Dora Sanger's. So I took them on with me to lunch chez un marchand du vin – a great adventure for Mrs. – and then she told me that Virginia Woolf had quite a following in America – a little group that swore by her. So you see I have not been wasting my time in Paris. Besides, there was Mr. Gilbert Seldes, the editor of *The Dial*, with whom I lunched and got slightly drunk yesterday: but one is quite enough for one letter. [Raymond] Radiguet's book [*Le diable au corps*] is not at all bad, and has been duly "crowned". That is the latest method of publicity here. A small group of authors, aided perhaps by one or two publishers and an enthusiastic amateur, founds a prize – three prizes sometimes – which are duly décernés [*awarded*] to themselves. The public is impressed and buys. I don't know what prize Jean Cocteau's novel *Le grand écart* has got, and I haven't read it yet, though I received a copy with an exemplary dedicace. I have seen a good deal of Derain, who is very charming and affectionate and serious, wondering a great deal about himself, and talking about it more than I have ever known him do before – en tête-à-tête bien entendu. I don't know what makes me think of it, but have you been to see "At Mrs. Beams", it is a really good comedy, and there is a character in it after your heart. I am going tonight to see "Monsieur

Le Trouhadec saisi par la débauche". And then I have seen [Darius] Milhaud and [Francis] Poulenc and [Charles] Despiau and Copeau and Marcel Gaillard and Nils de Dardel and his pretty new wife and [Walther] Halvorsen and his pretty new mistress, and I am going to see Ethel Sands. Oh, and I went to see Betty Meinertzhagen in those bas-fonds de MontParnasse, where Nina Hamnett & Iris Tree are the queens of innumerable Poles, Russians, Americans, Armenians, Scandinavians, Check-Slovenes, Lithuanians, Jugo-Slavs, Turks, Arabs and not one Frenchman. She appeared to be boring herself considerably, and drinking too much, like everyone else in that sink of degradation. However I talked very little to her because I became more interested in a little Polish punk who was passionately in love with Jean Cocteau. And poured out her heart to me: she waits for hours outside Le Boeuf sur les toits to see him go in and out, but can't afford to enter, the drinks are so expensive. If that's not love what is. And décidement ce pauvre M. Hugh-Smith n'a pas de chance. In London he is a banker, but he comes to Paris from time to time for a little relaxation. Last year he was caught in a sheltered restaurant by Mary, Jack Hutchinson and Diana with a little blonde tart whom he elaborately explained was a widow lady whose affairs he was look-ing after. The other night Kisling, Nils de Dardel and I were dining in Montmartre when in came a monsieur most inappropriately "en smoking" with a tall dark doxy. It was Hugh-Smith, and by way of hush money he sent me a note by the waiter asking me to lunch with him today au Boeuf – à la mode; and I am just off.

Clive

Note

1. Leonard Woolf reviewed Aldous Huxley's *On the Margin* in the *Nation & Athenaeum*, 12 May 1923.

To Virginia Woolf
June 13 1926 3 rue Bonaparte, Paris

Dearest Virginia, as I shall be back amongst you on Wednesday, this, as you may suppose, is a business letter. I want the press to send a *Legend* and a *Poems* to Madame Gabory – 24 boulevard des Bati-gnolles, Paris (xvii).[1] Will the press be so good? And then, will the editor let me write a column or an essay on Proust, which I have

just read? I think it charming, intelligent, and full of amusing scraps of information. Also the English will like it, as it is written simply and straightforwardly, not in that tiresome, affected, alembicated style brought into fashion by Morand and Giradoux, and admired of Raymond Mortimer. By the way, that Madame Gabory of whom I speak – dimly a relation of Vita and Eddie whom she has never seen however – daughter of Oscar Wilde's last doctor – reads English perfectly, speaks it quite well Mary reports, and is a passionate admirer of Mrs. Dalloway. Shall I tell you a little news? Well, but I have hardly any. Of English I have seen only Mary, Peter Johnstone of *The Times* and old Lytton. Old Lytton did not enjoy Paris. He don't like France and he don't like the French, chiefly – in my opinion – because he can't cope with their language. Mary & I did our very best for him. I introduced him to the charming Duthuit; and to vulgar, vivacious, handsome little Lemasle – generally known in Paris as le médecin des péderastes. I took him to the very latest boîtes in Montmartre, and offered to show him Josephine Baker's backside ("chose de tout beauté, cher monsieur, unique au monde") at the Folies Bergères. All would not do. He preferred to traffic about (while Pippa [Strachey] was addressing at the Sorbonne the women of the world in forty different languages) with Mr. Medley, a young English painter of some promise, and Mr. Doone, nominally a dancer, in fact, I surmise, a professional catamite. With them he traipsed all day long in the lowest of spirits and the rain. For it rains incessantly, Virginia, and is as cold as heaven. And it says a good deal for my spirit, I think, and for the amiability of my French friends, that in spite of everything I have enjoyed myself. Tomorrow Vanessa and Duncan arrive. On Tuesday there is a private view of the new Picassos and Jean Cocteau's première – could Lady Colefax desire more? On Wednesday I return to London as fast as your restricted train service will carry me. If only it would stop raining I should look forward to London, notwithstanding that the French papers represent it as a city given over to darkness and despair.

Yours, Clive

Note

1. The Hogarth Press published Clive Bell's *Poems* in 1921, and his *Legend of Monte della Sibilla*, designed and illustrated by Duncan Grant and Vanessa Bell, in 1923.

To Julian Bell
February 2 1927 50 Gordon Square

My dear Julian,
 Nessa tells me that you now speak French fluently and have a
mind to make acquaintances. I have written to [Georges] Gabory,
a youngish poet and essayist, about 27, of whom I think well; to
Duthuit – one of the most charming men I know, intelligent and
erudite; to Waldemar George, an intellectual Polish jew, former
editor of L'Amour de L'Art, and probably you will hear from them.
They all know me and Duncan, Mary, Roger and know of Lytton.
Gabory takes no interest in politics, his wife – who is charming –
knows English well – don't let her talk it to you. Waldemar George
is an intellectual socialist, with a capable intellect, interested in
ideas in general and aesthetic <u>ideas</u> in particular. Duthuit is a sub-
tler and more complicated character: he will have something curi-
ous to say about anything. They should be a means to interesting
friends. Have you any money? If you meet in cafés – as probably
you will – insist on paying for drinks sometimes. If you are a party,
insist sometimes on paying the tournée (for everyone). Ten per
cent on the bill is always a sound rule for tipping.
 I shall go to Cassis next month. If you are coming there at Easter
you ought to get inoculated against typhoid before very long. If you
like my friends, I will write to others. In haste, CB

KCC

To Julian Bell
[April 1927] 3 rue Bonaparte

My dear Julian
 here is Flammarion's catalogue[1] – (Flammarion is the same as
the Odéon, but perhaps you had better go into the shop itself,
alongside).
 I have marked a number of books which I advise you to buy –
they will send them if you pay for them.
 To this list I should add: Anatole France: "Jeanne d'Arc" which
you can certainly buy under the arcade: [Gustave] Lanson Manuel de
la literature française – an invaluable book of reference: <u>Michelet</u> His-
toire des origines à la Revolution – Flammarion advertises a bound
copy which is too expensive in my opinion. They will certainly get for

you copies brochés, i.e. unbound. I advise you to get all your books brochés, one can always have them bound later. Unless of course you happen to see a bargain bound. To get a general idea of French 19th century history I would read Emile Bourgeois – Histoire moderne de la France – I am not quite sure of the name – 2 vols. I think that will be a start: and I think the volumes I propose will cost about 500 francs = £3.0.0 or so. I daresay the special books you will want for your courses[2] will run into another 500 francs. In that case you will have exceeded your £5.0.0 and will let me know, no doubt, by how much. I suspect buying these books will amuse you. In any case I am too busy at the moment to buy them myself.

I shall expect you and Pinault at 8.0 on Wednesday at the Medici grill. If you have no plans for Sunday come to lunch with me – call for me here at 12.30 – and we will make a grand battue[3] of the quays from end to end.

In the greatest haste, CB

P. S. If you want a French-English dictionary you can certainly get one under the Odéon
KCC

Notes

1. A leading French publisher and bookshop, on the Place de l'Odéon.
2. With Henri Pinault, a private tutor.
3. i.e. 'beating', as when a beater startles birds into the air for shooting.

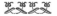

To Virginia Woolf
February 2 1930 23 rue Hoche, Cannes

Dearest Virginia,
 in the first place I have to thank you for the eminent Tom's address: in the second, I want to say a word in favour of Brian Howard. He has found a publisher for his poems – but that's not it. It is that I think he deserves a little – a very little – encouragement. I know you saw him and didn't take to him. Neither did I at first. But I have seen a good deal of him lately and come to the conclusion that he is intelligent and not without talent, possessing one of those rapid, hopping and skipping modern minds which I like better than you perhaps, but which in any case are not negligible. And anyhow he had the resolution to refuse to become a lawyer, though

his father was furious and Lord Birkenhead offended. In the third place I want you to send me some news. I can offer you very little in return. Cannes – except for the little old town and the port – is one of those quite ridiculous places that look as though they had been run up over night like a flower-show tent – as indeed they have been. The fact that Cannes has been in a state of being run up during the last sixty or seventy years adds to the joke. I shouldn't be surprised if what appears to be sands were really made of gutta-percha[1] and I'm not persuaded that the sea is really wet. But the sun – when it happens not to be raining – shines so brilliantly that one flings open the window and sits reading in one's pyjamas. Also the country is beautiful. Across this strange scene flits a rather small population – for the season is deplorable, all along of that "crack en Amérique" say the natives – of old women and male prostitutes with here and there a professional lawn-tennis player, who may be a professional prostitute too in his off time for all I know. I am well in with one real Riviera ménage at any rate – old Mrs. Squires, as mad as a hatter, widow of an American diplomatist and involved in the siege of the Legations at Pekin. There she lives, in a villa at La Napoule, about five miles away, with a more or less bogus Russian baroness, several nieces (of the baroness I imagine), dogs, doves, and tame fishes. According to Brian Howard she has conceived a violent passion for me, and threatens to take away Peter Spencer's allowance (he is her gigolo) and transfer it to me. So who knows what good may not come of it. By the way, I beg you to say nothing about Peter Spencer to Brian if you happen to see him: most likely he will volunteer any information you may desire and perhaps more. For the rest I live amongst males: Cannes – more especially Le Boeuf sur le toit at Cannes – having become the headquarters of mediterranean buggery – the Sodom of le côte d'azur. Taormina is said to be nothing to it. And in the cabarets and boites de nuit all the comic songs that used to be full of double entendres about men going to bed with women are now about men going to bed with each other. They aren't a bit funnier for that.

Yours, Clive

Note

1. A form of imported latex widely used in Britain for domestic and industrial purposes in the nineteenth century.

To Vanessa Bell
March 6 1930 Cannes

Dearest Nessa, I got your letter an hour ago and I shall answer
it at once because tomorrow I go to Paris, and once in Paris God
knows when I shall find time to write. Also, in an hour's time I go
for a farewell dinner with the Napoule gang to La Majolaine – an
admirable and admirably cheap bistrot – I must say painters are
clever at things of that sort – finding good cheap restaurants even
in Cannes. I shall stay at the Londres, and I propose to return to
London on Sunday 16th. How pleasant it would be if you could
arrange for a Bloomsbury reunion that night. Also could you ask
Grace to ring up The University Tailors and ask them to call on
Monday (17th) for several suits to be cleaned. If she will remember
that I will remember her suit-case. The following Saturday I shall
go to Seend for a night or two: and I hope to spend the whole
month of April at Charleston. I have a good deal of work to do
before I go to Italy. Do come to Italy. In principle I shall be with
Frankie [Birrell] – Eddy [Sackville-West] and the Huxleys mean to
be about in the quadrilateral also – but we are not going to "travel
together" but to criss and cross and make arrangements to meet
in various agreeable towns. Talking of Charleston – what about
staff? Would it be possible for me to invite one or two friends of
whom I shan't see much otherwise – Fanny [Partridge] for instance
and Lytton? You might consider this. No, John Banting hasn't
grown fat – he is mad however. It's a pity he thinks about nothing
but drinking and fucking because I believe he has a talent – not
for painting pictures – but for decorating. I shall be surprised if it
comes to much. The unknown youth is Sandy Baird, who was at
the Baronin's with Quentin: – Quentin I believe didn't much like
him, but he speaks most affectionately of Quentin – also, he seems
to me very sweet, quite sufficiently intelligent, and admirably hand-
some: he drives his car much too fast but then all the young do that.
The female is my German secretary-factota [Benita Jaeger], who
has turned out very well, gets on with Eddie, Raymond and the
boys, is infinitely discreet with Sir Louis Mallet & Lord Stanmore,
looks handsome in the cheap evening frock I gave her, and does no
one any harm unless it be me – whom she bores from time to time.
She will be sorry to leave me, and we shall meet from time to time
I make no doubt. All my contacts with the outer world – and they
are numerous & various – come via La Napoule. I am on Christian
name terms with a score of painters, journalists, negro chanteurs,
saxophone players and French poets – all buggers I need hardly

say. I met Hazel Lavery at the opera the other night and bowed and smiled – invitations from Guinnesses, Lady Cholmondely and the Colebrook I simply refuse. If the last three years have done nothing else for me they have saved me from that world at any rate.

Your CB
P. .S. Did you do anything about Enid?
P. S. 2. We had a grand Shrove Tuesday in Nice – an international party of about a dozen – French, English, German and one American whom we contrived to lose before dinner. Confetti, dancing, and, to wind up, a fine pornographic cinema.

To Mary Hutchinson
October 13 1936 3 rue Bonaparte

Picasso has disappeared, Mary: and they say – that is Marie-Laure de Noailles says – he has gone to take up his post in Madrid.¹ That I don't believe. For one thing it would take him all his time to get there nowadays, for another, if he got there he would surely be done in by Franco's blacks – and Picasso, for all his 'vie tourmentée' has no wish to be done in. To Barcelona he may have gone. He will be safe enough there, and can fall in with Georges [Duthuit] and talk about Matisse. But Miró, whom I saw the other night, and who had just come, with difficulty, from Barcelona by sea to Marseilles had heard nothing of him. What a strange woman that Marie-Laure is. I lunched there again yesterday to see the pictures in a good light. My word, the Goya portrait of a woman – the long black one with the little white dog – is a stunner. I didn't realise that she knew you well: perhaps she doesn't, but she spoke as though she did. Not only were you 'intelligent and charming' – compliments of course – but 'efficient and practical' – now from what incident or conversation do those two unexpected epithets come? I suppose the mixture of Marquis de Sade and Jew blood may account for anything; but I confess the pervasion of the hammer and scycle [sic] in that overwhelmingly rich palazzo strikes me as a little absurd. And her disconnected talk and mad, meaningless laugh, and that way of looking as though she were going to say one thing and saying another . . .? Is she, perhaps, a little off her head? Incidentally, she cleared up your Bergeric mystery. Drieu La Rochelle does write sometimes for his paper, because Drieu has become a follower

of [Jacques] Doriot and though fascist is 'revolutionary' which apparently is all that matters. I have seen old Derain and his beautiful little niece. What is more, he is going with her to London in a day or two – or says he is. He has taken a house at Chambourcy, close to St. Germain-en-Laye, and in an hour's time he should call for me in his big car and take me there for lunch. Also he has designed clothes for Lydia's *Misanthrope* and is thinking about the scenes. I believe I am to see the sketches. Yes, I found Jouvet and Bébé [Berard]'s Molière enchanting. Do you remember? You recommended it last summer; but when I arrived in July they had all gone on holiday. I was a good deal impressed by the scenery. In fact, when the curtain went up on that tall house I was not only pleased but startled – a delightful experience. They say it is the only good thing in Paris. But tonight I go to the repétition of Bourdet's new play – in Daisy Fellowes' box – with a supper-party afterwards chez Madame Serte, – tout ce qu'il y a de plus chic;[2] and supper-parties they say have become events in Paris. I have got the Symbolist catalogue. There are fifteen or sixteen illustrations some of which will amuse you I think. One of the oddities of the show is an early portrait of Gide by [Jacques-Emile] Blanche in which he resembles extraordinarily Oscar Wilde. I wonder whether K's [Kenneth Clarke] lecture went off well – I take it for granted they found you a place. I wonder what you are all up to in London – you particularly. I shall come back towards the end of next week. Will you lunch with me on Monday 26th at 1.30? I will tell you all the news; but the theory is that all the news now comes from London. Madame de Polignac is going there for a couple of months to organize a series of Gregorian concerts – which might be remarkable – and Daisy Fellowes goes with her to make a cure in a cemetery – textuellement. At present she is on a simple regime which consists in eating precisely nothing at all. Anyhow she is in great beauty. I have seen a few of our friends: Maurice Bidel – but I'm not sure that he is a friend of yours – the Lacretelles – young Mr. Ford, the pretty poet and bugger's delight – Baba d'Erlanger as she was; what is she now? Fancigny de Lusinge I think – and next week I shall see [Georges] Duhamel, just back from America. The popularity of Cecil Beaton in this town always surprises me. Perhaps he is charming after all. Is he? Have you read 'Les Jeunes Filles' by Montherlant? It is tolerable rosse [*nasty*] and, I think, amusing.

Clive

Notes

1. Picasso had been appointed director in absentia of the Museo del Prado by the Republican government but did not go to Spain.
2. Daisy Fellowes, Paris editor of *Harper's Bazaar*, was the niece of Winnaretta Singer, Princess de Polignac. Édouard Bourdet's play was probably *Fric-Frac* (1936); Misia Sert was a pianist and patron of artists; she was witness at the marriage of Picasso to Olga Khokhlova.

To Frances Partridge
April 29 1948 Charleston

Dearest Fanny it seems to me you may be amused to hear something of my French adventures. But I have just written a longish account of them – or some of them – to Janice [Loeb]. Would you think it base if I were to repeat my letter, making such changes as must be made? I hope not: for really I haven't the energy this cold, wet morning – not but what I'm delighted to see the rain – to invent new ways of telling old tales. One day I remember George Gage's schoolboy son, Nicky, missed an opportunity of getting two woodcock, right and left. "If you had got that right and left", said his Lordship "I would have written to *The Field* about it". Well, I felt that I ought to write to *The Field*: for on a Saturday I got the maître de Valauris [Picasso] and on the Monday le maître de Vence [Matisse]. We started off from Victoria on a Thursday and went straight through to Nice, where, after an amusing journey – a pretty Russian girl (Mrs. Alexander by name, however) being so persistently pursued by French, Portuguese and American gentlemen, that she put herself under Mary's protection – we were met by the charming, intelligent, helpful, and I will say it – charming-looking Janie [Bussy], who conducted us to a comparatively cheap, comparatively comfortable hotel close to the rue Verdi – Le côte d'Azur – nom à retenir. Nice was in full summer: the beach crowded with naked bodies, the town with flowers. Not a cloud in the sky, the heat satisfactory even to me – and so it continued. The very first night the Bussys gave a delightful dinner-party to which they bade Roger Martin du Gard; and it was from him we learnt that Picasso was at Valauris and not, as I had supposed, in Paris. I said I should go and see him and his pots. Simon insinuated that he would greatly like to go with us; but that he was shy. I said Picasso might not wish to see me but could not refuse to see me. Now I

have but one fault to find with the dear – and more than dear – Bussys: having always been hard-up they are as economical as the French are supposed to be – and are. Simon wouldn't hear of my hiring a car. Valauris is almost as far from Nice as Nice is from Cannes. The day was hot; and in meridional autobus there is no nonsense about "standing room": they just go on piling up and fitting in passengers till they can pile and fit no more. However, about half past eleven we arrived – with one change – at Valauris, a large, grubby village back in a green hole in the hills, given over entirely to small potteries. Picasso has discovered a remarkable one, with an eighteenth-century court-yard and, I surmise, eighteenth-century methods. However the great man – he is recognized as such throughout the village – wasn't there at half past eleven. He and his état major and his girl and his baby live in a hotel at Juan-les-pins some miles away. He generally came up to the pottery – they said – about three in the afternoon. So we were directed to one of those bistrots in which, out of a dark and dirty void, suddenly appear a most appetizing meal, and we all got so tipsy on the vin corsé du pays that we had to loll on a bench in the Place Publique and sleep it off. Back to the pottery at three to sit all in a row, on my coat, with our backs to the wall, awaiting the master. Will he come? And if he does won't he be surprised? He did come and he was surprised. In he came marching in his old grey sweater followed by his magnificent black car. He was most amiable – affectionate I might say. What he is doing is extraordinary. He does not throw; but models and adds ornaments and paints. His colours are of an extraordinary intensity, his designs unlike anything one has seen or dreamed of. Sometimes, in the manner of Bernard Palissy, he will clap clay eggs and bacon, a knife and fork or a bit of boudin on to a plate. The whole effect, as you won't be surprised to hear, is slightly "inquietant". Even Matisse has been to see what he is about and has come away worried. The return journey: by some miraculous piece of luck we got seats; but unluckily, just before Antibes, Mary remembered there were important decorations by the master in the fortress-museum. Simon refused to leave his hard won seat – he had enough – but I could hardly desert a belle dame. Also, the decorations are remarkable: so was the rest of the journey. But all's well that ends well, and Simon confided to his ladies that he couldn't remember a day that he had more enjoyed. On the Sunday we gave a dinner-party to the Bussys and M. Louis de Gautier-Vignal – an old friend and indeed a discovery of Frankie's – whose father bought a papal title. He

is a ridiculous old creature who wrote a not bad book about Macchiavelli – that was how Frankie came to know him – and, like everyone else, was a friend of Proust. Wisely he retired to Nice where he is made happy by being put on every committee concerned with "cultural interests", instead of remaining in Paris where he was what he is – nobody. The dinner itself was execrable; but I had the lucky idea – after dinner – of ordering a couple of bottles of Champagne, and so the party became a success. Monday's expedition was very different from Saturday's. Matisse, as you probably know, has always been sweet on Mary. She telephoned and asked for a date. We were both invited for four o'clock precisely. This time we had a car. The beautiful Lydia [Delectorskaya], his slave and body-servant, his rapin, his model, his house-maid, his art-director, she who stanches his wounds and replaces his bowels, received us and was in attendance the whole time. Matisse was in bed with his cat in his lap. He gets up in the morning, works in his studio – where are some dazzling pictures – even walks a hundred yards or so – then returns to bed for the rest of the day. "Je ne suis pas un malade", he told me, "mais un mutilé [*wounded*]." We saw his pictures, we saw the curious cuttings he makes out of paper painted by himself, we saw the Picasso he has bought (Picasso had bought one of his), we saw the two illustrated books *Jazz* and *The Letters of a Portuguese Nun* (Lydia turns the pages, but Mary had to read the text of *Jazz* aloud, words and handwriting are both the master's). We were favoured with a number of reflections – profound poetical platitudes on Life, Death and the Grand Forever, to say nothing of the art of painting. And we were dismissed at six-thirty without bite or sup, though Lydia did press a bunch of Banksia roses into Mary's hand on leaving. Anyhow the confidences were heartfelt and touching, and it was thought they must have been provoked by Mary's beaux yeux or more probably her elegant figure. Imagine, then, our dismay when, having bought at the Gare du Nord a copy of *Le Figaro Litteraire*, we discovered that a day or two earlier the same secrets had been imparted to a female interviewer.

Paris was lovely in lovely weather. But I have written enough, and I shall say very little about it. I saw much of the Duthuits, Roland de Margerie, Marie-Louise Bousquet, Segonzac. I saw something of innumerable collections. I saw a play by Sartre – *Les mains sales* – rather like a lesson in algebra by an unsympathetic school-master. I enjoyed again *Occupe-toi d'Amélie*, but found the fun rather spun-out. Mary took a young English poet – [David]

Gascoyne – to a play by Kafka – but by then I had enjoyed a belly-full of play-going. I heard that in May Aldous and Maria [Huxley] are coming to Europe. And now, dearest Fanny, will you and Ralph [Partridge] come to lunch with me at the Ivy on Thursday May 20th.

Clive

≈≈≈≈

To Vanessa Bell
March 29 1956 Menton, Garavan

Dearest Nessa – your letter, which gave universal pleasure, arrived yesterday, or at any rate was handed to me by Janie [Bussy] yesterday. She and Barbara [Bagenal] went off to San Remo to flatten their noses against shop-windows and left me to recover from the exertions of the day before. We had been to Antibes where the gallery is now finished and admirably arranged, and in the evening to the opera at Monte Carlo, instigated by Avilda & Jim [Lees-Milne] who were making their second visit, to hear Don Giovanni. It was the best performance I have heard. The singing seemed to me admirable – but, as you know, I am no great judge of that: however it received the approbation of Eddy [Sackville-West] who had been with Avilda and Jim to the first performance (there were but two). During Eddy's stay of just over a week there was not one fine day. Nevertheless he enjoyed himself immensely and made himself agreeable to everyone. His transformation is a miracle no doubt: whether due to religion or money is a question. To return to Don Giovanni: the production was remarkable, they made of it an intelligible and logical drama instead of a series of more or less disconnected scenes and songs. Best of all, it was a pleasure to look at. The setting throughout was based on the teatro olympico at Vicenza with its curious perspective effect of converging streets, slightly varied from time to time to suit particular incidents. In the one long entre-actes – and how badly we all, Avilda, Barbara, Jim and I, needed a drink after an hour and a half in what I fancy must be the hottest opera house in the world (built by Garnier in the richest 1870 baroque), well, in the foyer we fell in with Willie Maugham[1] and his amiable boy friend. Only one topic of conversation: the princely wedding.[2] They had all been invited – Willie and his boy, Avilda and Jim. They all pretend to be cynical; they are all thrilled. Will the Princess Margaret come? What to wear?

Willie knew – so did I, for that matter, but nobody would believe me. At ten o'clock in the morning, full evening dress, white tie, top hat, decorations. There is a great deal of sending to London for tail-coats, etc. But what will the girls wear? Ball-dresses say I. And what with the service, and the banquet and the party, there they will be all dressed up, and perhaps with nowhere to faire pipi till late in the afternoon. I, however, shall be in Paris. We (Barbara comes too) are due to arrive there on April 10 (hôtel d'Angleterre) and I have half promised to attend a committee meeting on the 12th in London. On the way up we propose to lunch with Douglas [Cooper] and he may induce us to stay the night, though I had rather not. As for Mr. and Mrs. S[utherland]. I haven't seen them; I shall tomorrow perhaps. They are rather in disgrace, under a mist would be perhaps a better image. She is generally disliked: he is thought to make himself rather ridiculous with his incessant harping on his troubles with Churchill. The old boy does seem to have been pretty short with him. However Cathy asked Barbara to bring Janie to lunch, and apparently it all went off well enough. They had some trouble in finding the house, which the natives described as "comme un bateau" but it is, in fact – I have seen it from the road – more like the festival of Britain. Tomorrow (Good Friday) is the night of the famous Roquebrune procession, when the inhabitants dress up as Jesus Christ and Judas Iscariot and Pontius Pilate – in the Roman taste anyhow – and carry snail-shells converted into lamps round the village. M. Hannoteaux says the feast dates back to remotest classical antiquity. La Suco[3] is giving a stand-up supper-party at half-past seven to which the Sutherlands are invited. I hope it will be fine: at this present writing (eleven o'clock in the morning) the rain is pouring down and shows every inclination to continue. I have hopes that Georges [Duthuit] and Marguerite are coming to Nice for Easter – to look after the heritage of course – I shall try to pump him, not only about that heritage but about the Matisse funeral imbroglio. I meant to say more but now the salon is filling up – result of the wet morning – and I find it impossible to write in my bedroom because the table is too high. The ladies at La Suco are all well I think – though Dorothy wanders sadly – but terribly bored I fear. At least I judge so from the joy unfeigned with which they greet a visitor. Your letters are a source of great pleasure and I don't hesitate to show them. Pippa is remarkable. I hope Duncan is recovered from his "chill" or hangover. Barbara sends her love.

Clive

Notes

1. W. Somerset Maugham, the writer.
2. Of Albert Rainier to Grace Kelly.
3. La Souco, the Bussys' house in Roquebrune, was variously spelled by Clive Bell.

To Vanessa Bell
March 3 [1958] Hôtel Britannia

Dearest Nessa, our letters must have crossed. As I have replied to the business part of yours, this will be a mere packet of gossip. About our day with Picasso for instance. That was charming. As I had expected he has bought an enormous third republic house & garden, and let the whole thing go wild. He has turned the three big salons into a studio, which is full of extraordinary junk, most of which, should he live long enough, will probably be turned into statuary. Other rooms are full of the stuff he took over with the house, pianos, sofas, book-cases, packing-boxes piled up anyhow. In the studio there is hardly a chair to sit on. The inmates consisted of Jacqueline, his girl, young, pretty, simple and most agreeable:[1] a young American photographer, who wandered about clicking and clicking snap-shots of everything and everybody, and seemed quite harmless and rather nice: a funny little freckled girl in trousers married, I gathered, to an American called Duncan, who, like everyone else, has produced a book of Picasso photographs.[2] She might be Spanish; but she spoke French perfectly, and I rather think I heard her talking English to the photographer. All the gates of the house – there is a largish courtyard in front of it – are kept locked. I rang the bell: a pleasant middle-aged woman issued from a lodge, asked my business, and went off to consult the master. Meanwhile her son returned from school – it was about half-past twelve – and we had ten minutes lively conversation before his mother returned to say that Picasso was in bed – would we take a turn round the garden. The garden has been allowed to go wild – save for a bed of broad-beans in flower – and contains nothing but sculpture, mostly by Picasso, partly by the salon (1880) master admired by the former owner.

Picasso now keeps Spanish hours and it was two o'clock before we all went off to lunch chez Felix on the Croisset. A delicious and gay meal. The patron embraced me almost. "Alors vous le connaisssez" said Picasso. I shook my head. Under cross-examination

by Picasso, the stout little Italian admitted that he had taken me for Douglas Cooper. When we left, under a volley of camera-shots, he announced to the photographer, by way of compromise, that I was Mr. Duff Cooper. Picasso was charming and affectionate and made me promise to come back once at least before I left the coast. And I believe I shall. He declined to show pictures – "Clif [sic] Bell connait tous mes trucs" [knows all my things] – and I want to talk. We reminisced incessantly. For these young people, said Picasso, we might as well be talking about the painters of Lascaux.

Last Thursday we went to lunch with Rory Cameron, or to be exact, with his American mother, Lady Kenmare (?). A vast party, with black servants in white gloves. I was to have been shown "one of the most beautiful gardens in the south of France", but as there descended all day long alternate showers of rain and snow all I saw was what could be seen from the window. However, next day we were lunching out of doors, and now I have come in to write because it is too hot in the sun. If I wasn't shown the garden I was shown some paintings by a young American bearing a great French name – Aymon de Roussy de Sales, and asked to give advice. As the paintings consisted of juxtapositions of patches of bright colour, it was impossible to guess whether he had some talent or none whatever. I advised him to take drawing lessons. To my surprise this advice was well taken. So I suggested L'Académie Ransom. However he wants to come to London. I said I would write to Bill; and to Bill I have written asking him to be kind. I was very glad to have the Lit Sup, though I must thank the French post office as well as you and Duncan; for the paper band had burst, and the packet had been recently tied up with coarse string. I have seen Janie and Dorothy [Bussy]. No change in that quarter. But there is talk of Marjorie [Strachey] coming out, which would of course make a great difference. And now I must go to lunch out of doors. Please send another packet when you can. Next Friday we dine with Willie Maugham to meet the Clarks.

Clive.

Notes

1. Picasso met Jacqueline Roque in 1953; they married in 1961.
2. David Douglas Duncan's *The Private Life of Pablo Picasso* was published in 1958.

To Douglas Gordon
April 26 1958 Charleston

My dear Douglas, I returned to these shores last Monday, and
I am just come to the bottom of a mountain of boring corre-
spondence. So my first pleasure will be to answer your letter. If
we are to meet this summer it must be in Brussels. There I shall
certainly go. But as all arrangements are in the hands of Ray-
mond Mortimer, and as Raymond is at the moment in Persia, I
can't yet tell you what date he has fixed. I am delighted to hear
that you are going with your car to southwestern France – the
part of France I know best (bar Paris) and like best. It is the
only part in which there is little or no sign of the Welfare State.
The peasants don't hold much with machinery, preferring oxen,
and are in consequence the despair of the ministry of agriculture.
Gastronomically, as you know, it is the ne plus ultra. I am not
going to be such a fool as to detail the beauties and curiosities
you will find adequately set forth in your guide bleu; but one or
two suggestions, based on personal experience may be useful.
When you have satiated yourselves with Poitiers – perhaps the
most fascinating town in France – make a good morning start for
St. Savin (three quarters of an hour's drive) – by mid-day you will
have made a complete study of the most remarkable paintings –
then drive on to Montmorillon – half an hour's drive at most –
where you will find paintings of a hundred years later, scarcely
less remarkable. Also you will find an admirable bistrôt (France)
for déjeuner. On the way south don't miss Melle or Parthenay. La
Rochelle may be a little out of your way but vaut bien un détour.
In the sacristy (or is it the treasury?) of the cathedral of Bordeaux
are some good and little known pictures – you can exercise your
connoisseurship in attributing some of them to whom you will.
Toulouse is a gritty, ugly, squalid town which reminds me always
of Sheffield. But I hope you will go there. When you have seen
the sculpture in S. Sernin and in the musée des Augustins you
will have seen the finest collection of romanesque sculpture in
the world. There is a very good, expensive restaurant – Lafayette.
Should you push down to les Pyrénées I would advise a stay at
Amélie-les-bains rather than Perpignan – not but what Perpig-
nan is an agreeable town. But at Amélie you are in the heart
of Rousillon romanesque. (Hôtels: Thermes good and expensive:
Toque Blanche quite good and cheap.) Bespeak rooms; and buy
the guide to Rousillon. I shan't bore you with information about
Provence which doubtless you know as well as I do. Lately I

discovered a charming little town with an admirable and cheap hôtel on the watershed between the Atlantic and the Mediterranean, St. Pons – between Narbonne and Biziers. I will bore you with no more guide-book stuff. Only this I will say, the people of the southwest seem to me particularly amiable and welcoming. They delight in giving information; and in the churches you are apt to find a sacristan or an intelligent youth who knows what he is talking about and is more than willing to talk. Once at St. Bertrand de Comminges I asked the old lady who was serving me lunch in the restaurant to whom I should apply for the keys of the church and cloister. Unbeknown to me, she sent for M. le maire, who turned up, red ribband and all, and proved a delightful cicerone. But St B de C. will be, I fear, a little out of your way. I am relapsing and will say no more; though, if you have any specific questions to put you know I will be very glad to answer them. I haven't yet seen The Club: I haven't been to London yet; indeed I have been in England only four days. Pray give my love to Winnie [Gordon, his wife], and to all the other Baltimore beauties, if you think they would like to have it.

Yours ever, Clive

To Vanessa Bell
[1958] Hôtel des Ambassadeurs, Menton

Dearest Nessa – very many thanks for your letter, and for letters – none was pleasant, but two were of importance. Raymond arrived last night, and Barbara and I took him to lunch in the sun at Castellar. Poor Fanny was today sitting up, but is not to come downstairs till the day after tomorrow. It's a wonder I did not have to retire to bed also after what I went through on Saturday. Picasso telephoned in the morning to say we must come to a lunch-party he was giving in honour of Miguel Doming[u]in – the champion matador – to whose infant by a lovely and charming Italian film-star [Lucia Bosé] he was standing lay god-father. Lunch at one. Spanish hours. At 2.30 I was feeling so ill with hunger that I whispered to Jacqueline that I must esquiver en anglais [said in English that I must slip away]. Picasso would not hear of it, but sent me off in his car to Mougins – where the feast was to be held – in a restaurant, not his new house. Begin at once, he said. Barbara and Jean Cocteau came with me. I had

effectually broken up the party. The others followed on my heels –
14 in all. A magnificent repast – oceans of champagne – and for
me a most enjoyable tête-à-tête with Cocteau. At 5.30, lunch fin-
ished, began Spanish songs and flamenco dancing. Again I had
to escape, Douglas Cooper drove us back to La Californie; and
Barbara contrived to get us home before 8.0. Next day I felt all
the better for it.

I enclose a document, not because I grudge Chailey Rural Dis-
trict Council a pound, but because I have no notion what it is all
about. I suspect it is Quentin's business. The weather is kind. I will
write again before long.

Yours, C

To Pablo Picasso
December 27 1958 Charleston

Cher maître et ami

C'est trop beau, votre cadeau de Nöel; et vous êtes vraiment
trop généreux. Rémarquez bien que je n'ai pas encore vu les
dessins. Barbara a très bien fait de les garder chez elle. A cette
époque, quand les bureaux de poste sont encombrés, et pleins de
voleurs et maladroits pardessus la marché, c'est pas le moment
d'envoyer courrir les routes les dessins de Picasso. Cependant,
Duncan Grant, qui était à Londres hier les a vu. Il dit que les deux
que vous avez destinée à votre serviteur sont charmants et exquis;
et que le dessin Pompéien que vous avez envoyé à Barbara est une
chose vraiment superbe. Elle a de la chance la petite Barbara. J'en
si enchanté, comme vous pourrez imaginer. Le jour de Nöel j'ai
déjeuné avec Lydia, et je lui ai annoncé la bonne nouvelles – ou
est-ce qu'on doit dire les bonnes nouvelles? Lydia était très en
forme, gaie, charmante, portant un de ces chapeaux de plumes
qui sont tant à la mode. Elle vieillit un peu, mais elle vieillit bien.
Seulement, elle porte sur le visage une espèce de squame – pas très
voyant. Il y a des gens qui prétendent que c'est simplement de la
poussière – poussière, non poudre. Le seul moyen de s'assurer
serait l'embrasser. Vous pouvez essayer la prochaine fois que vous
viendrez en Angleterre.

Vers le fin de janvier je partirai pour le midi. Premièrement je
passerai dans le Rousillon; puis, je suppose, j'irai a Menton. J'ai
l'intention [?d'exiter] autant que possible, les fêtes de Parques à Aix.

Peut-être aurais-je la chance de vous revoir, vous et cette merveilleuse Madame Jacqueline. Je connais le château de Vauvenargues – c'est à dire je connais le jardin. Dans la rue de village j'ai rencontré par hazard un aimable et admirable paysan qui était sorti pour chasser les pigeons. Puisqu'il n'y avait pas de pigeons il a bien voulu me faire les honneurs de la propriété. Le château était vide. Je n'y suis pas entré. Mais j'espère. Et, esperant, je vous rémerci mille fois pour un cadeau magnifique, et suis, et reste.

votre vieil ami, Clive

[*Dear maître and friend*

Your Christmas gift is too lovely; and you really are too generous. Please note that I haven't yet seen the drawings. Barbara was right to keep them at home. In this season, when the post offices are congested and full of thieves and blunderers to boot, it's not the moment to post drawings by Picasso. Meanwhile, Duncan Grant, who was in London yesterday, saw them. He says that the two that you've chosen for your servant are charming and exquisite; and that the Pompeian drawing you sent to Barbara is truly superb. She's in luck, little Barbara. As you can imagine, I am so delighted. On Christmas day I lunched with Lydia [Lopokova] and told her the good news. Lydia was in great shape, gay, charming, wearing one of those feathered hats that are so in fashion. She has aged a little, but she is aging well. The only thing is that her face seems to be covered with a type of scaliness – not very noticeable. There are those who claim it's just dust – dust, not powder. The only way to be certain would be to kiss her. You can try the next time you're in England.

I am leaving for the Midi towards the end of January. First I'll pass through Rousillon; then, I suppose, I'll go to Menton. As far as possible I intend to avoid the Easter festival in Aix. Perhaps I'll have the chance see you again, you and the marvelous Madame Jacqueline. I'm familiar with the château de Vauvenargues – that's to say, I know the garden. In the streets of the village by chance I encountered a friendly and admirable provincial man who had come out to hunt pigeons. Since there weren't any pigeons he kindly did me the honours of showing me the property. The chateau was empty. I didn't go in. But I hope to. And, hoping, I thank you again a thousand-fold for a magnificent gift, and am, and remain, your old friend, Clive.]

To Frances Partridge
Sunday March 1 1959 Hôtel Britannia, Menton

Dearest Fanny – this, I think will find you still in Portugal, so I shall try to make some return for your admirable, long letter. A poor return it will be, not because I have no news, but because I can't collect my wits to tell it. Long, long ago, we left London in a fog, reached Le Havre in a drizzle, and drove along the west side of France in bright, bitterly cold weather. All the time at Nice it was warm & sunny. We made the mistake of spending a week in the Roussillon – a favourite haunt of mine: it rained six days out of the seven. During the last three weeks we haven't seen a cloud. We drove here by slow stages, stopping to lunch with Douglas Cooper in his fantastic folly, stopping a couple of nights in the pleasant town of Arles; lunching with Picasso at Cannes; and here we have been for the last ten days. People are swimming all along the coast, and the gardeners are watering their plants. Never, they say, has there been such a February. Douglas Cooper was full of news from all over the world – much of it amusing. He was admirably disagreeable about poor Roland Penrose and his book and the way in which (conscientious British Council officer that he is) he caused Picasso to abandon his birthday party by trying to drag in the B. B. C. As for the book, now that I have read it, I am disposed to agree with all but Douglas's most violent censure. He had staying with him a young man who seems either to know or know about everyone we know or have ever known. His name is Mervyn Evans. Do you know him? The day we lunched with Picasso (Douglas was there because it was his birthday and he brought Mervyn Evans with him) Jacqueline whispered to Barbara "le fiancé de Douglas". But there, I think, Jacqueline was wrong: I have seldom seen a young man less physically attractive (he reminds me a little of Eddie Playfair) and Douglas didn't seem in the least gone on him. Nevertheless, the affair with handsome John Richardson is, I fancy, quite at an end. Picasso, who was as gay and lively as ever, has, as you probably know, bought Vauvenargues – one of the most attractive places in the south of France but on the north side of the mountain. (He is in fact M. de Vauvenargues.) The property includes the greater part of La Montagne St. Victoire. Picasso telephoned to Kahnweiler – "J'ai acheté la montagne St. Victoire". "Yes", replies the dealer, "but which, Cézanne painted so many paintings of that subject". Picasso: "L'originale." We have seen something of Janie [Bussy], looking at least ten years younger – positively gay – and charming as always. This is thanks

to Mrs. Sharp (?) – type hospital nurse – but thoroughly up to her job. Dorothy [Bussy] has accepted her ministrations without difficulty, as she might accept the weather. I doubt whether she is aware of her as a human being: she might be anyone (except Janie) or a dog or an act of God. We lunched at La Souco last Sunday – on the terrace of course. On Wednesday Janie came with us to San Remo for a delicious lunch at La Lanterna. Afterwards she and Barbara shopped. Though I say it who should not, it was a great success. She has been out with Alvilde and Jim (the Lees-Milnes) too. We lunched with them one day last week and found Nancy Mitford there – a great pleasure. I would like to see her again – this evening perhaps, but I don't suppose I shall. Our future plans are uncertain. Easter in this hôtel is intolerable because the Belgians arrive with hordes of children. One must find a hotel in a town without a garden and not by the sea-side. We had thought of Aix because Picasso assured us that he would be at Vauvenargues – "seven kilometers by a farm road" he said. Would you believe it? Not a room in Aix because there will be no less than three conferences going on there – all at the same time. It doesn't matter much because I'm quite sure Picasso will not be there for more than a few hours perhaps. In fact I doubt whether he will ever get himself and his innumerable accumulations out of La Californie. My notion is that he will gradually build up a studio at Vauvenargues – will go there from time to time to paint – will acquire a caretaking old woman and a sofa – in the summer may stay there a night or even two; but in Cannes he will continue to live. This, however, is my notion only. Anyhow, we shall be here till March 23. Tomorrow we dine with Willy Maugham – a full dress affair.

Love, Clive

To Duncan Grant
Jan 28 1962 Clos du Peyronnet

My dear Duncan
 It was a great pleasure to receive a letter from you a fortnight or so ago; but if possible, a greater to get one yesterday dated January 1st. To be sure it was rather a long time on the road, travelling via strike-ridden, snow-bound England; and now I hardly know whither to address this. Charleston will perhaps be safest. Yes Angelica came and is now gone alas! taking in Paris and Goya on her way home.

Needless to say not a word has come from her, though she left us ten days ago. As a letter from Fanny reached me by the same post as your latest (i.e. letter of January the first) I was able to form a pretty distinct idea of your Andalusian weather. Now, however, if one may trust to the Nice Matin map, you inhabit the delightful zone in which we have revelled for the last three weeks – mid-June till four o'clock, after that fine and bright but somewhat chilly. We live very quietly but cannot altogether escape visitors – Americans, Canadians e tutti quanti. Our only real friends are the Graham Sutherlands – with whom we dine again this evening. I cannot make myself believe that he is a great painter, nor can Douglas Cooper; but he is a most agreeable man, and she is pretty and gay. Fish: oh yes, all along the Mediterranean coast. But here we get good chicken too, and very tolerable gigots. I find the vin de Provence a bit tough; but Humphrey Waterfield (who is due here on February 13th) has put me on to a drinkable and moderately priced Bordeaux. I have read a good French novel by a new author: "Clem" is the name of the book – I forget the name of the writer. And here come the last two volumes of Merimée – Correspondence Générale. I am hoping to see Jean Cocteau next week; but Picasso I fear is far from well. Nevertheless, I shall see him. Douglas Cooper has a birthday before long, and that always means a party. I should like to see Segonzac, but S. Tropez is the hell of a drive from here. We should have to stay the night. So far I have ventured no further than Castellar. Your company sounds delightful; though, as you know, I dislike anyone getting drunk except myself. The garden is glory; if not precisely roses all the way, at least a good few of them and the hills yellow with mimosa. Willie Maugham sees to it that the newspapers keep us aware of his existence; and I suppose I must lunch there one of these days. But 88, deaf and grumpy. You know La Souco is sold. Noone seems to know for how much: the purchasers are said to be Belgians. Janie's charming friend Tonnie came to tea one day, But even she didn't seem to know much about it. I have just re-read a letter from Grace, who says you are returning on February 3rd, so this goes to Charleston. Useless to give my love to Edward [Le Bas]: you will have parted.

Yrs Clive

Barbara sends her love. She asks me to tell you that "les maisons" have desserted [*sic*] the match-boxes. Instead they give us fish.

Tate

7

Travels

No country compared to France, in Clive Bell's estimation, but, in common with most of his peers, he also travelled widely in other European countries. Unlike most of those in the inner circle of Bloomsbury, he also visited the United States, giving lectures there in 1950 and 1952, and even once took a cruise to Africa. Early in his marriage, Bell went on holidays to Italy with both Vanessa and Virginia, trips that ended in tears and a sudden return home for Virginia after quarrelling with her brother-in-law. Wherever he was – Berlin, Venice, Rome or at sea – Bell sent letters home to Vanessa, Virginia, Mary Hutchinson and, later, Frances Partridge, with detailed accounts of his daily activities and highly opinionated descriptions of the local inhabitants.

To Lytton Strachey
September 9 1908 19, via Belle Arte, Siena

My dear Lytton,
 such splashing and dashing, grunting and squealing, cursing, swearing, and complaining is labouring our large, cool room, as Vanessa washes Virginia's hair with icy water, that it will be a miracle if I can collect my thoughts and write a letter at all. I am coiled up too in the most comfortable position, and writing with a fountain pen almost spent. How we got here I scarcely know, but I am disposed to attribute our comparative success to my genius for organization and the extreme good temper and sense of my travelling companions. The second-class carriages were all full of evil-smelling Italian holiday-makers who were going either to a naval review at Spezia or a motor race at Bologna. Italy in autumn is doubtless the most beautiful country in the world, and would, I daresay, be almost perfect if it were ruled by some decent people like the English or French or even by the Germans. I suspect it was better when the Austrians were here; but the modern Italian with his nasty southern democracy and incompetent, practical, mind is a creature altogether odious. I find I can converse with him pretty freely. I walk on the heights of the Fortezza and contemplate the lovely Tuscan hills, thinking, not without a smile, of the Landseer-like crags in the Highlands, their blatant, obvious picturesqueness, and their absurd banalité.
 We take our meals with the other boarders in this house, and very good meals they are too; as for the boarders, English, German, & American, I would dearly like to give you some account of them, did I not hope that Virginia would do it for you in her own inimitable fashion. Vanessa appeared to me in a rather new light during our Scottish visit. Her French blood seemed to assert itself, and I sometimes thought of her as resembling one of those great women of the Empire who were, I think, in many respects, as interesting and more remarkable than the earlier salonières. She appeared so very beautiful and intelligent and bold, and always a little contemptuous, and at the same time so delightfully conscious of that charm peculiar to the best specimens of her sex, which you, perhaps, can hardly feel.
 By the way, if you thought my compliments extravagant, I don't think you should have given Virginia an opportunity of making them out to have been more extravagant than they were.

Saxon, whom I saw on my way through London, complains of me, I know, on that account but then Saxon is notoriously severe; he has been taking Virginia to task and lecturing her about love-affairs, I gather; he says that he has never kissed a woman, with passion at any rate, but I wonder whether that amounts to any-thing more than a 'suppressio veri' [*suppression of the truth*]; did not you once invent a scandal about him and Angus, or was it Archer Hind? We stay here untill [*sic*] next Wednesday and then to – The Grand Hotel (Brufani), Perugia.

Yours, Clive Bell

To Saxon Sydney-Turner
September 17 1908 Hotel Brufani, Perugia, Italia

My dear Saxon,
 I have been meaning to write these last 10 days and have never succeeded somehow. I think I know why; we always write our letters in the siesta hours, between 2.0 and 4.30, and after all writing letters is not taking one's siesta. Well, accept half a sleepy hour and know that we are lodged in a fine new English hotel, surrounded by all the latest improvements and respectable English tourists, an atmosphere profoundly depressing after our romantic Sienese lodgings. Perugia too, in spite of some glori-ous pictures, is a very inferior place, with its nasty vulgar little Gothic cathedral coming right on top of the gorgeous duomo at Siena. There, in the cathedral at Siena, I spent a good many exquisite hours entranced by the richest interior I have ever seen, lost in infinite splendour of colour & line, sucking in the thick blue smoke of incense, watching the slow evolutions of splendid droning priests, while the organ & choir helped each other out with the odd florid chants of the later renaissance, sentimental enough at the moments of elevation & adoration. Siena was, I think, perfect or almost so; & in the hot, sweet, vintage-weather surpassed my most deliciously languid dreams; it was more like the good white wine of Orvieto than anything else that I can think of. The 'pavimento' [*mosaic floor*] looks better in photographs than in the original. I have brought away what I hope you will consider a fairly representative selection. You are not to suppose that Perugia is really a bad place; it is only rather poor by comparison, more especially as it strives to

emulate Paris, or is it only Milan. This is the best I can do in the siesta. God forgive me.

Yours, CB
P. S. Vanessa & Virginia are both well & incredibly charming.
Sussex

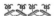

To Molly MacCarthy
Wednesday May 22nd [1912] Siena

My dear Molly,
 As I staggered back to lunch through torrents of rain, prepared for a miserable afternoon over a miserable Italian novel, that I had just bought off a barrow and had already become saturated in my pocket – faring forth into the rain again out of the question – I passed the post office, and, my cup being already full, risked a disappointment. Nothing of the sort. Your letter had arrived. So, instead of reading, I can write. But not gossip. If you have been loving Virginia she will have been getting me deeply into your black books on that score. She resents my gossiping about her, and proclaims me a sieve. As a matter of fact, I can hold my tongue as fast as anyone alive, and do, about somethings [*sic*]. But not about Virginia. When one considers how much she talks about herself, and how much about other people, reticence on the part of her friends appears a little too ludicrous. Anyway, in this matter I am a freelance. Virginia has been at infinite pains to throw dust in my eyes – Vanessa has been sworn to secrecy etc. etc. – so, of course, I have been at as many to keep them open. And there was plenty to see. No; I feel no shame at gossiping about Virginia. The facts, I think, are these. Some time ago, – when I don't precisely know – Woolf, (Leonard she calls him) proposed; Virginia still vacillates, uncertain of her feelings but enjoying them immensely; within a few weeks she will come down heads, and it will all be very satisfactory. I fancy she knows that she means to have him, but likes being wooed. The other bit of news is quite different. It would certainly give pain and would most probably do harm if it got about; and I can't tell you till I have an opportunity of explaining why absolute secrecy is so necessary. There are wheels within wheels; and parts of the machinery I respect immensely; so patience! patience! By the way, you halloed before you were out of the wood. The travellers raphsodies [*sic*] came along all right. Would you like to know about Siena?

It's like ten fingers on one very small hand, and that hand on the top of a bed-post. You have to go up hill from anywhere to get to Siena; and down hill and up again to pass between any two points in it; – unless you go right back along one finger to the hand, and then down another finger. Before the rain it was brown and red and green; since it has been green and white and gray. Nessa and Roger paint about half a dozen pictures of it a day, and the flies creep over them in clouds. So they do over me, God damn them. I had meant to go off to Monte Oliveto tomorrow. Monte Oliveto in the sun is delightful, but Monte Oliveto in the rain must be hell. Roger, who has been often enough in Italy to know better, says it will be fine; so he and Nessa are preparing their boards for an early start – cursing like mad things. But unless the sky takes a turn before sun-set, I think I shall make for a Romanesque church at Lucca and join the painters in Pisa. The Paris exhibition chez Barbazanges – had you heard about it? – was a great 'success' – d'estime![1] But no sales, alas! As for that old Henry James, thank God I took to abusing his novels before I knew that he had taken to abusing me because I was "clever but dirty." Dirty! I, who was warned by my doctor that it was unwholesome to take two hot baths a day. Oh these painters! Roger's grumbling because he meant to paint something like Lorenzetti and it's turned out like Maresco Pearce; probably it's just like Roger Fry. They generally are. And Vanessa's never going to touch a brush again; and her hair's fallen over her eyes, which keeps the flies out I dare say. And I've sat down on a wet masterpiece that had been left injudiciously to dry, propped against the back of the only arm-chair in the room. It's one of Roger's. Now who has most cause for complaint? The master-piece might have fetched fifteen pounds, but my coat cost seven two years ago. In fact neither seems to have taken very much harm, and both the owners are perfectly sweet-tempered about it. You see what nice creatures we are really.

Yours ever, CB
Lilly

Note

1. Roger Fry hung a small show at this Paris Gallery where Percy Moore Turner, the owner, introduced the Bells to the writer Charles Vildrac, the painter Henri Doucet and theatre director Jacques Copeau.

To Virginia Woolf
January 26 1928 Hotel Bellevue, Dresden

Dearest Virginia,
 I am counting on finding an enchanting letter from you when
I reach Berlin – two perhaps. Don't disappoint me. I have had no
London news – to call news – since I came away. Only I know that
Lord Sackville has been at the point of death and is rather better,
wherefore we found our Eddie [Sackville-West] awaiting us, nowise
changed, trim, pale, refined and neat. He is very charming and
almost too considerate, and a little nervous about the way in which
Raymond and I push forward, send messages by waiters, throw
paper darts (it is carnaval), ask the less plain girls to dance with us
(they have an enchanting habit of dancing from time to time an old-
fashioned Viennese waltz – and even I can revolve) and requesting
conductors to play our favourite tunes. He is infinitely kind to us;
he is fond of Raymond; but he will not be sorry to see the last of
us, and has definitely decided not to come on to Prague – whither
we go tomorrow. Oh Virginia, I wish I knew German, and I wish
I could dance modern dances. Given those two accomplishments,
Munich would have been Paradise. Indeed, it was Paradise, and
I should be a wretch to be ungrateful. But there might have been
more overtones. If Munich was Paradise, Dresden is Aberdeen –
Aberdeen with one of the finest galleries in Europe, with an admi-
rable opera, with restaurants – cabarets and 'dancings' – but Aber-
deen grey, gritty and bleak. Where Munich was gay, Dresden is
lively only. Where Munich was spacious, Dresden is no more than
open. All Germany is bourgeois evidently: but in Munich lives a
haute bourgeoisie – people who live for pleasure, all the pleasures –
amongst which they reckon dining, dancing and flirting. Here the
"night-life" is lived by businessmen in search of 'relaxation'. To
have tea in Munich with the Countess Bernstorff – one of those
typical Americanesses who talk about interesting things in an unin-
teresting way – seemed an outrageous waste of time; here it would
be boring merely. From Munich I learn't the one and only impor-
tant principle of town-planning. You construct your capital for a
population of three millions and you keep your population at seven
hundred thousand. Amenity follows as does night the day. Their
secret of life I had no need to learn. It is to live for pleasure. Quen-
tin is settled in a delightful family. The Baronin herself is still young
and gay – a pleasing mixture of French, Finn, Russian and Ger-
man. She has five charming children – three of whom (the young
ladies) speak French quite well – and with Fraulein "Honolulu" – a

small exotic beauty – I have left 'quelques fragments de mon pauvre coeur'. Quentin is all for making the best of a good job, and has set about learning German and dancing with a will: later he proposes to learn to drive a car.

And now, dearest Virginia, as you don't want to hear about [?illegible] and Raphael nor yet about Wagner and Strauss, how am I to fill up the remaining page? I'll tell you one thing. We are quite right about Hardy, and Lytton is quite wrong. The Woodlanders, which I took to read in the train, is a masterpiece, rising at moments to the heights of poetry. Otherwise I have read nothing but a comic, frivolous little book called Jérome by a new author, Maurice Bedel. From the Cassidiens [i.e. Duncan and Vanessa at Cassis] I have heard not one word, though I hope for news at Berlin. And as my bella inhabits the country I am a little starved for gossip. Be lavish. I doubt Valerie [Taylor][1] is not a brilliant correspondent – at all events no crumb of information (of a factual kind as Roger would have said in 1911 at the time of the first post-impressionist exhibition) reaches me. Emotionally, I understand, the situation develops favourably. I shall pass through Paris on my way back, and I shall be back on Feb 10th at latest. That is a Friday, and on the Sunday I count on you and Leonard for supper so that what remains of old Bloomsbury may be reunited at the earliest moment possible.

Clive

Note

1. A young actress who had captured the attentions of several among Clive Bell's circle.

To Virginia Woolf
February 3 1928 Hotel Excelsior, Berlin

Dearest Virginia,
happily I find it impossible to believe that your head was not in best case when you penned the delightful letter that arrived last night. All the same I should like to be assured, so perhaps I shall hear from you – be it only a line – at 3, rue Bonaparte, Paris (VI) where I mean to arrive on Tuesday. I shall be in London on Friday night (late) or Saturday morning; and, I repeat, I am counting on

you and Leonard for supper on Sunday. Would I had the gift of Snow [Marjorie Snowden] for butter-pat making. I would like to roll up my impression of Berlin and present it to Virginia on the end of a wooden spoon. As I don't sprechen a word naturally I don't imagine that it would have the least value as history, sociology, comparative ethnography or anything of that sort; still it would be my impression – the impression made on me in all my ignorance – and as such – after all Berlin is hideous; and though Baedeker says it is the second town in Europe it lacks the metropolitan air. It doesn't roar like London or rave like Paris (the idea as you may be aware is Tennyson's not mine) and unlike Rome it has no past. I suspect it of being rather like Denver U. S. A. with this important difference, – you feel that the inhabitants have intellects though probably they are not intelligent. Berlin is shabby and middle-class but – and herein it seems to differ from other German towns I have seen – it contains elegant people. Owing to our letters of introduction to the Horstmanns, Riezlers, etc we have fallen amongst these. We lunch in elegant houses and sup in restaurants which would pass for chic even in Paris or London. The women are mostly plain – the Germans being a race of Niebelungs – but unlike the Dresdeners they do not all look as if they had escaped from pictures by Hieronymus Bosch. Being elegant they contrive to make something amusing and personal of their odd heads and misshapen bodies. They wear pretty frocks sometimes. They are cultivated. So far as I can make out they have no aesthetic reactions at all. But they care genuinely for ideas about and arising out of art. Consequently their taste is of the oddest. In the great private collections you find the finest French 19th century pictures mixed up with the vilest German. They welcomed the Impressionists because they could hitch on to Impressionism all sorts of absurd ideas about "realism" "scientific representation" and whatnot: they do the same by Picasso and Matisse: their own painters give them plenty to think about and nothing to look at. (It is disquieting to observe translations of Galsworthy's novels in all the best book-shops and all the best drawing-rooms.) I have seen Carmen, Fidelio, Othello and Don Giovanni: the production seems to me remarkable. On no account will they allow a work of art to become a classic. They modernize and vitalize everything. I imagine Beethoven would turn in his grave could he see Fidelio produced as a Russian ballet. I found it most exciting. How such things come to be suffered in the state opera-houses is a little mysterious. I put it down to the famous German docility. The intelligent, or at least intellectual, few imposes its will: whereas in

England what passes for a cultivated upper-middle-class insists on getting what it likes and gets (God forgive them) Nigel Playfair and Mr. Norman Wilkinson of Four Oaks. To be sure I have seen a [Max] Reinhardt production that would suit them to a T; but Reinhardt seems to be as much despised by the intelligent here as elsewhere.

I have been taken to several of the prime buggery-booths (Eldorado – for tourists – La Bohème – Zauberflotte) and have heard plenty of young men in low necked dresses and feathers sing Carmen, and have seen bald-headed bank-clerks charleston-ing and discreetly kissing in corners: it is all very touching and passably ridiculous. The boys are dressed as sailors or girls and when they are at all presentable turn out almost always to be girls. The professional Lesbiennes are quite as funny and about as comely. It is all rather like a German treatise on Vice and Liberty, and in my opinion highly respectable.

I have met only one woman to whom I have lost the least part of my heart even. She is Frau von Horstmann, a very attractive and tolerably handsome Jewess (née Schaube). [*Page missing*] Farewell, dearest Virginia. Look forward to seeing me. I look forward to seeing you.

Clive

❀ ❀ ❀ ❀

To Vanessa Bell
Saturday [July 1931] 254 S. Gregorio, Venice

Dearest Nessa,
 It would very easy for anyone to, and I make no doubt someone will, give you a true account of my life that would be extremely misleading. It might be said that Clive spends his time hobnobbing with queens, princesses and dukes when he is not en tête-à-tête with Mary Baker (the shy bride). As a matter of fact, as I set my face resolutely against the Lido, I spend the day sight-seeing the evening in social festivities and the night – not yet all of it alas! – with my bella. I frequent the queens and princesses partly because Mary Baker, being an Americaness is a snob, partly because I find myself invited to the most lovely villas and palaces and almost invariably find the royalties (one of whom is the Kaiser's own sister) in attendance. Then there is the indefatigable Sybil [Colefax] who gets one in everywhere

and really has the most astonishing erudition and culture. There is Eve Fleming beseeching one to come to lunch and show her the lions. There is Lady Ancaster with a palace and a box at the Fenice always at the service of I tre signori – as we are called.[1] There is old Ozzi [sic] who knows everyone and goes everywhere. And then there are the cultivated fanatics who have read my books. If I add that I have had the sense to pick on a lady for my devotion who possesses not only a palazzo, but a launch and two motors on the mainland you will judge that I have chosen sagaciously.

We are extremely comfortable in this funny little flat though at such close quarters that Raymond and Frankie share a bedroom. But I have a fine big room of my own, and we have a large communal sitting-room and a sham tri-cento dining-room and a giardinotto. The cook is excellent and a handsome though incompetent young gondolier called Julio waits at table. The house is in the calle Ca-Ballà, two minutes walk from the Zattere and three from the Salute. The weather is of the oddest, alternating between clear and warm, grey and icy cold, hot and damp – last night there was a thunderstorm and today, thank God, it is really warm and sunny. People are even complaining of the scirocco – which is absurd. Venice is en fête today and in great beauty – the king of Italy and the fleet are here – hangings are out of all the windows – just as they were in Canaletto's time – and tomorrow we shall see the regatta from the balcony of the Palazzo Baher. Tonight, after a gala performance of Norma, we shall find the piazza illuminated, and I have some hope there will be fuochi artificiali [firework display]. Julian will be pleased to hear that today at lunch Eve Fleming's son [Ian Fleming, creator of James Bond], an extremely elegant and agreeable young man from Eton and going into the Foreign Office asked me whether I was any relation of Adrian Bell – whose country idylls he did not like – or Julian Bell whose poems he greatly admired. I must now dress – oh yes there is a good deal of that – to dine with the Signorina and go on to the Fenice.

Yrs Clive

Note

1. i.e. Clive, Frankie Birrell and Raymond Mortimer.

To Vanessa Bell
February 7 1933 [on board M. S. Gripsholm]

Dearest Nessa – I've hardly yet realised what an odd situation I find
myself in – a pack of Scandinavians, elderly and businesslike (Ger-
man type) or young and handsome (type Anglo-American) these
last for the most part attached to the ship in some capacity or other:
elderly women who might come out of any English vicarage: pretty
fresh girls – would-be parisiennes – all exactly alike – never really
pretty always presentable. For conversation only old Sir Richard
Winfrey – about 75 – ex-liberal agriculturalist – who once had some
vague job in the ministry of agriculture. Weather – at last becoming
warm – men sitting in flannel trousers and shirts – girls in pyjamas:
in fact I have bathed twice – not in the open-air tank on deck but in
a puddle of warm-water below stairs. I heard a middle-aged French-
woman this morning exclaim, with passionate conviction "j'en ai
assez de ce voyage" [*I've had enough of this voyage*] (And there are
five more weeks of it for her.) Not so I. I enjoy the sea, and sitting
in the sun, and reading enormously. What I dislike is the incessant
guzzling – guzzling and swilling all day long, and most of the night.
Notwithstanding that I forego three of the six meals a day provided
by the company, I feel overeaten. Then there is nothing for it but
three quarters of an hour's constitutional with Sir Dick. At such
moments I can't help rather hoping that it's cold and wet in England.
Exciting, though, to think that the day after tomorrow I shall be
at Dakar, within measurable distance of the equator. I trust Lottie
has been able to follow my simple instructions and that at Havana
or even at Port-of-Spain I shall find a bundle of letters and some
"Nations" even. One gets the vaguest impression from the wireless
reports of what is going forward on land. Have they shot president-
elect Roosevelt, I wonder. There are no Americans on the boat to get
excited about it, and only eight English who probably wouldn't be
much excited even were they more.

Clive

To Vanessa Bell
February 25 1933 [on board M. S. Gripsholm]

Dearest Nessa, late tonight or early tomorrow morning we reach
Port-of-Spain, which, as you may or may not know, is in Trinidad,

which is about the southernmost of the West Indies, just off the
coast of S. America – and from there I suppose letters will go back
to England. Let me say at once that, for the second time in my life,
I have found weather-reporters speak truth. The first was when
you and Duncan reported favourably on Cassis in the months of
June and July. We are in the tropics – winter tropics – all right: the
thermometer remains steady between 92 and 86 in the shade. It is
like the very best week of an English summer – need I add that the
outcry against this "oppressive heat" goes up all day long? You can
guess how I enjoy it. It is Saturday morning – we have been steam-
ing steadily since Sunday evening from the African coast. There
has been no wind worth talking about since the bay of Biscay, but
of course there is an ocean swell, & the boat, which is too high
out of the water, pitches a bit. I wonder whether you would think
the weather worth the pitching. I still find myself mostly with the
French gang – still agreeable, sprightly, on-the-spot but second-
rate. For the moment I am ever so little en froid with the ex-tenor,
having, over that one too many glass of brandy, given him a piece
of my mind last night on the subject of Massenet – and le faux in
general. I am on cocktail, ducking, terms with a number of bright
young Scandinavian things of both sexes. I have added to my graver
connexions Sir Gerald Kinnaird – ex-minister, Foreign Office gos-
sip and all that. Sir Richard [Winfrey] has still much to make me
learn about small-holdings. All the gossip of the ship – and there is
plenty of it – feuds, complaints and reconciliations – comes to me
through Benita, who with her good temper and handsome, brown
body is naturally a great success with all the handsome young
Swedes, who want to give lessons in shuffle-board, deck-coits, and
side-stroke. She seems to prefer dancing with the French. She is a
perfect holiday companion – for me – good-natured, good-looking,
self-amusing, helpful, practical, utterly unpretentious, sentimental,
popular and never there when she's not wanted. It seems to me, if
English and French intellectuals must marry – I can't imagine why
they should – they should pay serious attention to the claims of
German girls. The most interesting person on the boat is a Scan-
dinavian painter – about 45 – Paris-époch héroique de Matisse et
Picasso. He has very little talent, but an abundance of ideas, and
good ones. A Roger of the North? No, nor nearly. A Scandinavian
Simon Lévy perhaps. Unluckily his French has gone rusty, but con-
versation is furbishing it up. Then I read a great deal – in my short-
sleeves, under an awning, with a lemon-squash within reach – ça
vous donne les idées. And then at lunch – a pic-nic lunch for the
young on the front deck by the swimming pool, I hear the gossip

of the ship. Very little love gossip – the Scandinavian pretties – and pretties they are – are too constantly in the water or on the parallel bars for love. It is all about quarrels & complaints. These come mostly from the elderly business-men and their wives, who, despite the climate – some 100 degrees warmer than what they are accustomed to – guzzle and gorge and swill all day, and spend restless nights under a clammy sheet or on the W. C. The exacerbation of their tempers keeps pace with the deterioration of their livers, and they find that the young dance too late, make too much noise in the corridors, & are altogether too happy – or else that some one of the six daily meals is inadequate. Perhaps they will feel better when we get amongst the islands. This last week we have been holding such a southerly course that we have passed not a single ship – they seem incapable of reading – so there is nothing to do but look out for flying-fish and squabble. I wonder dimly whether I shall find a post waiting for me at Port-of-Spain. I hardly expect one. England seems very far away – and is.

C.

To Mary Hutchinson
nd [January 1950] Dana-Palmer House, Cambridge MA USA

Darling Mary, this note, written in the most awkward conditions – on Colette on my knee – is only to tell you that I lunched today with Mizzy (Roland [Burdon-Mueller] for long) and that he was deeply touched by your affectionate thought. He is writing to thank you. To me he is a ministering angel; but then so is everyone in America. Someone's car is always waiting to take one anywhere. And one is not allowed to pay for anything. Meanwhile dollars roll in, and as I don't intend to bring many back for Sir Stafford Cripps you may expect a parcel before long. In Baltimore – though I say it who should not – I had what is called a personal success. And in Washington they laughed like anything at my lecture. Here, I fancy, they are more critical. Both the quantity and quality of works of art is bewildering. The arrival at New York was pretty terrifying; indeed I doubt whether I should ever have left the dock if Janice [Loeb] had not met me. I was very happy to see her again; indeed she is one of the most intelligent and virtuous – in the classical sense of the word – human beings I have ever known – a charming companion. But I am dreading my stay with Mina [Kirstein Curtiss]

who has now abandoned Proust and M. le Prince and fancies she is writing about Bizet. Rumour has it – or rather Mizzy says – that Christabel [McLaren] is coming here soon. I can't congratulate her on the Queen Mary. The boat is not sea-worthy.

C.

To Mary Hutchinson
February 5 1950 The Century Club, New York

The thinnest paper I can find and therefore most suitable to Air Mail

Darling Mary – if I were to begin to tell you even the stories that might amuse you, there would be no end to it. I am always hearing of people of whom you might be glad to hear. But I can't get hold of [E. McKnight] Kauffer and I don't want to waste a morning on Marion [Dorn, his wife]; and so tomorrow morning I shall go off alone to find your bag. Alone – it is the rarest thing in the world to have five minutes to oneself. I have been talking about Tom and Virginia all the afternoon, and this evening – at dinner – talking about nothing – but talking. Mina Curtiss, with whom I stayed at Washington, seems to know more about what is doing in Paris and London and Rome than I have ever known. Gilbert Seldes rings me up for a drink and I find there Anthony West [Rebecca West's son]. Lincoln Kirstein invites me to lunch with Freddie Ashton and Poulenc. [Lewis] Galantière is translating Sartre for the stage. Baltimore and Boston are in many ways pleasanter than New York – more racy – more provincial. But nothing here is as provincial as Raymond [Mortimer] and Maurice Bowra, shocked because American ways are not those of France and England. They remind me of solicitors and clergymen I knew in my nonage, at Cleeve House, who complained that on "the continent" one couldn't get a nice cup of tea and a Bath bun. To change the air: I reread La fin de Chéri [by Colette] in the train – New York-Washington, there and back – the phrasing is marvellous, the images sometimes breath-taking, but I can't make Chéri come real – Edmée yes – it's my fault I know. You must explain to me. I believe the Americans would do well to concentrate on high-brow movies. That after all is a new art, and they stand as good a chance as anyone else. Their painting is deplorable. I don't pretend to know their writing. But I do know that there are plenty of intelligent and civilized people in this country. To qualify

that distasteful avowal I had better add that they seem to like me, whether I am dining or lecturing. When I stand up to address some six or seven hundred of them, I feel a perfect imposter. But that might happen anywhere. Tom's play is now a declared success – I am told that the house is sold out for a month or more. The intelligent are critical but appreciative. The snobs enthusiastic without reserve.[1]

So far as I can make out I shall be back about February 25th. I shan't attempt to see you till the election is over. How glad I am to be out of it all. I suppose once I am back at Charleston I must settle down to write my piece [on the Cone Collection, Baltimore Museum of Art] which is, after all, the fons et origo of my visit. Probably I shall have other American commitments. But don't forget that we are to visit Paris before the end of April.

Clive

Note

1. T. S. Eliot's *The Cocktail Party* won the 1950 Tony Award for best play.

To Douglas Gordon
February 4 1951 Charleston

Here you come, my dear D. G., putting ideas into my head. Of course I should love to come to America next January; but I hadn't given the matter a thought because I didn't think it possible. And is it possible? I doubt it. Let us consider the two main difficulties – there are others: lack of dollars and lack of ideas. Last year, you must remember, I lectured merely for "pin money," the munificence of Baltimore was my foundation. This time I should have to give enough lectures to pay my way. How many would that be? And how often would it be decent to repeat the same lecture? As you know, I don't want to take a dime home with me, but I do want to be able to invite a friend to dinner and to stay ten days at the Algonquin without counting the cost. Oh! I know what my friends here – Raymond Mortimer, Leigh Ashton – will say – "You can always rely on the fantastic hospitality of the Americans." Better still, I can rely on the enchanting hospitality of the Douglas Gordons. In New York my dear Janice would look after me. But

even when one has lost one's last shred of pride, one has one's taste for independence. Besides, I want to visit other places (not only Baltimore, New York and Harvard) but places where I have no acquaintances even. I have friends in Chicago. And I might even push my way to the South-West and visit Aldous Huxley. But this is day-dreaming. To return to my difficulties. If one makes bold to lecture in America I think one should bring a few new ideas with one. Have I any new ideas? I doubt it. I have some reminiscences – Les fauves (Paris 1904–1914) – but I doubt whether they are good enough. "Bloomsbury"? hardly of sufficient general interest. And so you see.

Well, now, let me state the case in what I consider a business-like way.

(1) I should like immensely to come to America for six weeks or so, arriving about the end of January 1952.

(2) I should love to spend a week or ten days with you, if you and your wife can bear with me for so long.

(3) I should like to see Mr & Mrs Duncan Phillips again, revisit their collections, and perhaps say something in their gallery about their Bonnards. Do you think they would like that?

(4) I want to see my friends in New York.

(5) Besides revisiting the collections I have already seen, I should like to see those of Detroit, Chicago, San Francisco – and many others no doubt – Worcester, Toledo etc.

(6) I should like to see something of the southern states.

(7) I should have to make enough money to pay my passage, travel in America, and – American hospitality notwithstanding – hotel bills.

(8) How much would that be?

(9) How much lecturing would that involve?

(10) How many lectures should I bring with me?

Here are a nice set of conundrums: pray answer them at your leisure and pleasure. Give my love to all my friends in Baltimore. It is really surprising what a deep affection I feel for that city and its inhabitants. In about a fortnight's time I am off to France, first to stay with the Bussys at Nice, then a week or ten days in Paris. England is a pretty miserable place just now. I hope it may be a little less gloomy when you come here in the summer. A change of government would cheer us up wonderfully.

Yours ever, Clive

To Douglas Gordon
February 8 1952 The Chicago Club

Things have so fallen out, my dear Douglas, that I have a free three
quarters of an hour; how better can I spend it than in writing to
you. My western adventure is almost at an end: tonight I shall be
in Cleveland, on Sunday morning in New York. I have enjoyed
myself: here and in St. Louis extravagantly; in Kansas City, tem-
perately. Nothing could have been kinder than the hospitality of
the Porters, and their friends were amiability itself: but perhaps
the change from Baltimore and the Brenta was a little sudden. Too
often I found myself "making conversation" – a shameing [*sic*]
experience – at a party: "Do you go much to the play?" Mr. Por-
ter is really far more interesting than his predominant partner. A
retired business-man, who concerns himself with local history and
Indian archaeology, he can be amusing and instructive and is not
without a sense of fun. Madame is alarmingly efficient and takes
her efficiency pretty solemnly. But she is immensely kind and help-
ful, though her house is full of hideous knick-knacks. The most
interesting person I met in "K.C." was [Lawrence] Sickman of the
museum – first-rate in every respect – I wish I had seen more of
him. He is thick with Osbert Sitwell, but you mustn't judge a man
by his friends. I will confess – to you – that I wasn't sorry to leave
Kansas City, but you must not infer from that that I was unhappy
there. All I will say is this – Kansas City claims to have the largest
Browning Society in the United States, and Mrs. Porter is proud of
it. St. Louis was the greatest fun from the word "go." I got on like
a house on fire with [Perry Townsend] Rathbone and his staff, and
within five minutes of meeting, Miss F – I have suddenly forgot-
ten her name – the assistant curator – was sewing on one of my
buttons that had fallen off in the gallery. Tom Eliot – born in St.
Louis – was a constant source of merriment. I was very sorry to
say "good-by." Here I have fallen in with old friends – Frankfurter,
Rousseau, Shapiro, Alice Roulier, and our consul-general, Gage, a
relation of my friend and shooting-companion.[1] The collections
are indescribably rich – but you know them – the Cézanne exhibi-
tion is superb. I wish I could stay longer. But duty calls; and I must
see [Rosalind] Constable [of *Time Life*] on Sunday in New York.
Is there any chance of your being there before I sail? The week
beginning Monday is out: I shall be in Long Island and Boston.
If not – till London. I haven't yet thanked you for forwarding so
many letters. I haven't half thanked you, or Winnie, for anything.
I haven't told you or my other Baltimore friends how much I love

them. I am rather relying on you to do that. If ever I recross the Atlantic it will be to enjoy myself with you all. No lectures. I shall borrow some dollars from little Janice and live for pleasure. But long before that we shall meet and have fun in London or Paris or somewhere else. Already I am looking forward.

Yours ever, Clive

Note

1. Alfred Frankfurter, editor of *Art News*; Theodore Rousseau, curator of paintings at the Metropolitan Museum in New York; Meyer Schapiro, art historian; Alice Roullier of the Arts Club in Chicago; Berkeley Gage.

To Vanessa Bell
March 4 1952 The Century Club, New York

Dearest Nessa, the big envelope containing your fascinating account of "home affairs" reached me here only yesterday and reached me open. Indeed it had the air of never having been stuck down. Besides your letter, and a letter containing a cheque, there were but three. Do you think any have fallen by the way? Even if they have I daresay most of them will return to Charleston at last – the American post-office, unlike our own, being both efficient and honest. Your letter was most entertaining and informative, and I have allowed Janice – with whom I dined and went to a musical play last night – to take it with her to read at leisure. After the accounts given in the American papers of the despair and desolation of the English people at the loss of their beloved King, I regard your letter as something in the nature of a state document. Not that one's civilized friends are taken in by the special correspondents. And when a silly woman in Baltimore rang up one of my friends to enquire whether she ought to cancel a cock-tail party she was giving in my honour the day after the death, my friend replied that she made no doubt I was as much upset as the cock-tail giver would be when she heard of the death of Harry Truman. (The upper classes of Baltimore are staunch conservatives.) My ten days in Baltimore were delightful. It is a delectable city, rich, old-fashioned, cultivated and comfortable. The girls are notoriously pretty – as the Bonapartes, Wellesleys and even the duke of Windsor knew. Capital works of art abound,

and some are to be found in the most unlikely places. Best of all, my nonsense seems to suit their nonsense. After Baltimore came a seventeen hour railway journey to Kansas City. There I was the guest of an infinitely kind but formidable and silly Mrs. Porter. (Her downtrodden husband – a retired business-man with a taste for Indian archaeology is much to be preferred.) They all did their best to be kind and made me autograph innumerable copies of 'Art' & 'Since Cézanne'. But when I tell you that Kansas City boasts of possessing the largest Browning Society in the United States, you will surmise that it is no place for me. I was glad to leave. On the other hand, St. Louis – pronounced Saint LEWES – was the greatest fun. I had not been in the gallery above ten minutes when a button flew off my jacket, and a pretty under-secretary immediately sewed it on for me. Her name I have inscribed in my tablets, but for the moment I can't recall it, anyhow the first question she asked me when she and I and her chief sat down to lunch was "Do you know Anne Popham?"[1] And then I set the whole department to work on discovering the birth-place of Tom [Eliot]. At last it was discovered; and it was the pretty girl who took me off in her car to take photographs of the site – a theme for a new Waste Land. You shall see them. From St. Louis to Chicago and its marvellous collections of French nineteenth and twentieth century pictures. There was also a magnificent Cézanne exhibition – the occasion of the symposium in which I took part, along with [Theodore] Rousseau of the Metropolitan (wearing his old Etonian tie) & [Meyer] Shapiro [sic]. I had a delightful dinner – in the French style – with our consul-general, one Berk[e]ley Gage, a cousin of dear Grubby, but a good deal more enterprising and determined. A particularly agreeable man. I also had a look at the Block collection. I wish I could have stayed longer in Chicago. But on to Cleveland, where I stayed at a hotel – a much better one than I dropped into at St. Louis – but was entertained lavishly by charming and civilized people. My entry to New York was mildly dramatic. It had been snowing all night – by the way I have come in for good weather everywhere with exceptional sunshine – and I packed up the blinds of my sleeper at dawn, just as the sun was rising in a steel blue sky – a Sunday morning at six o'clock or so – on a New York with streets white and empty and silent. I must say Janice's new young man [William Levitt] is a great improvement on her husband; in fact he is a charmer. Consequently Janice looks pretty and happy and young, and is as charming and intelligent a little chatter-box as ever. Next Sunday, after a dinner-party, she will drive me out to her ten-acre estate on Long Island. From

there I go to Boston for a couple of days. Back here on Sunday 16th and sail on March 21st. I ought to reach London some time on the 26th. I will ring up Charleston and we can decide whether I shall come to Sussex or whether I had better wait in London for the Memoir Club on April 1st. I dine with Mr. & Mrs. George Bergen on Wednesday.[2]

Yours, Clive

Notes

1. Anne Olivier Popham married Clive and Vanessa's son Quentin Bell in 1952.
2. The artist George Bergen had begun an intense friendship with Duncan Grant in late 1929, causing Vanessa Bell some anxiety.

8

Love, Gossip, Home

For most of his life, with whomever he travelled, and wherever he had been, Clive Bell's first concern upon returning to London was to have dinner as soon as possible with Vanessa, Duncan, Julian, Quentin, and Angelica, Leonard and Virginia Woolf, or as many of them as could be gathered together. Bell had many domiciles, but in a certain sense no 'home'; he tended to make himself at home wherever he was. He lived, of course, at 46 then 50 Gordon Square in Bloomsbury, and after 1939 full-time at Charleston, yet his was in many ways a peripatetic life, with Vanessa Bell at its centre. His 'letters home' to the important women in his life – Vanessa, Virginia, Mary Hutchinson, Frances Partridge – were full of the gossip in which they all reveled, but they usually contained also detailed accounts of his opinions, movements and social life. When Vanessa began to travel regularly to Cassis in the south of France, that, too, became another home for Clive.

During the First World War, home for Clive Bell was Lady Ottoline Morrell's Garsington Manor, which she and her MP husband, Philip, opened to conscientious objectors who could satisfy the requirement of doing 'work of national importance' by working its lands. Garsington became a hub for different generations of thinkers, artists, writers, politicians – Bertrand Russell, Siegfried Sassoon, D. H. Lawrence, Katherine Mansfield, Mark Gertler, Dorothy Brett, the Asquiths, Aldous Huxley, and many others. Some came only for weekends; others were more permanent residents, like Fredegond and Gerald Shove.

His own family home, Cleeve House in the village of Seend in Wiltshire, was a peculiar kind of horror for Clive Bell, devoid as it was of any interest in art and culture. But he always loved the countryside in which he had grown up, and where he learned to hunt and shoot. That rural upbringing served him in good stead at Charleston, too. When Vanessa died in 1961, Bell continued to live at Charleston with Duncan Grant, until old age took its toll.

To Virginia Stephen
Tuesday April 17 [1911] Hotel d'Anatolia, Broussa, Turkey

Dearest Virginia,
 everything is going on all right. Vanessa went down and sat in
the sun today from about 11.30 to 4.0. She was rather tired by the
descent, but made a good lunch, and during the afternoon one could
watch her improving as one watches a butterfly growing. We only
brought her up because the cold wind that began to blow gave her
a touch of neuralgia: now she is lying comfortably on her bed, pre-
tending to read, but more probably contemplating the view, which
is exquisite. Alas! the cold wind will probably bring rain tomorrow;
one can but hope. Vanessa feels so much better that she talks of
going from Constantinople to Vienna & from Vienna to Venice. We
shall see. Be sure we shall not let her do anything stupid.[1]
 Poor Harry [Norton] stept into a carriage at seven o'clock this
morning with Mr. Hill, brother of that unfortunate young woman,
who arrived safely at Constantinople nevertheless. I feel that Harry
has not been happy, and certainly he has been jealous. The three or
four days before Vanessa's collapse were not quite easy. But I have
little pity to spare, for I feel sorry for myself. Nessa's fainting fit
worried me; and now I feel lonely. There is no one to whom I can
say all the silly things I think – for, of course, Nessa is not to be
bothered. We have allowed our life to become disproportionately
disorganized; I feel as I used to feel the first few days at school. I
feel as though I had not been able to carry my home with me. This
is a confession of weakness. By the time my letter reaches you life
will have again become normal; but, at the moment, I would give
a good deal to have you here, even to be in your bad books, which
I shouldn't be when chastened & unhappy. It is the other side you
dislike. I will write again tomorrow a word of news. But really
everything is quite satisfactory again, & it is merely a question of
future movements. Tomorrow V. will finish a letter to you that she
had begun before her eclipse.

Yrs, C.

Note

1. Vanessa Bell had a miscarriage in Turkey while travelling with Clive,
 Roger Fry and Harry Norton.

To Mary Hutchinson
Christmas Eve 1914 Cleeve House

Well, figure, my dear Mary, all that one should figure. A family
party, holly, Port, and the village choir in the Baronial hall – built
in 1860 and entirely rebuilt in 1900 but all's one for that – Good
King Wenceslas, Noel, God Save the King. The party – the squire
and his wife, my elder sister great with child by one soldier at the
front, my sister-in-law like circumstanced (save for the child) my
younger sister, a gallant captain from Salisbury-plain itching to
be at 'em. Vanessa and myself feeling rather like spies. All talk-
ing about the war and its incidents and nothing else just as if it
were the most thrilling cricket-match that ever were played. I find
it very disquieting because it makes me feel that the thing really
is a nightmare come true instead of being just a bore. And these
are the people to go on forever because they're made up of three
tons of insensibility and one of sound professionalism. The one
part of professionalism makes them take killing and getting killed
for granted, the other three make them quite sure that nothing
will ever happen to themselves; nor will it. So now I've crept off
leaving my father and the captain to talk what sounds to me like
obvious nonsense about wire-entanglements and musketry: "the
ladies retired" half an hour ago, a relic of barbarism that shocks
me more and more; and now I'm going to enjoy for ten minutes
that best of all luxuries – a fire in one's bed-room. And then to bed.
 Christmas Day 1914
 What reflective possibilities for anyone as brave as the children
of those who fell at Waterloo! But we dare not even be cynical
on the old themes. How comforting! They say that elephants are
the most intelligent of beasts and the greatest cowards. Also they
say that they have le sentiment de la jalousie, le goût péderastic
et la nostalgie de la mort, which proves, according to Richepin
of the Academie française, that they have immortal souls. Souls
suggest hearts, and hearts broken ones. Vanessa is going to spend
next week at Guildford with Roger, Duncan has gone to Lytton
in the country, if you desert me I may well be found floating, like
a boat, bottom upwards below Chelsea bridge. And that reminds
me that Vanessa and Duncan possessed themselves of your pres-
ent to me, made a man of one of the figures, and then put both
through a series of obscenely realistic antics. I begin to feel uneasy
about the capers of their twelve-foot marionettes with which they
threaten an interlude on la nuit des rois [*Twelfth Night*]. Don't for-
get that you both [i.e. Mary and her husband, Jack] are engaged.

It's so beautiful this morning that I scarcely regret the civilization of Bloomsbury – a white frost thawing and falling from the trees in slow, persistent, and perfectly dignified drops. I rather wish you were here to see a very bright squirrel nibbling cones from the top of a pine-tree, which I must stop watching from my window, to go out.

Come to a pic-nic dinner at 8.0 on Monday. I fancy our slaves have gone to their homes for Christmas, but there must be one or two left to tend my solitude.

Clive

❦ ❦ ❦ ❦

To Mary Hutchinson
March 29 1915 46 Gordon Square

Dearest, many happy returns of this and of yesterday to you both. I had no idea that you had yourself run so near a squeak of being an April fool. I'm so glad it's a boy [Jeremy Hutchinson]. Did you have a very bad time? But I asked all these questions yesterday of Mrs. [Lesley] Jowitt, believing that I could not write to you for several days. Vanessa says that's nonsense; so I only wish I had written yesterday a letter to reach you on your birth-day. What a hole you will leave in my life! April, I forsee [sic], will be rather like the twenty-four hours after a big back tooth has been pulled out. How shall I fill it? With pacifist propaganda? I've a notion I might write a rather brilliant pamphlet;[1] and, after all, I don't quite see why I should consider that beneath my dignity which Milton, Swift, Voltaire and Demosthenes did not. Have you ever read Milton's pamphlets? If not, there's something for a rainy day. Also, there's Virginia's novel [*The Voyage Out*, published 26 March]: it's just the book for convalescence because it's all about illness. And, as you know, it's delightful to read about people dying just when one's very much looking forward to being alive. The book's a good one, but nothing more I'm afraid. The psycology [sic] and observation are amazing and amazingly witty; but it's all about life and states of mind and nothing about that other thing which you have discovered to be the essence of a work of art. She's an analitical chymist [sic], not God. But Lytton's coming here to lunch – in twenty minutes that's to say – to talk about it, so I won't spoil my appetite. By the way, it's rather horrible, on Saturday night I had an utterly crazy letter from Virginia – sheets:

a furious diatribe shot with flashes of extraordinary acumen, raking up old quarrels, 'old, forgotten, far-off things', bitter and hateful: someone has told her about you, and there were gibes – fierce ones: but all utterly mad. There was a very nice covering letter from Woolf, saying that he had promised to send it and that he thought I should know how to understand it. I tell you about it now, only because it strikes me as just conceivable that she may try to slip a note through to you. You, too, would know how to understand it, wouldn't you?

Well, this time I'll venture on a second sheet, because if you ought not yet to read letters you won't be allowed to read this one. And so I'll tell you that yesterday I went to one of Ottoline's tea-parties where she had assembled, reading from East to West, a Japanese sculptor, a Russian dancer, an Hungarian musician, a German sculptress, a Belgian refugee, some English, and a painter from Chili [sic]. Business was going on as usual, and Ottoline looked as much like a griffon and Philip a valet de chambre as ever. I saw Marjorie Strachey on Saturday night and she talked of Love and Literature, two subjects about which she knows next to nothing. She is going to while away the days of Jos's absence by writing an historical tragedy the subject of which is to be the rape of Lucretia. Yesterday I saw "Bunny" Garnett and he told me about walking-tours in Germany and the Oliviers. Today I shall see Lytton and Duncan and enjoy a little conventional conversation let us hope. And now you know all about it. If only I weren't afraid that you might have suffered for it. I should be enchanted the [?*letter damaged*] that your son – Sinbad? – was born in so characteristic an atmosphere of courageous vagueness. I shall certainly come to see you as soon as it is good for you to receive visitors, and not a moment earlier. Pray be prudent and submissive. I have tried to write in a large, clear hand easily legible by one lying on her back. Have I succeeded I wonder? There are plenty of houses in this and the Regent's Park district to be had for moderate rents, near the park, suitable for children, etc. So, from time to time, at any rate, I shall think of you.

Yours, Clive

Note

1. *Peace at Once* was the result.

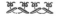

To Ottoline Morrell
August 4 1915 Cleeve House, Seend, Wiltshire

My dear Ottoline,
 I have sometimes wondered what millionaires say when they
feel that the occasion demands a few well-chosen words of grat-
itude to the Almighty. There would be something ridiculous in
thanking you for a delightful week-end, or even for three. So for
what can I thank you unless it be for a whole slate of affairs which
seems almost too good to last. I might, indeed, strike some spark
out of comparing Garsington with this amazing place; but I know
of no net so wide that I could rake both in. Cleeve House, when I
was born in it, was a nice, ugly, square house. It is now a gigantic
villa, and all the money in the world will never make it anything
but a still more gigantic one. No beings were ever so completely
pleased with themselves as its inhabitants. They feel that they have
the run of God's cupboard and they help themselves judiciously to
all that's not worth having. I wish it could all be expressed on a
recruiting poster, and below this legend –
 "Is this worth dying for?"
 Well, this time tomorrow (I am writing after dinner) I shall be
in my country cottage; and if I were Cowper or Southey I should
draw here an edifying paralell [sic]. I suppose you know Cowper's
letters – almost by heart I dare say. Even cottages, though, have
their little vanities, and mine is pleased to call itself The Grange,
Bosham, Chichester. To be sure, it belongs to a musician. When
are you coming to see it? I wonder whether you ever read Cham-
fort? He is an entertaining writer. Beaumarchais you certainly have
read, but 'The Vision of the mouth of Evesham' may have escaped
you. I forget who wrote it – someone who lived in the fifteenth
century and bore, I think, an Italian-sounding name. I shall go to
bed and pray that it may come to me in my dreams.

Yours ever, Clive Bell
HRC

To Mary Hutchinson
January 20 1917 Garsington Manor

Princesse, a thousand thanks for your long and very interesting and
very amusing letter. 'How right you are' as the stunt says (though I

fancy only Marie Beerbohm is sufficiently démodé still to affect the phrase – {a narrow squeak that, I say, for a split infinitive}) – How right you are – (by the way, I wonder if anyone has yet satirized me in the character of Melantha,[1] I'm about as Frenchified in my language; no longer, I notice, using the words in any sort of season but merely when I can't think of the English ones or don't know how to spell them) – well, as you will remember, I was saying "how right you are" about children. It's not the vote you want nor divorce-law reform but state crèches and more money. O, I know it's very nice having children tumbling about the house and all that (Melantha). But imagine yourself a woman with no servant or only one, which would you prefer – to be your own nurse-maid or to have your child cared for and educated in a government estab-lishment on the edge of Ravenscroft Park? Good food, good edu-cation, and a fair chance to make something of life? What better had I, brought up in an unsympathetic middle-class home, a pri-vate school of eighty boys, and a public of 640? And yet I believe I've managed to preserve most of the individuality I had the luck to be born with. I'm damned if I'll admit that I've been stamped into one of a pocketful of shillings. Yet the circumstances of a well ordered crèche would have been far more favourable to me than those in which I was bred. Besides neither the maternal nor the paternal instinct's very strong in the most highly civilized people. We do make more fuss about the welfare of our babies than we feel. There's hardly one of us that escapes some insincerity, some conventionality, in the matter; and that's the devil. Here endeth the first lesson.

You are quite right; Roger was going to bed – well to dinner first – with Lala [Vandervelde]: and he was quite right; he did ask me to order the wagonette: and I forgot: God forgive us all. Talk-ing of Roger – and before I forget it – there will be a pretty strong agitation I foresee in favour of a reading on February 10th; what will you say? I shall have to see Roger next week-end, and Bertie [Russell] too, I think; I have suggested Saturday night or some time on Sunday. The fact is, there's a new literary project afoot, by which the Cambridge Magazine, which has already a considerable circula-tion amongst the illuminati, is to be converted into the organ of tous qu'il y a de plus moderne, de plus spirituel, et de plus grivois [juicy]. Probably it will come to nought; besides, shouldn't I be crazy to add to the duties of an agricultural labourer, a lover, and the master of the Garsington revels, those of a literary editor? I should look to you for help I can tell you, so pray sharpen your pen on the chance. By the way, all crises and perplexities notwithstanding, I can count on

Friday can't I? I have arranged that we are to be happier than we have ever been before.

Just after I had licked up my last letter to you I was prayed to come over to the manor and try to dissipate the gloom cast by a sudden summons to Maria [Nys] to accompany Brett's sister [Sylvia] as far as Paris on her way to Italy. She (Maria) has certainly left Garsington, but whether she has got any nearer to Florence than 3 Gower Street I doubt. Brett, in her letter, gave some account of a party at Augustus John's, which appears to have been a rather nasty orgy, redeemed partly by the appearance of Lytton in a mantilla and vizard, partly by Mizzy's emerging from the kitchen just at the moment when Lady Constance Richardson was going through some Terpsichorean evolutions on the sofa, which he (Mizzy), mistaking for the contortions of a cholic, offered to alleviate either with a glass of warm water or hand friction, and partly by the incredible consumption of raw brandy. Lytton's liaison with John is very curious, is it not? At one time it was passionate almost, (he was to write John's life even), though all pour le bon motif bien entendu. Indeed, I fancy, it was chiefly entre barbes [*between beards*]. There was also a reply from Lawrence, who, from what I was suffered to hear, appears enchanted with the success of his malice [in *Women in Love*]. Ottoline, it seems, had demanded the return of a rather expensive pearl pin that she gave him in the days of her extravagant infatuation. But, naturally, Lawrence has either sold or pawned it by this time, and so he had to enter upon a long philosophical, de amicitia, rigmarole to explain why he felt bound to keep it. O Mary, my dear Mary, only ladies and gentlemen should have passionate loves and quarrels.

Clive

Note

1. In Dryden's *Marriage à la Mode*.

To Mary Hutchinson
January 31 1917 Garsington Manor

I shall never write to you, Princess Polly, except of an evening; in the middle of the day I'm too cold and peevish: the consequence will be less matter but better we hope. Tonight, however,

promises a poor beginning; I never felt less in a mood for letter-writing: my fingers are cold and sore, the lamp burns wretchedly because our feckless slave has let the oil run low, and I'm bored with Garsington and the Garsingtonians, their hiss and scandal and trumpery inquisitiveness. Of course I dined at the Manor last night: Brett was there and Aldous. Ottoline was wild with rage at Carrington's triumph, and degraded enough to take the moral line about the disgustingness of people getting drunk; Aldous, if you please, backs her up. I was tired and irritable enough – with a passing twinge of tooth-ache too – to declaim – though not until my opinion had been asked for – against the intolerable vulgarity of censoriousness. Brett had the pluck to back me up, said for her own part she should dislike to get seriously drunk and be kissed and pinched on all sides, but that Carrington hadn't been in the least disgusting though she might have been ridiculous. I, then, took up the tale and said that one might be annoyed if one heard of someone with whom one was in love behaving in this way; but that that was a personal matter, a matter of jealousy really. As for generalisations about unbecoming conduct, they were middle-class and unbearable, everything depended on the people who did the things, how they did them and in what circumstances. On this Aldous tried to creep back to the civilized world and did it lamely enough; her ladyship hadn't even the sense to follow. Pipsy [Philip Morrell], only half aware of what had happened, came down heavily on our side. I suppose because he thought it was the liberal one. Afterwards I was induced to give a reading from Racine, whom Aldous can't approach. His reasons are quite interesting though: he's too completely in the English literary tradition: he sees that Racine keeps very near the ground and can't see that he only touches it with his wings: he thinks it's Graeco-Roman sculpture instead of seeing that it's Ingres. Brett seemed to be rather puzzled about your Chelsea revue: she had been asked to be a John chorus-girl, but by Horace Cole, and for the Y. M. C. A. To her it had all sounded louche and second-rate and she had refused. When I arrived yesterday I found the house buzzing with ice projects and Aldous just starting for Oxford to buy a sackful of skates; there was some talk even of a moon-light flitting over the pond. Fortunately a fall of snow put an end to that plan, and still more fortunately indications of a thaw promise to put an end to all winter sports for this season. Do you think when next you go shopping you could get me some packing needles – or a packing needle – and some pack thread? everyone in the house would be the better for it. Aldous is getting uneasy

about his passport – as well he may – and is today gone to London to make enquiries about it at the Ministry of Cannon-fodder or whatever the proper place may be. Do you think they will ever let us leave this bloody ice-bound country again? I wish we were in Spain. Anyway the gossip that comes through from Fredegond [Shove] makes me glad I'm not in Cambridge. I had almost forgotten the horror of the provincial chit-chat that crackles on for ever in those semi-detached castles where live the dons wives who have gone to the war office. Lady Darwin and Fanny Cornford are at loggerheads about a cook, and they still chew away at Rupert [Brooke]'s mouldy vendettas and think Bloomsbury a dreadfully dangerous place. Lord! I wonder the sanitary inspector hasn't closed the whole thing down long ago.

CB

To Vanessa Bell
2 February 1917 Garsington

D. D. in the first place may we come down on Saturday 17th? If you have got your servant by then we might have a reading; otherwise a mere visit. I'm very glad to hear that you're going to have a better servant, though I suppose such things are hard to come by nowadays – what bloody days! what bloody news in the papers! What bloody, fucking weather! By the way, wasn't there another copy of Lear, a big folio from the London Library. You might have a look for it, or ask Mabel where she put it if she took it up with her. I couldn't find it. Also, do you know at all what became of the two Duncans that used to hang in my room – the sketch for Macbeth and May: I can't find them either. I suppose you heard about Carrington's triumphs, and how Augustus John rang the bell repeatedly at 3, Gower Street with arms full of flowers and drawings. Ottoline is furious, and rages against the drink and drinking parties like a teetotal preacher. But she doesn't do much harm. The fact is, the iron has entered into her soul. She dimly perceives that Lawrence's portrait [Hermione Roddice in *Women in Love*] may represent the general opinion; she is positively subdued. But her chief confidante comes to tea with me sometimes; she is very loyal but not very clever and so I am often able to put two and two together and discover that they make her ladyship in a state of unmistakeable disintegration. I wish you'd broach the

money question to Maynard: you really know him better than I. We don't get much for £150 a year do we; and as a matter of fact we pay more. Insurance etc. etc. Also I seem to have paid some of the things that really go to Maynard, but that can't be helped. I want very much to see the bantings, given your account of their latest developments sound so very amusing. By the way, isn't it Julian's birthday before long. Anyway I must bring them some presents next time to make up for last. You ought to go to the National Gallery when next you are in London; there is a glorious Renoir there from Lane's collection and some other fairly interesting impressionists – the big Manet's terrible stuff, but there's a pretty little one and a good Pissarro. Also there's a lovely Poussin from some duke or other's house. I suppose Virginia will write to Lady Cromer; will you?[1]

Yr CB

Note

1. Her husband, Evelyn Baring, 1st Earl of Cromer, had died on 29 January.

To Vanessa Bell
January 2 1918 Garsington Manor

D. D. a happy new year. And, in spite of the rather disconcerting news in this morning's "Daily News" I still believe it will be the best that we have had for some time. Duncan will have told you about our doings in London and I see no chance of this being much more than a Collins [a thank you letter]. There is Garsington to be sure; but what of that. Ottoline has driven Fredegond away with her incessant and unseasonable attentions. She (Fredegond) is to stay in London for a month at least, living in Hampstead – possibly with or by Alix. Katherine Mansfield has come to convalesce from pleurisy at the manor and that I suppose will make me safe for some time to come from being killed with kindness. And there are other dangers. The Christmas festivities, for instance, seem to have been marred by one of those characteristic little mishaps that diversify life at Garsington – a gangrenous turkey this time. Young Murry and Julian [Morrell] were sick on the spot: Brett dropped out a day or two later. Her Ladyship tried to make out that it was appendicitis; but the doctor knew better, and with a little rhubarb

and calomel we may look for complete health before long: besides Brett lost hers years ago. So far as I can make out the chief merry-making consisted in Gertler telling Ottoline all the evil he had ever heard spoken or reported of her. You will not be surprised to hear that I am in high disfavour. I don't know how it may be with Lytton who comes here next Saturday. My Christmas card[1] seems to have worked like a pill: Roger was the fifth of my friends to address me in verse. I thought his contribution delightful besides being highly flattering. Next year I think I shall publish a selection from my answers. Chatto & Windus are going to print Lytton [*Eminent Victorians*]. [Robert] Graves is going to marry, in a few weeks, Nancy Nicholson – the painter's daughter. There, isn't that news enough. I think you said that I never gave you your share of my mother's present. Here it is. And will you approach Maynard about his share of [handyman] Shaw's bill?

Yr CB
P. S. I wrote to [Hugh] Massingham in a friendly way to say that, as none of the artists concerned were showing in London, I thought it would be ridiculous to print my article ['The Mansard Gallery'], and that I should like it back for my book of pot-boilers. His reply was even more friendly and evidently he had wanted to publish it only he was snowed under with his damned politics. However, it's too late now.

Note

1. As a Christmas gift in 1917, Clive Bell had sent several friends a privately printed collection of his poems, *Ad Familiares*.

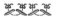

To Vanessa Bell
Monday [June 24 1918?] Garsington Manor

D. D. I very much approve your notion of writing to my mother; but there is one thing to be taken into consideration. A rapproche-ment, which might be extremely profitable to us both, and would necessitate neither of us going to Seend, may easily lead to a request for a visit from the children which it would be exceedingly difficult for us to resist. Well, what about the C. O. question? The more I think the more I see that the letting of that cat out of the bag would be fatal to everything – it would probably lead to a

rupture with the whole family and the loss of all our prospects. Now do you think it would be possible to see to it that the little boys should share the almost universal opinion that I am medically unfit and pretending to do other work to keep myself out of harm's way. It's worth taking some trouble to preserve our lien on the Bell millions. Julian I'm sure may say terribly indiscreet things and it would be much better to disarm than to warn him. What say you? As for the Charleston ménage – I undertake to put that right before there is any question of a visit to Seend.

Virginia's unconcealed jealousy of Lytton's success rather shocks me. E. V. [*Eminent Victorians*] may not be as good a book as the politicians and pressmen think, but it is a good book. And, quite apart from Lytton being our friend, isn't it marvellous & delightful to see for once a great fuss being made about a book that is really good? I did so much & saw so many people in London that it would be hopeless to try to tell you about it all. I shall be in London again between July 2nd and 5th and I wish you would ask Roger whether he will be there as I particularly want to fix a dinner at which he would make one. Indeed, after what you say, I should be glad of any news of Roger. I think you ought to see the Gaudier sculpture & drawings: there are no great masterpieces, it is all quite experimental still, but extremely interesting: he had amazing gifts and evidently meant to make something of them.[1] Ottoline has a young intellectual couple spending their week's holiday here – the Sullivans –, they are intelligent and interesting though they come from the underworld. Mr. S. has been reading The Voyage Out and is not much impressed, he is altogether too much given over to Dostoievsky & Tchejov [*sic*]. I am dealing with the income tax question.

Yrs, CB

Note

1. The artist Henri Gaudier-Brzeska was killed in France, June 1915.

To Mary Hutchinson
January 5 1919 Charleston

Dearest, I'm afraid there's no chance of this letter reaching Glottenham before you, but it ought to find you lying in bed on Tuesday morning and wring a reply from you before you get up. As for the

paper on which it's written, Charleston can afford no better: I ransacked the children's play-box for it and thought the find a lucky one. All goes well here, with mother and child that's to say [Angelica Bell, b. 25 December 1918]; the little boys are at Richmond with Virginia; Bunny with his family. For my own part I find the discomfort un peu fort and am writing to Blanche for my bath. I don't feel as though I should be able to do any work, but that may come. As if to heap coals of fire on your head Vanessa has been talking most affectionately of you, asks me to send you her love, wishes you would come and stay here, and thanks you a thousand times for the baby-clothes which have proved invaluable. I told her – but not as you told me – that you called them Regan and Goneril and the mot had a great success, Duncan thinking the names most appropriate. Nothing could have exceeded Mother and Minnie's kindness to me after you had left unless it was the amiability of the porter, the comfort of my journey, or the deepness of the mud between here and Glynde. I explored the penetralia of the Queen's Hotel – 'the Dug Out' is but an annexe – and enjoyed a view of the sea, an excellent lunch and a bottle of Bass'es [sic] Beer, at what seemed to be pre-war prices. The company, however, left something to be desired. I noticed that most of the ladies, all of whom seemed to be elderly, indulged in a glass of Port. I wondered, as I came along from Hastings, whether you had ever taken a Martello tower for the summer. It is just where I should have expected to find you six or seven years ago, with an exquisite cook and a spotted parasol. The towers seemed to be particularly thick round about Pevensey and I wondered whether Mr. Pitt had had them put there, recollecting that it was there that William the Conqueror landed – that is the way one would expect government minds to work. The new baby is said by the experts to be a great beauty – large blue eyes, a pronounced nose, and certainly an exquisite mouth. She is obviously going to be very dark. Vanessa has plans for a complete domestic reconstruction which is to centre on a certain Budge who was a general servant in the same place for seven years and has since been forewoman in a munitions factory: to me it all sounds rather too good to be true. They are wondering very much where the story of the approaching Carrington-Gertler marriage came from. There seems to be no confirmation. It is thought that Lytton would find himself very much in a hole were anything of the sort to occur, though he might also be rather relieved. I keep abreast of the times by reading the young poets in bed. Mr. [Gordon H.] Luce in manuscript disappoints me; there are some interesting philosophical poems, but the descriptive ones will not do I think – they are

furiously poetical. Of Fredegond, on the other hand, I think very well indeed: she has been very much influenced by the masters, but her verse is not pastiche as some people's is said to be. Really, she is rather charming. Also, I have a good word for Miss Edith [Sitwell]: but perhaps I grow soft-headed before this wood-fire. My chief complaint – there are a good many others to be sure – is that she is all on one, or at most two, notes. News of the great world reaches me fitfully through Maynard and Roger. I half believe that M. le Prince [Antoine Bibesco] is destined to play a part in our lives.[1] However, Duncan's view of him is at least as unfavourable as yours – a 'fade' [*bland*] character – prince de Waggon-lits in fact. His house is said to be miserably arranged, and his good judgment in pictures mere continentalism. All this is very sad but will make no difference to Leslie [Jowitt] I dare say.

Clive

Note

1. Bibesco married Elizabeth Asquith in April 1929.

❀ ❀ ❀ ❀

To Mary Hutchinson
Christmas Eve 1924 Charleston

Dearest Polly, I had meant to settle down and write you a letter in this room, which was last the day-nursery, which has been my room, and Roger's, and Polly's – the room opposite the dining-room; but the din outside the window is so great, Julian lopping branches with a bill-hook, Quentin picking holly with his fingers and emitting intermittent and piercing yells, and now – sure enough – Angelica joining the glad throng – that I'm not sure I shall be able to do anything with my hands but stop up my ears. Well, it is not cold, and that is much: but this pic-nic life in midwinter is not much to my taste. However, I shall return on Tuesday: shall we dine at The Ivy at 8.15? Let me know. The postman seems never to come near this house – I suppose he must, for how else does *The Times* come, but *The Times* and a certain amount of flirting in the kitchen are the only signs I get of his existence. The main flirting in the kitchen, however, is done by a young married but deserted man on the farm, of which I am extremely glad as he comes at seven o'clock in the morning and lights the fires, so that towards nine I enter the bath-room with the

greatest confidence. I am now one of the few people in England who know what Surréalisme is – having read M. André Breton's manifesto – and I will take you into the secret: it is automatic writing, neither more nor less. Also, after a holiday of many years, I have re-read [Thomas] Carlyle – Heroes & Hero-Worship – never did anything ring more hollow: just words, words, enveloping moral-religious platitudes – which aren't even true. O, now the boys have got a wheel-barrow (and it squeaks and shrieks like a slate pencil in pain) and are having a torch-light procession – for it has fallen dark. And the postman has not yet come. Will he bring a blue letter, do you think? Quentin is playing what he calls a "Devil's tatoo" on a biscuit tin. His school report says that he has "a quite remarkable sense of rhythm".

Clive

To Virginia Woolf
April 6 1926 Charleston

Dearest Virginia,
 if you could see me crouching in the ingle nook – the ingle recently discovered in the dining-room – with a candle insecurely balanced on a waste-paper basket on a chair, and even so unable to see a stroke, you would understand that this can be no more than what it purports to be – a begging letter. The reason why I write in so wretched a posture is that the new heating system leaves everything to be desired, at least on such a day as this when the sea-fog beats in at every chink – well now I have fixed an electric torch in the back of my chair and we shall see whether I shall see any better. The bath water is cold of a morning too, but of that I say nothing – my words are precious. It's about Renoir I'm thinking – Edmond Renoir – nephew of the old Auguste. He wants to spend the summer holidays – August-September – in England, and he can't afford it. So he is in search of a nice, cultivated, English family, with a child or children in need of instruction; small pay and a great deal of leisure. There is everything to be said for him – a charming character – simple tastes – English, French, Latin, Greek, mathematics, Arabic, I believe – crowded with culture, music, painting etc. And the only thing against him that I know of is that he squints. Surely you know someone who wants a paragon; think dearest Virginia. No news, no news; all your friends

and relations round the Wrekin are well; even at the great house they have only a touch of influenza. Tilton[1] is becoming gradually what it should be, the neat retreat of a great financier. Charleston is frankly disappointing, and less commodious than a Sabine farm. But Nessa doesn't care a rap – not she. She digs all day in the garden with the handsome one-armed boy from mother Standen's and sometimes goes out on the motive. Duncan craves for society, and threatens sometimes to call on Robin Mayor, sometimes on Lord Gage's aunt. Crusty Roger comes tomorrow. When do you come?

Yours ever, Clive

Note

1. Maynard Keynes's house, close to Charleston.

To Vanessa Bell
Friday evening [pm May 27 1926] 50 Gordon Square

Dearest Nessa.

Your letter has just reached me. I dare say you did well to go, though by waiting a little longer you might just have had a less horrible journey. The channel service has never stopped, and now is running freely – not quite as many boats between Dover & Calais as usual I think. I am staying in London. Why? I hardly know – out of curiosity perhaps. Who knows, I may become a policeman? There is nothing dangerous about the situation here [the General Strike] – or in the south generally: I am less clear about the north, though the government says all is well there too. Here, as you would expect, things improve gradually. There are quite a fair number of trains; the tubes run services said to be almost normal; there are 'busses' which get attacked – the only serious violence we have had. In the country – and people from the country come up in cars to London frequently – everything is completely normal, save that there were no newspapers at first but now they are appearing in swarms. So have no uneasiness about Charleston. I only hope they have plenty of coal for cooking. I fancy it may be a month before we get supplies of coal again. The general notion – based on what I know most – is that in the South the strike will have fizzled out by the end of next week. In the north I shouldn't be surprised if it were to come to machine-guns. That is what the bourgeoisie seems to

hope, at any rate. Most people of sense blame the government for breaking off negotiations and precipitating a crisis. Certainly the responsible Trade Unionists didn't want one, and would make peace now if they could. Naturally one has to fear that the direction of the strike will slip out of their hands. I am now going to dine in Soho with Leonard & Virginia & Francis Birrell. To add to poor Mary's troubles Jack is down with tonsilitis – and he is a very bad patient as you might guess. The weather is vile, which has a depressing effect on the public. Yesterday when the sun came out they seemed to feel as though the strike were over. Viola's book, which promised to become a 'best seller', is dished completely.[1] I will let you have some more news when I know your address. The advice given by the government is perhaps just worth repeating to people abroad. – Believe no rumours.

CB

Note

1. Viola Tree's memoir, *Castles in the Air*.

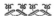

To Vanessa Bell
Friday 28 [January] 1927 50 Gordon Square

Dearest Nessa,
 I shall arrive at Cassis on Saturday February 13th. Can you make sure of a gîte [*lodging*] for me? I propose to stay till the end of the Easter holidays. At last I am going to write that book about civilization. Your knowledge of the human heart will probably lead you to surmise that something less vague than the divine afflatus put it into my head that I wanted to retire to the country and write a book. I will tell you all you care to know when we meet. I hope you and Duncan won't feel that I am butting in. I am very unhappy, and you and Duncan are the only people in the world with whom I can even imagine feeling better.

Clive
P.S. Everything about Quentin – passport, ticket, etc. is being arranged.

To Vanessa Bell
Sunday February 6 1927 [from Cleeve House]

Dearest Nessa, by this time the first instalment of books should
have reached you. Others will follow as soon as Birrell & Gar-
nett can collect them.¹ I hope I have chosen well. It is quite easy
to send books in small parcels to France, so let me know your
wants. I think of leaving England about the 23rd, but as I don't
want to be tied to a day, I shall take my chance of getting a berth
at the last moment. If I can't I shall stay a night or two in Paris.
I will keep you informed. My "story" [the end of his affair with
Mary Hutchinson] – which I will tell you, in so far as there is
anything to tell, when we meet – is the dullest on earth because
there are no facts in it. Even the small, solitary fact I believed to
exist does not apparently. It has all to do with feelings & states
of mind – and those of the most normal. All the same, it is an
appalling shock to discover suddenly that one neither feels nor
inspires what one had always taken for granted one did feel and
inspire. And yet it's what happens to everyone: I daresay most
people squeal less vigorously when they're hurt. Nothing that has
happened can conceivably affect your life – except that you may
get a little more of my company than of old, and that you say you
don't mind. I appear to have made myself out more interesting
than I am; at present all I do feel violently is a longing for two or
three months peace – such as one has at Charleston – not to go to
luncheon parties every morning and dinners every evening, not to
be on the telephone, and to express certain ideas that have been
in my head these ten years.

Roger has given his first dinner-party. He was in high good
humour because Lesley had bought a picture of his – a smallish
landscape – out of the Lefevre show; Philip Richie & I were the
guests. It was all very pleasant, and reflected great credit on Helen
[Anrep]'s cooking – if hers it was. His own room is very well done
indeed, and such a gallery of modern masterpieces as never was –
Seurat, Matisse, Bonnard: your still life holds its own in this grand
company with the greatest ease. I found Bicknell slinking about
at Lefevre's and he showed me what I take to be a sham Sisley
acquired by the Tate Gallery. Old Lytton has been in London: I
didn't see him, but both Mary and Philip did. He appears to be
working again. Perhaps his trip to Rome with Roger Senhouse was
such a success that he feels more than ever the need of money –
pour se payer des folies. Anyhow, he has asked me to go to Ham-
spray next week-end, and perhaps I shall. Today I am taking leave

of Seend – quite alone – no one works harder for his living than I. I shall go up to London by the evening train and take my second inoculation before I go to bed. It was as much from Frankie as from Ellie that I got my idea of the shocking insalubrity of Cassis; and as he happened to be there when Bertha [Penrose] was so ill I dare say he has got a distorted view of the place. By the way, talking of invalids, Sickert is said to be very much better and about to resume the brush. This, however, comes only from that worm Wilson – the conscientious objector and picture-copier. I'll tell you one thing – while I remember it – however delicious your weather may be by the mediterranean it can't be much bluer or better than it has been in England these last days. It's fine and warm enough to make me forget a broken heart; but not, alas! the eczema with which also I am afflicted. Tomorrow I go to hear Frankie Birrell lecture on women to women (female students of London University so far as I can make out). Christabel [McLaren] takes me, and also the chair, (at least she has been asked to do so) – isn't she perhaps a born chairwoman? It was thought that old [Augustine] Birrell would have to give evidence in the Gladstone-Wright affair,[2] and as he has fallen into the habit of remembering all sorts of things that never happened and forgetting hundreds that did, his friends and admirers trembled for him under cross-examination. Luckily, they were able to prove that Captain Peter Wright was a silly liar without him. I had a delicious evening with Puffin [Anthony] Asquith and Eddie S-W last week, all in the high university tradition, taking down Wordsworth from the shelf and reading passages against each other. How I like the young, and how I detest the self-satisfied middle-aged, especially Locker Lampson and his wife, young Mr. Selfridge, Sir Malcolm Robertson and Somerset Maugham, who surrounded me at Argyll House the other day and put "art – you know, music, painting and all that sort of thing" – in its place. It was like Maple's showroom coming suddenly to life. Tomorrow dine with me, Henderson, Adrian Bishop and Sanger: I expect we shall have fun. Quentin's affairs are all well in train – his passport almost complete – I will leave money for his ticket with Adrian who will see him through. He can spend the night in my flat if he wants to. Also I have written to Duthuit, Gabory, Waldemar George, and Julian himself. There are others to whom I can write if Julian finds that he likes society. Here they are back from church, and I think I ought to walk around the garden.

CB

Notes

1. Francis Birrell and David Garnett's bookshop opened on Taviton Street in Bloomsbury in 1919.
2. The sons of the former prime minister William Gladstone had sued Peter Wright, author of a book claiming that Gladstone was immoral.

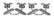

To Vanessa Bell
July 7 1929 50 Gordon Square

Dearest Nessa, many thanks for your two letters: the young person should now consider herself handsomely provided for.[1] For my part I am very glad to know your plans, which will condition mine. I am going to spend the 20th week-end at Seend. I think I will make my Le Touquet jaunt on the Tuesday (23rd) and instead of returning direct to Charleston I will come back on Friday 26th to London – you might dine with me that night (if 37 is not very convenient you might stay in this flat when you arrive) – and on the Saturday we could hire a big car to take you, Angelica, me and the luggage, at least, to Charleston. I had thought of sending Alice to Charleston with my luggage the day I left for France, but now I will leave her with instructions to make herself useful to you. Is that right? For general plans: I think I must be in London a good deal in the months of November and December – it would give too much pain if I were to give up the Wiltshire shooting. From January I hope to be more or less out of England till this time next year – that is if you and Duncan can bear with me somewhere in the midi (Cassis I suppose) next June and July. Your description of your present way of life makes me envious, and I have rather set my heart on sampling it next year. I seem to have been seeing the Woolves almost daily since last I wrote. I have had several long conversations with Virginia in which I am conscious of having formulated the most fantastical day-dreams as though they were well conceived and almost determined projects. But Virginia has that effect on one because she lives half in a world of particularly solid reality and half – not in a fairy tale – but a Victorian novel. Besides, it doesn't matter. Raymond, Frankie and Bunny all lunched with me at once – and great fun it was. Bunny was in better form than for many a long day (so far as I can judge which isn't very far) – he was the life and soul of the party. At present old Mr. Birrell is staying at Charleston. On Tuesday I will try to get into touch with Raymond, who will be coming to London for

a ballet, and discuss Charleston questions with him. By the way, I think well of Bunny's last book, which I believe you don't – though it's only Virginia who says so. I spent a delightful evening and half the night with Desmond, who is in surprisingly good spirits, but as we talked almost exclusively about Lord and Lady Byron perhaps it wouldn't have seemed so delightful to others. Did you know – this came to me from my own observation first, and then from various sources (Bunny, Biddy Stratton etc.) that Francis Meynell had a dash of the tar-brush and that the characteristic has come out emphatically in the younger generation? It is presumed that at some time or other the sainted Alice got off with a blackamoor; but is that likely? I was walking down to the Ivy the other night on the stroke of half past eight. A very large car (a kind of Daimler no doubt) was blocking narrow West Street. Into it stepped a stately dowager, white hair and flashing jewels, powdering her nose and drawing – "drawing" is the word – her opera-cloak about her. She was followed by a dapper little man whom I recognized as Jennings: but it was only as the car moved off towards Covent Garden that I realised that the dowager was Molly [MacCarthy]. Last night I dined with Roger, Helen, Kennedy and Igor [Anrep]. Roger is now in the highest health and spirits so Helen is Souffrante, and has been forbidden to start for France till she has consulted a lady doctor for ladies. She tried to get me to say that Frances Marshall was unhappy because [Ralph] Partridge had gone off to Holland with Lytton and Carrington; and when I refused to admit anything of the sort became pensive and noble and feared that Partridge "was not good for Frances." That woman is as fond of soul doctoring as Roger is of body. However I see she has great merits and I positively begin to like her. Meanwhile Roger contemplates buying a Renoir, though his flat is already no better than an old curiosity shop, with a Cézanne propped up behind the wash-hand stand and a Seurat in the W. C. Julian, by the way, is married and Roger was on the verge of discovering a way of sending him a cheap telegram of congratulations for 7/3½ [seven shillings three-and-a-half pence]: the worst of it was he had a right to 25 words and he could think of no more than fifteen.[2] Next week belongs to Cory and Cricket; but I shall see a good many people, including the Asquiths (who have taken me into favour) and Sir William Jowitt – I like the combination. I did not go to Elizabeth [Ponsonby]'s wedding so must refer you to the illustrated papers; I did not go to the first night of the ballet; I did not go to Mrs. Maugham's party or Lady Ravensdale's or the Circus or L'Embarquement pour Cynthère; I have not seen a single Guinness this week – in fact I am no longer

a man of fashion. Occasionally I hear a little about the fashionable world from Georgia Sitwell and Virginia. Amongst other things I hear that Rosamond Lehmann (Runciman during a short interval) has fallen in love with Roger Senhouse, which would amuse me faintly if it were true; & that Osbert is deserting Christabel in favour of pretty young Mr. Horner (old Lady H's nephew) of which I may hear more. And now I must go and have a bath.

CB

Notes

1. Clive had asked for advice concerning a girlfriend who thought she might be pregnant.
2. Roger's son had emigrated to Canada, where he married Eva Hambledon in 1929.

To Julian Bell
Saturday [November 16 1929] Cleeve House

My dear Julian, it appears that the second shoot had long since been fixed for Nov. 30 & Dec. 1, and the party made up. It appears also that I had long known this: if so, I had forgotten. However we will have three good days at Christmas, as there are plenty of birds. I fear there won't be room in the house, or the field either, for any but the family party. While on the subject of shooting may I give you a word of friendly advice? At lunch the day before yesterday in a genial, bantering way your 'dangerousness' was commented on. Now if you want to shoot to get a reputation for being 'dangerous' is fatal. However much people may like you, they won't ask you and won't shoot with you. That I know because I've seen it happen more than once. There are two things to bear in mind always: never allow your gun to point, whether loaded or unloaded, at anyone: never to say to yourself "I think I was justified in shooting". If there's any question of justification one ought not to have fired. One ought never to fire if anyone, gun or beater, is in the line of fire and within a hundred yards. One should never fire at anything on the ground or only a little above one's head if it is between one and someone else – unless that someone else is at least a hundred yards away. And remember, shot spreads widely – a person ten yards to the right or left of the object is in the line of fire.

Another point – which isn't a question of danger – never shoot at a rising bird if it will give the next gun a better shot when it has got going. Above all: all the pheasants in the world aren't worth a lost eye.

There's a good lecture for you.

CB
KCC

To Julian Bell
June 19 1930 La Bergère, Cassis

My dear Julian,
 here is a cheque for £100, which should put you straight I think. With the fifty you had a couple of months ago it brings your income up to about £400 a year – which is as much as I can afford – especially in these hard days. If you look any morning at the financial columns of The Times you will see that the moment is not propitious. Also Quentin & I, who go in here for low living & high thinking, and what is more money-making – at least so far as I am concerned – are inclined to regard you as a mere butterfly, flitting hither & thither with a lady in your car while we take the 'bus'. I gather Quentin has got the copy of verse with dedication to Josephine: so at least you know where you are. I suppose I shall see the rest of your tripos in 'The Times' – if M^{de} Germiny doesn't fail me – she is less likely to do so than you are to write.

Yours, CB
KCC

To Vanessa Bell
November 3 1931 254 S. Gregorio, Venice

Dearest Nessa, I am finally determined to come back to England on the 20th and not before. I shall go straight to Seend – where I fear my prolonged absence is regarded with some anxiety – and stay there two or three days. As one of my excuses is that my flat is let, don't give me away. Also will you tell Grace, and any possible correspondent, that there is plenty of time for letters to be

written and to reach me. I have just finished The Waves which I consider a work of the highest beauty though not above criticism and perhaps sometimes just on the verge of silliness. I don't really care for the purple passages and am glad they are in italics. Also Julian should have corrected her natural history. Does any bird save a sky-lark sing on the wing? Anyhow I swear red admirals and birds' nests are never to be found simultaneously. What does the world say about Leonard's history [*After the Deluge*]? I don't think I shall send for it as I have plenty to read here. Besides I don't read much. We drive about on the mainland – which is still in the greatest beauty – and I have rediscovered Giotto whom I suspect of being the greatest painter of all time. I am more in the mood for pictures than books. Occasionally I make excursions into the colony, which is amazing – more provincial than Seend. Mary [Baker]'s Parisian frocks are stared at with undisguised disapproval and envy; but the fact that she was once engaged to a real English duke shrouds her in a robe of social prestige which hides all blots. The only 'men of the world' are old Leslie Hartley – you know, the one who reviews novels in the Week End Review – a dear old creature who lives here in cosy sin with his gondolier for three months of the year, and one Sir Hubert Miller, who in England is under a cloud, a cloud no bigger than a handsome lance-corporal's hand I imagine. Leslie is my chief ally – a civilized human being who keeps me supplied with reading matter. Then there is Hugh (?) Latimer an extraordinary little old red and white American, who still has a flat in the famous Curtis palazzo where he was rocked on Browning's knee and dandled by Sargeant [*sic*] and Henry James: and the English consul and consulessa and the American, and old Miss Norris who has a wig to make her look like Queen Alexandra.

I hear from Cory that he is recovered at last. If he comes to London for a day or two, as I suppose he will, do you think you and Duncan could invite him to a meal and put in an excuse for me? Also can you resign yourself to Christmas at Seend, for I perceive I shall have to go there to make my peace completely: but it seems hard that the brunt of the peace-making should be borne by you and Angelica.

I get no letters except business-letters, and they of the most pestilent description, so pray stir up my friends – Raymond, Fanny, Francis. I feel sure they have had a good laugh together at my expense, so now they might laugh a little with me. I want to hear all the humours of the election too. I can't help being glad that Julian and Quentin's efforts were not crowned with success: not that I have any love for the national government, but it strikes me

as distinctly the less and less immediate of two evils. What does Maynard say? I'm amused by the fate of the New Party and at William Jowitt's discomfiture – I must say the nerve of that man, combined with a certain Quaker unctuousness, is rather more than I can stomach.

Please write,

Yours, Clive

To Vanessa Bell
Friday June 14 1935 50 Gordon Square

Dearest Nessa, although I have had no answer to my long and informative piece from Paris I write again. Probably you will want to know what's on in London, and unless I write tonight – when I am free – heaven knows if I shall ever write at all. The press of business and pleasure here is appalling and, frankly, rather disgusting. On top of it all, Mary Baker arrives next Tuesday. It will be charming to see Mary – it always is – but I wish she could have arrived at any other time. Besides how much shall I see her in the midst of this Ballyhoo, as Sir Stafford Cripps calls the Jubilee – much to the scandal of *The Times*? Julian came in yesterday evening – looking extremely well, and in high spirits – just off to Ireland for a fortnight. He wants to know who has "power to act for you" because [Augustus] John – who has sold his house in Mallord street – wants to take your studio for a bit. I expect the whole thing had best be left in the hands of Helen Anrep. But so long as [Filippo] De Pisis wants to stay and pays his rent, I presume you have no intention of turning him out. Of course I will do anything you like in the matter; but to deal with John Helen seems to be the person indicated. Julian also suggested that if we go to Cassis later, it might be convenient and possible to borrow Roger's car, which is now at Ethel [Sand]'s. If you think that there is anything in this it would be best I think to make arrangements with Julian who must be responsible for the automobile department of our complicated and scattered lives. The Woolves dined with me last night, and so successful was the evening that Leonard allowed Virginia, without protest, to stay till half past twelve. There was plenty to chatter about, but most of what I heard you will have heard already, or will hear soon from Virginia. As usual, they seemed to be on the crest of the wave; though I'm not sure that Virginia was not slightly annoyed by there having been a

photograph in *The Times* that morning of Morgan [E. M. Forster] presenting the Femina prize to Betty Jenkins. Virginia may be going off to attend a conference of forward-looking writers in Paris next week. For my part, I am going to Seend. Next week is black with engagements; but I hope somehow to see Georges Duthuit. Marguerite, I gather, has been here for a week, on the verge of suicide all the time. Helen and Mary Hutchinson have been driven almost out of their wits: the latter at last took the sensible step of flying to Vienna where Barbara [Hutchinson] is having her tonsils taken out. It all sounded very sudden and rather alarming, but I don't suppose it is the latter. Today I lunched with the Clarks off your handsome service which was much admired by the company[1] – David Cecil and Rachel, Tiny Cazlett, the baroness Bixtin (if that is how one writes it) John Sparrow. It was extremely pleasant, but I am always disappointed by a luncheon party at which one doesn't sit on till four at least. I shall see them again before long. Christabel and Osbert are in the offing – them I shall see at least twice next week. Meanwhile "the court" seems to play a considerable part in the lives of a surprising number of my friends, and I imagine that Jane is not averse from sporting her feathers. London is full of pictures too: magnificent Renoirs chez Lefevre and a fine collection of nineteenth century masters in the cellar at Wildenstein. And then there is a young Canadian in London, engaged on a life of old [James W.] Morrice – to be exact he is in Paris at this moment pumping Matisse – who worries [Gerald] Kelly and myself out of our minds. He is a nice young man, too; but really this retracing of old Morrice's life step by step, visiting every zinc where the master drank and every pisotière where the master peed, seems just a trifle absurd. However, I am doing what I can for him, and will try to put him in touch with Sickert when he returns. Meanwhile he has grandiose schemes for buying the Hermitage Giorgione for the National Gallery, and getting Sam Courtauld made chairman of the trustees: he has bought off coups more surprising. Did I tell you that in Paris an old painter friend, Gerbaud – not the navigator – whom I hadn't seen for ten years, wrote me a note asking me to come and see his pictures. I saw them – they made pleasant seeing – and then he said "Do wait a bit, my wife will be back in a moment, she has only taken the baby for an airing in the Luxembourg gardens." This I took for pure politesse; and then his wife came in, and who do you think she was? – Loulou Vildrac. I had a pleasant evening with Drieu La Rochelle. "I want you to dine with me tonight not too far from the boulevards" said he "because I think something may happen." What did happen was a smart shower

of rain, and when we went out into the streets even the policemen were à l'abri [*sheltering*]. So instead of overthrowing the republic we went to the bal tabarin. It's true France was without a government for a week, and so far as I can judge France could do very well without a government for a year. The left, which is powerful, has been told to keep quiet and support a patriotic government, which will build thousands of aeroplanes; and there aren't any fascists. I saw a good deal more of Derain, who talks, as usual, of coming to London and spending some months at what he calls Chis-wick. Derain reminds me of the ballet – and the ballet reminds me that Maynard is down with the 'flu. In spite of the weather – which is vile – Glyndebourne appears to be a great success, so I hope the Herbert Reads are enjoying themselves. I suppose you haven't yet decided what you are going to do in August and September; do let me know as soon as you have. Oh, by the way, will you tell Quentin that I met [Pedro] Pruna in a bar. Apparently he was in jail – in Spain – but whether for sedition or picking pockets no one seems to know. He looked none the worse for his sufferings, or rather none the better, for he is still as fat as a hogshead of Danish butter. He sent his love to Quentin, and gave me his address. Elsa Lanchester and I are trying to get Lott and Nell into friendly, or unfriendly, rivalry as to keeping <u>down</u> their books.[2] I said to Lott – "I don't think I ought to spend more than Mrs Laughton – there are three of them in the house and she's ten times richer than I am." "Yes, they are rich aren't they, sir, and they're posh people, aren't they?" "Of course they are, Lottie . . . what are you driving at?" "Well, you know, they chip Nell, saying she's come down in the world." "How do you mean, Lottie?" "Well, I mean they aren't aristocratic, like Mrs. Woolf and you and your friends." "How ? ? ? ? ? ? ?" "Well, there aren't any sirs in the family."

Do let me know your news and your plans

C.

Notes

1. The 'Famous Women' dinner service commissioned from Vanessa and Duncan by Kenneth and Jane Clark.
2. Nellie Boxall was the Woolfs' cook until 1934, in which year she went to work for the actors Elsa Lanchester and Charles Laughton. Lottie Hope worked for Clive Bell as cook-housekeeper from 1932–1941.

To Mary Hutchinson
August 12 1936 Charleston

Dearest Mary, I'll send you a bit of good news tonight. I saw
Virginia yesterday: she was in high spirits, fantastical, spiteful,
in fact herself again. I am delighted. She greeted me with 'This
has been an 'annus mirabilis' for me; I picked up sixpence in the
High Street today; that makes five and sixpence since January all
in shillings and sixpences from floors and pavements.' She never
looked back: – how Sybil [Colefax] had explained to her why
Leonard reminded her of Arthur [Colefax] – how Cyril Connolly
was nothing but a "smartyboots" – till finally she settled down
to the pages or postcards she gets daily from Ethel Smythe and
about once a week from Dottie Wellesley and occasionally from
"Christopher St. John" – who appears to be an old Lesbian who
directs a submerged theatre on the south coast – all about poor
old Vita "who has quite lost her face and figure" – to be sure
she has encouraged a heavy cavalry moustache – but whose only
crime in their eyes – for they say nothing about the books she
writes – is that she is so much gone on her sister-in-law, Gwen St
Aldwyn [i.e. St Aubyn]. Have you ever seen her, Lady Aldwyn? I
never saw her but once, and got the impression of a good, solid,
tweedy coated country-woman. I certainly didn't believe Vita
when she said that Gwen was irresistible to men – all save her
husband, who, nevertheless, has had six children out of her. Be
that as it may, Virginia is deliciously herself again; and I strongly
advise you to go and see her – she seems to be expecting a visit. I
feel I ought not to write to you, Mary, lest you should feel obliged
in civility to reply, now that I know what a grief putting pen to
paper is to you. Believe me, I shall be well content with a post-
card. Send me a pretty picture one, obscurely sentimental maybe,
from Chichester, or a photograph of the place in which you are
living; I like to think of you with a background. We have just
had a visit from Grubby [George] Gage. His objects were, unless
I mistake, (a) to slip away from Lady Gage and make a hearty
tea – cakes and scones and honey and all that – which she won't
let him do because he is getting gross, and he is; (b) to tell us how
much he dislikes Maynard's chauffeur, Edgar, who got drunk at
the Flower Show, mounted a small pony, collided with a game
of ladies' stool-ball, fell off and broke his wrist. He hopes I shall
hand it on to Maynard but I shan't; for when Edgar gets drunk,
as he does often and sometimes to police-court point, Maynard is
persuaded that he is being attacked by prejudice and malaria and

gets him off. Oh! Mary, don't lose your taste for books. Someday even you and I will grow old, and then what shall we do if we don't read? I recommend Dick Wyndham's *Gentle Savage* – but most likely you have read it. How those painters can write; and how much better their photographs are than anybody else's. I wish I could put in a good word for Rosamond [Lehmann]'s new novel [*The Weather in the Streets*] – I liked 'Invitation to the Valse' [*Invitation to the Waltz*] – but really this new one won't do – wordy and smart and a bit common I'm afraid. However Elizabeth Bowen admired it, and hers is not an opinion to be tushed away. I'm glad you liked the figs, and I hope you liked 'the thought that prompted the action'. I wish I could say, as B. M. [Bonne Maman, Vita's mother] always said when she bought a few damaged ones in Brighton for Vita to take to Virginia, that they 'came from Thomas à Becket's garden', but they came from Adam's in Bond Street. And figs remind me of Anthony and Cleopatra, which I have just finished. Might I – if you really are so unbookish – recommend Shakespeare? I find him, with Sterne, the most readable of English authors. I am told one can hear Tom [Eliot] on the talkies – an educational film presumably. But can it be true? It was Virginia who told me. It would be worth going some way to see and hear. And, sure enough, I am going to London tomorrow to have lunch with a Mr. Widross from Acton who wants to know about old Clutton Brock's writing. What odd things people do want to know. I may as well stay the night and eat a grouse, so if Tom were showing Didn't you tell me that you were staying in Sussex only for a month? Where do you go next? I like to know dimly where you are. I am fixed here till I have written my lecture, and now Ivor Churchill has thrust the preface to the catalogue on me. I purpose to be a trifle tart. The exhibition will be magnificent, but magnificent with all the old familiar faces. After all there were other French painters in the nineteenth century, and some of them are almost unknown in England. I particularly wanted them to have Chassériau and Géricault, and even Guigon and Huet. Perhaps they will yet. When that is done I dream of flying to the Midi – Toulon perhaps – and sunning myself for a fortnight. I wish you could come with me.

Clive

To Frances Partridge
July 30th 1937 Charleston, Firle, Sussex

Dearest Fanny,
 I liked your letter. Also it was a definite pleasure to realise that
I could ask you and Ralph to take in Janice without a moment's
misgiving.[1] I hope you will enjoy her visit. She is a charming
child and highly intelligent, though New York and her family
between them seem for the moment to have quite destroyed her
self-confidence.
 As you say, it is much worse for Vanessa than for me. My life
is so full of things – mostly vanities – that the hole will fill up.
What I mind most is not that a particular kind of family fun and
good fellowship has lost an essential ingredient for ever; but that
Julian will not get all the good things out of his life which I think
he would have got – for you know his capacity for enjoyment was
huge. But I doubt whether the hole in Vanessa's life will be filled up
ever. However she has Duncan, and two children who are devoted
to her, and painting, which is a great deal more than most people
have.
 You know my plans; and I shall know yours. Is there any hope of
meeting before the autumn? Don't get mumps, nor let Ralph get it. I
am not sure about the baby.[2] There is much to be said for getting it
over young, for it is a horrible illness when one is grown up.

Yours ever, Clive

Notes

1. Janice Loeb's arrival in England for a planned holiday in France with
 Clive coincided with the news of Julian Bell's death in Spain, where he
 was an ambulance driver for Spanish Medical Aid. Clive had hastily
 arranged for Janice to stay with Frances while he hurried to Charleston.
2. Frances and Ralph Partridge's son, Burgo, was born in 1935.

To Frances Partridge
August 22 1940 Charleston

Dearest Fanny,
 would it be possible for you – you and Ralph – to lunch
with me at the Ivy (1.30) either on Monday September 2nd or

Wednesday 4th or Thursday 5th? R. S. V. P. I must say old Gerald Brenan seems to have got himself into a fix.[1] I have written to the colonel [Cory Bell], and I hope a well placed word from him may relieve the situation. Meanwhile, if you have any side-lights to throw on that situation do let me have them. We have been enjoying (I think that is the word) a series of raids and battles, and the neighbourhood is peppered with the wrecks of German planes. If I may judge from what I see the official reports of German losses are not exaggerated. For my part, I enjoyed a good deal more a visit from Raymond and Desmond, which was a pure joy till the last evening when we got into a hot and unprofitable wrangle about the desirability of a negotiated peace. Of course if people really believe that after a victorious peace the whole world would live happily ever after, there is no sense in arguing. Why they should believe it I can't imagine. Every single argument advanced against negotiating I heard between 1914 and 1918. However, on the whole, it was a delightful visit. Do you think it's ever going to rain again? The last war was supposed – by means of gunfire and wireless – to bring it on, but this war is quite different. Don't you think Duff Cooper should be sent back to his prep school? Vanessa is going to London tomorrow to see poor old Helen [Anrep], of whom we have bad accounts. Her school of painting [Euston Road] is no longer there to cheer her. [William] Coldstream, I gather, has got a camouflage job; Graham Bell is in the navy; Fatty [Claude] Rogers – on the strength of his highly successful show in the spring, I suppose – has set up in what is said to be an "extremely fashionable flat in Russell Square" – could it be old Beryl [de Zoete]'s gymnasium? Did you see [Lawrence] Gowing's portrait of Julia [Strachey]? I even fancied you might buy it. I suppose you know that Adrian [Stephen] has a commission in the R. A. M. C. He must look extremely imposing in uniform. I understand he is to have as many half-wits to experiment on as the army can provide, and I am in hopes he will begin at the top. Karin [Stephen], on the other hand, still has a large private practice. Judith [Stephen] and her handsome, stupid young man are honeymooning at Rodmell. She has a scholarship (anthropology) to Brinmair (?) [Bryn Mawr] and is to be allowed to sail next month. Her eagerness to be off is not very flattering to Mr. Leslie Humphreys – but love among the communists is, I dare say, a thing apart. I had three pleasant days at The Camp – the Rupert Beckett's house which Mary Baker has taken – and found Julian Goodman – Morrell as was – much improved and full of bright anecdotes

touching her parents. Also I heard from Johnnie Bowes-Lyons the full and true story of the Glamis monster which amounts to just nothing. He thinks he may have had a younger brother, born cretinous and amorphous – and that the doctor may have made away with him.

Yours, Clive

Note

1. He had got into trouble for being outside with a torch (flashlight) during the blackout.

To Frances Partridge
June 11 1944 Charleston

Dearest Fanny, I wonder whether this letter will find you where the invasion [D-Day] found you. And where may that have been – in Devonshire I surmise. I was moving about the south of England at the time and was not at all incommoded – by which I mean that travelling was neither more nor less bloody awful than it always is. Also everyone seemed to be taking the "greatest event in history" very calmly; and I behaved as well as everyone else. All the same, I speculated a little from the first as to how long it would take the new front to become as great a bore as any other. Can I be right in thinking that a faint film of the dust of boredom already shows signs of settling? Perish the thought! Who knows, perhaps the news will never grow tedious any more than Hamlet does. On the Wednesday I lunched with Raymond – fresh and modest from his African triumph: since Scipio of the name and General Montgomery there has been nothing like it, I understand. You may be sure he was in a fine state of excitement, and even went so far as generously to admit – what everyone knew – that so far the Americans had the battle honours. "Generously" I say, because for months he had been irritating me with tales of the incredible cowardice, unheard of inefficiency, and hopeless lack of stamina of the Americans. The sort of tales that are told at Prep. Schools of unpopular boys – "he wets his bed", for instance. These stories emanate, of course, partly from the Lefties, who consider politeness to Americans treason to Russia, and partly from the French, who are furious with anyone who will not agree that five francs

are worth a dollar. So Raymond is well exposed; and he takes the infection a treat. On Thursday I met Duff Cooper at lunch: he gave a less glowing account of the Algerian politicians – but not of Raymond's success with them. Old Dismond was of the Raymond luncheon-party – the party you should have been at – as well. And at one moment he and I set pretty sharply on the New Statesman. I have shaken myself free of that nest of lice. An impertinence from [G. W.] Stonier was the pretext – the cause, a longing to have nothing more to do with it. Besides I have a couple of little jobs which will keep me busy for the rest of the summer. Oh, talking of bed-wetting, as I was just now, here is something that may amuse you. As you know, Rosie [Rosamond Lehmann] is producing a magazine to be called Arion or Orion – I am not sure which – a magazine which, according to Rosie and her boy-friend at all events, will be so advanced that poor old Cyril-the-sponge's monthly [Cyril Connolly's *Horizon*] will look like a stopped watch. Well, Leonard was asked to contribute. He had written for the Memoir Club some time ago an account of his dealings with a colleague in Ceylon, which we all found extremely entertaining. Well, one of the things that embittered the life of this unfortunate civil servant was precisely this habit of bed-wetting. Leonard dished the story up, altered names and places, and sent it to Rosie. Rosie replied, thanking him effusively for the M.S. but begging him to strike out all reference to bed-wetting. Leonard declined. Followed a letter from Rosie saying that she and "the other editors" (who?) must insist; also that they must ask him to amend his frivolous references to God. According to Leonard, he has stuck his toes in. I shall be curious to see how it all ends. Do you find your friends growing great? Rosie has long been the great female novelist; now Willie Walton – Dr. Walton I mean – is turning into a great musician, Eddy is of course the great B. B. C. producer, "K" [Kenneth Clark] is the great authority on art and town-planning, Mary Hutchinson the great progressive and provincial hostess, Peter Quennell the great lover and Cyril Connolly the great man tout court. Oh! I had almost forgot that only the other day I heard one, Noel Annan, described as "a great reviewer", and Kingsley Martin of course remains the great bore. Probably this only means that I am growing old and sour. Anyhow, I find myself seeking the company of micromaniacs – Duncan, Morgan, Osbert Lancaster and Yvonne Hamilton. Where will it all end – in a bow-window in St. James's Street I dare say. I am now reading a most comfortable book, which will last me to the end of the war or of my life – whichever comes first: The Golden Bough. Previously I had read

a mere précis – a matter of a thousand pages or so; but now I am launched into eternity. If I should outlive it there is always Totemism and Exogamy. Believe me, dearest Fanny, it is happier to be an ignoble smart-Alec than a noble savage. How right Hobbes was. I have to be in London for a couple of nights this coming week to do my duty by the British Council and scramble for three tons of "art-paper". Then I hope to stay here for a bit and write an account of [Renoir's] Les Parapluies. Tell me what you have been doing and what has befallen our favourite topic of correspondence. Also please suggest a date for lunch at the Ivy (say) about the beginning of July.

Clive

To Frances Partridge
Sunday January 20 1952 Charleston

You wrote me a delightful letter, dearest Fanny, full of facts and reflections of the first interest; and what can I offer in return? Valediction. I sail on the 31st and I shall be in London for a day or two before that – sorting things out. I don't know that I have much to sort – packing of course, and trying to prevent the Wayfarers going right off the rails – mixing up my tickets with Raymond's for instance. Otherwise I am, or imagine myself, in philosophic mood – like you – only doubtless you are and I imagine – and besides I am nowhere near Existentialism. Quite the reverse. Life seems to me well worth living for its own sake without hope of Heaven or Hell or even of the universal Welfare State. All this going down with one's black tie on is not for me. One may just as well go down in one's pyjamas, screaming. The point is; one goes down, which doesn't matter; and grows old, which does. That's the respect that makes calamity and I begin to envy my old buddy Eric MacLagan. All this mumbling is probably the result of the weather. It can't be much colder in the grave. And that's another reason for being glad that I'm going to America. God knows it's likely to be chilly without – I can stand that when the houses and trains and public lavatories even are gloriously over-heated. Well, now, what news? None. I can't even shoot straight – that's another provocation to philosophy. Also it raises a practical problem, and I hate practical problems. What does one do in England in the winter

if one can't shoot? Next year I think of taking a leaf out of Raymond's book and going to India; or out of the king's and going to South Africa. You say "I hope they will make a match of it". I dare say they will. It would be what is called "suitable" I suppose. The worst of it is that when people marry – even middle-aged, sensible people – they want to have children: indeed, as often as not, what induces them to marry is that a child is on the way. Now I don't like that. Children, without nurses – and who can afford a nurse these days – seem to reduce intelligent, civilized women to the level of the "workers" – that is of brutes. Angelica? She makes something of life, I admit; but how much less than she might have made, and with what shifts, what contrivances. Besides, what chance has any child born these days of living a rich, civilized life? I am not thinking so much of the atomic bomb as of the egalitarian state, with the lowest common factor of the human mind held up as the ideal. However, as I said, life seems to me worth living for its own sake; and so I suppose it will seem to some in every generation. In case you should think of writing to me in the course of the next two months, here are my plans. On arriving in America, I go straight to Baltimore (-c/o Douglas Gordon Esq., 1125 Fidelity Building, Baltimore MD). There I shall spend a few pleasant days with my friends, and then my troubles begin – Kansas City, St. Louis, Chicago, Cleveland, Washington – lectures. But I expect to be in New York about the beginning of March, and to have three weeks in which to enjoy myself. I might go to Boston for a night or two, to see some friends and the Hoyt exhibition. My address in New York – Century Association 7 West 43rd Street, New York 18. I have just read a longish book that has enthralled me: "Le coup de Decembre 2" by one Guillermin (Gallimard). I don't know whether it would suit you. The author is an extreme lefty – perhaps a communist, though I doubt it. Also, it begins with some rather heavy left-wing sarcasm; but you will soon get through that, and for the most part the story is well, though by no means impartially, told. So far as the drama goes – for the story is a melodrama – the hero is – or at least all one's sympathy is with – Louis Nap [*sic*] in his crossing and double-crossing of the Burgraves. Much to my surprise, Victor Hugo comes out extremely well. There – that's enough.

Clive

To Frances Partridge
August 3 1955 Charleston

The drought is broken, dearest Fanny, it is raining; and everyone
is pleased, except me. The prophets say it will be all right again
tomorrow; but I dread the beginning of the end. Stop a bit – here
is the sun shining and miles of blue sky to the north, and Duncan
says the glass is going up – it never fell very far. Perhaps for once
the Air Ministry is right. So we can change the subject. Well,
now, we are in a sad way at Charleston. Grace [Higgens] has
fallen ill – has been in bed these four days – is better, but I'm sure
ought not to work for a week at least. And the house is full – the
usual inmates, plus Quentin, plus Olivia [*sic*], plus Julian [Bell, b.
1952] plus Henrietta [Garnett, b. 1945]. The last named, I must
say, is helpful and capable and charming to boot. And Julian
makes less noise than he made last year. Also I can't say that I
suffer much myself, unless I consider making my own bed suffer-
ing – I do rather. However life is pleasant in the country this sum-
mer, and my companions are pleasant; though I do wish Olivia
was not always great with child when I see her. Leonard, driven
to distraction by the American biographer (whose name so far
as I can make out, is Miss Pippet) and Vita[1] and by Julian Vino-
gradoff[2] – or, if you want my private opinion, fearing that if the
cream is skimmed tea-spoon by tea-spoon off Virginia's letters
there won't be the looked-for fortune in the "complete edition" –
contemplates publishing two or three volumes of "selected". He
has asked me to look through mine. My dear, it turns out I have
a trunk full; and I must go through them, and do my own select-
ing before I send them on. Well, as you may suppose, they are
brilliant, and scurrilous to a degree. I don't see how any of the
later and more amusing ones can be printed. To be sure, there are
some nice little compliments to her brother-in-law, which could
offend no one; but they might look odd standing by themselves.
But many of the early ones may be just what would suit "Vir-
ginia fans", being about writing and ideas – mostly Virginia's
writing and ideas – and books in general. But God! how touchy
we all were in our young days. I can't remember whether I wrote
to you about a luncheon party with K. and Raymond, Maud
Russell, Janie [Bussy] and Angelica. It broke in two rather, so
that, though I had some good talk with K. and Janie, I had hardly
a word with Maud or Raymond. However I go to Mottisfont for
a long week end on September 16th (my birthday) and perhaps
Raymond will be there. After that Rome – Raphael – and servants.

I wish we could have a few of your 'Donzellas' in Sussex – I would learn Spanish exprès. As I can't remember what I told you in my last letter, I dare not tell you – for fear of falling into the old man's vice – repetition – what K. told me about Benedict [Nicolson]'s marriage and possible complications. But I won't forget: it is amusing. Meanwhile Harold and Vita are off to Florence, where they will appear in full evening dress on the stage of the Signoria at eleven o'clock in the morning, precisely. Poor Janie was charming and clever and keeping her spirits up wonderfully, but she is down on her luck. No escape at all from London this summer, and during Elizabeth's holiday she will be maid of all work. However this coming week-end she goes to Barbara [Bagenal] at Iden, and is looking forward to it "immensely". She is quite right. Barbara may be a nonentity – I don't think she is – but anyhow she is one of the nicest nonentities in the world, as people as unexpected as Willie Maugham and Douglas Cooper have discovered. I wish I had made the discovery twenty years ago; it would have given her a better chance of being appreciated. As you can easily believe not much gossip comes this way. You don't want to hear about the Firle flower-show, or about Moggie's enthusiasms or Grubby's reservations. And I think I told you of old Angus's worries and anxieties. I was sorry to hear that Connolly and his Barbara had finally parted company; it was a pleasure to think of two such disagreeable people afflicting each other. However it took Connolly a long time to rectify his error – the error being that he had jumped to the false conclusion – observing that Barbara had a flat on the corner of Park Lane – that Barbara was rich. A little – a very little – research would have put him wise to the fact that the flat was payed [sic] for by John Sutro. And that, too, was a queer business; for John, as those who should know confidently assert, is quite inapt pour le service. I can't end this letter, as I fear I end most, with a little advice on home-reading; for I read nothing but Virginia's letters and the memoirs of le chancelier Pasquier. The latter I can't seriously recommend, though I read them with a certain half-witted contentment. Really, in his handling of the French language the old gentleman is distinguished to a degree hardly permissible. They would not let him write a leading article in L'Eclairer de Nice. And I suspect he was stupid; at any rate he couldn't see that Talleyrand was intelligent, but attributed his successes to a certain verbal smartness. (Do you remember how Frankie used to speak of "old Tally (as in Tally-ho) Rand (as in randy)"?) Now please write and tell me something of yourself and your

surroundings. Are they really satisfactory. And give my love to Ralph.

Yours, Clive

Notes

1. Leonard had been annoyed when Vita Sackville-West allowed Aileen Pippett to quote from Virginia Woolf's letters to her in her biography of Woolf, *The Moth and the Star*; Leonard himself had declined Pippett's requests.
2. Ottoline Morrell's daughter, Julian, married Igor Vinogradoff in 1946.

To Duncan Grant
10 January 1962 Clos du Peyronnet

My dear Duncan – I suppose this will reach you in Spain, though in England we had become so used to letters taking a week or so to reach their destination – or not reaching it at all – that I almost hesitate to address it to Cadiz. We arrived here yesterday morning, more dead than alive despite the comforts of le train bleu, and I am still half asleep and Barbara is only a little better. However we improve, and so does the weather. Also this flat, lent us by kind American ladies, is positively luxurious though encumbered by innumerable and hideous trinkets and what-nots. But one must not look a gift horse in the mouth. Angelica, as I think you know, suddenly and spontaneously offered to drive Barbara's car to Menton and stay with us a few days. I hesitated to accept so generous an offer. But "I should love it", she said, "and on my way back I shall stop in Paris and see the Goyas". All I could do was to finance the trip. Whether she is coming alone or with a companion I do not know. Her plans are shrouded in mystery. But we are to expect her on Friday or Saturday. I had two weeks between my departure from the clinic and my departure from England; but as during most of that time I was imprisoned by frost and snow there was little scope for convalescence. No lack of visitors, however. Why so many people should wish to converse with a decrepit, ill-washed, unshaven octogenarian passes my understanding. Presumably I am become a "curiosity". Mary was particularly gracious. And then there was a doctor's wife – a St. John's Wood neighbour – who from childhood had cherished a passion for Bloomsbury. And others. But I must cut this letter short.

Barbara is a magnet. Yesterday – the day of our arrival – she slipped out after tea to buy something or other at a shop on the other side of the railway line, and fell in with a young man from the Foreign Office, who had been at Kings, and who this morning paid us a morning call. He brought news of Sheppard who, it seems, having celebrated his eightieth birthday – a luncheon party in his honour in hall – has thrown discretion to the winds, and boasts openly – in the presence of judges of the High Court – of his conquests. He is now living in Roquebrune with his young friend, and his friend's mother – to cook for them. His address is not yet known. I fancy he spends much of his time in Monte Carlo. Barbara sends her love, thanks you for a letter, and begs me to explain that she has been distraught these last six weeks and unable to collect her ideas. I say much the same. But this sheet will at any rate give you our address and let you know that we are still more or less alive.

Yours ever, Clive
Tate

To Mary Hutchinson
9 February 1962 Clos du Peyronnet, Menton-Garavan, France

Dearest Mary, you were good enough to tell me when last we met, that I could write letters. Alas! it is true that I could, but now I can't. I find it an effort to trace out a page. Only in the early morn-ing – between that salving cup of tea and breakfast – am I good for anything – and then I am not good for much. Also I can hear Josephine in the next room bustling about the coffee and crois-sants. Anyhow, I have time to tell you that the infinitely kind Amer-ican ladies who lent us this palatial flat full of hideous objects are returning on February 23rd; and, so on the 20th we purpose to move into a new and, so far as I can judge, comfortable hôtel, Hôtel Paradiso – Quai Lorenti – Menton-Garavan. Please hand this information on to anyone who, you think, might be interested. You may be surprised to hear that the friends of whom we see most are the Graham Sutherlands. I am no great admirer of his painting, but he is an extremely agreeable companion and he takes art seriously. She is a pretty Irish rattle and great fun. We do not entirely escape the attentions of the English colony, but keep their intrusions and invitations within bounds. Picasso has been lying up – unwell; but I believe we shall see him next week – that is if I can face so long

a drive and so late a lunch. I begin by experimenting with Willie Maugham on Monday. But lunch at the Villa Mauresque is punctual and short; and Willie himself – his cigar smoked – goes straight to bed. We have had a visit from Angelica who drove Barbara's car out – alone – and seems to have enjoyed her trip immensely. Angelica fascinates me. (She stayed here five or six days). She is as tough as her mother, and as beautiful. She is immensely intelligent, and far more lively than Vanessa. She is undemonstratif, rather cold, critical and perhaps harsh. She is mysterious. She is as serious as Duncan. I fancy she is Lesbian. But no one knows anything for certain. If I were twenty years younger I should probably fall in love with her and be made very unhappy. We have also had Barbara's daughter-in-law staying for a week (Tim's wife) – a nice young woman – not stupid. I read Elizabeth and Leicester with great pleasure. A thoroughly scholarly work and well written, like all that Betty Jenkins writes. I have also finished the two final volumes of Merimée's Correspondence Général. Someone lent me Paddy Leigh-Fermor's thriller – too much description and too elaborate. Have you read "George"? I thought it brilliant – about as close to life as one can come in writing. And if you have read it – who was "Charles". Jeremy might know. They would have been more or less contemporaries at Oxford I suppose; also Peggy [Ashcroft, Jeremy Hutchinson's wife] would know all the stage gossip. I am short of English news. Perhaps you will send me some. I don't even know whether Duncan is back from Spain nor whether Fanny is still there. Also I have forgotten the number of your house, though not of your flat, and so must address you c/o Duncan. I think he must be back by the time this letter reaches England; or Grace could look you up in the telephone book. There is much more I could say; but instead of keeping this letter open I will write again when I know – or remember – your address.

Yours ever, Clive

<center>⚸ ⚸ ⚸ ⚸</center>

To Duncan Grant
December 23 [1963] 24 Great Cumberland Place W. 1

My dear Duncan,
 I am proposing to send Bush a cheque for rent, and at the same time I propose to give notice from September 29th. For me – but if you wish it, I will add that you would like to continue the tenancy.

My friends and my doctor (who has never seen Charleston but knows what I and my friends think) believe that Charleston is quite unfit for an invalid. The mere drive up or down the lane gives me pain in my imperfectly healed wound. Add: the fact that there is nowhere for me to work except the garden which is not very pleasant in the winter. Add the cold and the draughts. Add water-worries, mud-worries, fly-worries, defective beams and a general sense of desolation. Add Sammy's unwillingness to be helpful in any way I really cannot face another year of it. I shall not send my cheque and notice to Bush till I know your wishes. Will you let me know what they may be as soon as possible? I am very sorry to make so much trouble. But I am at the end of my tether.

Love to Hilton[1]

Clive
Tate

Note

1. Bunny and Angelica Garnett's home near Cambridge.

Index

Page numbers in **bold** indicate recipients of letters

CPSIA information can be obtained
at www.ICGtesting.com
Printed in the USA
LVHW021102170423
744531LV00002B/88

9 781399 515979